— an angel is
nothing but
a shark
well
governed

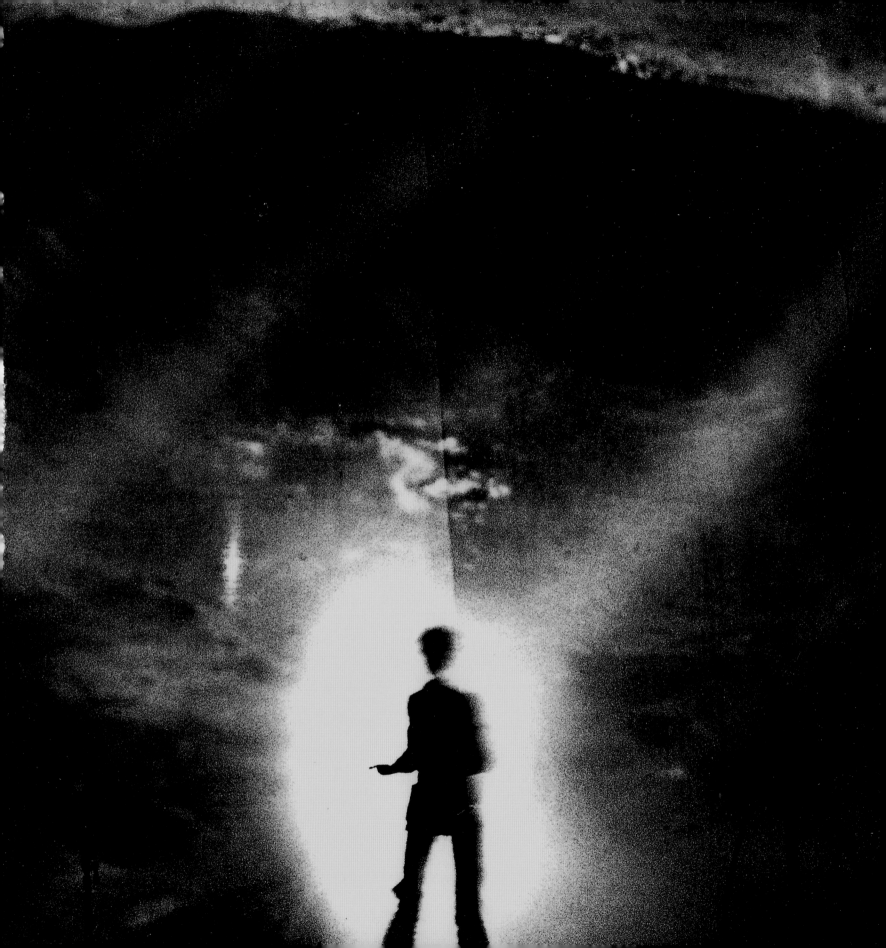

LAURIE ANDERSON

By RoseLee Goldberg

Harry N.

Abrams, Inc.,

Publishers

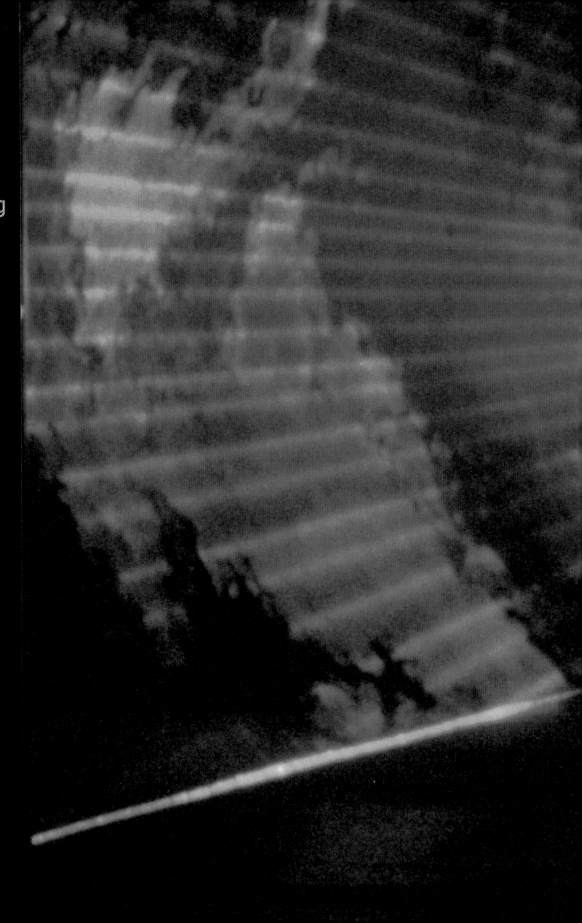

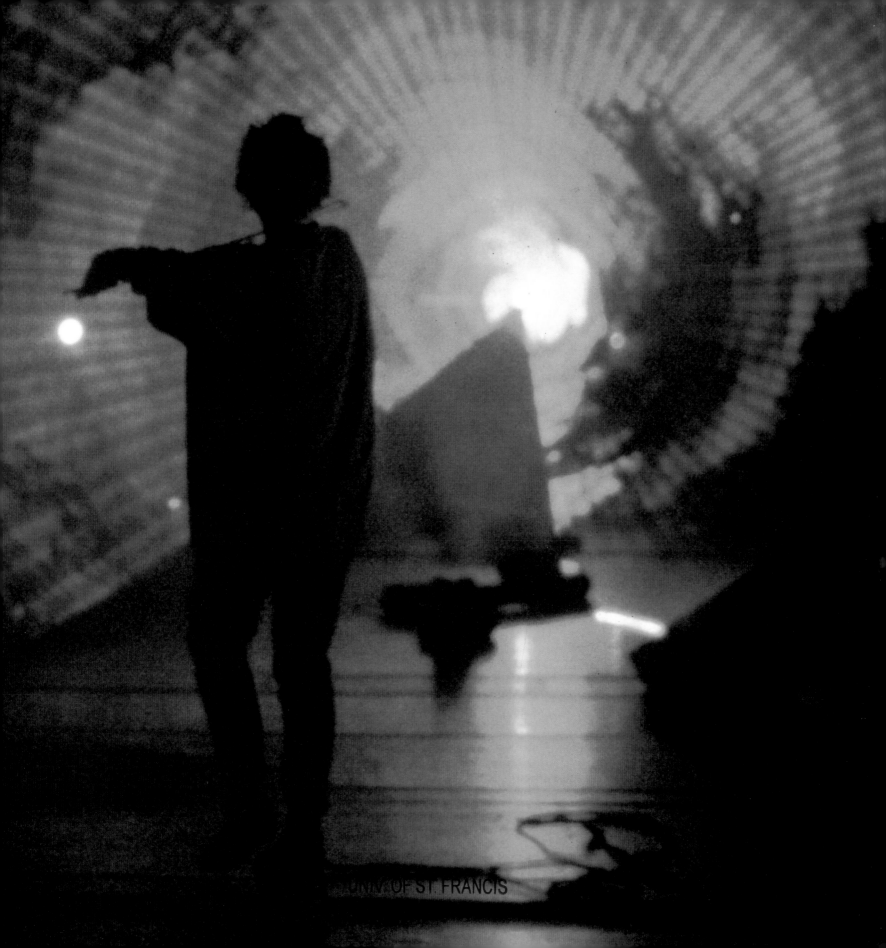

For Dakota

EDITOR: Diana Murphy
ASSISTANT EDITOR: Julia Gaviria
DESIGNER: Ellen Nygaard Ford

Library of Congress Cataloging-in-Publication Data

Goldberg, RoseLee.
 Laurie Anderson / RoseLee Goldberg.
 p. cm.
 Includes bibliographical references and index.
 ISBN 0–8109–3582–1
 1. Anderson, Laurie, 1947—Criticism and interpretation.
 I. Anderson, Laurie, 1947–
 II. Title.

 NX512.A54 G65 2000
 700'.92—dc21 99–044944

Text copyright © 2000 RoseLee Goldberg
Illustrations copyright © 2000 Laurie Anderson
Published in 2000 by Harry N. Abrams, Incorporated, New York

Endpapers: *Working Drawings for "Songs and Stories from
Moby Dick,"* 1999
Page 1: *United States*, 1983
Pages 2–3: Laser tunnel from *Stories from the Nerve Bible*, 1994
Page 4: *O Superman* video, 1981
Page 5: *Stories from the Nerve Bible,* 1992
Page 7: *Songs for Lines/Songs for Waves,* 1977
Pages 8–9: Budapest, 1990

Printed and bound in Japan

Harry N. Abrams, Inc.
100 Fifth Avenue
New York, N.Y. 10011
www.abramsbooks.com

Introduction 10

The 1970s 30

Inventions **64**

Violins **76**

The 1980s 82

Videos **126**

Body Instruments **138**

Stage Sets **142**

The 1990s 146

Art Instruments and Installations **174**

Biography **190**

Records, Films, Videos, CD-ROM's, Scores, and Songs **195**

Selected Bibliography **196**

Acknowledgments **199**

Index **200**

Photograph Credits **204**

"My work is always about communicating."

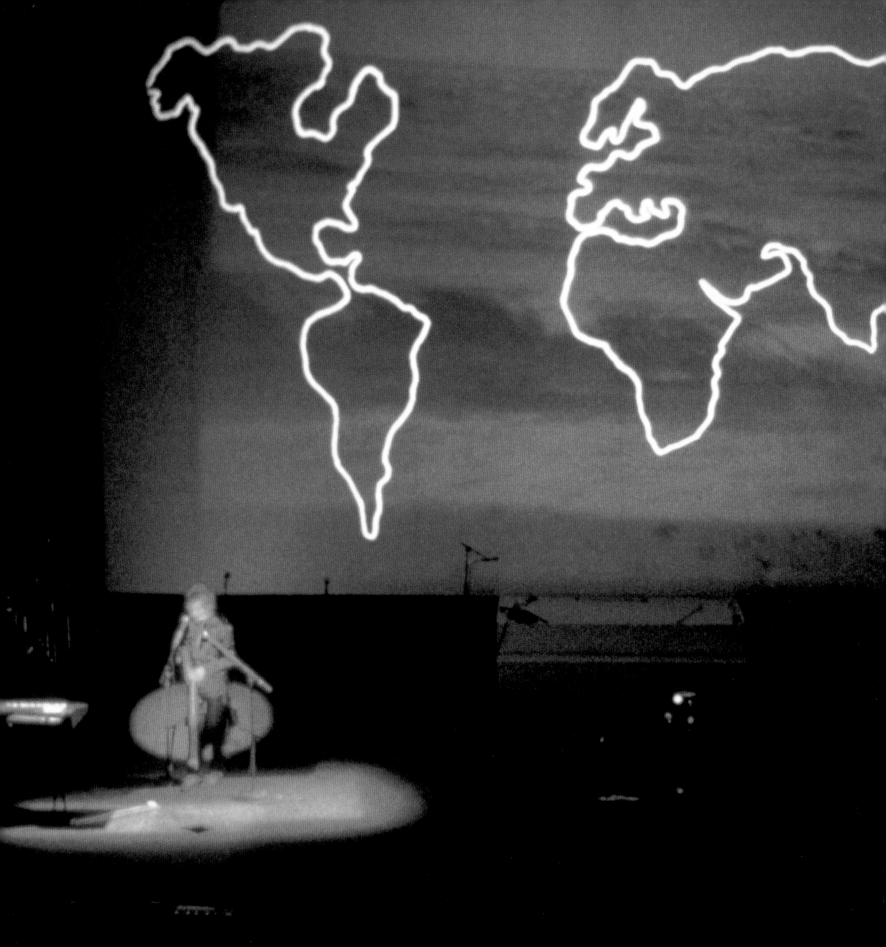

INTRODUCTION

Many of us who saw Laurie Anderson's *United States* at the Brooklyn Academy of Music in New York in 1983 knew that we had witnessed an event of historical significance. Visually startling, featuring an ingenious combination of sound and text, and pieced together with equal amounts of political commentary and intellectual inquiry, *United States* made it clear that Anderson's use of media and her analysis of its role and meaning in American culture would become a yardstick for measuring this debate in the future. Not only did she use a broad range of tools—some classical, like a violin, others custom-built, like a vocoder or a hologram—but the ways in which she single-handedly meshed almost eight hours of material into a large-scale portrait of a country were breathtaking and unforgettable. Most remarkable was the fact that the production was accessible to audiences. It was this achievement, of crossing from avant-garde obscurity into the so-called mainstream without compromising her ideas or aesthetic integrity, that would indelibly establish *United States* in the annals of art history.

Communicating with an audience was Anderson's goal from the start. "One of my jobs as an artist is to make contact with the audience, and it has to be immediate," she has said, an approach that, in the history of "live art," was a radical departure from past tactics. The Dadaists and Futurists in the 1920s and Fluxus artists in the 1960s intentionally provoked their audiences. *Epater les bourgeois*—to shock the middle classes—was an expression adopted to describe all sorts of actions intended to raise questions about the very meaning of art, and to force a reassessment of the practice of everyday life. In her work Anderson chose to affect viewers differently. Rather than shocking audiences to new levels of awareness, she took a far more subtle approach to change their minds. She floated pictures—thousands of them, in the form of film or slide projections—before their eyes and used streams of words, straightforwardly delivered but cleverly arranged and full of surprising observations. "You're walking, and you don't always realize it, but you're always falling," she sang in one song. She used music to stir her audiences viscerally; her melodies, which she found in the regular rhythms of ordinary conversations or in the to and fro of arguments, were matched with lyrics good enough to qualify as poetry. The result was a collection of songs that combined the complexity of abstract discourse—"History is an angel being blown backwards into the future"—with the 4/4 beat of rock 'n' roll.

In *United States,* Anderson transformed herself into a new kind of artist. She exploded the scale of her work by rising to the occasion presented by an opera house, adding technicians as needed to maintain the flow of slides, film, and lights on the giant backdrops behind her. She constructed photomontages of film and slides, collages of pictures and texts, and paintings made of light, in front of which she

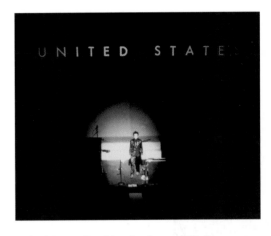

United States. **Brooklyn Academy of Music,
New York, 1983**

OPPOSITE:
United States

INTRODUCTION **11**

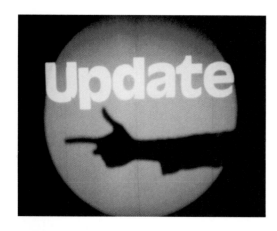

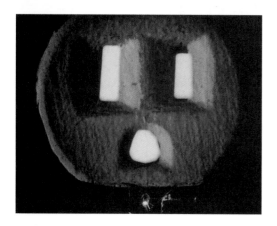

United States. 1983

Thousands of images were projected behind Anderson throughout the performance. Many of them were blow-ups of ordinary household objects or body parts—a wall socket, a pillow, a pointing finger. Their large scale imbued them with haunting and sometimes ominous meaning.

sometimes created shadow puppets with her hands and other parts of her body. She built platforms to layer the space of the stage and employed illusionistic projections that appeared to extend it into the auditorium. She designed original instruments that were marvelous objects in themselves. To top it all off, she played the violin, alternating virtuoso bowing with atonal swoops that wailed through the air like a siren. She coaxed lush orchestration from an electronic keyboard, dense with preprogrammed sounds, added live back-up musicians to further complicate the texture of her music, and littered the stage with additional sound-makers—an accordion, a pitch transposer, a digital echo. All of this while signaling, with the grace of a conductor, to technicians in the balconies and sound booth when to run the slides, projectors, prerecorded tape loops, and floodlights.

By the end of eight hours it was evident that Anderson was indeed an artist of extraordinary talent. She had utilized a variety of media with ease and invented a repertory of her own. She had sashayed between disciplines, creating seamless borders by frequently crossing them, and she had provided an iconography of visual references that would keep art historians busy for years to come—houses, the sea, mountains, dogs, airplanes, telephones, televisions, metronomes, violins, the face of a wall plug, a light bulb, clocks, maps, the American flag, the open road, clouds, sky, the head of a president engraved on a coin. All were distinctly drawn or represented in signature Anderson style, and each held a clue to her storage bank of obsessions: "house" with its reference to home, family, architecture, and her personal stage; "clocks" to time, fast and slow; "presidents" charged with power, sexuality, and mythology; "television" with the politics of control. Each had appeared in her earliest material, whether in the handmade books of the early 1970s or in performances that she toured continuously on several overlapping circuits to American and European art schools, museums, and galleries throughout the decade. And each was a signpost for the future, since every one of them has continued to appear in Anderson's work to the present day.

While *United States* was for Anderson the fruition of more than a decade's worth of work, it also represented the culmination of a unique era in New York. During the 1970s artistic inquiry ran the gamut from conceptual art to body art, land art, performance art, video, sound art, artists' books, and other areas. This great variety provided fertile ground for Anderson's many interests. Downtown artists encouraged one another *not* to choose between disciplines. Composers, choreographers, architects, filmmakers, sculptors, and painters borrowed freely from various media. A work by Vito Acconci, who was originally a poet, might appear uncannily similar to one by a sculptor such as Scott Burton, both of whom made several street-works. A walk by choreographer Trisha Brown, in which she explored gravity by descending the face of a building supported by mountaineering equipment, might complement a huge cut-out in the wall of an abandoned building made by architect Gordon Matta-Clark to emphasize the structure's sculptural quality. This mood of adventurous creativity gave Anderson license to follow as many paths as she pleased, and she produced handmade books, sound installations, film performances, and more.

This generation of artists rejected the aestheticized art object, critiqued the meaning of art, and attempted to find ways to take their polemic concerns far away from the confines of the art gallery and the elaborate system that supported it. All of them, particularly the ones working "live," such as Meredith Monk or Robert Ashley, Joan Jonas or Robert Wilson, set their own terms. They found alternative venues for their work, recorded their own music, and made art especially designed as a vehicle for their varied talents. These artists simply could not think in terms of one discipline at a time. Rather, their creative impulses took visual, aural, and spatial form, and their multidimensional thinking resulted in remarkable works that appealed to all the senses. They had the discipline, control, and impetus to keep all mediums working simultaneously, like a row of plates spinning in the air.

Not only was *United States* a summation of the sensibilities and value system of the 1970s, but it was also a gateway to the 1980s. Artists who were in their mid-twenties in the late '70s—Troy Brauntuch, Thomas Lawson, Sherrie Levine, Robert Longo, David Salle, Cindy Sherman, and Laurie Simmons, among others—had grown up on a steady diet of twenty-four-hour-a-day television, B-movies, fast food, and rock 'n' roll. Now they were pointedly examining the overwhelming effects of media on American cultural and political life as well as on their own day-to-day experiences. The format Anderson chose for *United States,* a large-scale opus, provided an extensive ground on which to lay these issues, and her system of riveting the audience's attention with a continuous flow of images paralleled their method of culling pictures from movies, magazines, or the media and of framing, rearranging, and projecting them to create iconic pictures of the times. These artists were as conscious as Anderson was of current affairs—of the insidiousness of Reagan-era media politics and of the '80s consumer frenzy—and were as determined to include critical reference to it in their work. Like Anderson they juxtaposed references to television's past, such as episodes from "The Twilight Zone," and to its current crop of advertising logos, with fragments of narratives from daily newspapers, creating several layers of meaning in their work—from the literal to the metaphorical. Indeed, *United States,* with its sophisticated manipulation of many media, biblical references, and prescient overtones of a futuristic world commandeered by technology, was considered to be a deeply allegorical rendering of contemporary America. In this context, it holds masterpiece status.

It also holds mythical status, because just one year earlier Anderson had signed a contract with recording industry giant Warner Brothers committing her to produce six albums for the label, a move that would cause a flurry of excitement in the downtown art world. Such a leap into the mainstream was unimaginable before that time, and for an avant-garde artist it was considered something of a contradiction. Many of Anderson's peers responded to her defection with some disdain, and she felt it. "It was considered 'selling out,'" she recalls. Yet hers was a complicated situation. "O Superman," her eight-minute song that had reached the number two spot on the British pop charts in 1981, was compellingly beautiful. It was composed in the context of an art performance, and its popularity took Anderson by complete surprise. The suggestion that she had intentionally created a work for the world of mass

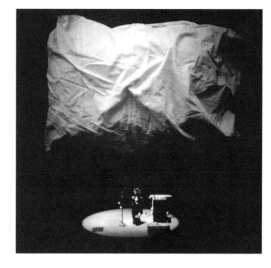

In *United States*, Anderson is dwarfed by a large slide-projection of a pillow, suggesting sleep and dreaming—frequent subjects in her songs and stories.

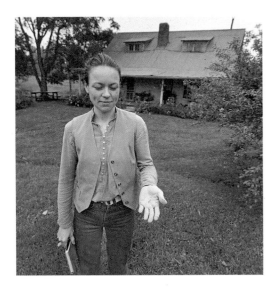

Anderson as a migrant worker in Kentucky, 1978

Anderson frequently took off on unplanned trips—"field trips," she called them— "to see what was happening outside New York, back out there in America. I had no money. No tent. No definitive plans. Just a sleeping bag, a lighter, some Burroughs books. A few packs of Camels." Once she hitchhiked through Kentucky, slept on a roadside, and eventually went home with a local couple who fed her a dinner of road kill. She spent a few weeks with them, working as a hand on a tobacco farm. She eventually used descriptions of incidents and observations from this trip—in particular a recipe for cooking possum—in her performances.

entertainment was entirely inaccurate; rather, its success was an odd kind of proof that extraordinary artwork can transcend categories and reach wide audiences. The mystery of how "O Superman" broke through the barricades separating so-called high and low art seemed unfathomable; it inevitably provoked sentiments of envy as well. Nevertheless, her move inspired many artists, especially those who toyed with mass media as content in their work, and provided a model for them to follow. Some, such as Longo, Salle, Julian Schnabel, and Sherman, would eventually translate their own ambitions to straddle high art and the mass media into Hollywood movies, while performers including Eric Bogosian, Spalding Gray, and Ann Magnuson achieved mainstream name recognition in the 1980s in the worlds of theater and television. "A couple of years later," Anderson notes, "crossing over was looked on more favorably. . . . But by the mid-1980s," she adds, referring to the overwhelmingly consumerist ethos that drove the art world of that decade, "there was no longer much of an avant-garde left to comment on it anyway."

The immediate benefits of Anderson's contract with Warner Brothers were the facilities that financial backing afforded her. She built a fully equipped professional recording studio in her downtown loft, which gave her immediate access, around the clock, to equipment that could instantly translate her ideas into freshly made music. It also allowed her to invent ways of combining lush orchestration and spoken words to form a sound vocabulary all her own. Only her film *Home of the Brave* (1985), which she directed, produced, and starred in, suffered some of the negative effects of '80s excess, since it was far more polished than anything she had done before. Glamorously dressed back-up singers transformed Anderson's conceptual material into finger-snapping songs, musicians in masks and jaunty hats spoofed behind her, and music-hall lighting made the film far more picturesque than might have been anticipated from her earlier work. *Home of the Brave* was not highly regarded as a concert movie, nor was it a commercial success. But it was a training ground for Anderson in digital recording and film, and for several devices that would reappear in future productions, such as electronically controlled stage sets with cables and equipment hidden under custom-built flooring, or her Drum Suit, a percussive outfit with electronic drum sensors sewn into its seams, which produced a big "boom" whenever she tapped her knee or chest or made particularly expansive movements.

Always fearless in the face of technology, Anderson incorporated it into her work from the start, whether film projections, fake holograms, wired mouthpieces, or electrified door jambs. Self-taught, she would invent new uses for old equipment by taking apart cheap electronic objects found in second-hand shops on Canal Street near her loft, and putting the pieces back together again for her own unusual ends. "A lot of my work comes from playing around with equipment, seeing what it will do," she has said. As it was for other artists of the 1970s—Acconci, Jonas, Bruce Nauman—the point for Anderson was to undermine the push toward perfection that high technology proffered, and to treat it as just another tool. "I use technology as a way of amplifying or changing things," she explains. She has also employed it to doctor the most ordinary objects: a pillow has a tape recorder embedded in it

so that one can hear a story when one's head is laid on the pillow; a table is wired so that a poem can be heard when one places one's head in one's hands and then one's elbows on particular points on the tabletop (sound is transmitted through the lower-arm bones); a book's pages are turned by an electric fan. On stage, custom-built microphones change her voice from female to male, human to computerese. Light projections throw her shadow onto building-high backdrops. Neon bows and violins glow in the dark. Stick figures of animals and people run back and forth across the screen, and ideograms of houses, televisions, and airplanes drop in vertically, like rain. But no matter how many electronic filters and computerized devices go into creating this material, the overall sensibility is fragile and fragmented. "Technology," Anderson insists, is "the least important thing about what I do."

The personal, hand-drawn quality of Anderson's work has kept it relevant in the high-tech art world of the late '90s. Artists such as Douglas Gordon, Mariko Mori, Pipilotti Rist, or Sam Taylor-Wood, who use sophisticated mixes of film projection, video, and computer-enhanced photography to create eclectic narrative landscapes, have recognized Anderson's work not only for its pioneering status but also for the fact that she has responded to technological shifts as they occurred over a period of more than two decades, as is evident in her use of equipment, from telephones and answering machines early on, to laser beams, CD-ROM's, and the Internet more recently. For them, her art has held its own because it contains prescient criticism of the media they all use and of the politics that continuously shape and are shaped by it. Anderson understands how media works, both technically and perceptually, on the senses, and she questions the artist's role in colluding with the aesthetics of a "cold, speedy, techno world." "We tell ourselves how to get more and more perfect, more and more in control," Anderson has said. Even "time out" is disallowed in the technological world, she notes. "There's no such thing as digital silence," because "silence triggers the 'disconnect' button." Anderson counters this orderliness with subject matter that underlines human frailty: melancholic and frequently surreal tales of animals, dreams, families, and angels fill her somewhat chaotic and even anarchic universe.

Accelerated media-use in the 1990s attracted a new generation of artists to video and film in numbers not seen since the 1970s. Museums and galleries, responding to the trend, included Anderson in group exhibitions for the first time in almost a decade, signaling a return of sorts for her to the art-fold. Anderson approached the situation with some caution, not least because she found the relatively inconsequential scale of art exhibitions, compared to that of performance, uninspiring. "In a gallery, I need one idea to fill a room," Anderson has said. "On stage, I need five hundred." Her audiences, though, built through years on the music circuit, were thrilled by the opportunity to view the Anderson legend close up, and to spend time with her art objects and instruments, some of which they recognized from stage concerts. Violins displayed on a wall—Tape Bow Violin, Viophonograph—or installations—*Whirlwind* (1996), *Dal Vivo (Life)* (1998)—introduced them to her simultaneously bold and whimsical aesthetic and to her elliptical way of thinking. When the works were displayed in a so-called alternative space, such as Artists Space in New York, her enduring attachment to a 1970s belief

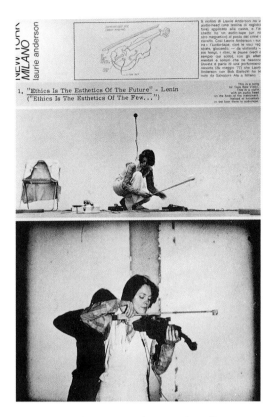

Anderson performing at Salvatore Ala Gallery, Milan, 1977

Anderson traveled regularly to Europe in the 1970s, performing more frequently there than in the United States. "I really felt European," she says, "and when I did things in the U.S. it even felt kind of odd." She traveled light—a case full of violins, microphones, amplifiers, slides, and projectors—stopping off at galleries in Genoa, Amsterdam, Dublin, and "every town in Germany, it seemed, that I had an art school or an alternative space," she recalls. Determined to connect with her audience in each new locale, she incorporated the language of the country in which she performed into her material, reading from cards on which the text had been printed phonetically. "A lot of the material was written for translators," she explains. She also remembers how she responded differently to audiences in each country. "In Dublin I did a lot of work with language because everyone there uses the language so beautifully and so playfully. It's a strong storytelling culture. It was in Dublin that I really heard English as an art form."

system—one that proposed concept over product and a less-formal environment than museums in which to engage viewers—was obvious. *Dal Vivo* was held in an elegant Milan gallery space, and here her desire to function beyond the walls of a gallery was made literal: the piece consisted of a live projection inside the gallery, transmitted via cable from a nearby prison, of a man incarcerated for life.

Anderson's achievement in straddling the art and music worlds is remarkable, especially since, in the end, she belongs to neither camp entirely. Her music fans are often puzzled by her art connection, but they would be no less mystified by her music's complete genesis if they knew it, since it is based in the work of some of the most radically inventive and paradoxical composers of the late twentieth century, from John Cage to Philip Glass and Robert Ashley, with their investigations of everyday sounds and silence, serialization, and language, respectively. The way she makes music from a variety of sound sources also exhibits an obvious empathy for Fluxus artists Charlotte Moorman and Nam June Paik and members of the Italian Arte Povera group, all of whom adventurously collaged instruments from found objects and irreverently "performed" on them as well. Anderson's installations, such as *Chord for a Room* (1973), are also part of a history of art objects made of sound; this lineage includes Marcel Duchamp's *With Hidden Noise* (1916) and Robert Morris' *Box with the Sound of Its Own Making* (1961). The rhythmic undertow of her music shows how much she absorbed the moody intonation of the '70s downtown music scene, which was made up of composer-musicians such as Peter Gordon, Blue Gene Tyranny, and David Van Tieghem, among others, and the smoothly asymmetrical melodies of English musician Brian Eno. While audiences may be unaware of Anderson's distinctive musical family-tree, they nevertheless perceive at once that her concerts—which comprise a diminutive, solitary figure at the center of a large stage flipping knobs on a console with one hand and playing chords on a synthesizer with the other, operating pedals with her feet while turning her head from side to side, speaking into voice-altering microphones—are quite different from the multimedia extravaganzas of rock 'n' roll. Incorporating subject matter such as politics, censorship, and war, as well as references to the eccentric scientist Nikola Tesla or underground filmmaker Rainer Werner Fassbinder, for example, her shows are uniquely disarming as well as intellectually stimulating.

Anderson has an uncanny capacity to make philosophical reflection palatable to a broad public. Without being the least bit patronizing, she merges an intense cultural and political critique with music and visual art in performances that can be read by a wide gamut of viewers—from language theorists and cultural critics to general theater and rock-music audiences. The real vehicle for her thoughts is, of course, language, which she manipulates in hundreds of ways. Words and sentences are cut, spliced, routed electronically through vocoders, pulled backward on a Tape Bow, projected on screens, spoken, and sung; they are filled with meaning and emptied of it with the regularity of waves crashing on a beach. Everyday language—"Hello, this is your mother, are you home?"—is juxtaposed in performance with a large projected shadow of a clenched fist, transforming an ordinary message on a telephone answering machine into an authoritarian threat. More obscure prose—"Language is a virus from outer

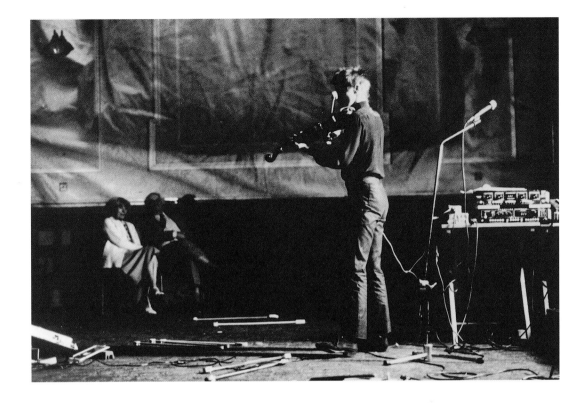

space," a quotation from William Burroughs—accompanied by a "picture puzzle" used in an essay by philosopher Ludwig Wittgenstein is a parody of theorists sung to a seductive rock beat. Even foreign languages are part of her analysis of communication as an elaborate but universal system of codes. When on tour in non-English speaking countries she separates phrases or words into visual or aural modular units to simplify articulation, as in the Japanese alphabet or in the German "sh" sound.

Extensively analyzed by scholars, Anderson's songs such as "Language of the Future" or "Language Is a Virus" have been connected to the writings of several philosophers and linguists, including Walter Benjamin, Julia Kristeva, and Marshall McLuhan. The songs have been interpreted as spoofs on language theories, they have been deconstructed to show the signs and signifiers of postmodern thought, and they have been critiqued as aural samplings of power relationships between the genders. But no one is more aware of the multiple references in her work than Anderson herself. She intends that the viewer pay attention to the way "things pull at each other," to what she describes as the audio and visual layering of each piece, and she makes no effort to disguise her many sources of inspiration. "If You Can't Talk About It, Point To It" (1980) is dedicated to Wittgenstein, while "The Dream Before" (1989) is "for Walter Benjamin." Even though many in her audience might not recognize the names of these heroes of the twentieth-century intelligentsia, they may nevertheless leave a concert humming melodies of songs that have been dedicated to them.

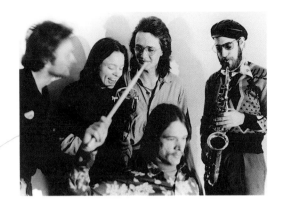

The Fast Food Band performing at the Fine Arts Building, New York, 1975. Anderson with Jack Majewski at left (bass), Scott Johnson, center (guitar), Arthur Russell (drums), and Peter Gordon (sax)

Many artists formed bands in the mid-'70s in response to the seduction of punk music and its assumption that anyone with energy and an instrument could play in a band. The fact that punk bordered on "noise music" and that it was often atonal connected it stylistically to downtown new music art-composers such as Glenn Branca, Rhys Chatham, and Blue Gene Tyranny. Anderson, an accomplished violinist, played in several art-bands and performed at the Fine Arts Building, The Kitchen, and the Mudd Club in New York.

Anderson explains, "'Fast Food Blues' was an interminably long song/complaint about photo documentation":

Just wrap it all up
And blow it up to wall size
Take it to a gallery
And give it to those guys
You'll never see it again
Good riddance!
Good bye

They might also hear the sound of Anderson's voice ringing in their ears for some time afterward. Her cadence and the range of voices she uses—everyone has about twenty, she suggests, the hail-a-cab voice, the telephone voice, the voice of authority (usually male)—are so particular as to be unforgettable. "I think of myself as a speaker," Anderson has said, and indeed her speaking includes the studied pauses and rhetorical punctuation of a riveting orator. "I have never thought of myself as a writer." Rather, she identifies with "a school of writers who work verbally," from the Greek epic poet Homer to the writer-speaker she considers the ultimate modern-day master, William Burroughs, whose voice she heard for the first time at the Nova Convention in 1978 and described as "gravel crunching under a ten-ton truck, plastic ripping in slow motion." Acconci's voice and "the way he repeats himself—he's a kind of one-man loop" inspired her to focus on the sound of her own voice; Acconci had "in turn, of course, read Burroughs." Later, in 1981, Anderson played several club circuits with Burroughs and John Giorno, two originators of American Beat Poetry and its preferred style of live readings. Being sandwiched between such decidedly male sound-makers, whose powerful intonation (even when raised to a high pitch, as was Giorno's on occasion) had a visceral reach, impelled Anderson to invent entirely new voices of her own. "The machismo surrounding Burroughs was thick, and this filter [which dropped the pitch of her voice to sound like a man's] was my weapon, my defense," she has said of the first of many "audio masks" she developed. She mixed these with electronic music, with the human-sounding strains of her violin, and with her own natural voice; she sang, whispered, stammered, yodeled, and cooed. The result was an entirely original approach in which words were *performed;* it was triggered as much by the work of her "spoken-word" friends as by her deep roots in the highly cerebral art of the 1970s and its elaborate investigations of words as an essential material of art.

Like Anderson, conceptual artists of this period such as Hanne Darboven, Joseph Kosuth, or Lawrence Weiner, and "narrative artists" Bill Beckley and Peter Hutchinson placed words, handwritten or printed, on a page or directly on a wall, at the very center of their work. The more conceptually oriented artists isolated, enlarged, and framed words or sentences, allowing each one to resonate as a simple graphic image and as a series of ideas related to perception and experience; the narrative artists used language to infuse pictures with as much meaning as possible, and vice versa. Both styles connected to an extensive history of artists using language, from Duchamp to René Magritte to Marcel Broodthaers, and of artists who employed words as isolated sounds in performances, such as Kurt Schwitters and Joseph Beuys. Anderson's earliest public actions were documented and made into wall pieces in the narrative-art style; for example, *Institutional Dream Series* (1972–73) and *Object/Objection/Objectivity* (1973) comprised large black-and-white photographs mounted on white card-stock accompanied by handwritten texts. She came to her first "spoken performances" by way of such text-based art. "Why flatten the words out [as text]?" she asked. "Just say them. You get so much more information from the voice." That voice would sometimes sound like a disembodied instrument, one more unusual sound-maker among the many custom-built objects she used on stage, and it would become a melodious singing voice when, in the late '80s, she eventually took lessons with a coach. But it was her creativity

in using words in such a variety of ways to construct compelling narratives that held audiences' attention and kept them eager for more. "Basically my work is storytelling, the world's most ancient art form," Anderson has said, explaining, in part, her fans' attentiveness.

Like the Bible, a book of stories she knew well from Sunday school, with its short stanzas and cataclysmic events described with the sparest of language, Anderson's texts are interpretations of the world. She takes up the great moral themes—love, family, community—and expresses her own utopian dreams. "If I were queen for a day," she sings in "Kerjillions of Stars" (1989), "I'd give the ugly people all the money/ I'd rewrite the book of love/ I'd make it funny." She calls on the powerful to attend to the weak—"I've written a lot of stories for nobodies," she says—and for everyone else to pay attention to others, too. "So when you see a man who's broken, pick him up and carry him/ And when you see a woman who's broken, put her all into your arms/ 'Cause we don't know where we come from. We don't know what we are" ("Ramon," 1989). She tends toward "huge ideas, transcendent and transcendental, dreamlike," and it is history, philosophy, science, religion, and the natural sciences that preoccupy her. That she is able to translate Herman Melville's apocalyptic sentiments into a modern idiom, to match his language in *Moby Dick* with passages from the Bible, and so metamorphose a nineteenth-century novel into an awe-inspiring parable for the future is further indication of the complexity of her intellect and of her unrelenting search for meaning. "It's in Isaiah, my favorite chapter," she said of locating Melville's inspiration for the whale, "the dragon that is in the sea." "The whale is the snake and the ocean is his garden," Anderson explains, pointing out also that Melville's line, "Consider the sharks of the sea," echoes one of the most famous passages in the Bible, "Consider the lilies of the field."

Songs and Stories from Moby Dick (1999), her most recent large-scale production, is in its own manner a portrait of America. "I like trying to look at this country in different ways, " Anderson observes, "so I thought, maybe I'll find out something about it from this book." For her, it is an American tragedy that explores themes of authority, loss, and madness; it is also about a search for the meaning of life. Told with the epic gravity of the author's own voice—"one tenth of the text is pure Melville"—and the adventurousness of a modern media-artist—one character wears shoes that pitch him at a forty-five-degree angle, so he is always falling—it is a mix of vivid images extracted from the original novel, such as sharks that turn themselves into circular shapes and start pulling out their own entrails, and Anderson's signature iconography of oceans, clouds, numbers, grids, maps, and turning worlds, all of which appear via front and rear projections of still photos and video onto screens, objects, and actors on stage.

Moby Dick is quite different from Anderson's previous productions, based as it is on an existing book with complex characters propelling the narrative, and since she has actors performing alongside her. Visually it is a transparent, ever-shifting sea of images; technically it is a model of electronic engineer-

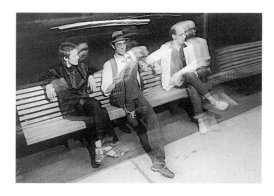

Anderson and the other members of the Blue Horn File, David Van Tieghem and Peter Gordon, New York, 1979

Anderson joined with art-rock drummer Van Tieghem and saxophone and clarinet player Gordon to form the Blue Horn File, a band "at the intersection of pop and classical avant-garde" that was a blend of rhythmic sound gesture, image, and electronics. They often played at the Mudd Club, a favorite late-night venue for artists. Anderson recalls, "I played violin and sang, David played toys and percussion, and Peter played sax and keyboards."

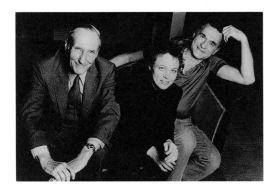

Anderson with William Burroughs and John Giorno at Giorno's loft, New York, 1981

Anderson met William Burroughs in 1978 at the Nova Convention, a two-day festival held in celebration of Burroughs at the Entermedia Theater in downtown New York. The festival included several generations of avant-garde composers, poets, and performers, including Anderson, Merce Cunningham, Giorno, Allen Ginsberg, Patti Smith, Susan Sontag, and Frank Zappa.

Two years later, Anderson, Burroughs, and Giorno performed together in several cities. Each used live performance and the distinctive sound of his or her own voice to draw a picture of the American landscape. "Beat Generation Meets New Wave," the press headlined the sold-out event. *You're the Guy I Want to Share My Money With,* a two-record set of this performance, was released in 1982.

ing. "Absolutely everything is run though a computer," Anderson notes. Yet it is a work in which she continues to develop some of her earliest ideas, particularly in devices such as the Talking Stick, a microphone filled with digital processing equipment capable of producing a full orchestra of sounds, which displays the ingenuity of her Tape Bows and Viophonographs from the 1970s. Other recent objects and installations, such as an electronic book and a live video project titled *Dal Vivo (Life),* show a deliberate reconsideration of past inventions. The former is based on her *Windbook* (1974), a handmade book housed in a simple wood-and-glass vitrine; its pages are blown in either direction by hidden fans. The current version is a digital projection of a book (its pages also blowing in the wind), rather than an actual object, that serves as an emblem for the centrality of the storied text in her work. Similarly, *Dal Vivo* is a large-scale development of a very small earlier piece, *At the Shrink's* (1975). Both comprise film projections of seated people onto cast-plaster figures in the same seated position—identities that are mere cyphers, whose existence is dependent on the act of turning on a projector. In the first version the subject is Anderson herself, projected eight inches tall. In *Dal Vivo* a prisoner in his cell is videotaped and the image is transmitted live (and life size) via cable into a gallery. He is extinguished the moment the current is switched off.

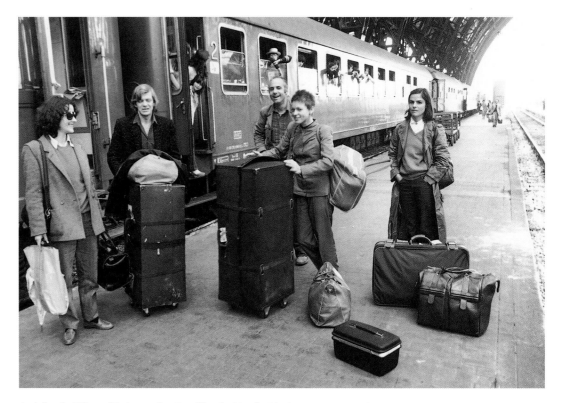

Arriving in Milan with Jacqueline Burckhardt, Martin Diesler, Jean-Christophe Ammann, and Judith Ammann, 1980

These imaginative reinventions of earlier material show the control and flexibility of an artist in her prime. While she uses her own work as a point of departure, these recent objects are not repetitions of ideas but instead show the consistency and discipline of her thinking. They are thoroughly contemporary electronic art works made by an artist who holds her own in the fast-moving stream of new technologies.

**

Anderson has by now entered the pantheon of late-twentieth-century American artists, joining such figures as Jasper Johns, Robert Rauschenberg, and Andy Warhol. Her work captures an essential "Americanness" of American art; it is large-scale, like the place itself, resplendent with images of the flag, the dollar sign, presidents, and maps depicting a vast country with its many familiarly shaped territories. It displays an ironic and carefully articulated nationalism that includes references to the best-known rights of this country's citizens—free speech, liberty and justice for all, the pursuit of happiness. The America she describes is viewed from "off-shore," as she once put it, from above (airplanes and satellites), and with both feet on the ground. She spends as much time on the road as she does at home in New York, and keeps a close watch on the idiosyncracies of a population whose millions are connected, home by home, television by television, as well as severely disconnected by the distancing effects of the same rectangular box. She both revels in and critiques the simplicity of "an entire culture that can be summed up in eight giveaway characteristics," and in *Voices from the Beyond* (1991) she read from a list of "don'ts" that appeared in a government warning distributed to American travelers in foreign ports: "Don't wear a baseball cap, don't wear a sweatshirt with the name of an American university on it, don't wear Timberlands with no socks, don't chew gum, don't yell."

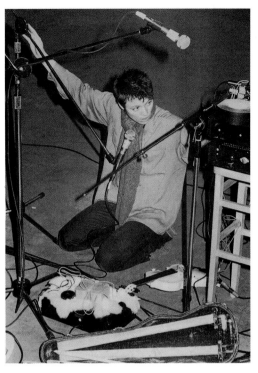

Setting up tech equipment in London, 1981

"The willingness to be a fool, that's what I love most about this country, " Anderson says. "We don't have the same rules as Europeans." Despite the barbs, there is a kindness in her that emerges as a deep-seated humanism, especially when expressed as ongoing social and political commentary. And, indeed, it is in the context of this country and its history that her work is most powerful. At the same time, though, she distrusts the notion of history as an established narrative of significant moments. She is more interested in the ways in which it can be made to shift, so that our reading of it can be completely altered. "What is history?" she asks in "The Dream Before" (1989). "It is an angel, being blown backwards into the future," she offers, referring to Benjamin. "It is a pile of debris." Time for her is long; it reaches way back beyond the biblical age and far into the future. It is also measured in space, which she relies on the sky to express; she metaphorically stretches it across the stage as a kind of permanent canvas on which to project her views of the country. Like Fred Astaire, Busby Berkeley, or Buster Keaton she creates cinematic spectacles; figures made of light, dancing in patterns across a vast plain of a screen, to music that seems to lift performers suddenly into the air as though on a fast-moving current. As do these artists, she draws a visionary, romantic, and pageant-rich America; her performances register the temperature of the time and offer indelible combinations for the eye, ear, and mind.

Roma Baran

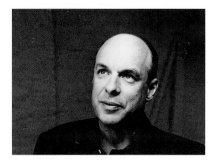

Brian Eno

Bob Bielecki

Producer Roma Baran, musician/composer Brian Eno, and engineer Bob Bielecki are among Anderson's many collaborators who have made key contributions to her work. Others include Robert Coe, Peter Gabriel, Bob George, and Perry Hoberman. Anderson has also collaborated in productions by other artists, musicians, and choreographers such as Trisha Brown, Molissa Fenley, Bill T. Jones, Lou Reed, Ryuichi Sakamoto, Wim Wenders, and Robert Wilson.

Despite Anderson's visibility and her reputation as an important American artist, her body of work is still relatively unknown. Because she cannot be singly classified as a musician, performer, sculptor, or multimedia artist but rather as a combination of all of these, discussion of her material usually appears, in newspaper reviews, for example, under one heading or another, most frequently that of music, the form that she admits moves her the most emotionally. "You rarely see people crying in front of a painting," she says. Yet, to be fully grasped, her work is best discussed in the context of the art world, which tends to expect the unexpected from artists—"I still think like an artist," she has noted—and of art history, which provides the background for understanding the many disciplinary threads that comprise the fine tapestry of her work. The term "performance artist" describes her appropriately, not least because it is her unique contribution to the field that has made it so easy to use the phrase in mainstream journalism. Since it remains hard to define, though, the argument about what to call Anderson comes full circle; the reply to the question, "So what is performance art, really?" is frequently that it is live art by a single artist—an amalgam of many disciplines, including music, text, video, film, dance, sculpture, painting—as in the work of Laurie Anderson.

**

The goal of this book is to present the full range of Anderson's creativity, to fill in the connections between disciplines, and to show her evolution as an artist—as an innovator in the '70s, a leader in the '80s, and a beacon in the '90s. The book's aim is to reveal that it is in the spaces between media, and her sophisticated comprehension of those connections, where the richness of her art lies. Stopping the action, extracting pictures from the many that play at her back, separating words from images, violins from performances, or body mics from her body—things she would absolutely never do, but which are the prerogative of the historian—serves not only to expose the special eloquence of her writing and the ingenuity of her inventions, but also to make evident the scope of an already vast oeuvre. Two hundred photographs selected from an archive of thousands; thousands of words culled from reams of texts and interviews; and explanations of the genesis of individual works have been shaped into a decade-by-decade overview. Not because decades are fixed markers, but because, in fact, these decades feel very real as distinct periods. Especially for those of us who have lived through the changes, it is clear that the '70s were characterized by an emphasis on the cerebral, the '80s exhibited a fascination with mass-media, and the '90s have had something of a global-village atmosphere. The structure of the book also allows the reader to refer to particular aspects of Anderson's art. For example, a section on inventions shows one aspect of her mind at work, and is a mini-manual for anyone wishing to try out some of her inventions on their own. Another on violins highlights the centrality of this instrument and its role as an alter ego and partner in her performances; it also shows Anderson's violins as the beautiful objects that they are, and their metamorphosis over the years into tape recorder, phonograph, or neon sign.

Dancers in Ponape, 1980

As part of a project called "Word of Mouth," organized by Crown Point Press, Anderson and eleven other artists, including Marina Abramovic and John Cage, were invited to participate in a colloquium about art and language on the island of Ponape, in the Pacific. They were welcomed by one of the island's tribal chiefs and attended a memorial ceremony for members of the tribe, which included the roasting of dogs, a local delicacy. Anderson was allowed to film the event. Anecdotes from the trip and film would appear in her performances—for example, footage of the dancers provided a colorful and languid backdrop to several songs in *Stories from the Nerve Bible* (1992).

Anderson with Putra Sukavati, the crown prince of Ubud, in Bali, 1984

Several years after her trip to Ponape, Anderson visited Bali and met with the prince of Ubud. A roundtable discussion with several Japanese art critics was held and touched on topics such as the role of traditional art in contemporary culture.

The energy of her newest projects seems sparked by a realization that she has been thinking about and working with new technologies for close to three decades, and that she has a particular understanding of their role in our current *fin-de-siècle* obsession with the future. *Dal Vivo* and *Moby Dick* read like manifestoes for keeping humanistic values visible in art, even as technology regulates and regiments our consciousness. Her material on CD-ROM's and the Internet focuses on personal predicaments such as writer's block as a means to keep viewers thinking about feelings even as their fingers race involuntarily across keyboards. "Artists have always enjoyed being ahead of their times," Anderson comments, but the speed of developments in new technology and the corporations that spur it on make the race far too fast. "There's a hysteria not to get left behind." Despite the dozen computers and digital equipment of all sorts that fill Anderson's studio, she also insists that she can do without. "I think amazingly beautiful and dangerous art can be made with a pencil. And it's the dangerous part that matters. Avant-garde art questions the mainstream. It's about originality, controversy, taboos." For her part, she half jokes, she is ready to join what she calls "The Lead Pencil Club," which abolishes computers, hardware, software, and fax machines and advocates going back to lead pencils and magic markers.

Women's Action Coalition (WAC) protest, Town Hall, New York, 1992

Like many women in the art world, Anderson was stirred to action by the swirl of political events of the late 1980s and early '90s. Censorship, the power of the religious right, a highly publicized rape trial by a member of a celebrated American political family, and the humiliating congressional hearings of Anita Hill and Clarence Thomas on the subject of sexual harassment galvanized women to form several committees and groups, recalling the energy of '70s feminist action. Anderson participated in a protest evening with WAC at Town Hall in New York. She designed the blue dots that the women held in front of their faces, a reference to the device used on television to hide the identity of rape victims when testifying.

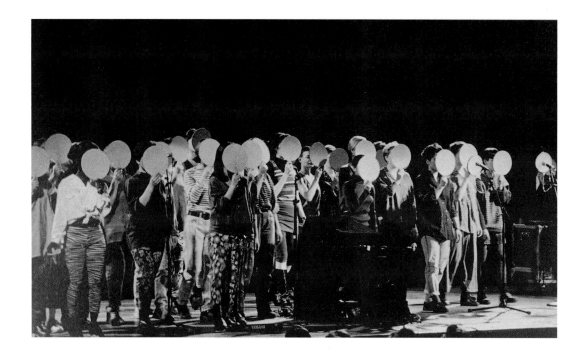

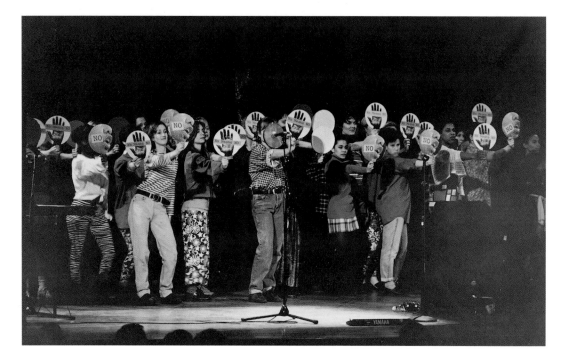

Of Anderson's many talents, her ability to seize the ordinary and make it extraordinary is the one that makes her such a compelling storyteller. It is a form that has preoccupied her since the beginning of her career. In *DEAR READER*, a film-performance of 1974, she referred to not one but three of her favorite storytellers—eighteenth-century author Laurence Sterne (to whom the film is dedicated), Melville (a scene is described as taking place in "the kind of low-ceilinged room that Melville must have lived in when he was a customs inspector"), and Mark Twain (who, like Melville, directly addresses his readers in his stories).

**

Anderson points to the family dining table as the first place where she learned the art of storytelling. All eight children were expected to recount the events of their day to the seated Anderson clan—her father, Arthur; her mother, Mary Louise Rowland; older brother, Christopher; Laurie; twin brothers, Craig and Phillip; brother Thor; and sisters Lisa, Lynn, and India. "All my family are great storytellers," Anderson says. "My childhood was spent listening to other members of the family telling stories about what happened to them. We even have family songs, composed by my twin brothers. Everyone liked playing with words." In their large, modern redwood house designed by their mother, set behind leafy hedges and at the end of a winding driveway—"it was like a country club"—in the wealthy Chicago suburb of Glen Ellyn, most of the Anderson children played musical instruments and were expected to perform for the family audience. "The family was her biggest project," Anderson remarks of her mother, whom she describes as a "wunderkind—a very bright woman who attended the University of Chicago at sixteen," and eloped with Anderson's father, who was her riding instructor, at about the same time. She organized family pageants and sewed elaborate costumes for each of them, as she did on one occasion, when the entire gang appeared at the local Fourth of July parade as members of a circus, some wearing papier-mâché horses' heads around their waists. "We were always a crowd," Anderson recalls. "Ten people. It was quite something to go into a restaurant and just kind of take over the place." While she says that "everything I've ever done seems to be tied to my father," it was her flamboyant maternal grandmother, Louise Edith Orban Phillips Rowland, a Southern Baptist missionary who "practically had the Bible memorized," sewed quaint dresses for the little girls, and led the children to church every Sunday morning, who instilled in the young Laurie a fascination with the theatricality of organized religion. Together they attended Billy Graham meetings in Chicago; of them she remarks, "going forward in groups, getting saved—*that* was real theater."

Anderson sought escape routes from a house always overflowing with siblings and friends in the form of long bicycle rides alone to a nearby lake and, on Saturdays, taking the train to Chicago. She attended classes at the Art Institute in the morning and, a talented violinist, would take her place at rehearsals with the Chicago Youth Symphony in the afternoon. High school provided her with her first taste for public speaking; she ran a campaign for student council, and in 1965, as a member of Talented Teens

***Absent in the Present (Looking into a Mirror Sideways)*.** 1975. Photograph, 8 x 10 in.

From her earliest student work to her most recent performances, Anderson has been intrigued by the notion of an alter-ego—a secondary version of, or replacement for, herself. In this portrait she photographed her face split in two by a mirror.

UNIV. OF ST. FRANCIS
JOLIET, ILLINOIS

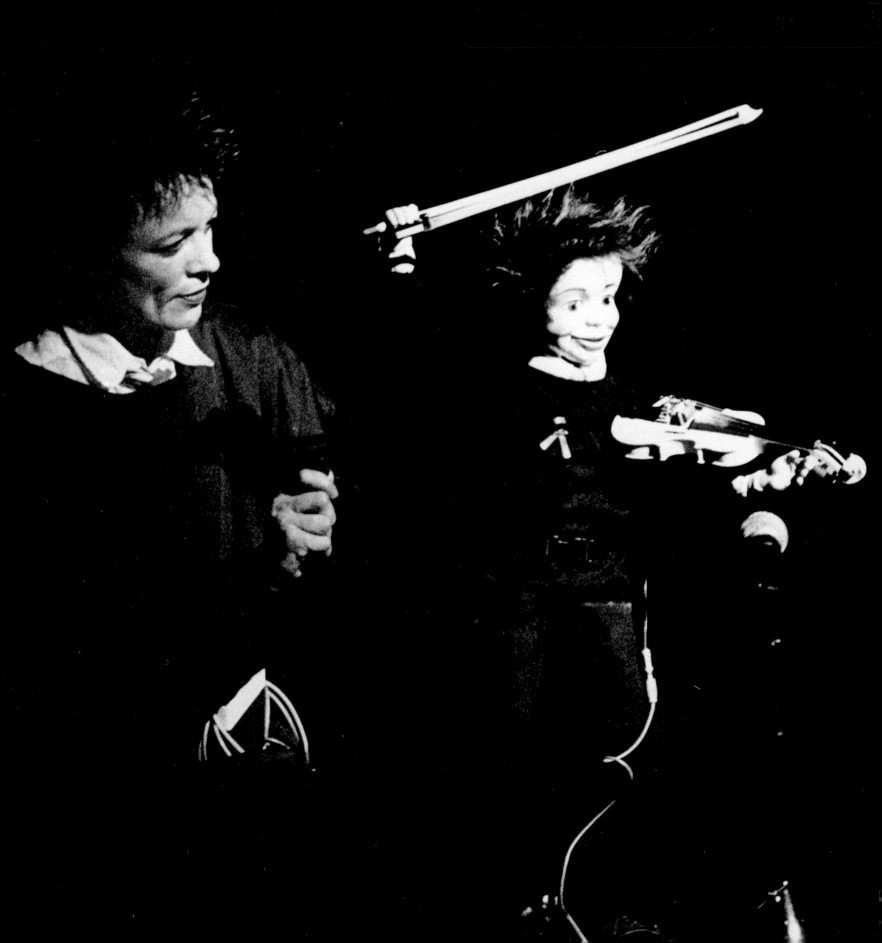

In 1993 Anderson went on a three-week trek in the Tibetan Himalayas with twenty-seven yaks, eight sherpas, and ten other hikers. Toward the end of a grueling walk, she contracted a deathly case of altitude sickness and was carried down a mountain wrapped in a stretcher. She made a remarkable recovery and described the harrowing incident in *Stories from the Nerve Bible*.

USA, traveled to Europe with a group of fifty American teenagers, wearing matching red blazers, to give talks at schools, town halls, and fairs about life in the United States. "My act was a 'chalk talk,'" Anderson says. She would describe "what Americans like to eat, wear, and drive; cowboys and Indians; high school, etc., while [drawing] cartoons on a huge pad of newsprint. Sometimes, what I was saying and what I was drawing weren't always the same."

Anderson left Chicago, her large family, and her violin classes for Mills College in 1965 to study biology toward obtaining a pre-med degree, but a year later she moved to New York City. "It was the exciting place to be," she explains. She was twenty years old and living on 110th street, not far from Barnard College. There she would sit in the darkened lecture halls of the art department, mesmerized by the hum of the speaker's voice and by the bright lights projected onto a ceiling-high screen, which sometimes caught the speaker in its beam. It was a structure that would later become her ideal form for communicating ideas.

**

While writing this book, I would often ask friends, as a way of making sure it would provide a service for readers, what questions they would ideally like to have answered in a volume on Laurie Anderson.

OPPOSITE:

Anderson performing with her violin-playing ventriloquist dummy at WAC protest, Town Hall, New York, 1992

The many violins that Anderson had custom built for her performances were stand-ins for herself, as was the ventriloquist dummy. Designed by Fred Buchholz, the dummy looked uncannily like her and carried its own miniature violin. It first appeared in *Stories from the Nerve Bible* in 1992. On tour in Germany and Israel, the dummy performed in German and Hebrew.

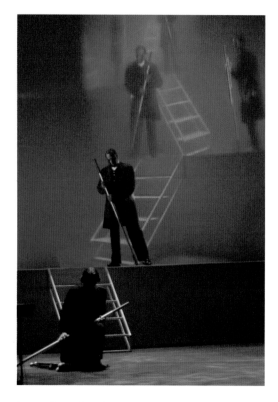

Tom Nelis and Anthony Turner in "Trio," in *Songs and Stories from Moby Dick.* 1999. Prince Music Theater, Philadelphia

In her most recent work Anderson returns to some of her earliest themes and heroes: language, time, memory, art, and illusion, and the author Herman Melville.

OPPOSITE:

Anderson performing violin solo in *Songs and Stories from Moby Dick*

More than once they responded, "What is she *really* like?" and I frequently checked my information against this question. As I wrote, I realized that the privilege of friendship has revealed many personal details, but what it confirmed for me above all is that Anderson is very much the sum of the many parts she presents to audiences on stage. What you see is who she is. Privately, she maintains a Buddhistic calm. She tends to glide slowly across a room, usually in stockinged feet. She is gracious and focused. She is tense and intense. She seems to notice everything but is disciplined about what she voices out loud. She is also completely in control. "Losing control is the worst thing that can happen," she says about the captain of the ship in *Moby Dick.* It is a danger that she well understands, and one with which she plays, like a stunt pilot, whose increasing recklessness must of necessity be matched by more and more control, and courage, in order to soar into the beyond and return safely to the ground once more.

There is very little separation between her life and her art. Once, I walked into her loft and she handed me two violin bows. "Spin," she said, and as I did so, a humming sound filled the room. Not surprisingly, a version of this appeared months later, in performance. Years afterward, we spent a weekend in a very old country-house with low ceilings, lopsided floors, and plaid quilt comforters. Over breakfast one morning she recalled a dream that sounded just like the beginning of one of her songs. "Last night I had this dream," she said. "I dreamed I was a troll doll in a farmer's shirt pocket." It was then that she told me about a special potion for good dreaming—salt and milk before bedtime. Of course this only confirmed what I already assumed, that is, the importance of dreams in her work. What I did not know was that she had devised a way to intensify them so that they would always be a vivid resource for her art.

On another occasion I learned something very personal, and shocking, at one of her concerts. "When my father died," she began. I went cold. I knew Laurie's father, and knew she was very close to him. She'd been on the road; we hadn't spoken in a while. But why had she not told me that her father had died? After the show I said, "I had no idea . . . I'm so sorry." "No," she said with a smile, "he's fine. He's really ok." Perhaps she wanted to prepare herself for the inevitability of his death. She wanted to feel the grief of losing him while he was still alive to comfort her. "I discussed it with him," she told me, "and he didn't mind at all." I never quite understood. Laurie called on January 8, 1999, to tell me that her father had died that morning. He was eighty-eight years old.

See-saw between life and art, art and life; back and forth between the two. Was Anderson really in a plane crash, the one she describes in "The Language of the Future"? Yes, she was, and she actually walked away from it, to catch a connecting flight. So most things are true, and they are more fantastic for being so. "One question that people often ask me," Anderson has said, "is 'Is this stuff actually true?' The answer is yes. Except for the songs, of course. For example, I never really saw a host of angels mowing down my lawn. I don't even have a lawn. It just seems like I do sometimes."

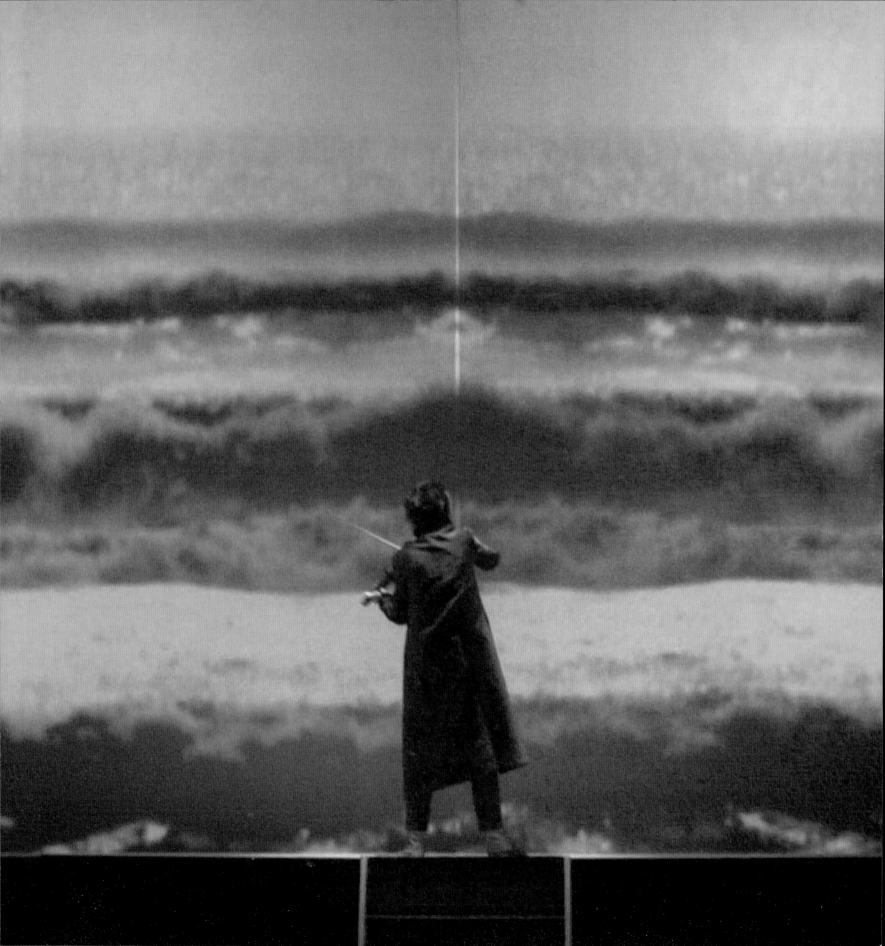

"My goal was never to do the same thing twice."

The 1970s

Anderson arrived in New York City in 1966. An art history student at Barnard College, she would soon become immersed in the politically charged atmosphere of the school and of the adjoining campus of Columbia University. This intensity culminated in April 1968 (just nineteen days after Martin Luther King, Jr., had been assassinated) in an eight-day occupation by more than six hundred students of the main buildings of Columbia. Downtown, the art world was in no less of a revolutionary mood. Events at the Judson Church on Washington Square and in the East Village reflected the political winds of change as much as the cultural ones; choreographers, musicians, poets, writers, and artists made original work that questioned the establishment art system—its galleries, museums, and critics—and the materials of art—whether music, movement, or language. Performances, screenings of underground film and video, and exhibitions took place in loft spaces whose tough industrial setting complemented the edgy aesthetic of the highly conceptual work being produced.

By the early 1970s, when the nationwide political agitation had subsided, artists in New York detached themselves from the machinations of the city at large and withdrew into their distinct community. "Downtown was another frontier," Anderson explains. "It was an alternate side of New York where everyone was hiding." She and her artist friends, including Joel Fisher, Tina Girouard, Philip Glass, Susie Harris, Jene Highstein, Dickie Landry, Gordon Matta-Clark, Richard Nonas, and Keith Sonnier, were very aware of "creating an entirely new scene, of designing a new world as opposed to just rebelling against the old," she says. Referring to the close-knit intellectual and social life that occurred within a compressed geographic location, Anderson adds that this period in New York reminds her of what Paris must have been like in the 1920s—except that New York in 1975 would be in a state of near bankruptcy. "Everybody was so much on the edge that the city falling apart didn't affect us very much."

Many of these artists spent months each year exhibiting and performing in Europe, and observing America from abroad. They watched as the international profile of the United States became increasingly indistinct during a decade in which the impeachment of Richard Nixon, the presidencies of Gerald Ford and Jimmy Carter, and the taking of American hostages in Iran became key markers of an intensely disenchanted populace and of an apparently stagnant government. Nevertheless, it was to New York City, in all its disintegrating glory, that they returned again and again. "It was unbelievably exciting," Anderson recalls. "We had taken a very dark part of the city and made it into something where ideas were everywhere. We really had a sense that we were making something new in a lot of different art forms."

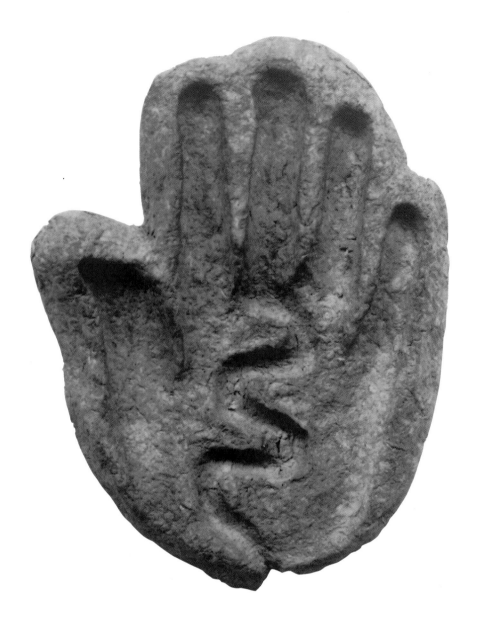

***Handwriting (Mudra).* 1972.**
Pulped newspaper, appx. 6 x 5 x 4 in.

In 1972, while still a graduate student at Columbia
University in New York, Anderson began studying
Buddhist meditation, especially posture and hand
gestures called "mudras," which signify states of
higher consciousness. Working from a book that
described how to form words and sentences with
hand gestures, she created a set of sculpted mudras
from pulped newspaper. "Each day," she recalls,
"after reading the paper, I pulped the *New York
Times*, and shaped it into a single word made from a
hand gesture." Other mudra sculptures she created
include *Memory*, *Prison*, and *Nature*.

In mudra, the sign of a hand means "writing." It
is an iconic symbol in Anderson's repertoire, for it
represents language and communication, both keys
to her work. The way in which the mudra is made—
that is, using her own body—is also typical of her
method of working, as is the fact that the sculpted
object has a highly conceptual component: it is
dense with references—to the content of newspa-
pers with which it is made, and to the meaning of
signs, for example.

PAGES 30–31:
**Several of Anderson's mudras and other
pulped-paper sculptures**

Other sculptures she fashioned out of pulped paper include *March Cancelled*—thirty-one "x's" representing the days of the month—and *Ten Days in May*. "I worked with news-paper," Anderson has said of this collection of work done for her graduating sculpture class at Columbia in 1972, "because it was cheap and because my studio was next door to a newsstand that carried all sorts of foreign and unusual newspapers." Anderson has described these some-what ironic objects—which grew moldy and began decom-posing the moment they were completed—as time-based capsules. They were made from newsprint (the news of the day) and they were calendars (representing the days of the week or the month). In addition, they reflected Anderson's interest in the conceptual art concerns of the period as investigated by artists such as Carl Andre and Sol Lewitt, with whom she would study at the School of Visual Arts, New York, the following year. The recycling of found mater-ial, an emphasis on ideas over finished product, and the ephemerality of art objects were notions that resulted in work of a far more tentative sensibility than was current at Columbia, where the esthetic, according to Anderson, "was that sculpture should be a) heavy and b) made of steel."

March Cancelled. **1972. Pulped newspaper and glaze, appx. 10 x 10 x 3 in. each**
Thirty-one "x's" represent days of the month.

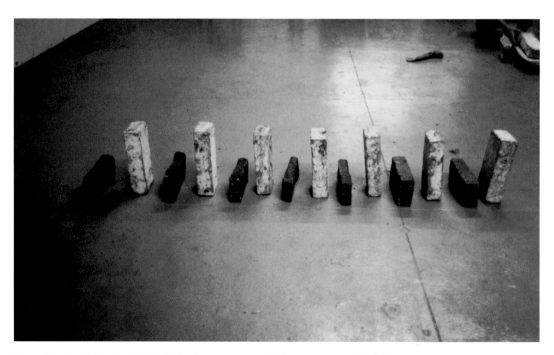

Seven Weekends in March. **1972. Pulped newspaper and glaze, appx. 10 x 5 x 3 in.**
The Saturday editions of the *New York Times* are placed horizontally, the Sunday editions vertically.

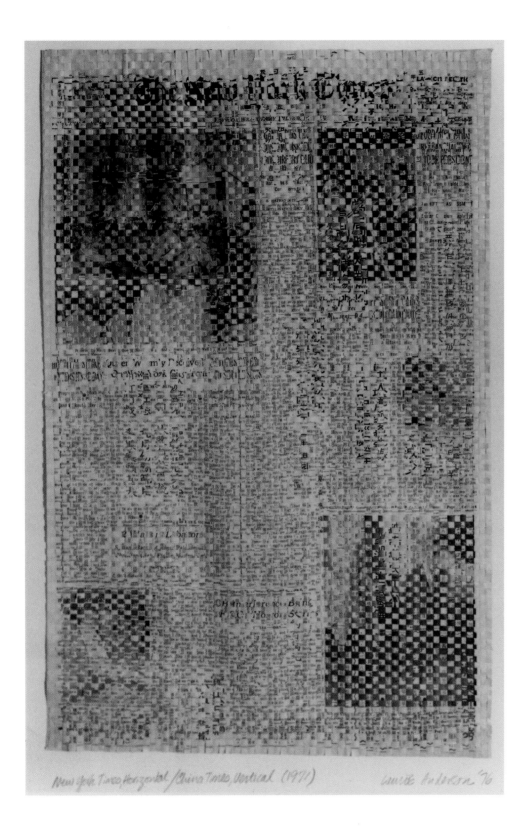

New york Times Horizontal / China Times Vertical (1971) Laurie Anderson '76

New York Times, Horizontal / China Times, Vertical. 1971. Newspaper, 30 x 22 in.

Anderson cut the front pages of the *New York Times* and the *China Times* into vertical strips and wove them together in a witty assemblage of separate cultural identities.

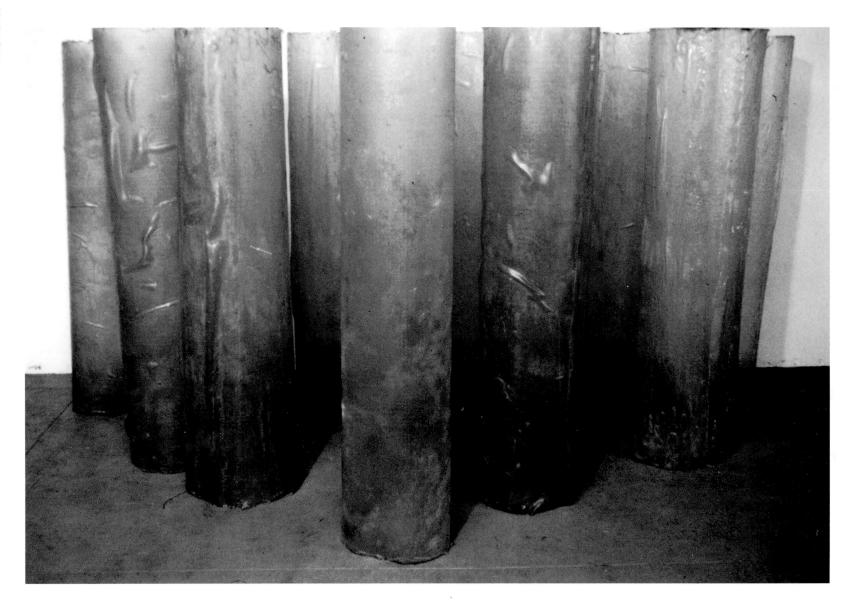

Eight Standing Figures. **1972. Polyester resin.**
Destroyed

Anderson conceived of these tall translucent forms,
reminiscent of sculptures by Eva Hesse, as self-portraits.
They were all approximately her height, 5 ft. 4 in.

Rochester Concert's a Gasser

By TOM SLAYTON

ROCHESTER — (Special) — The unregulated whisper of late summer rain provided the background here Sunday afternoon as the sounds of the automotive age were harnessed in the name of art.

A dozen automobiles gathered on the Rochester town green for, of all things, a concert. Most of the audience, quiet appropriately, sat in automobiles of their own. Almost everyone came to the site of the event, one of the state's prettiest town commons, in their cars.

At Sunday's concert there were varieties of car-door slamming, revs, frantic arm waving direction and horn blasts. In fact, there was a composition entitled "The Well Tempered Beep".

There was also "Hornpipe for Horn and Pipe," "Concerto for Landrover with Six Cylinder Backup", and (of course) an "Auto Da-Fe", which was described as "six-part fugue for the well fueled heretic".

Perhaps it was an unwitting commentary on the extent to which the external combustion engine has come to dominate life in even rural America. Perhaps it was a headache to local people who had to put up with half-an-hour of beeping, car-door slamming and laughter.

It was certainly a half-hour of good fun in the rain.

New art forms are never accepted when they first make their appearance. Sunday's gasoline concert may have been the beginning of a trend. Or maybe even the end of one.

If people can learn to laugh at themselves, they must be healthy. Now with automobiles in the saddle and driving mankind, we become blessed with an age that would love to be linked to the atom or even the stars — but has so far shown much stronger ties to the gas pump. If we could but learn to laugh at the automobile — that undercover mainstay of our society — we might regain the health we've lost while sitting down and rolling from place to place.

The organizers of the concert are members of a group called the Rochester Horn & Engine Society. Headed by one Ms. Laurie Anderson, they declare that "car horns have dimensions other than noise pollutants and nerve irritants."

The new-forms society notes the automobile has now invaded the farthest-flung reaches of human endeavor. But they add:

"We do not aim to bring urban sounds to the country, but simply to bring some order to this ever increasing stream of sounds."

And who could be upset at that?

Trumpet on, o Horn & Engine Society. There's a wry smile in your manner that's worth all your noise and bother. Perhaps Auto Triumphant can be conquered. Humanity may yet win the battle of the highway.

(Herald photo—Slayton)

Performers Are Ready at Rochester Concert.

An Afternoon of Automative Transmission. Town Green, Rochester, New York, Sunday, August 27, 1972, 3 p.m.

Anderson formed the Rochester Horn and Engine Society with friends Geraldine Pontius and Peter Schneider to "explore the musical potential of the automobile horn." Utilizing a local custom—audiences in Rochester traditionally blew their car horns to applaud summer concerts on the town green—Anderson reversed audience and performer locations by seating the audience in the park's gazebo, usually the stage, and the performers with their "instruments"—automobiles and trucks—on the surrounding grass. The concert featured "The Well-Tempered Beep," "Concerto for Land Rover with Six-Cylinder Backup," and "Auto-Da-Fé."

(LA) "Since most of the thirty driver/musicians didn't read music, the scores were designed as color bars, one color for each type of vehicle. The bars were printed on large cards that were propped on the musicians' windshields. I conducted the piece by holding my hand over the color bars on the cards to indicate the duration of each note."

Anderson's outdoor "concert," with its humorous use of the sounds produced by objects not ordinarily considered musical instruments, has precedents that reach back through twentieth-century art history. The Italian Futurists, for example, recorded radio programs consisting only of the sound of running water. A Futurist concert held in Baku, Russia, in 1922 most closely resembled Anderson's car concert: it consisted of an "orchestra" of factory sirens, whistles, and a choir, which Arsenij Avraamov conducted from a factory rooftop. In the 1960s several sound pieces were made: Robert Morris created *Box with the Sound of Its Own Making* (1961); Fluxus artist George Brecht scored a work for car sounds, *Motor-Vehicle Sundown Event* (1963); and Robert Rauschenberg built *Soundings* (1968), a thirty-six-foot-long wall piece that emitted electronic sounds and light in response to the movement and noises made by viewers as they passed by.

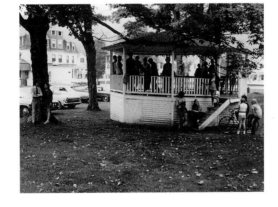

Night Court, 100 Center Street, December 29, 1972,
10:30 p.m.–1 a.m., from the *Institutional Dream*
Series. 1972

Anderson's interest in dreams and their connection to place
began, she relates, when she dozed through art-history
lectures at Columbia University and became intrigued
by the merging of nineteenth-century imagery with her
ordinary daydreaming. Working with her friend Geraldine
Pontius, then an architecture student and photographer,
Anderson set out to sleep (and dream) in public places, and
to record the changes in dream content that she believed
were the result of the various locations. She wished, she
says, to see "if the place can color or control my dreams."
Her sleeping and dreaming in public was not unrelated
to street works by other artists at the time, such as Vito
Acconci, Scott Burton, or Joan Jonas, many of whom
participated in Street Works I–IV, a festival held in down-
town New York in the summer of 1969. References to
dreams and dreaming appear in many of her songs and
certainly in all of her performances.

100 CENTER STREET
NIGHT COURT

DECEMBER 29: AT 10:30 P.M., GERI AND I
SIT IN ONE OF THE PEWS IN THE LARGE, BRIGHTLY-
LIT WOODPANELLED ROOM. DEFENDANTS AND
THEIR FRIENDS SLOWLY FILL THE COURTROOM.
 A WOMAN NAMED CANDY OR SANDY SITS
NEAR US. THE FIRST CASE IS #80,254: ROBBERY
AND ASSAULT.
 I CLOSE MY EYES, MY HEAD NODS DOWN, AND
EVERY TIME MY BODY STARTS TO SLUMP, I JERK
MY HEAD UP. MY EYES ARE CLOSED FOR A PERIOD
OF ABOUT 15 CASES, OR 45 MINUTES. DURING
THIS TIME, I HAVE THE IMPRESSION THAT
DARK CLOUDS ARE SCUDDING THROUGH THE
COURTROOM ABOUT TWELVE FEET FROM THE
FLOOR. WHEN I WAKE UP, I REALIZE THAT
THIS IMPRESSION IS PRODUCED BY THE PEAKED,
KNIT CAP I AM WEARING WHICH, WITH MY
HEADS PERIODIC BOBBING, ALTERNATELY
OBSCURES AND REVEALS THE BRIGHT LIGHTS
WHICH HANG ABOUT TWELVE FEET FROM THE
FLOOR.
 SUDDENLY A GUARD LEANS OVER AND
TAKES GERI'S CAMERA. HE HANDS IT TO THE
JUDGE WHO SAYS THAT "BLACKMAIL WILL NOT
BE TOLERATED IN MY COURTROOM. LET THE RECORD
SHOW THAT THE FILM WAS CONFISCATED."
(APPARENTLY, SEVERAL DEFENDANTS THOUGHT WE
WOULD THREATEN TO SEND THEIR PICTURES TO
THEIR EMPLOYERS – IF THEY DIDN'T PAY US OFF).
 THE JUDGE WHISPERED TO GERI FOR SEVERAL
MINUTES. SHE TOLD HIM SHE WAS TAKING THE
PICTURES BECAUSE SHE WAS STUDYING SPATIAL
HIERARCHIES AT COLUMBIA SCHOOL OF ARCHITECTURE.
 HE SAID THAT STANFORD WHITE, WHO DESIGNED
COLUMBIA, WAS SHOT IN MADISON SQUARE GARDEN
BUT THAT, IN HIS OPINION, THEY SHOULD HAVE
GOTTEN THE ARCHITECT OF 100 CENTER STREET
INSTEAD.

Women's Bathroom, Schermerhorn Library,
Columbia University, April 3, 1972, 1–4 p.m.,
from the *Institutional Dream Series.* 1972

(LA) "I lie down on the couch where I can see the women
coming in and out of the bathroom. I put a notebook over
my face and place my contact lenses under my tongue.
I dream that the library is an open-air market and all the
stacks are stalls stocked with vegetables."

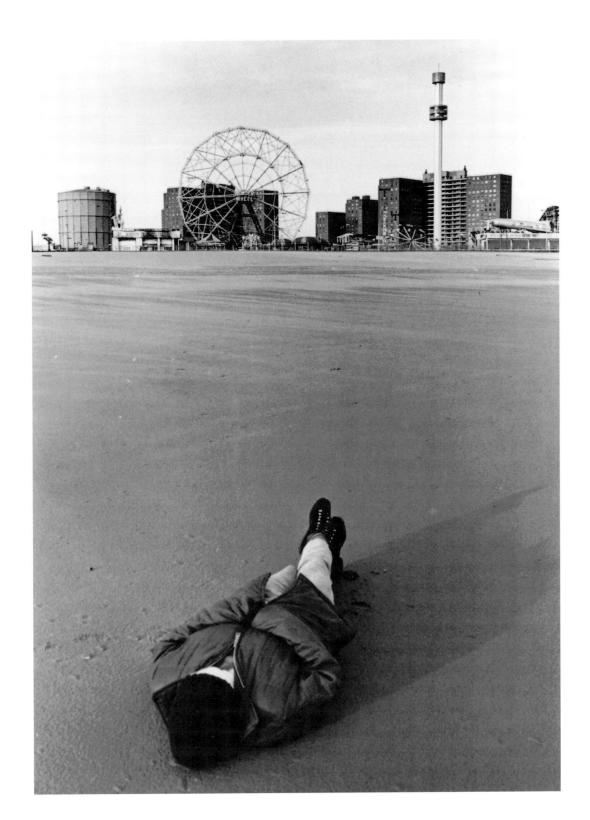

Coney Island, January 14, 1973, 4–6 p.m.,
from the *Institutional Dream Series*. 1973

(LA) "I lie down near the water, which is at low tide.
It is bitterly cold and the sand is damp. I pull my turtleneck
sweater over my face. After several minutes I begin to
relax and lose consciousness. I am trying to sleep in differ-
ent public places to see if the place can color or control my
dreams. At the moment this seems like a crazy idea. I can
hear the tide coming in. The water is beginning to cover
my frozen feet. I'm not sure whether I'm asleep or awake
so I keep my eyes shut tight.

"After a couple of hours, I hear a loud rushing drone.
It sounds like a giant wave is rolling toward shore. I jump
up and start to run. A large helicopter is hovering directly
overhead."

Anderson referred to this work sixteen years later, in the
performance *Empty Places*, 1989:

"Last night I dreamed I died and that my life had been
rearranged into some kind of theme park. And all my
friends were walking up and down the boardwalk. And
my dead grandmother was selling cotton candy out of a
little shack. And there was this huge ferris wheel about
half a mile out in the ocean, half in and half out of the
water. And all my old boyfriends were on it, with their
new girlfriends. And the boys were waving and shouting,
and the girls were saying 'Eeeeeek!!' Then they disappear
under the surface of the water and when they come up
again they're laughing and gasping for breath."

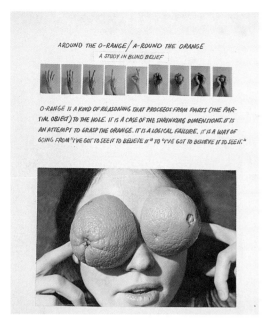

AROUND THE O-RANGE / A-ROUND THE ORANGE
A STUDY IN BLIND BELIEF

O-RANGE IS A KIND OF REASONING THAT PROCEEDS FROM PARTS (THE PAR-
TIAL OBJECT) TO THE HOLE. IT IS A CASE OF THE SHRINKING DIMENSIONS. IT IS
AN ATTEMPT TO GRASP THE ORANGE. IT IS A LOGICAL FAILURE. IT IS A WAY OF
GOING FROM "I'VE GOT TO SEE IT TO BELIEVE IT" TO "I'VE GOT TO BELIEVE IT TO SEE IT."

O-Range. **1973. Artists Space, New York**

O-Range was Anderson's first exhibition in New York City.
Chosen by Vito Acconci for the *Artists Select Artists* series,
Anderson showed unframed panels featuring handwritten
texts and black-and-white photographs, in the style of con-
ceptual "documentation." They incorporated references to
studies on perception by Merleau-Ponty and others, which
had so intrigued Anderson in a philosophy class she took
with Arthur Danto at Columbia. "For the duration of the
exhibition," Anderson has recalled, "I left my contact lenses
on the window-sill of the gallery and spent three weeks with
20/800 vision." It was her way, she said, of further testing
the way the eyes and brain actually see.

O-Range. **1973. City College, New York**

O-Range was also a large-scale sound work Anderson
created in response to a "giant piece of architecture, a
stadium." It took place in the Lewisohn Stadium at City
College, New York, where she was teaching at the time,
and involved ten of her students shouting stories through
megaphones across an empty field.

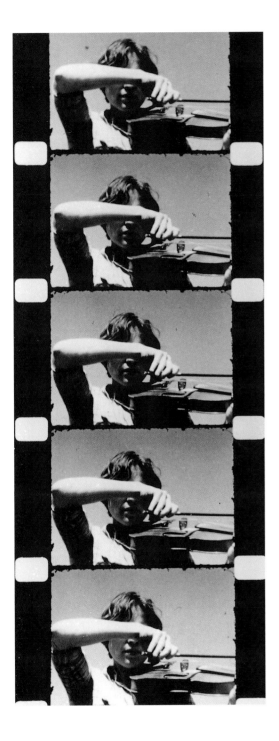

O-Range. **1973. Film, 5 min.**

Anderson also made a short film, which was on a loop
and was projected onto a wall in the exhibition *O-Range* at
Artists Space. It showed Anderson covering her eyes with
her arm, and continued the theme of blindness that ran
throughout the show.

Two Men in a Car, **from *Object/Objection/Objectivity.***
1973. Photo-narrative installation

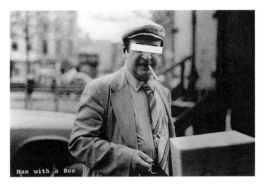

Man with a Box, **from *Object/Objection/Objectivity.***
1973

This was a street work that Anderson turned into a photo-
narrative installation in a gallery. It began on the Lower East
Side of New York, when she took portraits of nine men
who made comments to her as she walked down Avenue A.
"As I shot the photograph, I realized that photography
is a kind of mugging, a kind of assault," she has written.
Revenge was not so sweet however, since most of her
harassers, Anderson reported, "seemed pleased and flat-
tered that I wanted to take their pictures." Included in a
touring exhibition, *C7500*, organized by critic and women's-
rights activist Lucy Lippard in 1975, the work is often
referred to as a feminist document.

Anderson was always fascinated by bookmaking. Like many artists at the time, such as John Baldessari, Ed Ruscha, or William Wegman, she considered books as art works that had an irresistible immediacy; they could be self-produced and easily distributed to an interested network of people, at little cost. Like her close friend Joel Fisher, whom she had met in 1972, Anderson also made her own paper. Her books, which comprised handwritten pages stapled together, functioned as simple storyboards for performances or as clever objects in themselves. Turning the pages of *Handbook* (1974), for example, a hand-sewn work of seventy-five 9- by 11-inch pages, the reader is actively engaged in both a physical process and a conceptual game. In order to "read" the book, which is a single continuous sentence, one must keep turning the pages. "The important thing," it says, "is to keep turning," and as one does so, phrases explain how the book works; for example, "The recto side of this page . . . is the mirror image of its verso," or "By now turning . . . has become a habit." This process of turning the pages involves an interactive connection to paper and ideas, and talks directly to the reader in the same tone as many of her performances. The style and shape of these early books also became the prototype for some of her later publications, such as *United States* (1984).

Anderson applied her drawing skills to single line, diagrammatic renderings as well as highly detailed, naturalistic etchings made with fine crosshatching. Her abilities were employed to great effect in counterculture publications such as *The Street Wall Journal* (1969), or in a small children's book, *The Package*, which she wrote and illustrated, and which was published by Bobbs-Merrill in 1971. She also made a set of photocopied books called *Light in August* (1974), which documented the objects stolen from her loft when it was broken into that summer. "The books were visual lists of some of the things I lost," she recalls. "On each page there is an image of Dürer's *Melencolia*, the angel of depression; a single object in the print is highlighted in red to correspond to one of my lost possessions."

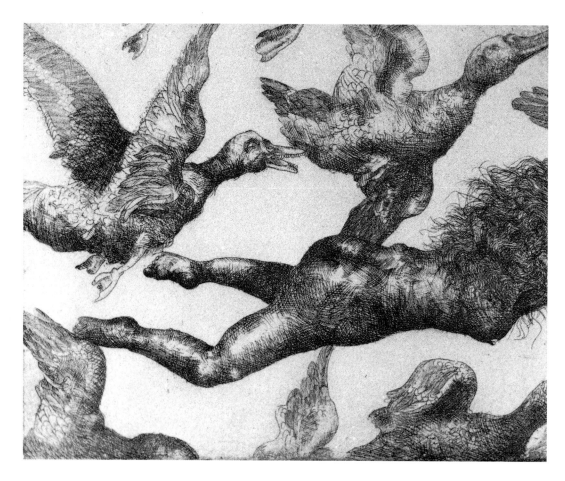

Flying Geese. 1971. Etching on paper, 4 x 4¾ in.

This limited edition of a student work shows the virtuosity of Anderson's drawing and etching techniques.

color tv set

Light in August. 1974. Book, 11 x 8½ in.

tools

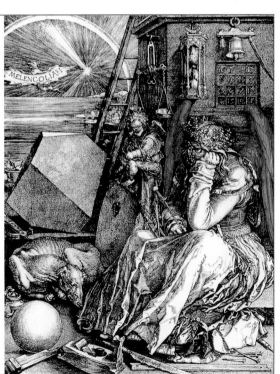

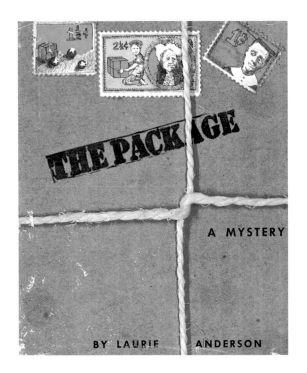 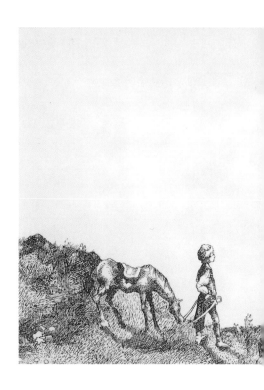

The Package. **1971. Book, 5¼ x 4½ in.**

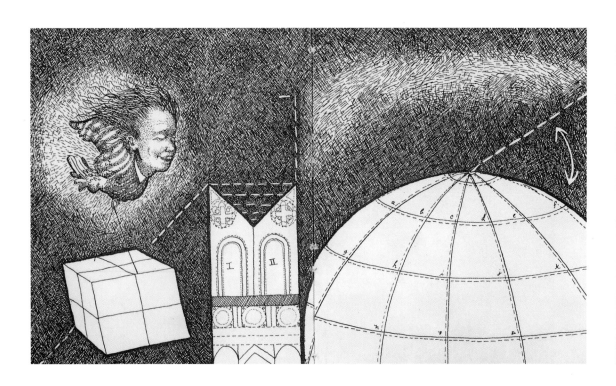

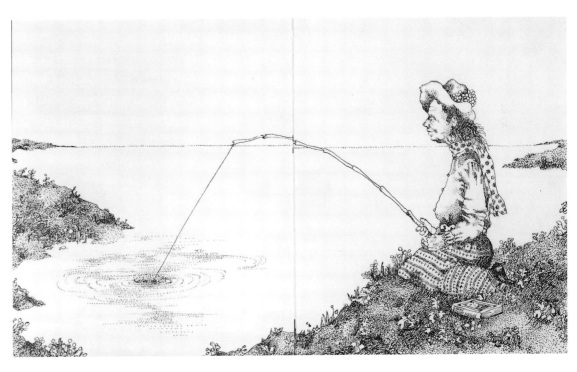

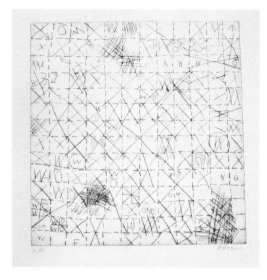

Cancellation. 1972. One of a series of etchings on plastic, 36 x 30 in.

"I have always kept . . . detailed accounts of all the important things that happen," Anderson has said of her many diaries, excerpts of which appear regularly in her books, stories, and songs. The writing process helped her "think more concisely," she adds. As a student she wrote several monthly diaries in which she restricted herself to one sentence a day per page. For example, *October 1972*, a privately published handmade book, 9 x 11 in., included the following observations:

On Canal Street, I do not understand the sexual pantomime
of the dog trotting by my side.
October 1

In New York, a rubbery rain is falling.
October 5

On Church Street, I decide to name my daughters
Luncheonette and Delicatesse.
October 7

In my dream, Eva Hesse's husband tells me how half her
face slid off and how her brain dripped like acid into a
paper cup she kept pinned to her neck.
October 18

At my desk, I feel the radio waves vibrating in the wood.
October 21

In my memory, my childhood merges with the
Old Testament: a series of obscure events in a distant
and barbarous land.
October 28

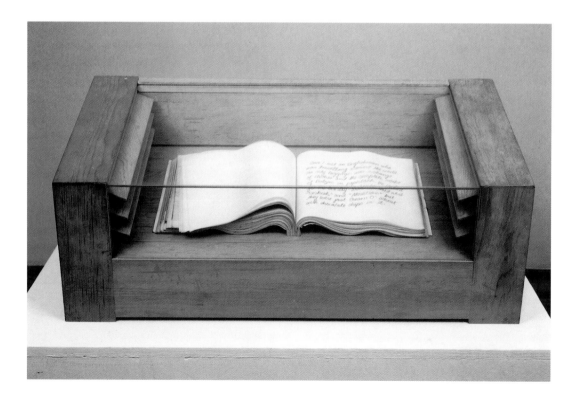

Windbook. 1974. Handmade book, wooden box, electric fan, 13¾ x 31¼ x 13½ in.

Windbook is a two-hundred-page diary of handwritten stories and photographs printed on onion-skin paper. It is installed in a glass case with fans concealed at both ends, which alternately blow the pages back and forth. The photographs for the book were shot "so that the corner of the room is the spine of the book and the walls are the pages," Anderson explains. "People move slowly through the room, light changes, stories appear and disappear."

DEARREADER: How to Turn a Book into a Movie was co-directed with Bob George and featured Geraldine Pontius. It was shot in one room and consists of nine autobiographical short stories read in a voiceover by a narrator. The film is dedicated to the novelist Laurence Sterne, whose book *Tristram Shandy* (1767) opens with the eponymous narrator reflecting on the circumstances under which he was conceived. Anderson begins *DEARREADER* with a quaint portrayal of a love-scene in the style of a '40s movie, followed by a series of intentionally cliched vignettes: the couple embrace, a clock chimes, nine pages from a monthly calender fall to the floor showing the passing of time, a baby cries. It is a theme that Anderson would return to in her song "Smoke Rings" (1984): "I'm thinking back to when I was a child/ Way back to when I was a tot, when I was an embryo/ A tiny speck, just a dot. When I was a Hershey bar in my father's back pocket." The title *DEARREADER* refers to one of Anderson's favorite storytellers, Herman Melville, for the manner in which he talked directly to his readers.

Anderson called this work a "performance film" or a "talking film," referring to the fact that she performed live on her violin at the beginning and end of the screening. She used film in performance, Anderson explains, because of the numerous film festivals of the early '70s, in which she participated. "By film festival, I mean eight people in a loft," she remarks. "I was always late; I'd barely finish editing the film, so I never got to the sound track. At the last minute, I'd grab my violin and run to the festival. I'd stand in front of the film, play the violin and do the dialogue live."

(LA) "When we were kids, my sister and I used to fight and steal each other's clothes. Sometimes she would steal my diary, memorize it word for word, and then, right in the middle of a fight, she would quote it to me in a flawless imitation of my voice.

"I used to know a painter who lived over by the South Street Seaport. She said that she almost went crazy because every time a ship went by, its shadow would curve around the room. It was the kind of low-ceilinged room that Melville must have lived in when he was a customs inspector in the neighborhood, the kind of room where he wrote all those songs about whales, all those stories about fast fish and loose fish. And I loved the way he talks to his readers all the time.

'Dear reader, dear reader.
Some fish are fast and some fish are loose
And you dear reader
Are a fast fish and a loose fish.'"

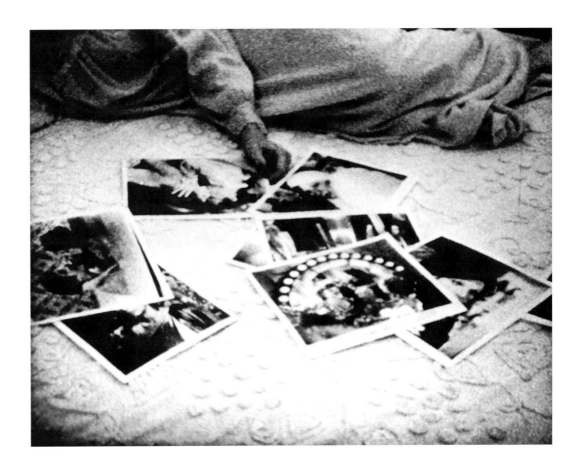

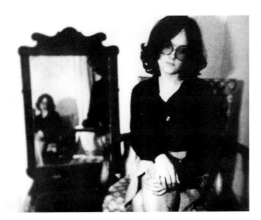

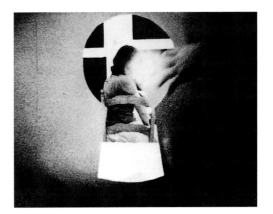

**Frame enlargements from *DEARREADER*. 1974.
Super-8 film, 27 min. Holly Solomon Gallery,
New York**

As:If. 1974. Artists Space, New York

A seminal work, with projections and violin playing, Anderson considers *As:If* her first full-fledged performance. It featured many themes that would recur in later work—her midwestern background, her grandmother, religion, a fascination with language and memory. It was the first piece in which Anderson inserted a speaker in her mouth, altering the sound of her voice. "The work was based on audiotape more than anything," Anderson has explained. "The only thing that was visual were very large words on slides—sets of words with colons." Much later she would comment with some surprise on the idiosyncratic simplicity of this work: "I can no longer really remember being the shy midwesterner who shuffled into an art gallery in 1974, wearing ice skates with their blades frozen into clumps of ice . . . and sat down with some homemade electronics and her mother's bronzed baby shoes and started talking about language and memory and telling very personal stories about her past."

The performance was presented in a darkened gallery, in a small spotlit area. Anderson shuffled into the space wearing white clothes and ice skates whose blades had been frozen into two large blocks of ice. She also wore a paper-thin sponge cross around her neck. She sat on a low bench, in front of which were placed her mother's bronzed baby shoes. Sets of slides showing two words separated by a colon—such as roof: rof, hood: hod, word: water—were projected on the wall behind her, while she alternately played her violin and relayed deeply personal stories:

"In 1956 I did a flip off the high board into a swimming pool. I broke my back and had to wear a back brace for a year and a half. The brace pressed on my lungs and it was hard to take a deep breath. I spoke very softly, almost inaudibly. I was sent to speech class."

The text was accompanied by slides of the following words:

"My voice is usually soft, and sometimes when I'm nervous, I stammer. I've cut out most of the flat midwestern 'a' from my speech but I still sometimes say 'rough' for 'root,' 'hoood' for 'hood,' and 'warsh' for 'wash.'"

"The day after my grandmother died, we went out to skate on the pond. The temperature had dropped suddenly the night before. There were a lot of ducks out on the ice and I got close to them and they didn't move. When I got closer, I saw that their feet had been frozen into the new layer of ice. They were honking and flapping their wings. I remem-

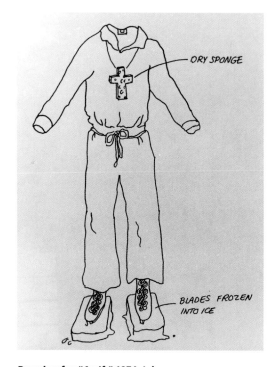

Drawing for "As:If." 1974. Ink on paper

ber thinking of the ducks' feet as little conductors that carried the honking down into the ice, turning the frozen surface into a giant sounding board."

On Tape:
"How to use your new Philip S. Olt Duck Caller: Pick a spot with minimum visibility and concealment. With your finger on the long protruding piece, produce a long, low, quavering sound, as if you yourself were a duck. If you don't get immediate results, move to another stand."

Performer follows instructions, blows duck caller.
Then a long plastic tube is inserted into the end of the caller.
This tube extension lowers the sound three octaves.
After a minute, the other end of the tube is inserted into a glass of water, drowning the sound.

Are words soft?

Some words are soft.

Which words are soft?

The word "soft" because you're saying it's "soft."

"In 1958, I was baptized by total immersion in the First Church of Christ. I wore a thin white robe with nothing underneath. After the baptism, I had to stand there soaking wet in this see-through robe in front of the whole congregation and give a speech about what it felt like to be washed in the blood of the lamb. My grandmother always said, 'The cure for nerves in public speaking is to think of something else while you talk.' But all I could think of was Bobby Darin's hit 'Splish Splash,' and my speech became more and more disjointed, garbled, more and more like speaking in tongues."

> Splish splash I was taking a bath,
> 'long about a Saturday night.
> Rub Dub, just relaxin' in the tub,
> thinkin' everything was alright.
> Well how was I to know
> there was a party goin' on?
> Reelin' with the feelin',
> Rockin' and a rollin'.
> Eeeee-yah!

During this section, Anderson dipped the cross-shaped sponge in water and it sprang out to its full volume. She then told of a story that talked of the effectiveness of sound in a space:

"In 1971, I tried to seduce someone through a door. This guy was going out with my roommate and I wanted to sleep with him. He would come over to our apartment and they would go into her room, shut the door and start to make love. Then I would get my violin and go into the living room, which was next to her bedroom, and play Tchaikovsky."

Violin is filled with water;
First 30 bars of Tchaikovsky played on it
performer hums hymn, performer mouths words to hymn,
removes ice skates, leaves,
in silence, words from hymn appear on screen:

the ties
that bind
of kindred minds
is like
is:like
as:if

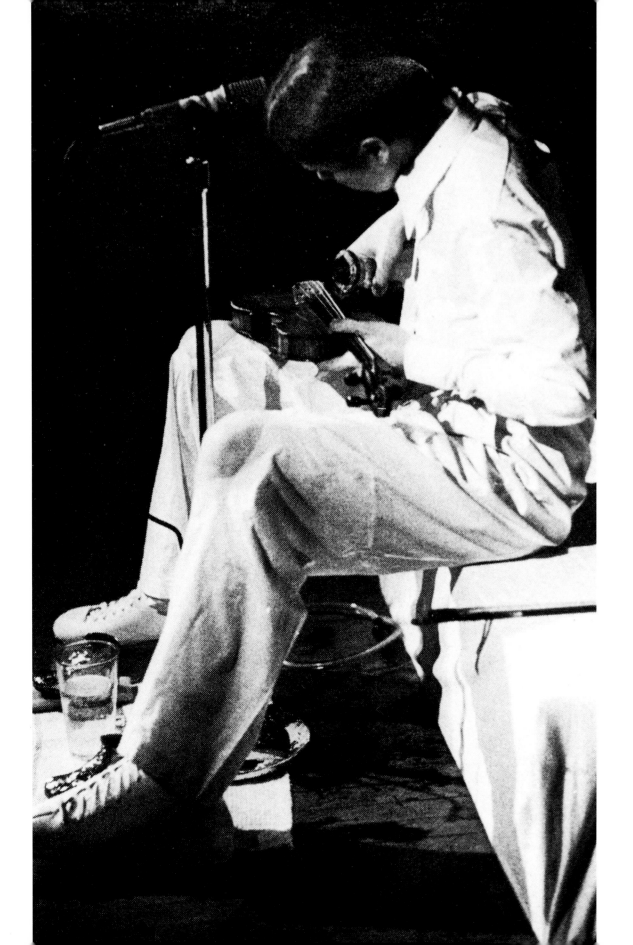

In the Nick of Time. 1974. The Clocktower, New York

Songs from *In the Nick of Time* include "Click!" "Don't Lose It Now!" "Bless This Bran," "Is Like," "That Chicken Float As I Lie," "1976," "Ya!" "Old Flames," "Waiting for You," "If You Were a Sport," "Black Water," "Hour of Power"

In Anderson's second extended performance, *In the Nick of Time,* she developed themes and devices from *As:If,* adding film projections and several custom-made musical objects, such as a Bible that, when opened, belts out "Gimme That Old Time Religion." It was also the work in which Anderson began investigating light as a key element in her performances. Moving between the projector and the wall, she painted an outline of the object in the film on the wall, so that once the film ended, the red shape remained. "It's about the layering of light, interrupting light," Anderson has said, "stretching the image and making 2-D into 3-D."

In the Nick of Time was as intensely autobiographical and intimate as *As:If.* This time the viewer learned the names of her three sisters (Lisa, Lynn, and India), that she has an Aunt Jean, and of her relationship with her father—"My father's name is Art, and everything I've ever done seems to be tied to him. Every book I've ever read seems to be somehow about him and about me. Everything I do, he approves of."

DON'T LOSE IT NOW!

Just before I left, Aunt Jean gave me something wrapped in brown paper. She pressed it into my hand and said, "Don't lose it now!" I thought it was a sandwich to eat on the train because it was kind of squishy and flexible. But when I got on the train, I opened the package and found a Bible. It was one of those very flimsy Bibles with tissue-paper pages. It seemed pretty well worn. Most of the pages were wrinkled because when Aunt Jean turned the pages, she would wet her fingers and kind of strafe them across the page. Every page was soggy like it had been marinated in saliva.

Performer opens the Bible; speaker inside blasts out "Gimme That Old Time Religion" by Eydie Gorme; performer takes out a "book" made of 2 slices of rye with lettuce leaves bound into it; leafs through it.

AS I LIE

My father's name is Art, and when I was a kid I thought that Art was God's name, too. You know, because of that prayer, "Our father (who) Art in Heaven, hallowed be Thy name . . ." I never understood why the "who" was there but there were a lot of things I didn't quite understand about English at that point.

Anyway, my father was never critical of me, he sort of idealized me, in fact, and it was always a strain to live up to this image. So sometimes I just lied. I pretended things were fine when they were really falling apart.

On Tape:
"'Image of a girl,' which begins with bells tolling the time, as I lie awake, resting from day to day,
I can hear the clock passing time away, oh,
I haven't found that image yet, that image of a girl"

For Anderson this work was above all an exploration of light—how to freeze it, bend it, enter into it. In some instances she became part of the projected shadow, in others a surface onto which images were projected. She once remarked that this interest was sparked by an art history seminar at Barnard College taught by Barbara Novak on the place of illumination in European and American painting.

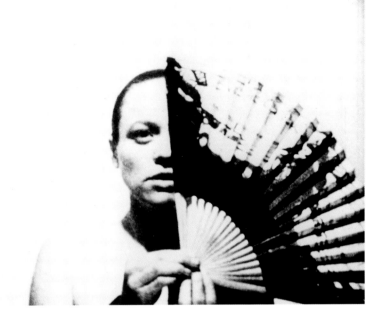

Songs and Stories for the Insomniac. 1975.
Performance of twelve films/songs at Artists Space,
New York

Anderson's evenings of songs, stories, and violin playing
took her across the country to numerous museums, colleges,
and galleries and frequently to Europe. For each venue, she
added new bits, gradually building a repertoire of written
and visual material. In this work she wore a Screen Dress
(see page 138) onto which film was projected and she
talked about the different realities of sleep and wakefulness.
She also sang a song about the elusive relationship between
art and life:

Art and illusion, illusion and art
This is the song that I'm singing in my heart
Art and illusion, illusion and art

Was it a real seal, or was it only art?
Was it a former seal, or was it really art?
Art and illusion, illusion and art.

Invitation to *Songs and Stories for the Insomniac.*
1975

The invitation disk could be spun around to reveal words
through a cut-out window, such as "An arch never sleeps."

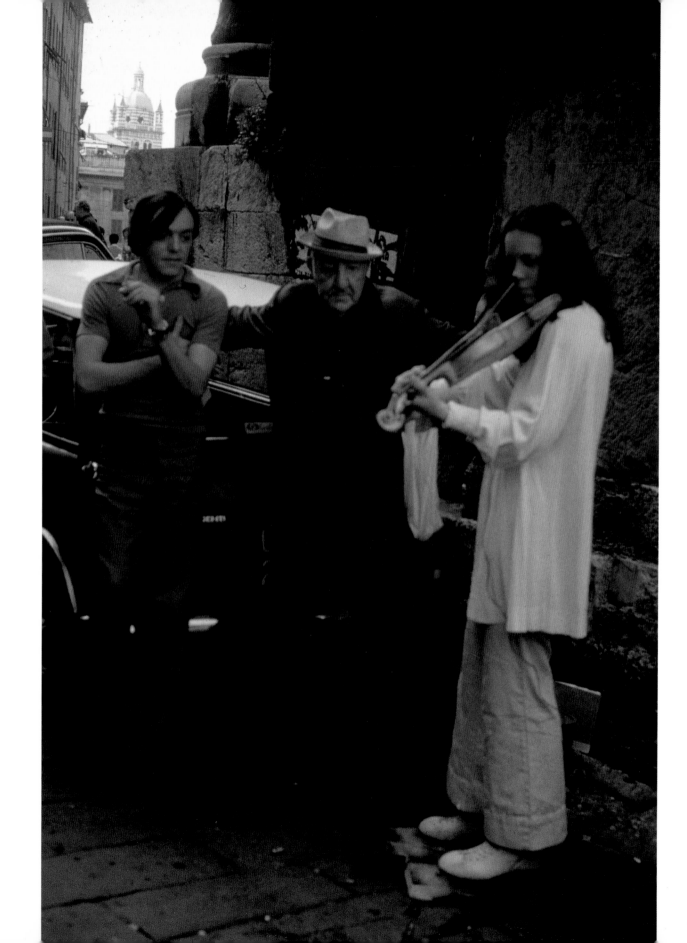

Duets on Ice. 1974–75. Series of live street-performances in the five boroughs of New York City and at the Monument of the Eternal Flame in Genoa, Italy

Duets on Ice was a reconfiguration of As:If as an outdoor performance, which she presented in New York and later in Italy. Wearing the same white outfit, her feet once again in skates embedded in blocks of ice, Anderson engaged small groups of people who stopped on the street to listen. She told the same intimate stories she had told in a New York gallery, but her sense of time and place was exaggerated by the ordinary settings. Anderson explains:

"I used the self-playing violin in Duets on Ice. The pre-recorded material was mostly of cowboy songs recorded on ninety-minute cassettes. I'd play along, but since it was a loop there was no definite way to end the concert. So the timing mechanism was a pair of ice skates with their blades frozen into blocks of ice (from As:If). When the ice melted and I lost my balance, the concert was over.

"In between songs I talked about the parallels between ice-skating and violin playing: blades over a surface, balance, simultaneity, the constant state of imbalance followed by balance followed by imbalance, like walking, like music, like everything.

"In Genoa, the songs were half-Italian, half-English, spaghetti-western style."

By the mid-1970s Anderson was already looking for ways to provide a surrogate for herself as a solo performer. Other artists, like Vito Acconci and Dennis Oppenheim, who had created performances earlier in the decade, soon withdrew from live performance, substituting their actual presence with recordings (Acconci) or small puppet replacements (Oppenheim). For Anderson "the point was to make someone else talk for me." An early alternate that she created for herself appeared in *At the Shrink's* in 1975. It was a "fake hologram," achieved by projecting a Super-8 film of herself sitting in an armchair situated in the corner of a gallery onto an eight-inch-high clay figure, and was the first of many clones she has constructed. "The clay figure was a stand-in for me," Anderson said. "It was a way of doing a performance without being there."

Anderson has talked about how this work represented both filmic and psychological projection, and the possibility of disappearing altogether once the projector was turned off. It suggested ways for her to use the body in film performances—as a kind of bulge in the film frame, as a cover, or as camouflage. The work also represented the difference between real and projected time, a theme that would run through all her work and would resurface in almost identical form nearly twenty-five years later in *Dal Vivo* (1998).

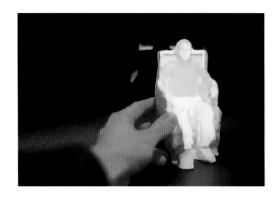

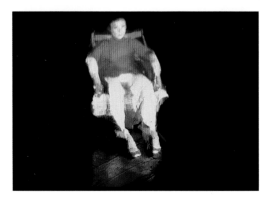

At the Shrink's. **1975. Holly Solomon Gallery, New York**

The installation included a recorded story about a visit to a psychiatrist. The figure was installed in the corner of a large room, and if one stooped close to it, one could see Anderson's lips moving and hear her story:

"I used to spend some time seeing a psychiatrist. I would get there around eight in the morning and come into the office, and she sat in a corner and on one side of her was a window and the other a mirror, and she could tell by slight movements of my eyes whether I was looking at her or out the window or at the mirror. I looked at the mirror a lot and one of the things I noticed was that on Mondays it was perfectly clean and clear, but by Fridays it was covered with these lip marks. This was a process that seemed bizarre at first and then predictable and finally more or less inevitable. Then one day, in passing, I said, 'Well, it's like the lip marks that appear on your mirror.' And she turned around and said, 'What lip marks?'

"And I realized that because of the way the sun was coming through the window and hitting the mirror at an angle, she couldn't see them. So I said, 'Why don't you sit in my chair? You can see them from here.' And I'd never seen her get up before but she got up (she could actually walk!) and she came and sat in my chair and she said, 'Oh! Lip marks.'

"The next time I saw her was the last time. She said she'd discovered that her twelve-year-old daughter had been coming into the office during the week and kissing the mirror, and that the maid would come in on the weekends and clean off the marks. And I realized that we were seeing things from such different points of view that I wouldn't have to see her again."

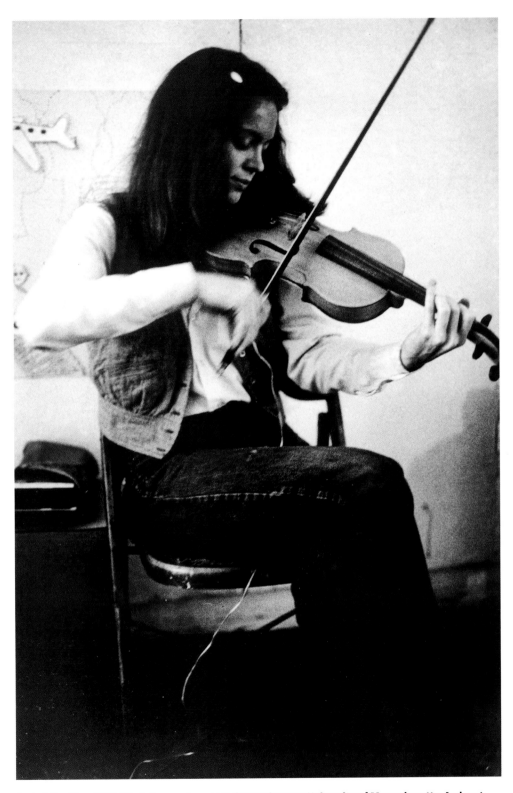

Out of the Blue. **1975. Workshop performance for students at University of Massachusetts, Amherst**

HEY AH HEY

One day last summer when I was in Canada on a Cree Indian reservation, some anthropologists showed up out of nowhere. They came in a little plane with maple leaves painted on the wings. They said they were there to shoot a documentary on the Cree Indians. They set up their video equipment in a tin quonset hut next to the Hudson Bay Company. Then they asked the oldest man on the reservation to come and sing some songs for their documentary.

On the day of the taping, the old man arrived. He was blind and wearing a red plaid shirt. They turned on some lights and he started to sing. But he kept starting over and sweating. Pretty soon it was clear that he didn't really know any of the songs. He just kept starting over and sweating and rocking back and forth. The only words he really seemed sure of were:

"Hey ah. Hey ah hey. Hey hey hey ah hey. Hey."

Hey ah hey hey hey ah hey
I am singing the songs,
the old songs, but I can't remember the words of the songs,
the old hunting songs.

Hey ah hey hey hey ah hey
I am singing the songs of my fathers
and of the animals they hunted down.
Hey hey hey ah hey
I never knew the words of the old songs.
I never went hunting.
Hey hey ah ah hey ah hey
I never sang the songs
of my fathers
Hey hey ah hey

I am singing for this movie
Hey ah hey ah hey
I am doing this for money.
Hey hey ah hey

I remember Grandfather
he lay on his back
while he was dying.
Hey ah hey hey ah hey
I think
I am
no one.
Hey hey ah hey hey hey ah hey

***For Instants: Part 3, Refried Beans.* 1976–77.**
Whitney Museum of American Art and The Museum of Modern Art, New York

In the mid-1970s the art world remained solidly downtown. In fact, it was not unusual to hear artists say that they never went above Fourteenth Street except occasionally, to visit museums. Yet two performance events, a four-day festival at the Whitney Museum of American Art and two evenings at The Museum of Modern Art, marked the first time that "performance art" on a fairly extensive scale was celebrated at key art institutions uptown. Anderson's presentation of *For Instants: Part 3, Refried Beans* was remarkable in those settings for its intimacy and elegance. The work was more polished than previous ones, both in terms of timing and the way in which she moved between one medium and another—film, violin playing, taped stories, and live stories. Her fascination with literally folding her body into the piece—becoming part of a film projection or a shadow thrown around the room—was the overriding theme of *For Instants.*

Later, Anderson would talk about how she used aspects of her own life, and other people's, in her work. "But the story, really, is in the telling," she has said. Referred to as one of a group of "autobiographical artists" in the mid-1970s (which also included Julia Heyward and Adrian Piper), Anderson has commented on the difficulties of using personal material over time: "The stories get more and more recent, and I have finally caught up with myself. The worst part about it is that now I find I don't have one past, but two—there's what happened and there's what I said and wrote about what happened."

The performance space was a corridor between the screen and the projector. The audience sat on both sides of this corridor more or less looking at each other and, as at a tennis match, turning their heads back and forth to watch the action. Three images (film and slides) were projected simultaneously onto the screen. By standing in front of one of the beams, Anderson blocked the light from that projector, making a shadow on the screen that revealed the other two images hidden underneath.

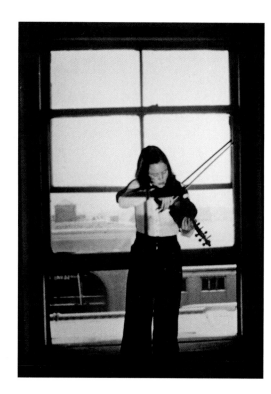

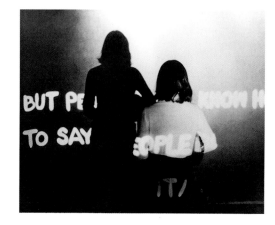

(boathorn)

I live by the Hudson River and a lot of boats go by. I've spent a lot of time trying to film them, so I set up a camera near the window, but I miss almost every one.

(camera clicking)

They glide by so quickly on the other side of the river, camouflaged against the Jersey shore. Sometimes it's hard to tell which is moving, the river or the shore, and it seems like all of Manhattan has come unanchored and is slowly drifting out to sea.

(feet running upstairs)

It's the kind of timing, the kind of synching, that's been getting into the songs I've been writing. It's like walking upstairs in the dark when you think there's one more step than there actually is and your foot comes pounding down with too much force and nothing underneath. Or like the piano we got a few months ago; only a few keys worked so we put it out in the hallway near the door and when people come in they rake their hands over the keyboard, hitting the few notes that work. It's kind of a doorbell now.

(doorbell)

I was trying to work on a song for a performance but all the sounds around were so distracting. It was impossible to concentrate. My mother called and said, "Why don't you come out here and write your song? It's real quiet, we've just put new carpets down." When I got there, I noticed that the carpets were so thick that none of the doors closed. The only door that still moved was the door to the parrot's room. It was a swinging door and every time someone opened it, it whacked into the parrot's cage and the parrot screamed and the scream filled the house through all the open doors.

(parrot shrieks)

And this is the song I finally wrote.

(violin)

Early on in the performance Anderson stretched out on the floor reading a story in the darkened space, a burning candle near her lips. With each breath, the flame (which had a photo cell connected to the lighting system trained on it) flickered and sent a shower of shadows across the room.

From INDIVIDUALS

I'm hiking through the woods in northern Canada. I haven't seen anyone for days. It's growing dark. Near a lake, I see six white canvas tents pitched on a steep gravel slope. There is no other sign of life. I walk up to the biggest tent. I can hear rattling and banging going on inside. There are voices, too, and some whistling. I knock on the canvas flap, then realize this is making no sound. Suddenly, the flap is pulled back and I am face to face with a squint-eyed man in white. "TABERNACLES! UNE FEMME!" he says and drops a stack of plates. At the table, six large men in red plaid shirts stop eating and stare at me. There is stew in their open mouths. They begin talking all at once in French. "Il y a trois mois que j'ai vu une femme," the squint-eyed man whispers in my ear as he hands me a cup of tea with soap bubbles float-ing lightly on the surface. After dinner, the geologists insist I be their guest for the night in "Le Musée de Balzac." They light a lantern and lead me into a small tent filled with sam-ples of soil, rocks, crystals, petrified wood, all wrapped in canvas bags and labeled. In the refrigerator, chunks of ice are stored in plastic bags. "We are studying the rates of the glaciers which will have been coming down," explains the only geologist who knows English. He tells me this tent is called "Balzac's Museum" because a few months ago an Englishman had stumbled onto their wilderness camp. He stayed for five weeks, cooking for the geologists dishes he called "Turkish" and "Moroccan," which were basically mix-tures of Cream of Wheat, blueberries, and chocolate chips. He says the Englishman was traveling light, except for the complete works (in paperback) of Balzac. Late every night they heard him singing songs from Balzac.

"Ma fanchette est charmante dans sa simplicité
O Richard! O mon roi! L'univers t'abandonne
Broum Broum Broum," he sings.

The other geologists join in the song.
"J'ai longtemps parcouru le monde
Et l'on m'a vu. Tra la la la la la."
I am no longer sure who's imitating who.

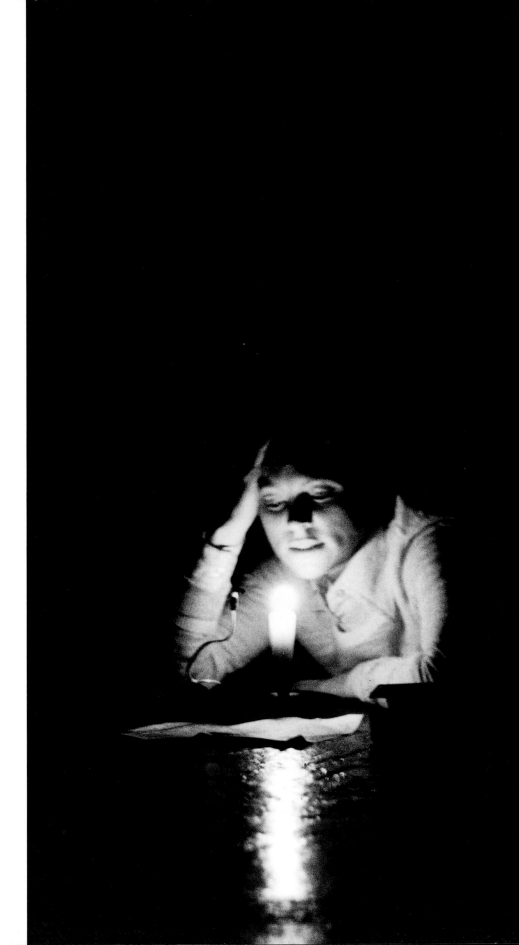

In the 1970s Anderson crisscrossed Europe, performing in art spaces large and small. Always obsessed with communicating with her audience, no matter the language, she developed a repertoire of songs that identified certain most frequently used sounds in various languages. Hence, when she performed "Engli-SH" at the Akademie der Kunst in Berlin, she stressed the "sh" sound common to both German and English. "Around 1976," Anderson has written, "I began to do a lot of performances and projects in Europe. At the time it was much easier to work in Europe than in the United States and I liked the romantic expatriate feeling I got every time I left. I traveled alone, dragging two black cases of instruments and electronics. The performances were in all kinds of theaters, art galleries, festivals, museums and improvised venues (a marketplace in Middleburg, Holland; a church in Venice; a shipyard in Hamburg). I'd meet the tech crew and we'd go over the score. I'd have to really spell everything out because often the crews had never done anything even remotely like this."

In *Speaking Swedish*, a film used in "On Dit," 1977, the soundtrack was played backward to sound like Swedish. The French subtitles, however, told another story. Anderson explains:

"Usually the performances were in the language of the country or they were subtitled. The language barrier occasionally became the subject of the piece. . . . In Berlin, the Wall became a visual metaphor for the language barrier. In 'That's Not the Way I Heard It' [Akademie der Kunst, Berlin] I told stories in English as German subtitles appeared on the screen. At the beginning of the performance, the translation was more or less accurate. Then gradually, the translation drifted until it had very little or nothing to do with the story being told out loud. Obviously this was a piece for a bilingual audience, but also a comment on the fact that language is already a code In performances, I loved to use the lowest setting on the Harmonizer, a digital processor that lowered my voice to sound like a man's. This was especially effective in Germany. When I spoke as a woman, they listened indulgently; but when I spoke as a man, and especially a bossy man, they listened with interest and respect.

"These performances [in Europe] were often in conjunction with an exhibition of my visual work or some collaborative workshop or media event. For example, when I did a performance in Amsterdam, I also worked with a group of ten-year-old kids. They wrote a series of two-minute ads that I produced for Dutch radio. The ads were for emotions— fear, jealousy, joy, and so on—and they just cropped up on the radio with no explanation."

NOVA CONVENTION

A two-day festival of performances, readings, film screenings, and a panel discussion in celebration of the author William Burroughs—the title of the event came from Burroughs's novel *Nova Express*—took place at the Entermedia Theater in the East Village on December 1 and 2, 1978. Organized in collaboration with New York University and the journal *Semiotext(e)*, the weekend was remarkable for the way in which it gathered the forces of several generations of New

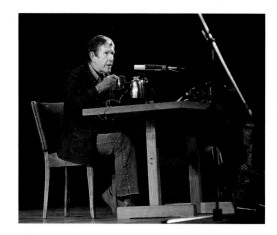

John Cage

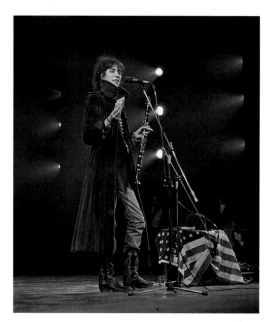

Patti Smith

York's avant-garde on one stage. Anderson and Julia Heyward opened the first night of festivities, which included excerpts from *Naked Lunch;* Kathryn Bigelow and Michael Oblowitz curated an afternoon of new films by Kathy Acker, Bigelow, Tina Lhotski, Eric Mitchell, and Amos Poe; Philip Glass and Patti Smith headlined the second evening of performances; and John Cage, Merce Cunningham, Allen Ginsberg, John Giorno, Timothy Leary, Susan Sontag, Ann Waldman, and Frank Zappa also made appearances. It was the filrst time that Anderson's work became known to this broad cross-section of artists, writers, and musicians.

(LA) "The Nova Convention was the first time I really used the word 'you' meaning specifically 'you in the audience.' As a performer I had used 'I' until I ran out of stories. Then I tried having other people read my words. But this, *this* was different! Finally, I wasn't just remembering things out loud! I was actually talking directly to people and it felt completely different.

"The Nova Convention was the first time I used the Harmonizer to alter my voice. This is a digital filter that I tuned to drop the pitch of my voice so that I sounded like a man. The machismo surrounding Burroughs was thick, and this filter was my weapon, my defense. It was the first time I used an audio mask, and being in drag was thrilling!"

William Burroughs

THE LANGUAGE OF THE FUTURE
(for harmonized male voice)

Last year, I was on a twin-engine plane coming from Milwaukee to New York City. Just over La Guardia, one of the engines conked out and we started to drop straight down, flipping over and over. Then the other engine died: and we went completely out of control. New York City started getting taller and taller.

A voice came over the intercom and said:
Our pilot has informed us that we are about to attempt a crash landing.
Please extinguish all cigarettes.
Place your tray tables in their upright, locked position.
Your Captain says: Please do not panic.
Your Captain says: Place your head in your hands.
Captain says: Place your head on your knees.
Captain says: Put your hands on your head.
Put your hands on your knees!
(heh-heh)
This is your Captain.
Have you lost your dog?
We are going down. We are all going down together.

As it turned out, we were caught in a downdraft and rammed into a bank. It was, in short, a miracle. But afterwards I was terrified of getting onto planes. The moment I started walking down that aisle, my eyes would clamp shut and I would fall into a deep, impenetrable sleep.
YOU DON'T WANT TO SEE THIS
YOU DON'T WANT TO BE HERE
HAVE YOU LOST YOUR DOG?

Finally, I was able to remain conscious, but I always had to go up to the forward cabin and ask the stewardesses if I could sit next to them:
"Hi! Uh, mind if I join you?"
They were always rather irritated—"Oh, all right (what a baby)"—and I watched their uniforms crack as we made nervous chitchat. Sometimes even this didn't work, and I'd have to find one of the other passengers to talk to. You can spot these people immediately. There's one on every flight. Someone who's really on *your* wavelength.
I was on a flight from L.A. when I spotted one of them, sitting across the aisle. A girl, about fifteen. And she had this stuffed rabbit set up on her tray table and she kept arranging and rearranging the rabbit and kind of waving to it: "Hi!" "Hi there!" And I decided: This is the one I want to sit

next to. So I sat down and we started to talk and suddenly I realized she was speaking an entirely different language. Computerese. A kind of high-tech lingo. Everything was circuitry, electronics, switching. If she didn't understand something, it just "didn't scan."

We talked mostly about her boyfriend. This guy was never in a bad mood. He was in a bad mode. Modey kind of guy. The romance was apparently kind of rocky and she kept saying, "Man oh man you know like it's so digital!" She just meant the relationship was on again, off again.

Always two things switching. Current runs through bodies—and then it doesn't. It was a language of sounds, of noise, of switching, of signals. It was the language of the rabbit, the caribou, the penguin, the beaver.

A language of the past.

Current runs through bodies and then it doesn't. On again. Off again.

Always two things switching. One thing instantly replaces another. It was the language of the future.

PUT YOUR KNEES UP TO YOUR CHIN.
HAVE YOU LOST YOUR DOG?
PUT YOUR HANDS OVER YOUR EYES.

JUMP OUT OF THE PLANE.
THERE IS NO
PILOT.
YOU ARE NOT ALONE.

THIS IS THE LANGUAGE
OF THE ON-AGAIN
OFF-AGAIN
FUTURE.
AND
IT IS DIGITAL.

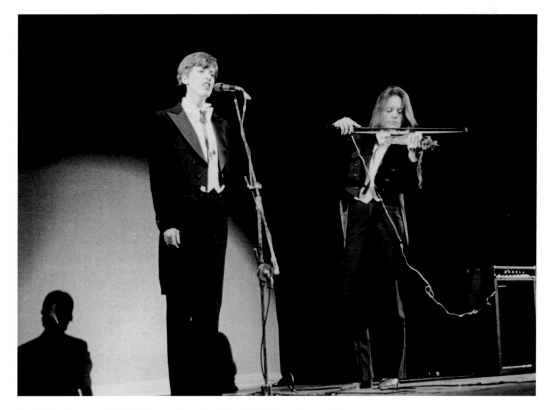

Laurie Anderson and Julia Heyward performing at the Nova Convention

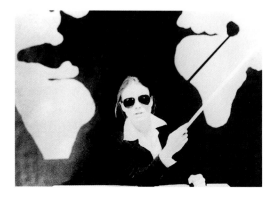

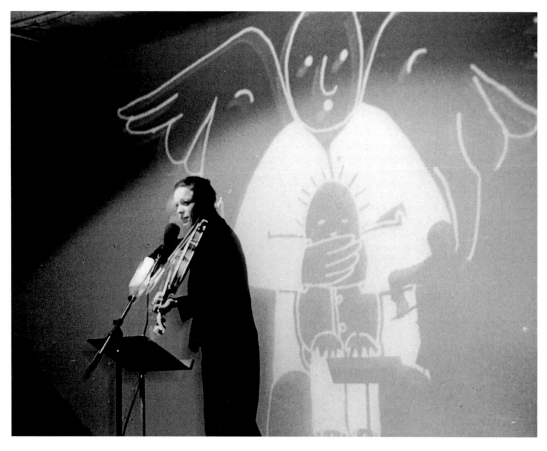

Americans on the Move, Part I. **1979. The Kitchen,
New York**

(LA) "This piece was performed on a long European tour.
I often had to set up my equipment very quickly, and was
usually part of a festival with at least three events on one
evening."

With *Americans on the Move*, Anderson realized that the
songs, texts, and images she had been creating for several
years were all about the United States. Each performance
became a more complex rendering of this material, and
strong themes connected one with the other. It would be
shortly after this production that she decided to combine all
the parts into a large mosaic of America, sorting the material
into four thematic sections—Transportation, Politics, Money,
and Love. For the next two years she wrote new work with a
heightened consciousness of her eventual design, which
would become the two-evening production of *United States*.
The piece premiered in 1983.

BEGINNING FRENCH

Lately, I've been doing concerts in
French. Unfortunately, I don't speak French. I mean, my
mouth is moving but I don't really understand what
I'm saying.
It's like sitting at the breakfast table and it's early
in the morning and you're not quite awake. And
you're just sitting there eating cereal and sort of
staring at the writing on the box—not reading it
exactly, just more or less looking at the words. And
suddenly, for some reason, you snap to attention,
and you realize that what you're eating is what
you're reading . . . but by then it's much too late.
After doing these concerts in French, I usually had the
temporary illusion that I could actually
speak French, but as soon as I walked out on the
street, and someone asked me the most simple directions,
I realized I couldn't speak a single word.
As a result of this inadequacy, I found
that the people I had the most rapport with there
were the babies. And one of the things I noticed
about these babies was that they were apparently
being used as some kind of traffic testers. Their
mothers would be pushing them along in their
strollers . . . and they would come to a busy street
and the mother can't see what the traffic is like because
of all the parked cars . . . so she just sort of edges the
stroller out into the street and cranes her head out
afterwards. And the most striking thing about this
is the expression on these babies' faces as they're sitting
there In the middle of the traffic
stranded
banging those little gavels they've all got.
And they can't speak English.
Do you know what I mean?

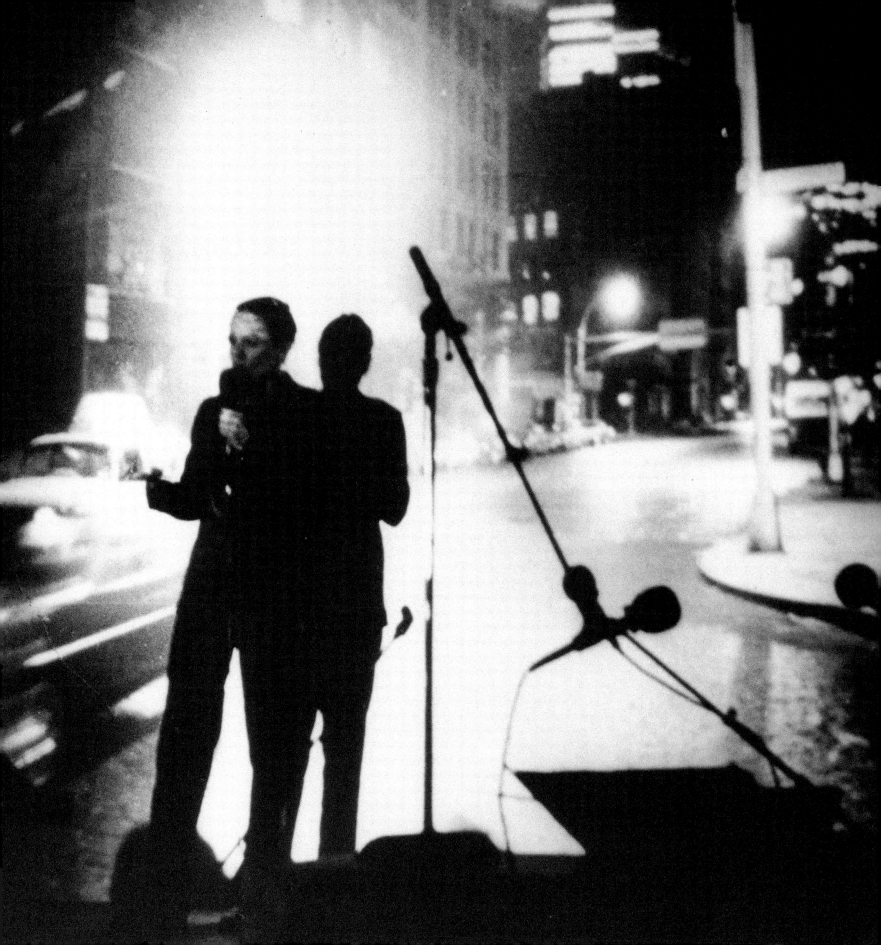

SCORES

Anderson has used a variety of devices for creating scores, from a notated drawing to orchestration based on language and texts.

(LA) "I composed *Quartet for Sol Lewitt* by assigning note values to numbers according to their placement in his drawings. The quartet is scored for four violins.

"In 1978 and 1979, I wrote several 'Talking Orchestra' pieces, that is, works for orchestra and chorus. I had become tired of my own voice but I loved the way spoken language could turn into music. The stories were extremely short, usually two or three sentences. The instruments would play for a while and then the stories would sort of float out over the music, like thought balloons.

"Performers were asked to both play and speak. This wasn't easy for professional musicians who associated talking with acting. They tended to overact, to ham it up. I had to remind them to talk as normally as possible. The string players had tape heads attached to their instruments and several Tape Bows each, with voices and sound effects recorded on them. At first the professional musicians didn't really want to use the electronics. Eventually, they came around when they realized that the Tape Bow instruments were quite difficult to play and that their right-hand bowing skills were crucial.

"The Talking Orchestra pieces included 'Born Never Asked' (performed by the Oakland Youth Symphony, directed by Robert Hughes, 1980), 'It's Cold Outside' (performed by the American Composers Orchestra and West Deutscher Rundfunk Orchestra in Cologne, directed by Dennis Russell Davies, 1981), and 'Like a Stream,' 1978, which was put together by many presenting organizations around the United States (including Hallwalls in Buffalo and D.C. Space in Washington, D.C.). I conducted the chamber pieces myself and it was exhilarating to try to shape the sound of breathing on twenty Tape Bows, which could sound like a family of sleeping giants (slow) or a wild sex orgy (fast)."

Drawing 1 for "Quartet for Sol Lewitt." 1975. Ink on paper

Anderson adapted Sol Lewitt's number system to create the score for *Quartet for Sol Lewitt*. A three-and-a-half-minute piece for four violins, it was recorded on 45-rpm disc and was one of the selections in *Jukebox*.

A guitar chord, as depicted graphically by a Synclavier. From "Sharkey's Day," *Mister Heartbreak*, 1984

Film Score for "White on White," for violin and Super-8 projector. 1978–79

Film Score for "Buy Buy Wright: Film/Song in 24/24 Time," for violins and voice. 1976. Musical notation and film strips

Anderson has made some scores by employing John Cage-like games of chance; others she based on found sounds, drawings, or numbers. *Buy Buy Wright* was a "film/song" in which both sound and picture were composed simultaneously from a mathematical score. It was written for four violins and voice and was performed in *For Instants: Part 3, Refried Beans* at the Whitney Museum of American Art, New York. It lasted only fifty-two seconds.

The score for *White on White* was written for violin and Super-8 projector. It was based on strips of film and was performed in *United States, Part I* at The Kitchen, New York. To perform these scores Anderson moved back and forth between projector and screen so that her movements through the beam of light, and the shadows that she cast, became an integral part of the piece. They are early examples of her ongoing interest in creating new ways to film live performance. In particular, she employed film to construct layered, three-dimensional effects on stage.

G

PIANO WIRE

CHORD FOR
A ROOM

"ABOUT 405
EAST 13TH ST"

HEIGHT

PIANO WIRE
STRETCHED TAUT
& TUNED WITH
TURNBUCKLES

WIDTH

LENGTH

PIANO WIRE

PIANO WIRE

C

E

C MAJOR
TRIAD

WIRE IS
BOLTED TO
WALLS & FLOOR

HEIGHT
WIDTH
LENGTH

INVENTIONS

(LA) "Many of the instruments and gadgets I've invented have been based on things I've seen in *Edmund Scientific*, a kind of catalog for amateur scientists and tinkerers."

Anderson's playfulness and her artful interpretation of every-day incidents and objects, from the creaking of an elevator to using as a doorbell the few functioning keys on an old piano left in her hallway, are an expression of her powerful inventive drive. Nothing is too mundane for her to reinter-pret as material for an unusual performance. Typically, she creates illusions or sound effects from simple, low-tech devices. It is her ingenious response to her surroundings, rather than her sophisticated understanding of technology, that produces the witty and unforgettable combinations of sound, text, and image for which she is best known. *Chord for a Room* is one early example, as is *Duet for Door Jamb and Violin*. Both focus on the shape of a particular space and the way in which sound can be used to characterize that space. Other works such as *Film Projection from Inside Purse* or *Fake Hologram* are two of her many inventions using light.

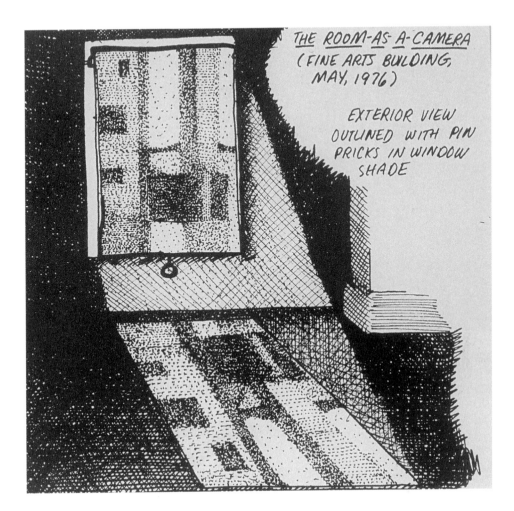

THE ROOM-AS-A-CAMERA (FINE ARTS BUILDING, MAY, 1976)

EXTERIOR VIEW OUTLINED WITH PIN PRICKS IN WINDOW SHADE

Drawing for "The Room-as-Camera." **1976.**
Pen on paper, 30 x 34 in.

This sketch for an installation at the Fine Arts Building, New York, May 1976, shows an exterior view outlined with pin pricks in a window shade. This image fell on the floor of the gallery.

Drawing for "Film Projection from Inside Purse," **from *In the Nick of Time*. 1974. Ink on paper, 8 x 10 in.**

(LA) "The performer lies down on zebra-skin rug, holding large patent leather purse. The performer opens the purse, and projects 8-mm film sequence onto the ceiling. On tape, a voice recites, 'As I lie awake, resting from day to day, I can hear the clock passing time away, oh, I haven't found that image yet, that image of a girl.'"

OPPOSITE:
Drawing for "Chord for a Room." **1972.**
Colored pencil on paper, 12 x 10 in.

Chord for a Room was included in the exhibition *About 405 East 13th Street*, organized by artist Jean Dupuy and shown in his apartment in New York. As Anderson describes the piece, "I tuned the room to represent the architectural space by stretching piano wire the length, width, and height of the room. In the corner, the wires produced a major triad when struck with a hammer."

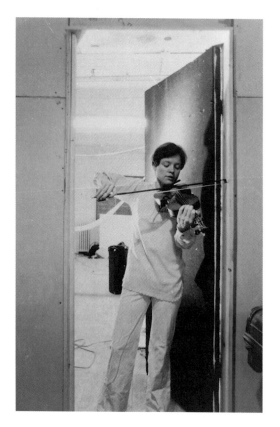

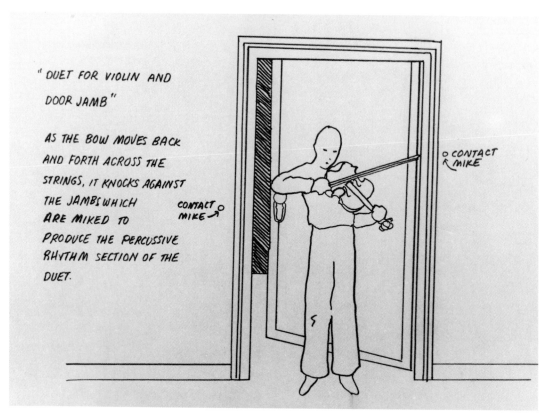

"DUET FOR VIOLIN AND DOOR JAMB"

AS THE BOW MOVES BACK AND FORTH ACROSS THE STRINGS, IT KNOCKS AGAINST THE JAMBS WHICH ARE MIKED TO PRODUCE THE PERCUSSIVE RHYTHM SECTION OF THE DUET.

CONTACT MIKE

CONTACT MIKE

Duet for Door Jamb and Violin. 1976

Drawing for "Duet for Door Jamb and Violin." 1976

(LA) "The duet is performed on the threshold. The length of the bow stroke is determined by the width of the door. Contact microphones are attached to the jambs at the impact points, amplifying the staccato, knocking sound as the bow moves back and forth. When the violin is electric, the violin speakers are located in one room and the door jamb speakers in the adjoining room. During the performance, tonal and percussive elements are alternately separated and mixed by kicking the door open and shut."

Drawing for "Some Experiments." 1976. Ink on paper, 8 x 10 in.

(LA) "In this experiment, two people have a conversation. Then the room is sealed off but the sound waves keep bouncing back and forth between the walls, back and forth, growing fainter and more garbled. Sometimes it can take fifty years for words to slow down and finally to stop. In this experiment, we listen with our microphones, trying to translate the waves back into words."

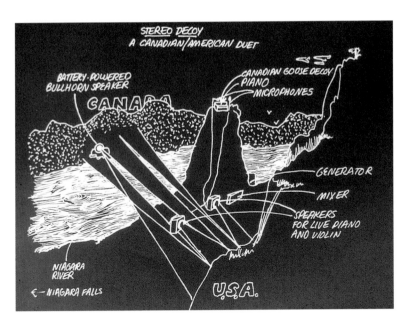

Drawing for "Stereo Decoy: A Canadian–American Duet." 1977.
Pen and ink Kodalith, 24 x 36 in.

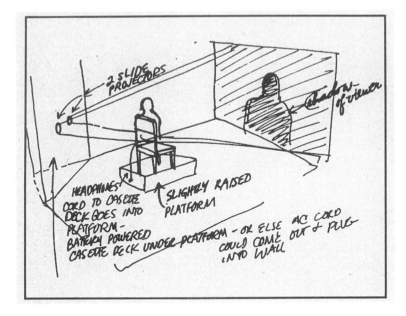

Drawing for "Nightdriver." 1978

Nightdriver was an installation consisting of audiotape, headphones, and slides presented at the Wadsworth Atheneum, Hartford, Connecticut.

(LA) "In this work, the 'viewer/listener' sits in a chair casting a shadow onto the screen. Projected slides of cars slowly pass toward and 'through' the body of the viewer, incorporating him or her into the piece."

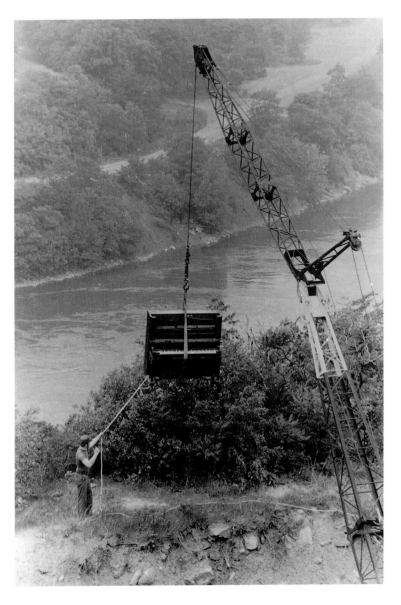

Stereo Decoy: A Canadian–American Duet. 1977.
Artpark, Lewiston, New York

The crew installs the piano on a ridge overlooking the Niagara River. Anderson recalls, "The songs bounced back and forth from side to side. The entire gorge was a mammoth speaker, an enormous hallway."

(LA) "In July I composed a piece for tape and live sound that would ricochet back and forth across the gorge. On both sides of the river there were violin-piano duets: the Canadian side was on tape, broadcast through a battery-powered bullhorn speaker; the American side was live. The idea was that the two countries would do a kind of call-and-answer duet."

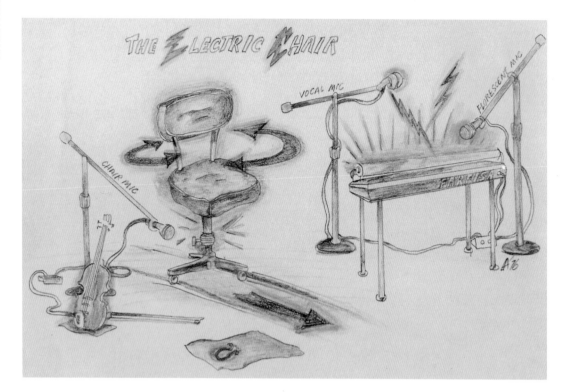

***Drawing for "Electric Chair."* 1977–78. Colored pencil on paper, 14 x 24 in.**

An office chair was miked to produce live percussion. It was used in "Stereo Song for Steven Weed" and other songs about arguments between men and women.

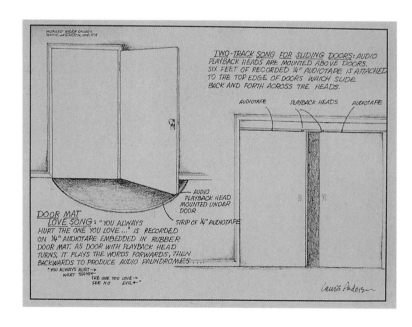

***Drawings for "Doormat Love Song" and "Two-Track Song for Sliding Doors."* 1978. Pencil and ink on card stock, 24 x 36 in.**

Anderson has always been interested in the relationship between music and architecture. "When I began to learn Italian," she once said, "I found that many terms on musical scores were architectural terms as well. *Canto* is 'song' and 'corner'; *scala* is 'stairway' and 'scale'; *stanza* is 'room' and 'quarter.' " Her interest in "tuning a building," as in *Chord for a Room*, extended to using moving parts of a space, like doors or windows, as instruments of sound. In *Doormat Love Song* audiotape was embedded in the floor, so that whenever the door was opened or closed, prerecorded palindromes were heard. Similarly, in *Two-Track Song*, sliding doors "spoke" whenever they were moved.

(LA) "I called these reversible phrases and words 'audio palindromes.' Of course, they were less predictable than written palindromes like 'god/dog.' It was only through experimentation that I found them—for example, 'say' is always 'yes' backwards."

Drawing for Fake Hologram, from _United States._
1983. Ink on paper, 24 x 36 in.

"Images of a room are projected. White violin bow cuts into plane of focus creating a 'screen.' Projection of room floats midair." Anderson tells how she discovered this technique:

"One of my work methods is to turn on all the equipment in my loft and just move around and see what happens. This is how I discovered cheap holography. I was playing the violin in front of a projector one night and noticed that if I waved the bow in front of the projector, the image would be caught on the moving bow. It hovered there like a ghost. This was a projection technique I used in _United States,_ creating phantom rooms and disembodied waving hands."

Anderson invented a recipe for making hot dogs in a hotel room. "I spend half my life on the road," she has said. The recipe was printed as part of a set of postcards.

HOTEL HOT DOGS À LA LAURIE ANDERSON

Ingredients: 2 bratwurst (Oscar Meyers will also do)
Utensils: 1 lamp, pocket knife, wire strippers
Unwrap the bratwurst and place on bedside table. Unplug the floor lamp. Using the pocket knife, cut the lamp cord approximately 3 feet from the plug. With wire strippers, peel the insulation from the cord, leaving about 10 inches of exposed wire. Thread the wire through the bratwurst and tie off the wire at the end. Then, just plug it in! Cook until the bratwurst is crispy on the outside (approximately 2 seconds).* Make sure the cooking time doesn't exceed 3 seconds since the meat will explode at very high temperatures. Then just relax and enjoy! This dish is excellent accompanied by a glass of cool tap water.

*In the U.S. or other territories where 110 is used, add 2 additional seconds to cooking time.

Numbers Runners. 1978. Installation at Neuberger
Museum, Purchase, New York

Anderson created this early interactive audio piece for a series of installation exhibitions in the late 1970s. When viewers picked up the receiver in this modified phone booth, they were connected to two tracks on a recording machine—one recorded the voice of the viewer speaking into the telephone, and the other played back those same words after a one-minute delay.

***Jukebox*. 1977. Audiovisual installation, Holly Solomon Gallery, New York. Jukebox with photo/text wall panels**

The exhibition comprised 45-rpm records in a jukebox and text/photo panels. The twenty-four songs for *Jukebox* were recorded at ZBS Media and in Anderson's home studio. "This studio was in the hallway next to the elevator," Anderson has said, "which is faintly audible in the background of almost every song produced there. I came to like this subtle industrial effect and sometimes featured it."

"*Stereo Song for Steven Weed*," from *Jukebox*

Steven Weed was the boyfriend of heiress Patricia Hearst, who was kidnapped in 1974 from her Berkeley apartment by members of a left-wing urban militant group called the Symbionese Liberation Army. Weed was interrogated by FBI agents following her disappearance. When Anderson performed this song live, she spoke into two mics located on either side of her head. She replied first into one mic and then into the other, suggesting in the continuous shaking of her head that while her voice was saying "yes" her head motion was saying "no." She sat in the Electric Chair and used it for additional sound effects.

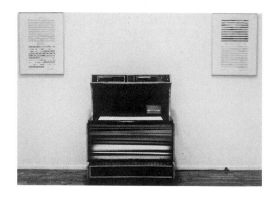

(LA) "In 1976 and 1977 I wrote a lot of songs for and about my friends. I wrote 'It's Not the Bullet That Kills You' for Chris Burden after being on a panel with him. Chris had talked about many of his recent pieces—being nailed to the hood of a Volkswagen, getting locked in lockers, crawling over beds of glass. But it was odd, he didn't want to talk about why pain interested him. He was entirely focused on technicalities: what caliber bullet he used, exactly how sharp the knife was, and so on.'

IT'S NOT THE BULLET THAT KILLS YOU (IT'S THE HOLE)

I used to use myself as a target, I used myself as a goal.
I've been digging myself so much, digging me so much,
I dug myself right into a hole.
Now in a hole it's so dark, can't see a thing
It's easy to lose sight of your goal.
It's not the bullet, not the bullet that kills you. Oh no!
It's the hole, it's the hole, it's the hole!

Like a ventriloquist, I've been throwing my voice
Long distance is the story of my life.
And in the words of the artist Joseph Beuys
"If you get cut you better bandage the knife."
Cause in a hole it's so dark, can't see a thing
It's easy to lose sight of your goal.
It's not the bullet that kills you. Oh no!
It's the hole, it's the hole, it's the hole!

SELECTIONS:

1.	Speak Softly, But Carry a Big Stick (Turn the Other Cheek, But Carry a Big Stick)	3:07
2.	The Wind-oh!	4:10
3.	Talk to Me (Lucille)	3:00
4.	Like a CB	3:01
5.	Break It	4:37
6.	Stereo Song for Steven Weed	1:55
7.	Flies in the eyes of a Baby	4:03
8.	Time to Go (for Diego)	2:45
9.	Man in the Empty Space	4:40
10.	New York Social Life	3:20
11.	Art and Illusion	3:40
12.	Is Anybody Home?	4:25
13.	If You Can't Talk About It, Point to It (For Screamin' Jay Hawkins and Ludwig Wittgenstein)	1:30
14.	Video Double Rock	1:58
15.	One Day in Dallas	5:29
16.	Quartet for Sol Lewitt	3:23
17.	On the BBC	2:15
18.	It's Not the Bullet that Kills You (It's the Hole)	3:00
19.	And Besides	3:16
20.	Photography and Other Good Designs	5:47
21.	Plants Are Sucked Back Underground	3:22
22.	Joshua	5:40
23.	Fast Food Blues	3:34
24.	Unlike Van Gogh	2:50

Dark Dogs, American Dreams. 1980. Audiovisual installation, Holly Solomon Gallery, New York. Central tape cassette console with photographic wall panels

From her first exhibitions to her latest, Anderson's installations have always been largely interactive. They have also been designed to make viewers aware of the relationship between images and sound. Both *Jukebox* and *Dark Dogs, American Dreams* make these connections very specific, since songs that are selected to be played by the viewer (on record or on cassette tape, respectively) have a visual equivalent represented on the wall in photo-panels. In *Dark Dogs*, a panel would be automatically illuminated when a particular audio selection was made on a console placed in the center of the room.

Dark Dogs, American Dream was about, says Anderson, "a kind of speechlessness, about dreams as silent movies, about the interchangeability of dreams and reality." The title suggested the wildness of dogs and the untamability of dreams.

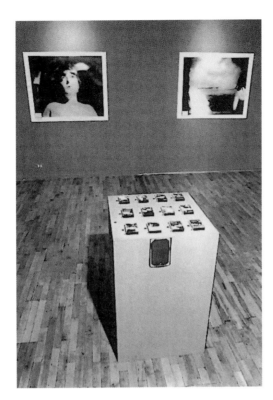

Dark Dogs, American Dreams. Installation view of console and wall panels

(LA) "On a central console the viewer could select one of the portraits and listen to an audiotape of that person reading a dream. These were my dreams but I liked the sounds of all their different voices. Each dream was like a short song."

The Mailman's Nightmare, from Dark Dogs, American Dreams

"I have this recurring nightmare, and that is that everyone in the world, except myself, has the proportions of babies. I mean they're normal height and everything, five feet, six feet tall, but they have these giant heads, like babies, you know? And enormous eyes, and tiny arms and legs, and they can hardly walk. And I'm going down the street and when I see them coming, I give them some room and step aside. Also, they don't read or write, so I don't have that much to do. Jobwise, it's pretty easy."

Girl on the Beach, from Dark Dogs, American Dreams

"I had this dream, and in it I wake up in this small house somewhere in the tropics. And it's very hot and humid and all these names and faces are somehow endlessly moving through me. It's not that I see them exactly. I'm not a person in this dream, I'm a place. Yeah, a kind of a . . . just a place. And I have no eyes, no hands. And all these names and faces just keep passing through. And there's no scale, just a lot of details. And I'm thinking of a detective movie, you know, when the hero is dead at the very beginning, so there's no whole person, just a slow accumulation of details. Or, you know, like films in the '20s where you're sitting there and you're hardly ever aware of the fact that twenty-seven out of every sixty minutes you're sitting in total darkness."

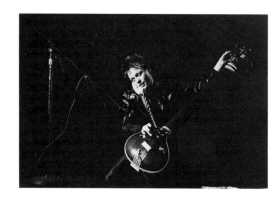

"New York Social Life," from *Jukebox.* 1977

This is a song for telephone, microphone, and tamboura. The performer alternates between telephone and microphone to distinguish caller and receiver voices. The song is performed very rapidly as one long run-on sentence. The tamboura is plucked percussively to produce an extremely irritating nasal tone. Based on a series of seemingly endless phone calls, "New York Social Life" was Anderson's ironic commentary on a day in the life of a young artist. Since she is too busy to see friends in person and obsessed with work, the telephone becomes the thin connection between friends.

Well I was lying in bed
one morning, trying to think
of a good reason to get up,
and the phone rang and it
was Geri and she said:
Hey, hi! How are you?
What's going on?
How's your work?
Oh fine. You know, just
waking up, but it's fine,
it's going OK, how's yours?
Oh a lot of work, you know,
I mean, I'm trying to make
some money, too. Listen,
I gotta get back to it, I just thought
I'd call to see how you are . . .
And I said: Yeah, we should
really get together next week.
You know, have lunch,
and talk.
And she says: Yeah,
I'll be in touch. OK?
OK.
Uh, listen, take care.
OK. Take it easy.
Bye bye.
Bye now. And I get up,
and the phone rings and it's
a man from Cleveland and
he says:
Hey, hi! How are you?
Listen, I'm doing a performance
series and I'd like you to do
something in it. You know,
you could make a little money.
I mean, I don't know how I feel
about your work, you know,
it's not really my style,
it's kind of trite
but listen, it's just my opinion,
don't take it personally.
So listen,
I'll be in town next week.
I gotta go now, but I'll give you a call,
and we'll have lunch, and we can
discuss a few things.
And I hang up and it rings
again and I don't answer it
and I go out for a walk and I
drop in at the gallery and they say:

Hey, Hi. How are you?
Oh fine. You know.
How's your work going?
OK. I mean . . .
You know, it's not like it was
in the sixties. I mean,
those were the days
there's just no money
around now, you know,
Survive! Produce! Stick it out!
It's a jungle out there!
Just gotta keep working.
And the phone rings and she says:
Oh excuse me, will you?
Hey hi! How are you? Uh huh.
How's your work? Good.
Well, listen, stick it out,
I mean, it's not the sixties,
you know, listen, I gotta go now,
but, uh, lunch would be great.
Fine, next week?
Yeah. Very busy now,
but next week would be fine,
OK? Bye bye.
Bye now.
And I go over to Magoo's
for a bite, and I see Frank
and I go over to his table
and I say: Hey Frank.
Hi, How are you?
How's your work?
Yeah, mine's OK, too.
Listen, I'm broke you know,
but, uh, working . . .
Listen, I gotta go now but
we should really get together,
you know.
Why don't you drop by sometime?
Yeah, that would be great.
OK.
Take care.
Take it easy.
I'll see you.
I'll call you.
Bye now.
Bye bye.
And I go to a party and
everyone's sitting around
wearing these party hats
and it's really awkward

and no one can think of
anything to say.
So we all move around fast
and it's:
Hi! How are you?
Where've you been?
Nice to see you.
Listen, I'm sorry
I missed your thing
last week, but we should really
get together, you know,
maybe next week.
I'll call you.
I'll see you.
Bye bye.
And I go home and the
phone rings and it's
Alan and he says:
You know, I'm gonna have a show
on cable TV and it's gonna
be about loneliness, you know,
people in the city who for whatever
sociological, psychological,
philosophical reasons
just can't seem to communicate,
you know,
The Gap! The Gap!
It'll be a talk show
and people'll phone in
but we will say at the beginning
of each program: Listen,
don't call in with your
personal problems
because we don't want to hear them.
And I'm going to sleep
and it rings again and
it's Mary and she says:
Hey, Laurie, how are you?
Listen, I just called to say hi
Yeah, well don't worry.
Listen, just keep working.
I gotta go now. I know it's late
but we should really get together
next week maybe and have lunch
and talk and . . . listen, Laurie,
if you want to talk before then,
I'll leave my answering machine on
and just give me a ring
anytime.

Songs for Lines/Songs for Waves. 1977. Film-video performance, The Kitchen, New York

In this work Anderson explored the connections between classical music and a cacophony of industrial sounds and spoken language, live performance and stored visual information. An important early work, *Songs for Lines/Songs for Waves* shows how Anderson would insert herself between light projection and video, essentially merging herself into the work and controlling the live image at the same time.

"Phase and Shape," video projection from *Songs for Lines/Songs for Waves*

Video projection of scanned numbers from *Songs for Lines/Songs for Waves*

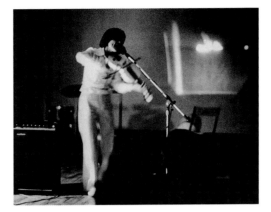

Slow-Scan Video System

Anderson developed a slow-scan video system that translated sound into visual information. The violin bow was fitted with audio tape that could retrieve the image information. Bowing this tape drew images on the video screen.

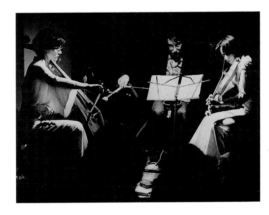

The Tape Bow Trio—Patrice Anderson, Joe Kos, Laurie Anderson—performing *Songs for Lines/Songs for Waves*

A trio of performers played Tape Bow Violins; the bows were fitted with prerecorded tapes that featured audio palindromes such as "Say what you mean and mean what you say," as well as the sounds of cars skidding and crashing.

Some of the text for *Songs for Lines/Songs for Waves* was played backward and forward:

One day you wake up and realize/
Ezilaer dna pu ekaw uoy yad eno

Oh you didn't mean what you said./
Dias uoy tahw naem t'ndid uoy ho.

You may want to take it back,/
kcab ti ekat ot tnaw yam uoy.

but the words are there to stay./
Yats ot ereht era sdrow eht tub.

Say what you mean! Don't lose track!/
Kcart esol t'noD! Naem uoy tahw yas

Words are strong and once they're gone/
Enog er'yeht ecno dna gnorts era sdrow

You can't take them back./
Kcab meht ekat t'nac uoy.

:Yas ro od uoy tahw rettam on os/
So no matter what you do or say:

Naem uoy tahw yas/Say what you mean
!Yas uoy tahw naem dna/and mean what you say!

You may have meant to be mean/
Naem eb ot tnaem evah yam uoy

You may have meant to be nice,/
Ecin eb ot tnaem evah yam uoy,

But if you didn't say it right,/
Thgir ti yas t'ndid uoy fi tub,

then you should just go home!/
Emoh og tsuj dluohs uoy neht!

No matter what you do or say/
Yas ro od uoy tahw rettam on

Say what you mean/Naem uoy tahw yas
and mean what you say!/Yas uoy tahw naem dna!

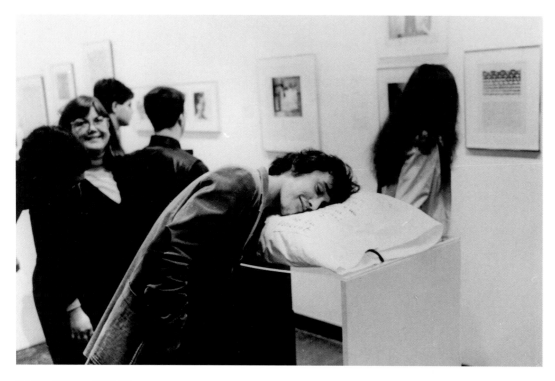

Talking Pillows. 1977–97

This piece featured pillows with speakers inside. The idea for the talking pillow came from a commercially available language-learning system that promised to "teach German as you sleep." Anderson used the device to record stories about insomnia.

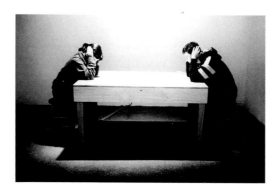

Handphone Table. 1978. The Museum of Modern Art, New York

The piece was dedicated to the electrical engineer and inventor Nikola Tesla. Bob Bielecki designed the electronics.

The Way You Moved Through Me. 1978. Photograph installed with *Handphone Table* demonstrating how to use the table

(LA) "I got the idea for the *Handphone Table* when I was typing something on an electric typewriter. It wasn't going very well and I got so depressed I stopped and just put my head in my hands. That's when I heard it: a loud hum coming from the typewriter, amplified by the wooden table and running up my arms, totally clear and very loud.

"So I built a table and rigged it for sound. Inside the table were cassette decks and powerful drivers which compressed the prerecorded sounds and drove them up steel rods. The tip of these rods touched four plugs resembling pine knots embedded in the surface of the table. When you put your elbows on these plugs, the sound rose through your arms via bone conduction. When you put your hands over your ears, it was like putting on a pair of powerful stereo headphones. The whole head became a speaker and in a sense, an amplifier; it's more like remembering sound than hearing it really. In the end, the same physical gesture—the head in the hands—was used in its invention as well as its reception.

"Three songs for the *Handphone Table* were split left and right but gradually traded places Both songs used the lowest ranges of the instruments, since bass frequencies, being wide and slow, travel well. Treble is more skittish and tends to evaporate. Since much of language is shaped by treble sounds—for example, it's the *t*'s and *s*'s and other fragile pointy sounds that define words—*it was difficult to make the table speak clearly.* Finally I used a line from George Herbert, a seventeenth-century English metaphysical love poet: 'Now I in you without a body move.' So with panning it sounded like

 Now I in you
 without a body
 m o v e"

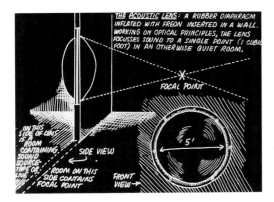

Drawing for Acoustic Lens. 1977. Pencil and ink
on paper, 24 x 36 in. Moore College of Art,
Philadelphia

Working on the principle of the optical lens, which precisely
focuses a broad span of sightlines onto one point, Anderson
and Bob Bielecki designed an "acoustic lens" that would
do the same thing with sound. It is approximately five feet
in diameter, made of rubber, and convexly curved. It was
installed between two adjoining rooms, one silent, the
other filled with the sounds of prerecorded tapes. The lens
absorbed the sound from the room where the tapes were
playing and projected it onto a focal point in the silent room.

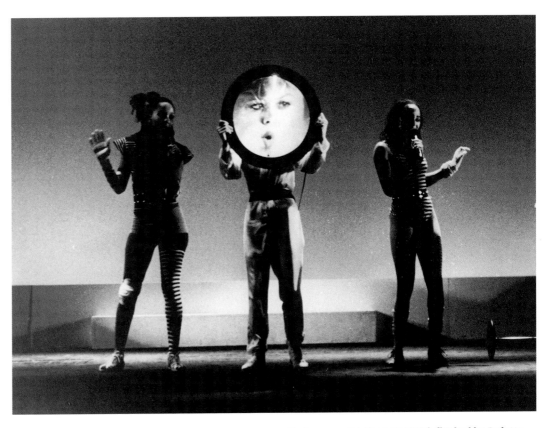

**Anderson using the Lens Head, flanked by Dolette
McDonald and Janice Pendarvis, in _Home of the
Brave_.** 1985

Anderson used a two-foot Fresnel lens as a mask: when
she held the lens up to her face, it created a magnified and
distorted image.

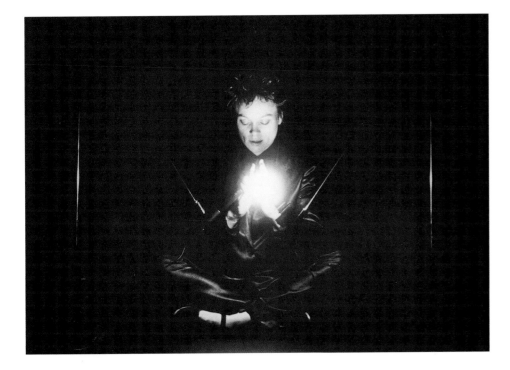

"Closed Circuits," from _United States_. 1979

(LA) "In 'Closed Circuits' I used digital processing that
produced very sibilant s's and turned the long boom on
the microphone stand into a tubular drum that changed
in pitch depending on where I hit it."

"You're the snake charmer, baby,
And you're also the snake."

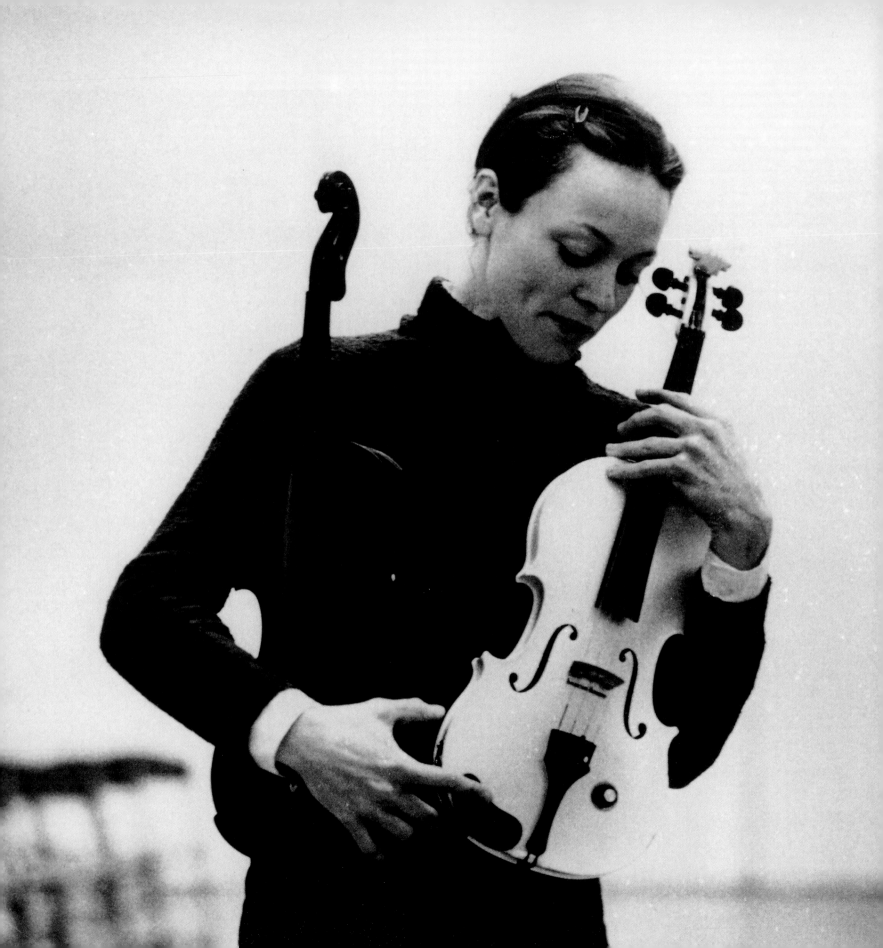

VIOLINS

"For me, the violin is the perfect alter ego. It's the instrument closest to the human voice, the human female voice. It's a siren."

"I've spent a lot of time trying to teach the violin to talk. I love the violin because it's a romantic, nineteenth-century instrument, and because you can hold it, walk around with it."

The image of Laurie Anderson with a violin and bow became the most frequently reproduced picture of her in the 1970s, and indeed the two seemed inseparable: the violin was both her partner on stage and in many ways an extension of her body. She used the instrument with all the confidence and knowledge of a classically trained musician, yet she manipulated it with a subversive delight that recalled concerts of John Cage and David Tudor's "well-tuned piano," performances of Nam June Paik and Charlotte Moorman's *TV Bra for Living Sculpture,* or the more whimsical sound-objects of an Arte Povera artist like Jannis Kounellis. "There must be reasons," Anderson said in a 1975 story, "Confessions of a Street-Talker," "why I've sanded a violin to the bone, covered a violin with camouflage material and yodeled with it, dressed a violin in imitation leopard, popped popcorn in a half-size tin violin . . . why I installed a speaker inside a violin so it would play duets with me, filled a violin with water, burned a violin, mounted a turntable on the body and a needle into the bow (the Viophonograph and its 'No Strings' records with fiddling instructions), reasons why I've tuned it, polished it, sung to it (songs of praise, songs of guilt) taken it on trips, taken it to bed, to the beach, to the woods."

Many of Anderson's early violins and inventions were built in collaboration with electronics designer Bob Bielecki.

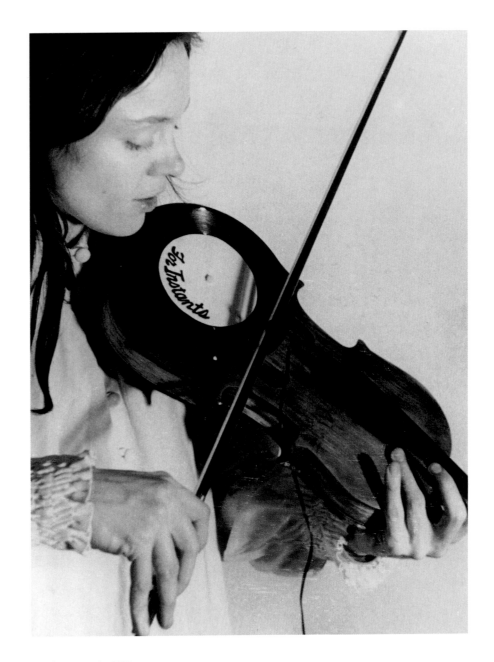

Viophonograph. 1976

Anderson recorded one note on each band of a 45-rpm record. A battery-powered turntable was mounted on the body of the violin and Anderson then "played" the record by lifting and lowering the bow, into which a needle had been inserted. She played the Viophonograph in *For Instants* and at the Nova Convention.

OPPOSITE:
In Basel, 1977

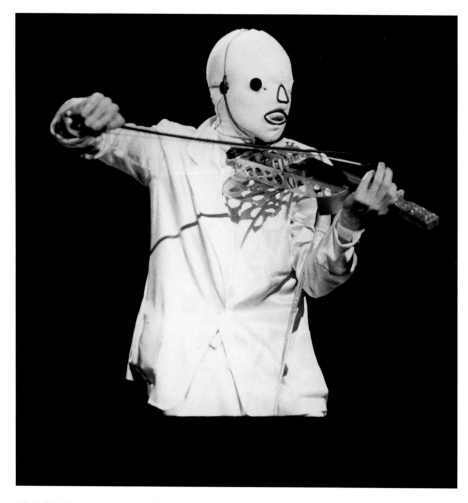

Digital Violin. 1985. Designed by Max Matthews

This digital violin was interfaced with the Synclavier, an
electronic keyboard instrument capable of playing any
sound stored in its system. Anderson played it in *Mister
Heartbreak*, her 1984 tour of the United States, Canada,
and Japan, wearing a mask inspired by Bauhaus artist
Oskar Schlemmer's dance costumes.

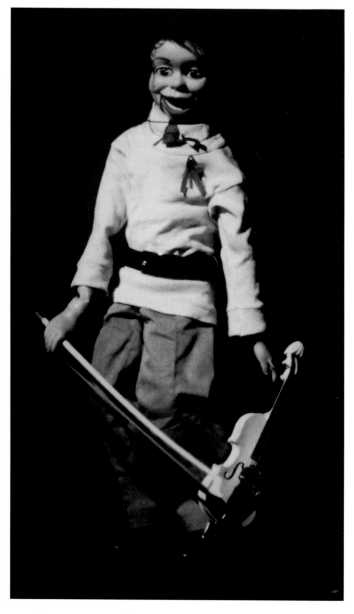

Ventriloquist Puppet with Violin. 1992

In *Stories from the Nerve Bible* (1992) a dummy, designed
to resemble Anderson, plays a 1/16-size Suzuki violin.
Anderson and the dummy also performed at Town Hall,
New York, in 1992. The dummy's violin produced a heavily
processed, quasi-symphonic sound.

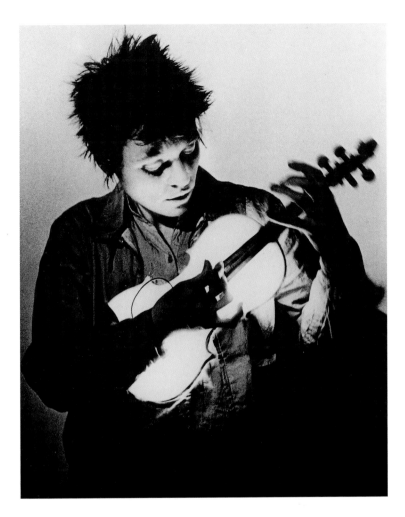 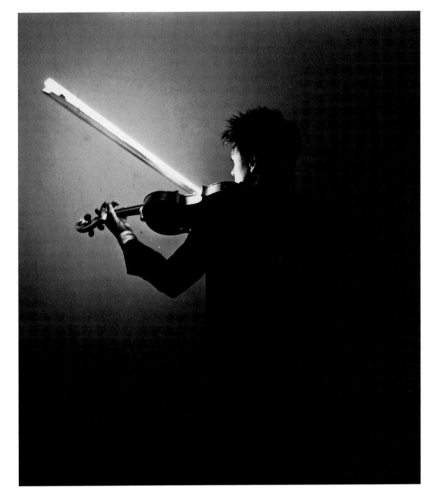

Neon Violin and Neon Bow. 1982 and 1985

The neon violin—a Plexiglas violin with a neon light inside—
was used in *United States*. These materials affected the sound
of the violin, creating an ominous buzz whenever Anderson
played the instrument. The violin also occasionally picked up
sounds from CB radios in the area.

Anderson first used the neon bow in "Gravity's Angel"
in *Home of the Brave*, 1985.

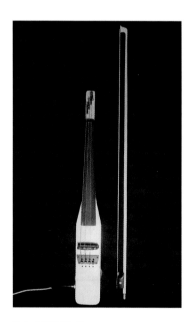

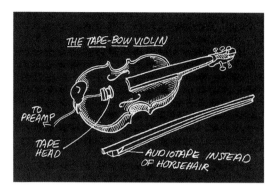

Tape Bow Violin. 1977

The Tape Bow Violin was designed by Bob Bielecki. He recalls: "We were at some concert uptown somewhere and all the violins were sawing away, and that's when I thought of it."

(LA) "At first, I used this instrument to play with the relationship of sight and sound. What you see is a string quartet in tuxedos. And what you hear (for example) are saxophones, drums, and barking dogs."

Self-Playing Violin. 1974

A speaker inside the violin gives the performer the option of either allowing it to play on its own or performing in tandem with it, in a duet. This camouflage version was used in *How to Yodel, a* work presented in Jean Dupuy's performance evening, "Soup and Tart," at The Kitchen in 1974. Anderson used self-playing violins in two other performances, *As:If* (1974) and *Duets on Ice* (1974–75).

Drawing for Tape Bow Violin. **1977. Pen and ink Kodalith, 24 x 36 in.**

A Revox tape playback head is mounted where the bridge would be. On the bow, instead of horsehair, there is a strip of prerecorded audiotape, so that as you move the bow back and forth across the head, sound is produced.

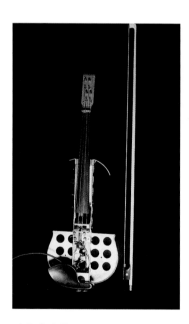

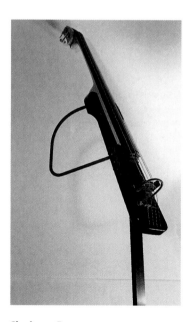

Zeta MIDI Violin

A Zeta MIDI Violin, custom designed for Anderson in 1984, was linked to audio systems that could retrieve samples.

Digital Violin. 1985. Designed by Max Matthews

Clevinger Bass

Anderson used this bass on "Gravity's Angel," 1984.

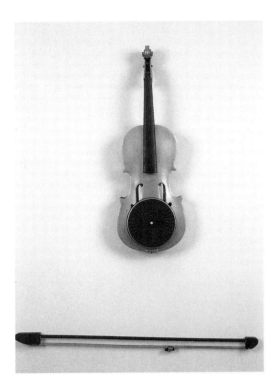

Viophonograph. 1976

This view shows the turntable mounted on the body of the violin and the bow with stylus.

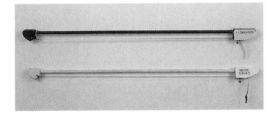

Tape Bows for Tape Bow Violin. 1977

Two of Anderson's Tape Bows. The labels indicate the sounds recorded on the tape of each bow: "I Dreamed" and "Voice Drums."

(LA) "I used the Tape Bow occasionally as a kind of 'translation tool.' My method was to record a number of colloquial sayings and proverbs in other languages. Then I would cut these up into strips and listen to them backwards to see if I could hear anything in English. One time out of twenty, this would happen. And one time out of twenty out of that, there would be some relationship between the two meanings."

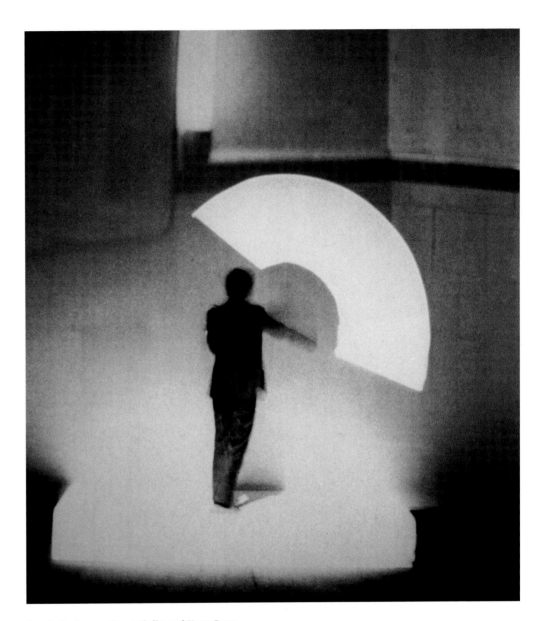

Laurie Anderson. Neon Violin and Neon Bow. 1982 and 1986

In the second song-story of *United States*, "Say Hello," Anderson created a fake hologram in mid-air by waving a white violin bow in the path of the projection of a film of a waving arm. The result was an illusory phantom arm, a "third arm," as she called it.

"One of my jobs as an artist is to make contact with the audience,
and it has to be immediate. They don't come back later to look
at the details in the background."

The 1980s

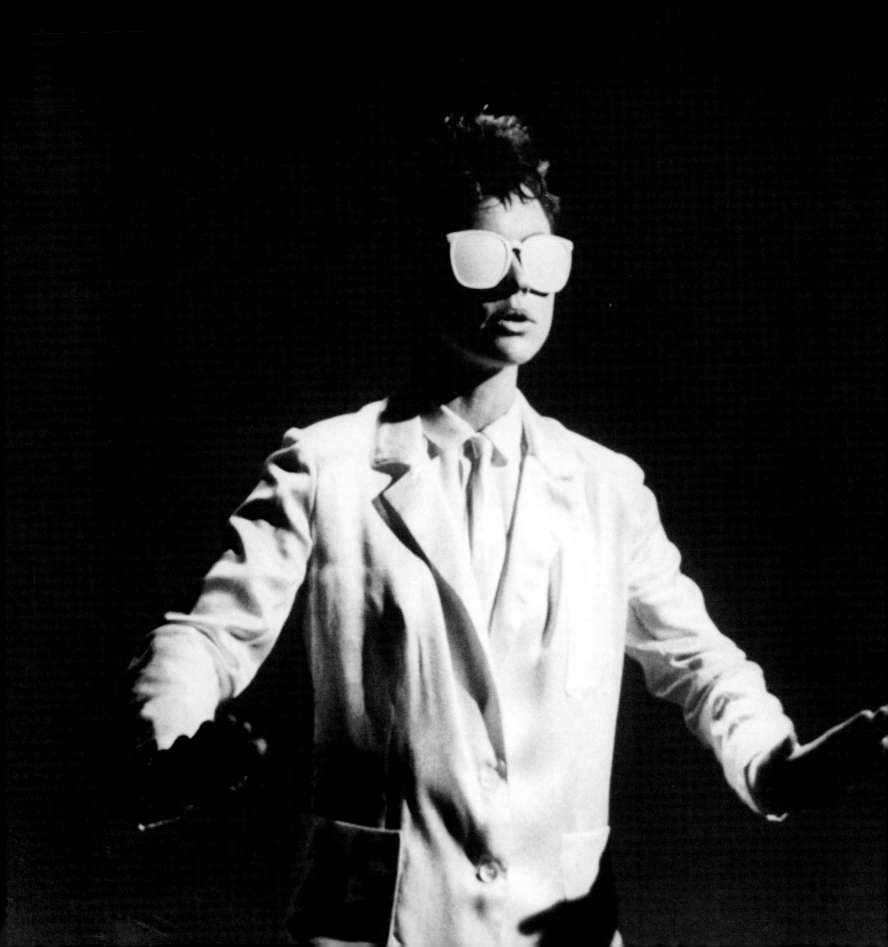

January 1981 saw the inauguration of former Hollywood actor Ronald Reagan as president of the United States. Anderson would mark the event some weeks later by performing with other artists in the Anti-Inaugural Ball at the Pension Building in Washington, D.C., sponsored by several alternative galleries, including D.C. Space and WPA. The intensity of the political atmosphere following the hostage crisis in Iran, Reagan's movie-business background, and the smooth-talking media politician that he promised to be only catapulted Anderson into more critically examining American culture than she had from the somewhat distant vantage point of Europe, where she had spent the latter part of the 1970s. Just three months earlier she had presented *United States, Part 2* at the Orpheum Theater in New York. It included a discussion about language and national identity, the extraordinary and ominous song "O Superman," and a section called "Talkshow," about the calculated "soundbites" of spin experts that were the media signposts of the times. "Big Science, Little Men," "Language Is a Virus,"— Anderson's songs and stories of the early '80s emphasized the anonymity as well as the pervasiveness of mass culture.

By the mid-1980s the economy was strong, the art market moved at a record-breaking clip, and so-called Yuppies generated an overwhelming mood of getting and spending. Artists became the rock stars of the decade; reportage of their sighting at celebrity events appeared in the gossip columns, and their decorator-designed homes and gardens were featured in life-style magazines. Many feared that the spirit of the avant-garde had been forever consumed by the mainstream. Side by side with consumerism went a creeping conservatism, which reached its zenith as the Reagan years turned into four more of Republican rule, this time presided over by George Bush. "As America gets more conservative," Anderson wrote at the turn of the decade into the '90s, "I find my own reactions to this are driving me even further into the politics of pop culture. I want to know what the motor is, what is driving this country further and further to the right. Consequently, much of my work has become political and engaged. I'm not even sure I'm an artist any more. More like a thinly disguised moralist."

PAGES 82–83:
Anderson's animation figures used as backdrops in *United States*, 1983

OPPOSITE:
Photograph used on the cover of *Big Science*, 1982

United States, Part 2 would be dramatically highlighted by Anderson's song "O Superman," which had become widely known since it reached the top of the English charts some twenty months earlier. Around the world, students had even recorded Anderson's rendering of a typical answering-machine message on their own machines—"Hi. I'm not home right now. But if you want to leave a message, just start talking at the sound of the tone." For Anderson, it was the song that in its physical presentation succeeded spatially above all else, because of the way she merged so completely into the corridor of light between the projector and the screen. The simple gesture of a raised arm, hugely enlarged when projected onto the backdrop behind her, gave the song a startling edge. Its unforgettable beginning—a quiet "ha-ha-ha-ha," paced to the timing of a heartbeat—and its conversational tone came across as an intense warning against the dangers of marching to the beat of nuclear power and might. In the midst of an evening that, up until that point, had only hinted at some of the pitfalls of futuristic progress, the dark tone of "O Superman," with its message of a high-tech world gone haywire, subtly shifted the emphasis of meaning in the songs that followed.

The manner in which Anderson had constructed the song had more to do with her methods of observation and responses to incidents in her life than with a plan to write a work that was driven by moral or ethical motives. It began with a concert that she had attended in 1978 in San Franciso, where an elderly soloist, Charles Holland, had given an unforgettable rendering of the spiritual "O Souverain" from Massenet's opera *Le Cid*, with its powerful refrain, "O Sovereign, O Judge, O Father!" Overwhelmed as much by the song as by the sincerity of the singer, Anderson identified with the huge emotions at its center. "'O Souverain' is basically a prayer for help," she explains. "All is over, finished! My beautiful dreams of glory, my dreams of happiness, have flown away forever!" Anderson wrote her own version of the nineteenth-century hymn elaborating on Massenet's themes of love and power but changing the appeal to more sinister, late-twentieth-century forces.

"O Superman" is addressed to the pillars of the American dream, Superman, Mom and Dad, the justice system, and the military. It describes a world where conversations between family members take place through messages left on answering machines, and where attempts to resist the intrusion of technology into everyday life only result in further alienation.

Many songs from *United States* lamented the fact that American life was overwhelmingly tied to technology and utterly fragmented at the same time. Nevertheless, they carried Anderson's signature irony and humor. For her, the intricate circuit of the digital world was also a maze with utopian ideals at its end. "If there is any throughline between the themes of transportation, politics, money, and love," she told a journalist, "it's some question about America as Utopia . . . a vision that is very bound up with technology." Anderson's interest in technology lay in its ability to connect people—"it's a tool to amplify and enlarge," she has said, and every performance had built-in channels for her to do so. Some were purely illusory—layers of space that appeared to link the stage and auditorium visually—while others were actual, as in a "diving board" along which she walked that projected from the stage into the audience.

OPPOSITE:

Anderson performing "O Superman"
in *United States*, 1983

Anderson's raised left arm created a giant shadow projection on the screen behind her while her right hand played the melody on the keyboard. Her ambidextrous and ambiguous sign language—the hand became a pointed finger, a fist, an innocent wave—was a subtext for the song.

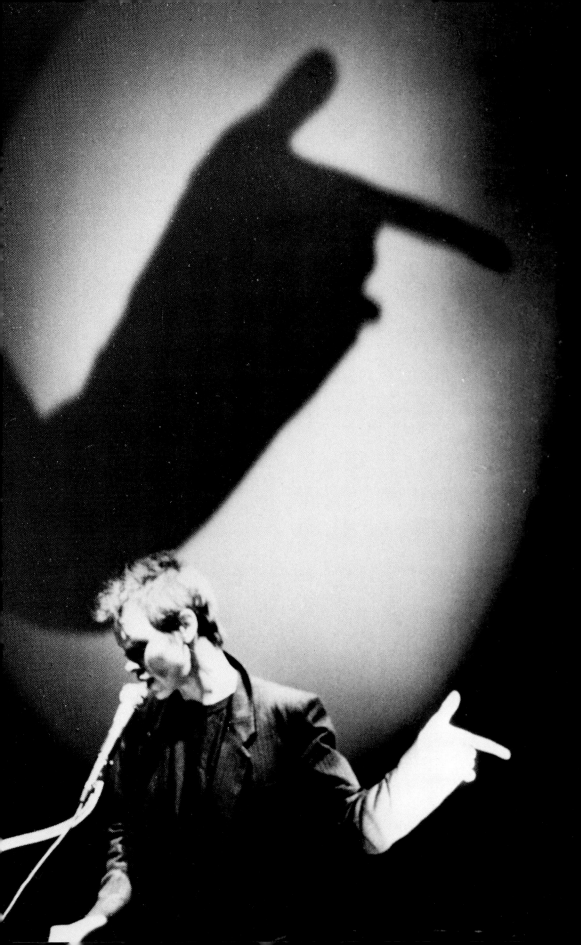

O SUPERMAN

O Superman. O Judge. O Mom and Dad.
Mom and Dad.
O Superman. O Judge. O Mom and Dad.
Mom and Dad.

Hi. I'm not home right now. But if you
want to leave a
message, just start talking at the
sound of the tone.

Hello? this is your mother. Are you there? Are you
coming home?
Hello? Is anybody there? Well you don't know me
but I know you.
And I've got a message
to give to you
Here come the planes.
So you better get ready
ready to go
You can come as you are
but pay as you go.
Pay as you go . . .

And I said: OK! who is this really?
And the voice said:
This is the hand. The hand that takes.
This is the hand. The hand that takes.
This is the hand. The hand that takes.
Here come the planes.
They're American planes, made in America.
Smoking or nonsmoking?

Then the voice said: Neither snow nor rain,
nor gloom of night shall stay these couriers
from the swift completion
of their appointed rounds.

Cause when love is gone, there's always justice,
and when justice is gone,
there's always force,
and when force is gone, there's always Mom. Hi Mom!

So hold me Mom, in your long arms.
So hold me Mom, in your long arms.
in your automatic arms
your electronic arms
in your arms.

So hold me Mom, in your long arms,
your petrochemical arms
your military arms
in your arms
in your electronic arms.

Still from *O Superman* video. 1981

The United States postal slogan cited in the song—
"Neither snow nor rain nor gloom of night shall stay these couriers"—was signed in international sign language for the deaf in a circular vignette.

(LA) "In 1980 I released 'O Superman' on a small New York label, Bob George's 110 Records. The idea was that we would sell it mail order, and the initial pressing was 1,000 copies, financed by a $500 grant from the National Endowment for the Arts. Then one day I got a call from London, an order for 20,000 copies of the single, immediately followed by another 20,000 by the end of the week. I looked around at the cardboard box of records and said, 'Listen, can I just call you back?'

"People from Warner Brothers Records had been coming to my concerts, and asking whether I wanted to make a record. I hadn't really been too interested; I thought that pop music was usually designed for the average twelve-year-old and I didn't want anything to do with it. On the other hand, I was really happy that so many people suddenly wanted to hear my music in England. So I called someone at Warners and asked if they could just press and ship some records for me. They said they didn't usually do this sort of thing ad hoc, that it would be better to sign an agreement. And that's how I got around to signing an eight-record deal granting Warner Brothers Records the right to own and distribute my music, 'in perpetuity throughout the universe.'

"I quickly found out that in my world (the New York avant-garde) this was considered 'selling out.' It took me a while to understand, but finally I realized this judgment was totally consistent. The avant-garde in the late '70s was extremely protective of its own ideas, territory, and privilege. I myself had benefited from this attitude. I had been supported and protected by this network. It had always been a safe place to work, until I signed a contract with a 'commercial' company. A couple of years later, this process was known as 'crossing over' and was looked on more favorably by the avant-garde. By the time it was considered a 'smart commercial move' in the mid-'80s, there was no longer much of an avant-garde left to comment on it anyway.

"This result of this for me was that I had a whole new audience, an electronic audience. And I had no idea what they expected or wanted."

"O Superman." 1981

"O Superman" was released as a 45-rpm disc by 110 Records, New York, in 1981. It reached the #2 spot on the British pop charts and led to Anderson's signing with Warner Brothers Records.

OPPOSITE:
**Anderson with Charles Fisher
and Bill Obrecht**

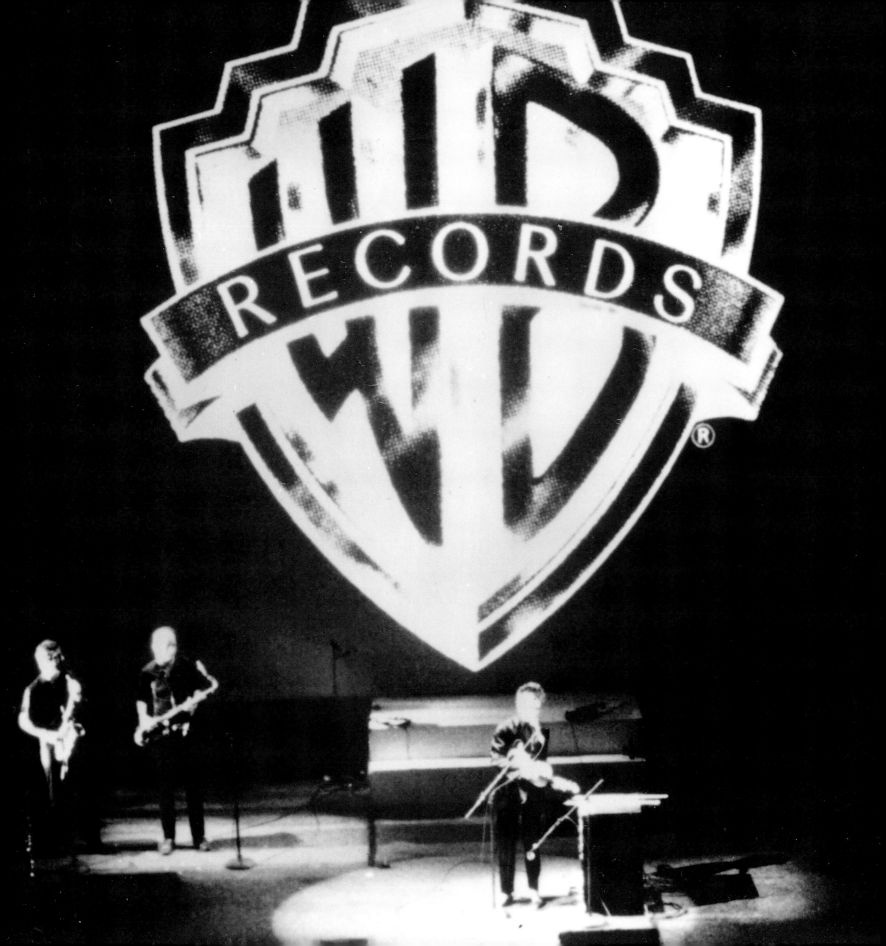

SAY HELLO
(for two microphones and fake hologram)

You're driving alone at night.
And it's dark and it's raining.
And you took a turn back there
and you're not sure now that it was the right turn,
but you took the turn anyway
and you just keep going in this direction.
Eventually, it starts to get light and you look out
and you realize
you have absolutely no idea where you are.
So you get out at the next gas station and you say:

Hello. Excuse me.
Can you tell me where I am?

You can read the signs. You've been on this
road before. Do you want to go home?
Do you want to go home now?

Hello. Excuse me.
Can you tell me where I am?

You can read the sign language.
In our country, this is the way we say "hello."
Say hello.

Hello. Excuse me.
Can you tell me where I am?

In our country, this is the way we say "hello."
It is a diagram of movement between two points.
It is a sweep on the dial. In our country,
this is also the way we say
"goodbye."

Hello. Excuse me.
Can you tell me where I am?

In our country, we send pictures of people speaking
our sign language into Outer Space.

We are speaking our sign language in these pictures.
Do you think that They will think his arm is perma-
nently attached in this position?
Or, do you think They will read our signs?
In our country, "goodbye" looks just like "hello."

SAY HELLO. SAY HELLO. SAY HELLO.

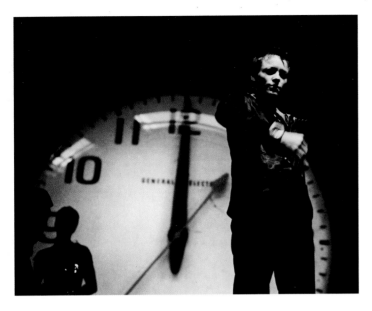

"How to Speak French"

Anderson has said that spoken segues between songs are as important to her as the songs themselves. Time changes in songs might also be expressed with small technological props used as segues, as in this work where the ticking of a watch was triggered by the banging of a child's hammer in the previous section. The wrist watch was also a light, so that when Anderson looked at the watch, it lit up her face.

"Talkshow"

This segment included a montage of two-syllable words about newscasters who were instructed not to use big words in their broadcasts.

OPPOSITE:
Drawing of man and woman from
United States. **1983**

Anderson adapted this image from one designed by Carl Sagan, Linda Sagan, and Frank Drake. It was engraved on a six-by-nine-inch gold-anodized aluminum plate, which was mounted on the skin of *Pioneer 10*, the first American spaceship to fly to Jupiter, launched in March 1972. Anderson used the drawing in "Say Hello." With this image and the story she told to accompany it, she made it clear that her analysis of the United States would be many-layered, complex, and filled as much with worry as with wonder. Its overtones of imperialism (as though the spaceship were making territorial claims on space), chauvinism (the male, with his hand raised, is active, the female at his side, inactive), and ironic (Americans, she suggested, use a raised arm both as an expression of welcoming idealism and as an aggressive sign of their country's formidable power) were potent themes that ran throughout the production. "In our country," she says, "this is the way we say hello. In our country this is also the way we say goodbye." Moreover, her use of alternating voices—her own gentle one and a much deeper, ominous "voice of authority," which she achieved by speaking into a vocoder—left no doubt as to her meaning.

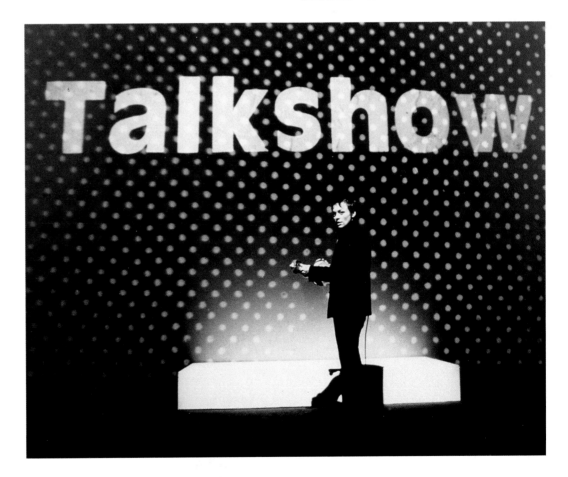

IT TANGO

She said: It looks
Don't you think it looks a lot like rain?

He said: Isn't it. Isn't it just.
Isn't it just like a woman?

She said: It, it goes that's the way it goes
She said: It's hard. It's just hard.
It's just kind of hard to say.

He said: Isn't it. Isn't it just.
Isn't it just like a woman?
It's hard. It's just hard. It's just kind of
hard to say.
He said. Isn't it. Isn't it just. Isn't it just like
a woman?
She said: It, it takes. It takes one.
It takes one to. It takes one to know one.

He said: Isn't it, isn't it just like a woman?

She said, she said it,
She said it to no.
She said it to no one.

Isn't it. Isn't it just,
Isn't it just like a woman?

FROM THE AIR

Good evening. This is your Captain.
We are about to attempt a crash landing.
Please extinguish all cigarettes.
Place your tray tables in their upright,
locked position.
Your Captain says: Put your head on your knees.
Your Captain says: Put your hand in your hands.
Captain says: Put your hands on your head.
Put your hands on your hips. Heh heh.
This is your Captain . . . and we are going down.
We are all going down, together.
And I said: Uh oh. This is gonna be some day.
Stand by. This is the time.
And this is the record of the time.
This is the time. And this is the record of the
time.

Uh . . . this is your Captain again.
You know, I've got a funny feeling
I've seen this all
before.
Why? Cause I'm a caveman.
Why? Cause I've got eyes in the back
of my head.
Why? It's the heat. Stand by.
This is the time. And this is the record
of the time.
This is the time. And this is the record
of the time.

Put your hands over your eyes. Jump out of
the plane.
There is no pilot. You are not alone. Stand by.
This is the time. And this is the record of
the time.
This is the time. And this is the record of
the time.

WALKING & FALLING

I wanted you. And I was looking for you.
But I couldn't find you.
I wanted you. And I was looking for you all day.
But I couldn't find you. I couldn't find you.

You're walking. And you don't always realize it,
But you're always falling.
With each step, you fall forward slightly.
And then catch yourself from falling.
Over and over, you're falling.
And then catching yourself from falling.
And this is how you can be walking and falling
At the same time.

SWEATERS
(for Jean Luc Godard)

I no longer love your mouth.
I no longer love your eyes.

I no longer love your eyes.
I no longer love the color of your sweaters.
I no longer love it.

I no longer love the color of your sweaters.
I no longer love the way you hold your pens
and pencils.
I no longer love it.

Your mouth. Your eyes.
The way you hold your pens and pencils.
I no longer love it. I no longer love it.

CLOSED CIRCUITS

Well I know who you are, baby,
I've seen you go into that meditative state.
You're the snake charmer, baby.
And you're also the snake.
You're a closed circuit, baby.
You've got the answers in the palms of your hands.

Well I saw a blind Judge
And he said: I know who you are
And I said: Who?
And he said: You're a closed circuit, baby.
He said: The world is divided into two kinds of things.
There's luck, and there's the law.
There's a knock on wood that says: IT MIGHT.
And there's the long arm of the law that says: IT'S RIGHT.
And it's a tricky balancing act between the two.
Because both are equally true.
'Cause might makes right.
And anything could happen. Che sara sara. Am I right?

Who? Do. Who? Do.
Who do you love?

Well I saw a couple of hula dancers
Just hula-ing down the street.
And they said: Well I wonder which way the tide
Is gonna roll in tonight?
And I said: Hey hold up hula dancers! You know
The tide's gonna roll out
And then it's gonna roll right back in again.
'Cause it's a closed circuit, baby. We got rules for
that kind of thing
And you know the moon is so bright tonight.

Who? Do. Who? Do.
And don't think I haven't seen all those blind A-rabs.
Around. I've seen 'em around.
And I've watched them charm that oil
Right out of the ground.
Long black streams of that dark electric light.
And they said: One day the sun went down
And it went way down, into the ground.

And three thousand years go by
And we pump it right back up again.
'Cause it's a closed circuit, baby.
We can change the dark into the light
And vice versa.

Well I know who you are, baby.
I've watched you count yourself to sleep.
You're the shepherd, baby.
And you're also one, two, three
Hundred sheep. I've watched you fall asleep.
Well I was up real late last night.
Must have just dropped off to sleep.
'Cause I saw you were crying, baby.
You were crying in your sleep.

You're the snake charmer, baby.
And you're also a very long snake.
You're a closed circuit, baby.
You've got the answers in the palms of your hands.

DEMOCRATIC WAY

I dreamed that I was Jimmy Carter's lover, and
I was somewhere, I guess in the White House . . .
and there were lots of other women, too . . . and they
were supposed to be his lovers, too . . . but I never
even saw Jimmy Carter . . . and none of the other
women ever saw him either.

And there was this big discussion going on because
Jimmy had decided to open up the presidential
elections to the dead. That is, that anyone who had
ever lived would have the opportunity to become
President. He said that he thought it would
be more democratic that way.

The more choice you had
The more democratic it would be.

LET X=X
(for vocoder, marimba, claps, and metronome)

I met this guy, and he looked like he might have been
a hat check clerk at an ice rink, which, in fact, he
turned out to be, And I said:
Oh boy! Right again!

Let x=x. You know, it could be you.
It's a sky-blue sky. Satellites are out tonight.
Let x=x.

You know, I could write a book.
And this book would be thick enough to stun an ox.
'Cause I can see the future, and it's a place.
About seventy miles east of here, where it's lighter.

Linger on over here. Got the time?
Let x=x

I got this postcard and it read, it said: Dear Amigo,
Dear Pardner,
Listen, I just want to say thanks. So . . . thanks.
Thanks for all the presents.
Thanks for introducing me to the chief.
Thanks for puttin' on the feedbag.
Thanks for going all out.
Thanks for showing me your Swiss Army knife.
Oh and uh . . . thanks for letting me autograph your
cast.
Hugs and kisses,
XXX OOOO

Oh yeah. P.S.
I I feel feel like I am in a burn-
ing building
And I gotta go.

Your eyes. It's a day's work looking into them.
Your eyes. It's a day's work just looking into them.

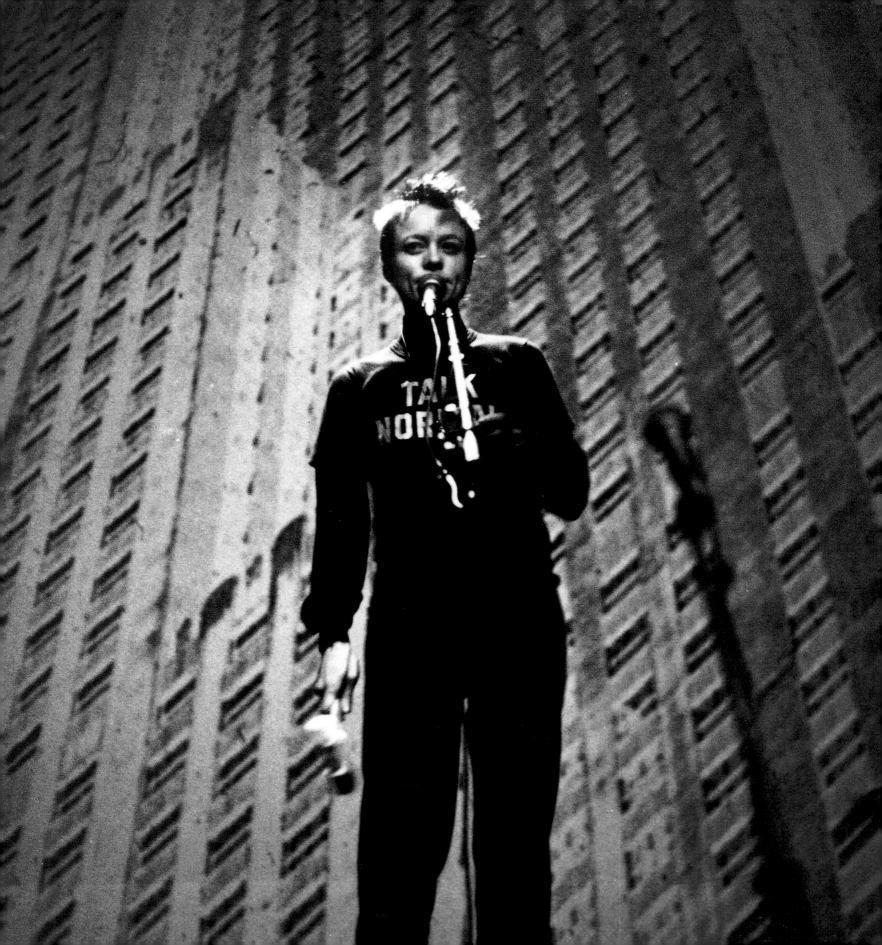

Anderson performing "Private Property" in
United States

The America that we live in, Anderson told her audience, is a country of the future, an electronic country, a TV country, a "closed circuit" that contains buried nuclear silos and Dolly Parton, rural farmers and William F. Buckley. It is a country driven by "news-speak" and "sound bites" and by a president who used the air waves as his own personal brzoadcasting system. Indeed, fragments of Reagan's America appeared regularly in Anderson's rendering of the country, while in general her songs showed a keen awareness of the winds of political change.

(LA) "William F. Buckley, Jr., Mr. Private Property, planned to give a little talk, a political speech, in a small town in Illinois. His advance men discovered that the center of town had disappeared, and that all the commercial action was out at the mall. When Buckley arrived at the mall, he set up his microphone near a little fountain and began to hand out leaflets and autograph copies of his latest book. Just as a small crowd of shoppers gathered, the owners of the mall ran out and said, 'Excuse us. This is private property, we're afraid you'll have to leave.'

"You know, when I got back from a trip this summer, I noticed that all of the old factories here on the outskirts of town had suddenly been transformed into luxurious condos and that thousands of people had moved into them almost overnight. Most of the new residents appeared to be professional barbecuers. Every night, they were out on their fire escapes barbecuing something. And the smoke rising from their little fires made the whole neighborhood look like a giant battlefield. And I would look out my window and say, 'Hmm . . .'

"You know, last night I came up out of the subway and I said to myself, 'Hmm . . . Do you want to go home?' And I thought, 'You are home.'"

Language, no less than politics, was carefully scrutinized. Anderson's intellectual fascination with semantics, and with philosophers who wrote on theories of language, from Ludwig Wittgenstein to Walter Benjamin or Jacques Derrida, could be detected in songs whose serious aspects were cleverly disguised by the rhythms of rock 'n' roll. "Language Is a Virus" has been cited by several academic writers for the way in which it so subtly and ingeniously translates theory into hummable song.

(LA) "In 1980, I wrote a song for William Burroughs called 'Language Is a Virus.' This was a quote from one of Burroughs' books. It's a strange thing for a writer to say that language is a disease communicable by mouth. It's also a very Buddhist thing to say. I mean, in Buddhist thought there's the thing and there's the name for the thing and that's one thing too many. Because sometimes when you say a word, you think you actually understand it. In fact, all you're doing is saying it, you don't necessarily understand it at all. So language, well, it's a kind of trick."

LANGUAGE IS A VIRUS FROM OUTER SPACE
–William S. Burroughs

I saw this guy in the chair. And he seemed to have gotten stuck in one of those abstract trances. And he was going "ugh . . . ugh . . . ugh . . . " And Geraldine said: You know, I think he's in some kind of pain...I think it's a pain cry. And I said: If that's a pain cry, then language . . . is a virus . . .
Language! It's a virus!
Language! It's a virus!
Well I was feeling really rotten the other day, I was feeling washed up . . . and I said to myself: I know what I'm going to do—I'm going to take myself out. So I went to the park and I sat down and I said, Boy Is this ever fun. I'm really having fun now. I'm having the time of my life now And then this little dog ran up, and this dog had ears like a drop-leaf table, and I said, Boy. Is this ever fun
Language! It's a virus!
Language! It's a virus!
Well I was talking to a friend the other day, and I was saying: I wanted you . . . and I was looking for you . . . but I couldn't find you. And he said: Hey . . . are you talking to me . . . or are you just practicing for one of those performances of yours?
Language! It's a virus!
Language! It's a virus!
You know, I don't believe there's such a thing as the Japanese language. I mean, they don't even know how to write. They just draw pictures of these little characters, and when they talk, they just make sounds that more or less synch up with their lips.
Language! It's a virus!
Language! It's a virus!
Well I walked uptown and I saw a sign: Today's lecture: Big Science and Little Men. So I walked in and there were all these salesmen there and a big pile of electronics.
And they were singing: Phase Lock Loop. Neurological Bonding. Video Disc. They were saying: We're gonna link you up. They were saying: We're gonna phase you in. They said: Let's look at it this way—Picture a Christmas tree with lots of little sparkly lights, and each light is totally separate, but they're all sort of hanging off the same wire. Get the picture? And I said: Count me out. And they said: We've got your number. And I said: Count me out. You gotta count me out.
Language! It's a virus!
Language! It's a virus!

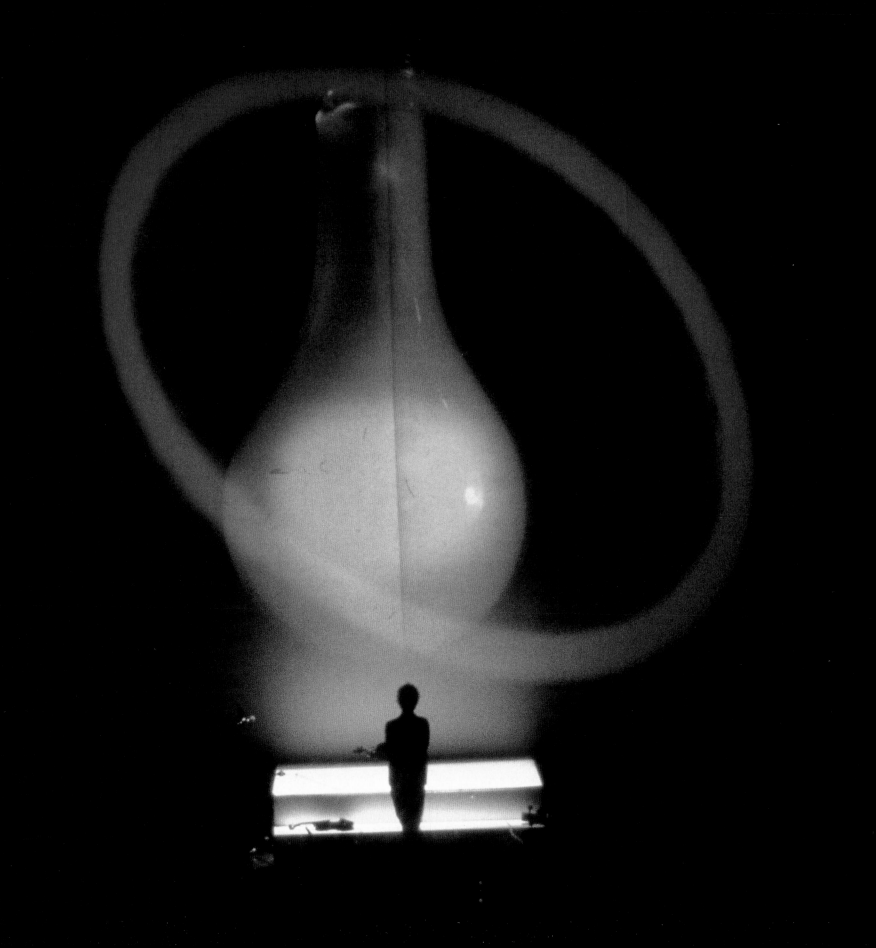

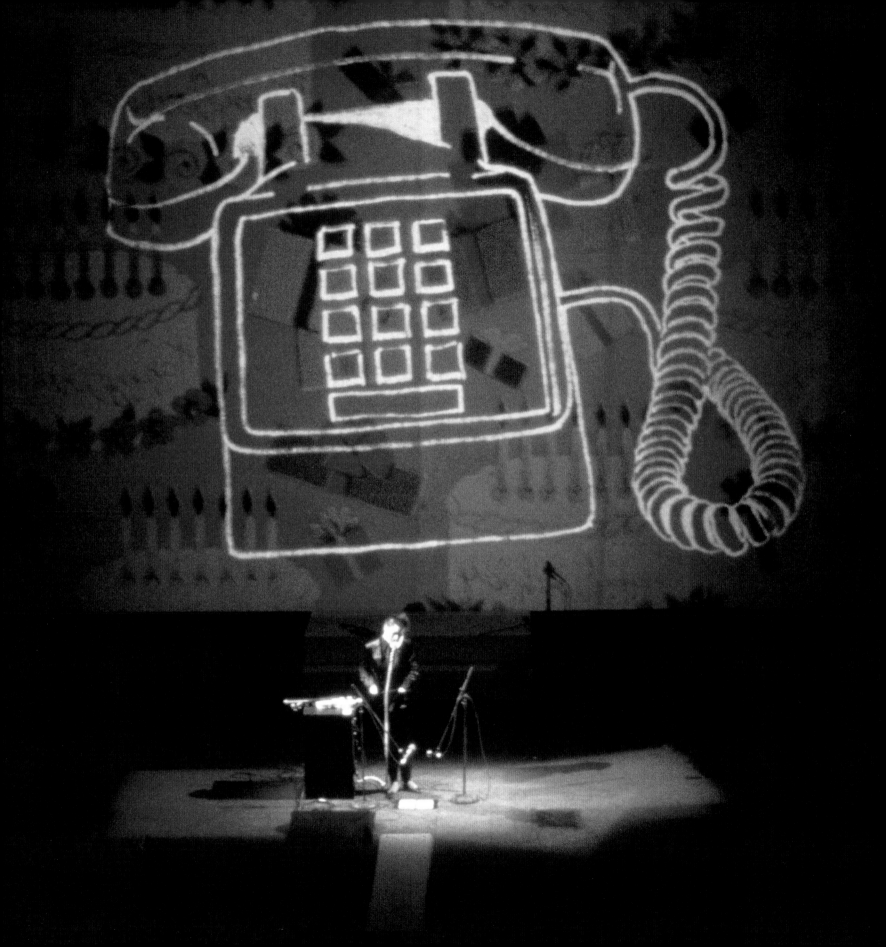

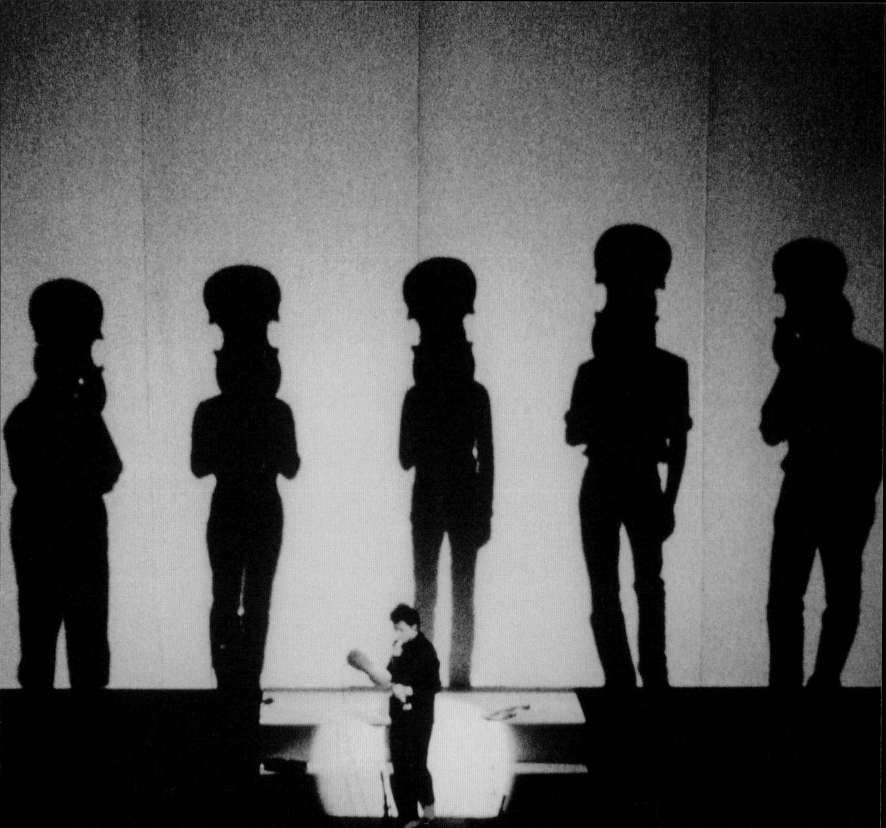

(LA) "For me, electronics have always been connected to storytelling. Maybe because storytelling began when people used to sit around fires. For me, fire is magic, compelling, and dangerous. We are transfixed by its light and by its destructive power. Electronics are modern fires."

THE DANCE OF ELECTRICITY

I saw a photograph of Tesla, who invented the Tesla coil. He also invented a pair of shoes with soles four inches thick to ground him while he worked in his laboratory. In this picture, Tesla was sitting in a chair, wearing the shoes, and reading a book by the light of the long streamer-like sparks shooting out of his transformers.

A while ago, I got a call from the Tesla Institute in Belgrade, long distance. The voice was very faint and it said, "Understand do we that much of your work has been dedicated to Nikola Tesla and do we know the blackout of information about this man in the U.S. of A. And so we would like to invite you to the Institute as a free citizen of the world . . . as a free speaker on American Imperialist Blackout of Information . . . Capitalist resistance to Technological Progress . . . the Western World's obstruction of Innovation. So think about it." He hung up. I thought: "Gee, really a chance to speak my mind . . ." and I started doing some research on Tesla, whose life story is actually really sad.

Basically, he was the inventor of AC current, lots of kinds of generators and the Tesla coil. His dream was wireless energy. And he was working on a system in which you could plug appliances directly into the ground. A system which he never really perfected.

Tesla came over from Graz and went to work for Thomas Edison. Edison couldn't stand Tesla for several reasons. One was that Tesla showed up for work every day in formal dress—morning coat, spats, top hat, and gloves—and this just wasn't the American Way at the time. Edison also hated Tesla because Tesla invented so many things while wearing these clothes.

Edison did his best to prevent conversion to AC and did everything he could to discredit it. In his later years, Edison was something of a showman and he went around on the Chautauqua circuit in upstate New York giving demonstrations of the evil effects of AC. He always brought a dog with him and he'd get up on stage and say: "Ladies and gentlemen! I will now demonstrate the effects of AC current on this dog!" And he took two bare wires and attached them to the dog's head and the dog was dead in under thirty seconds.

At any rate, I decided to open the series of talks in Belgrade with a song called "The Dance of Electricity," and its beat is derived from the actual dance—an involuntary dance—and it's the dance you do when one of your fingers gets wedged in a live socket and your arms start pumping up and down and your mouth is slowly opening and closing and you feel the power but no words come out.

In science fiction films, the hero flies in at the very beginning. He can bend steel with his bare hands. He can walk in zero gravity. He can see right through lead doors. But no one asks how he is able to do these things. They just say, "Look! He's walking in zero gravity." So you don't have to deal with human nature at all.

OPPOSITE:
Anderson's oddly shaped "aliens" were created by projecting shadows of performers holding violins in front of their faces

(LA) "You know, there are always lots of animals on my records; birds, wolves, dogs, crickets, mosquitoes."

Animals, especially dogs and parrots, appear frequently in Anderson's songs and films. In "Walk the Dog" (1979), for example, she recalls a dog she had seen in a movie— "thirty feet high/ And this dog was made entirely of light," while in "Dog Show" (1983) she dreamed that she herself was a dog: "My father came to the dog show/ And he said: That's a really good dog." Animals, in her iconography, represent an intuitive, natural version of hard-to-describe human sensibilities, like desire or fear. "I'm positive that animals have emotions," Anderson says, "not because of things like animal rights, but because this kind of mute emotion is something that we as humans share." The tension between "things that can be said and those that are unsayable," Anderson says, always fascinated her as a writer. It could also be seen as a strong link connecting her writing and her music.

WALK THE DOG

Well, I saw a lot of trees today.
And they were all made of wood.
They were wooden trees
And they were made entirely of wood.

I came home today
And you were all on fire.
Your shirt was on fire,
And your hair was on fire,
And flames were licking all around your feet.
And I did not know what to do!
And then a thousand violins began to play,
And I really did not know what to do then.
So I just decided to go out
And walk the dog.

I went to the movies,
And I saw a dog thirty feet high.
And this dog was made entirely of light.
And he filled up the whole screen.
And his eyes were long hallways.
He had those
Long, echoing, hallway eyes.

I turned on the radio
And I heard a song by Dolly Parton.
And she was singing:
Oh! I feel so sad! I feel so bad!
I left my mom and I left my dad.
And I just want to go home now.
I just want to go back to my Tennessee mountain home now.
Well, you know she's not gonna go back home.
And I know she's not gonna go back home.
And she knows she's never gonna go back there.
And I just want to know who's gonna go and walk her dog.

Oh! I feel so bad.
I feel so sad.
But not as bad as the night
I wrote this song.

Close your eyes!
 OK
Now imagine you're at the most wonderful party.
 OK
Delicious food.
 Uh huh
Interesting people.
 Mm hmn
Terrific music.
 Mn hmmh
Now open them!
 Oh no
Well I just want to go home now
And walk the dog.

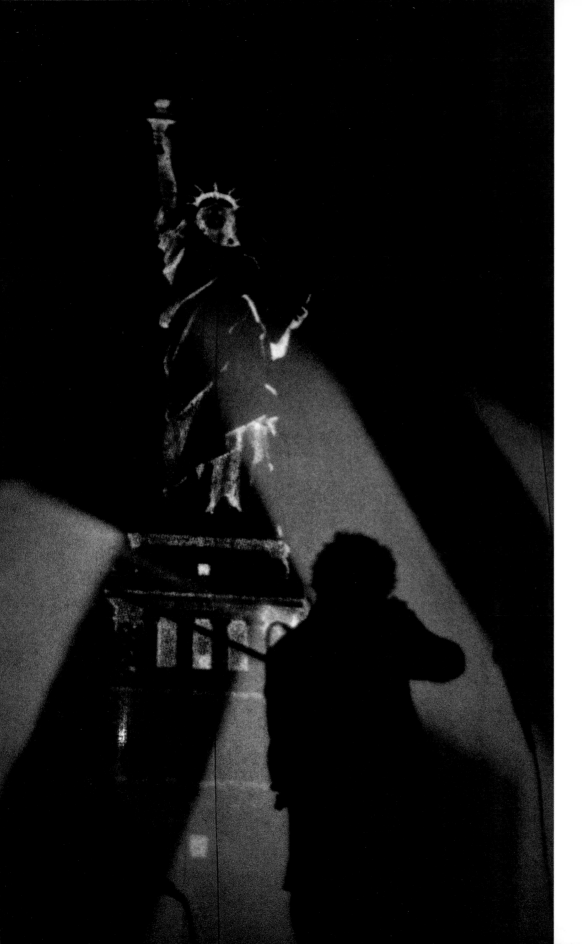

"Finnish Farmers"
(for voice, violin, and drums)

An image of the Statue of Liberty was superimposed
over a film of an American flag spinning around in a
dryer. The violin was played to sound like a siren.

FINNISH FARMERS

During World War II, the Russians were testing their para-
chutes. Sometimes they didn't open at all and a lot of troops
were lost this way. During the invasion of Finland, hundreds
of troops were dropped during the middle of winter. As
usual, some of the chutes didn't open and the troops fell
straight down into the deep snow, drilling holes fifteen feet
deep. The Finnish farmers would then get out their shotguns,
walk into their fields, find the holes and fire down them.

During the 1979 drought in the Midwest, the American
farmers began to rent their property to the United States
government as sites for missile silos. They were told: Some
of the silos contain Minutemen and some do not. Some
are designed to look like ordinary corn and grain silos. The
military called these the Decoy Silos, but the farmers called
them the Scarecrows. The government also hinted that some
of these silos might be connected by hundreds of miles of
railroad in an underground shuttle system.

This is the breadbasket. These are the crops.
The shot heard round the world.

The farmers, the Minutemen.
The farmers,
the ones who were there.

Breadbasket. Melting Pot.
Meltdown.
Shutdown.

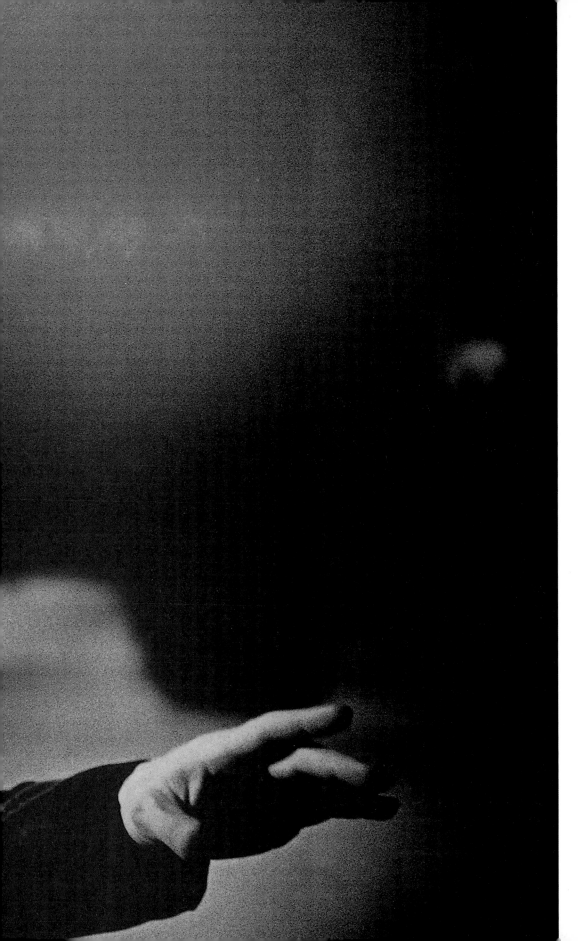

Anderson wearing Headlight Glasses in
United States

In the finale of *United States*, Anderson walked slowly toward the audience on a narrow diving board cantilevered over the orchestra pit, blinded by the light, moving like a sleepwalker with her arms stretched in front of her, her feet feeling the edge of the board. This kind of disturbing, "question mark" ending would become a defining feature of Anderson's subsequent performances.

LIGHTING OUT FOR THE TERRITORIES

You're driving and it's dark
and it's raining.
And you're on the edge of the city
and you've been driving all night.
And you took a turn back there
but now you're not sure it was the right turn.
But somehow it looks familiar so you
just keep driving.

Hello. Excuse me.
Can you tell me where I am?

You've been on this road before.
You can read the signs.
You can feel your way.
You can do this
in your sleep.

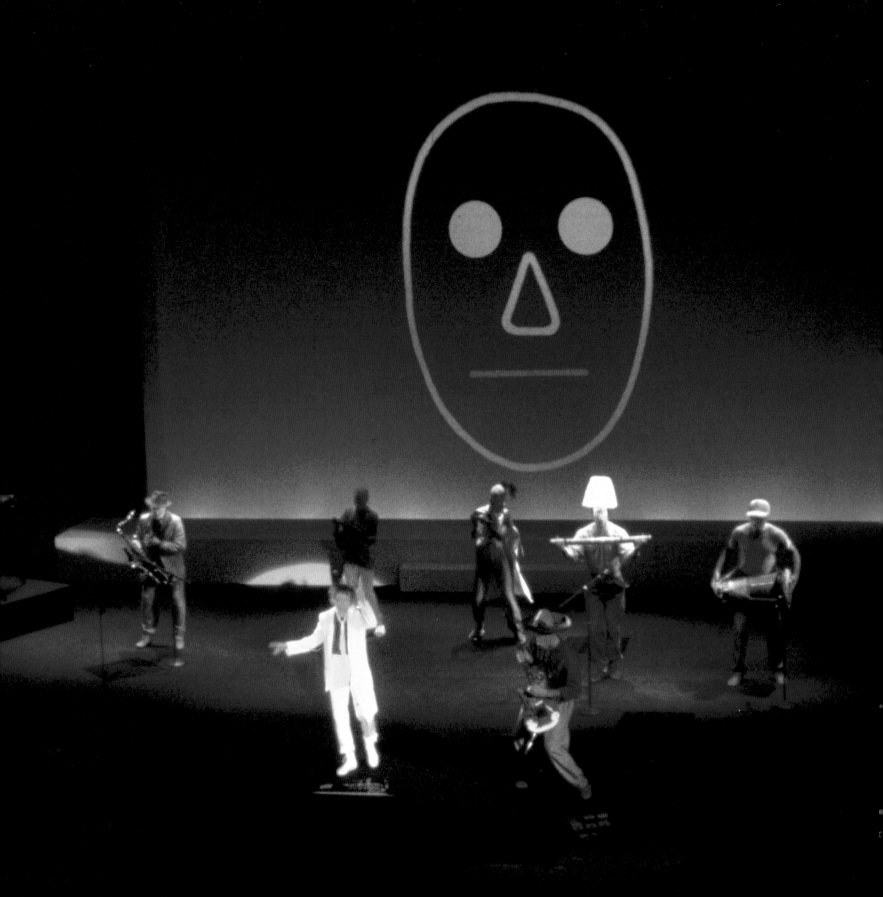

MISTER HEARTBREAK AND HOME OF THE BRAVE

Mister Heartbreak (1984), a performance tour of the United States, Canada, and Japan, coincided with the release of an album of the same name. It included several songs from *United States*, but comprised mostly new material written in the year following that production. This recording would become the soundtrack for *Home of the Brave* (1985), a concert movie of *Mister Heartbreak*. The next year Anderson toured the United States, Japan, and Australia, this time with a production called *Natural History*. "The idea of the tour was to promote the movie," Anderson says, "but because I had to put it together so fast, it never really became a performance." The many titles of this work—it began as *Mister Heartbreak* in concert (and as a recording), became the movie (and soundtrack) *Home of the Brave*, and later a tour, *Natural History*—shows Anderson's penchant for naming and renaming different versions of the same work. "Titles," Anderson explains, "are so iconic, which makes them hard to come by."

At the same time, her use of a range of titles for the various incarnations of the same work has a purely practical function. "It is a way for me to keep track of what I am working on; at any one time this might include a perfor-mance, a performance tour, a record, and a tour to promote the record," she says. Anderson even frequently refers to large-scale performances according to particular versions, the first being considered an early draft, the last being the completed work. "For example, the *Nerve Bible* performed in Philadelphia in 1992 was very different from the *Nerve Bible* presented in Jerusalem six months later," she observes. Similarly, albums and performances might share the same material, but the structure and overall concept of an album versus that of a performance can suggest distinct titles. Such was the case with the *Strange Angels* album (1989), which was launched before *Empty Places*, the performance and tour (1990). Both included many of the same songs, but Anderson felt the need to name them differently. "The space implied in the title *Empty Places* is appropriate for a staged performance," Anderson explains, "but I didn't feel that it worked as a title for an album."

For the film *Home of the Brave*, Anderson upped the ante of stage effects and costumes, building dance sequences and narratives that were far more elaborate than any she had created before. "The potential for real-time dis-aster" that she said she loved about live performance had been entirely eliminated from the film, and the lukewarm reviews that followed its opening made her wonder whether in the end her work could succeed without the live element. "It played for about a week in New York, and had a similarly short life in most cities," Anderson recalls. "I was devas-tated. I had spent two years on the movie, poured all my energy into it, and it had basically bombed."

Nevertheless, Anderson set off on an extensive tour of the United States, Europe, Japan, and Australia to promote the film, accompanied by a large crew of technicians and guest artists. The tour was a collection of songs from the movie, as well as material from past albums—but it lacked a narrative throughline, Anderson explains, and she found it an unsatisfying performance to sustain, night after night, city after city. Exhausted by the heavy touring schedule, she was frequently without a voice. In general the following year turned out to be a difficult one; the disappointments of the film and the tour and the relentless pressure of mid-eighties hype were taking their toll. Back in New York, she retreated behind a series of smaller projects, writing the sound track for Jonathan Demme's film of Spalding Gray's *Swimming to Cambodia* and a score for *Bird Catcher in Hell*, by Robert Wilson. It would be her voice lessons, which she had begun while on tour to counteract the physical demands of an overextended schedule, that provided the launch pad for an entirely fresh approach to her work.

Anderson performing "White Lily" in *Home of the Brave*. 1985

Home of the Brave was shot in 35-mm Panavision at the Park Theater in Union City, New Jersey, in 1985, and released through Cinecom International Films. It opened in New York at the 57th Street Playhouse in 1986.

What Fassbinder film is it?
The one-armed man
Comes into the flower shop and says,
"What flower expresses:
Days go by
And they just keep going by
Endlessly
Pulling you
Into the future?

Days go by
Endlessly, endlessly
Pulling you
Into the future?"
And the florist says,
"White Lily"

OPPOSITE:

"Sharkey's Night" in *Home of the Brave*. 1985.
Front row: Anderson and Adrian Belew;
back row: Richard Landry, Janice Pendarvis, Dolette
McDonald, Isidro Bobadillo, and Daniel Ponce

THE 1980s **111**

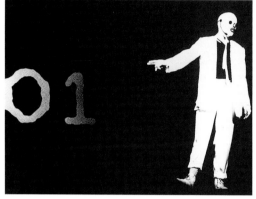

LOWER MATHEMATICS

Good evening. Now, I'm no mathematician but I'd like to talk about just a couple of numbers that have been really bothering me lately, and they are zero and one. Now first, let's take a look at zero. To be a zero means to be nothing, a nobody, a has-been, a zilch.

On the other hand, just about everybody wants to be number one. To be number one means to be a winner, top of the heap, the acme. And there seems to be a strange kind of national obsession with this particular number.

Now, in my opinion, the problem with these numbers is that they are just too close—leaves very little room for everybody else. Just not enough range.

So first, I think we should get rid of the value judgements attached to these two numbers and recognize that to be a zero is no better, no worse, than to be number one.

Because what we are actually looking at here are the building blocks of the Modern Computer Age.

Anderson's costume sketches for *Home of the Brave*

(LA) "At the end of the *Mister Heartbreak* tour, I realized I'd never filmed a performance for more than 30 seconds. I'd never tried to document them because they were about memory, and I wanted that to be the way that they would be recorded—in people's memories. Then I realized that people didn't remember them very well. They'd say, 'remember that performance you did with that orange dog four years ago?' And I'd say, 'There was no orange dog.'"

Home of the Brave was motivated by a desire to have, for once, a complete record of one of her performances. Even Anderson's most renowned work, *United States*, lives on only in the form of albums and photographs.

"Langue d'Amour," *Home of the Brave*

OVERLEAF:
"Language Is a Virus," *Home of the Brave*. From left to right: Richard Landry, Bobby Butler, Jimmy Carter, Sam Butler, Anderson, Adrian Belew, Joy Askew, and David Van Tieghem

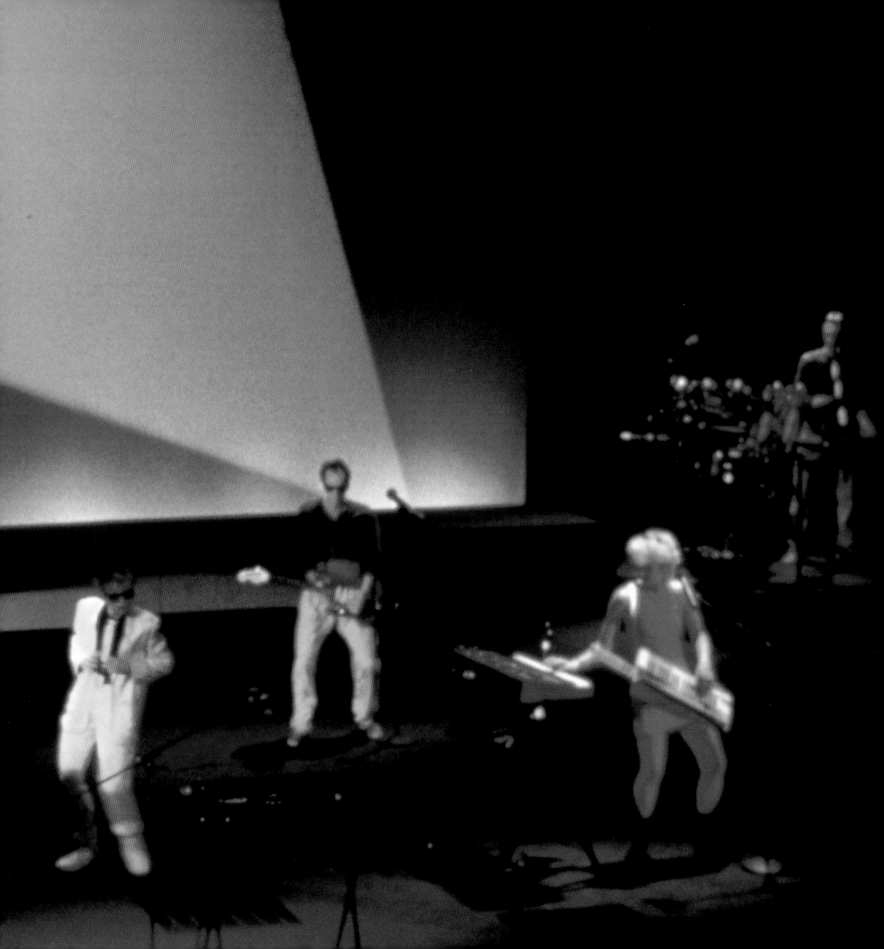

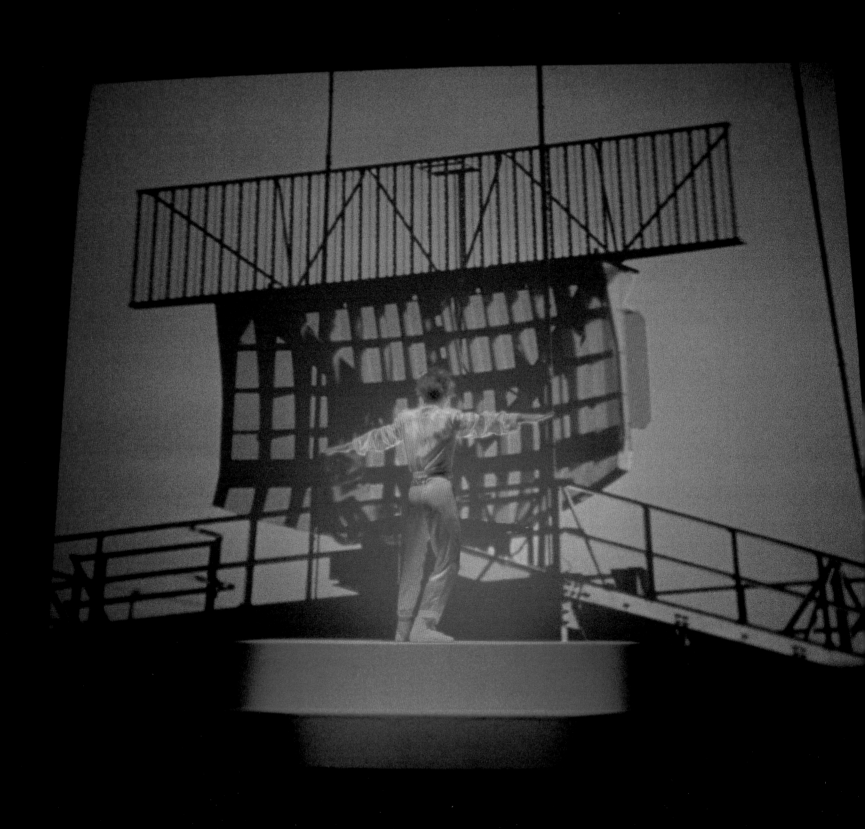

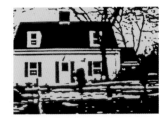

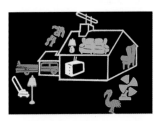

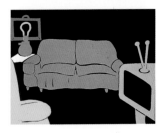

(LA) "In *Home of the Brave*, seven musicians on a bare stage play strange instruments wearing costumes that occasionally mutate into other strange instruments. Behind them is a thirty-by-forty-foot screen onto which slides and films are projected. There are eleven other people who come and go over the course of ninety minutes—a horn section, stagehands, Latin percussionists, and a game-show hostess. A telephone drops in from nowhere. Scribbled diary fragments and grocery lists flash on the screen. William Burroughs tangos by. Subtitles mistranslate a song in French. This is a 'kind of a concert film' the way my performances are 'kind of concerts.'

"The film was shot over a period of ten days in the Park Theater in Union City, New Jersey, in July 1985. Half the time there was an audience who arrrived every day by bus from Manhattan; the rest of the shoot was reserved to get difficult shots, especially of the screen.

"When I decided to make this movie, I began looking for a director. I asked a lot of people for suggestions and talked to directors whose concert films I admire, such as Marty Scorsese (*The Last Waltz*) and Jonathan Demme (*Stop Making Sense*). Both said, 'Do it yourself. Get a good director of photography, video playback, and a loud assistant director.'

"I'm not sure I would advise anyone else to star in their own movie. The special blend of schizophrenia and narcissism that you need to split roles can result in a power struggle. Eventually, of course, the director wins. Editing was like watching myself in a dream. I was never convinced by Jung's three-story model of the self, until one night, waking up

OPPOSITE:

"Radar," *Home of the Brave*. Anderson stood on a turntable that rotated in the opposite direction as the revolving image

from a particularly humiliating dream, I looked down and saw myself at a desk. I was writing the dream, casting myself as dupe. And I was laughing. Laughing my head off.

"After a few months of sitting in the editing room, working on *Home of the Brave*, looking at pictures of myself day after day, we paused on a close-up of my face, and I thought, 'If I ever see this face again, I'm going to shoot myself!' The simple truth is that you should never take that many pictures of yourself; and if you do, you should not sit around for months staring at them. Eventually, editing began to seep into my daily life. I'd be sitting in a restaurant talking with someone and suddenly I'd look around and think, 'Wait a second! This isn't very well lit! I wonder if we have any other coverage of this?' Or worse, 'Who wrote this, anyway?'

"*Home of the Brave* begins with a projected animation of products falling from the sky. Flintstone kabuki crossbred with the Bauhaus. A drum machine bangs out an odd time-signature. The central character lurches forward playing wolf-howl double stops on an industrial remnant of a violin.

"*Home of the Brave* took a year and a half to make and cost $1.6 million. Getting the money was the hardest part. As feature films go it was not much. But for me it meant months of emoting in front of storyboards as potential backers shuffled in and out. Eventually I got so good at it, it seemed like I was describing a film I'd seen a thousand times. It hardly seemed necessary to make it.

"My main commitment has been to live performances. I love the potential of real-time disaster. I like the contact, the feedback. I resisted the pressure to shoot on video because it's too flat and too lonely. Movie theaters are social—the gossipy ticket line, the communal high-velocity eating in the dark. And movie houses preserve the trappings of theaters—the parting curtains, the vestigial stages, too skinny for anyone to walk on but wide enough to suggest their heritage."

ANIMATION AND NOTATION

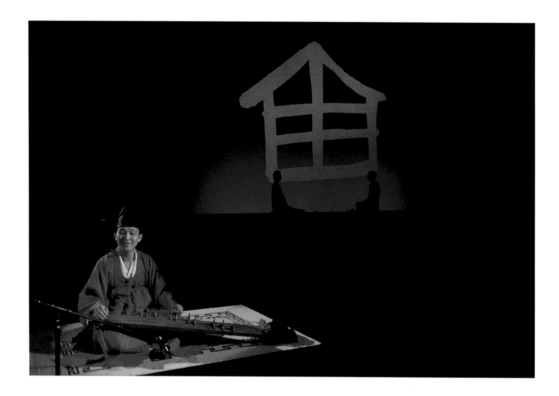

Anderson's fascination with language—spoken, hand signed, foreign—led to the development of her own ideograms. From the early mudras she made of pulped newspapers in the '70s, to her use of Japanese pictures for words like house or water, to her own easily recognizable graphics and animation films—a man, a woman, faces, houses, telephone, airplanes, clocks—she has created a highly personal and visual vocabulary of her obsessions. Thousands of these pictures are projected as backdrops in performances, sometimes thirty or forty a minute, others lasting for an entire song or story. Animation for *Home of the Brave* included a film sequence called *How to Write*, which showed drawings of objects and animals gradually turning into their Japanese ideograms. Anderson has also used handwritten symbols as well as body language as additional signage. Early backdrops included sequences of animation cells made on transparent paper. Later, film and computer techniques were used to create a repertoire of fast moving and visually startling animated film sequences.

I WAS TRYING TO READ "RAPID ITALIAN FOR STUDENTS AND TOURISTS".

THE ONLY OTHER PEOPLE ON THE PLANE WERE 20 MUSICIANS IN AN ALL-DRUM BAND FROM GHANA.

THEY WERE SITTING IN THEIR ASSIGNED SEATS FAR FROM EACH OTHER- EVEN THOUGH THE PLANE WAS ALMOST EMPTY.

WHEN I GOT UP, I SAW THAT ALL THE MUSICIANS WERE CRANING UP OVER THEIR SEATS, WHISTLING TO EACH OTHER.

THE FOREARM OF THE MAN SITTING NEXT TO ME KEPT DROPPING HEAVILY ONTO MY BOOK.

HE WAS CROSSING HIS EYES AND WHISTLING UP AND DOWN THE SCALE- ALMOST WORDS.

EACH TIME THE ARM DROPPED, I LOOKED OVER AT HIM BUT HE ALWAYS TURNED AWAY LAUGHING TO HIMSELF.

THE WHISTLE SEEMED TO DUPLICATE ITSELF- TO FILL THE PLANE.

IT SOUNDED LIKE ALL THE WING BOLTS HAD JOLTED LOOSE AND WERE WHISTLING IN THE WIND.

THE MAN NEXT TO ME SAID, "TWI-WE SPEAK TWI IN GHANA. TWI IS WE WHISTLE. I TEACH YOU TWI SONG."

SUDDENLY, HE TRIED TO JUMP UP BUT THE SEATBELT YANKED HIM BACK DOWN.

HE WROTE THESE WORDS IN MY NOTEBOOK:

ƏDƏ W ƆH JYI NOHO MIA PAPAO, LOVE IS A VERY IMPORTANT THING,

BUT PEOPLE DON'T KNOW HOW TO SAY IT,

I WILL BE WITH YOU EVEN IN DEATH,

In *For Instants* (1976–77), Anderson told a story about an all-drum band from Ghana while slides of the handwritten text were projected behind her

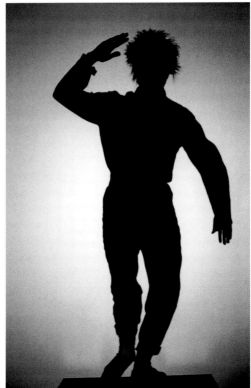
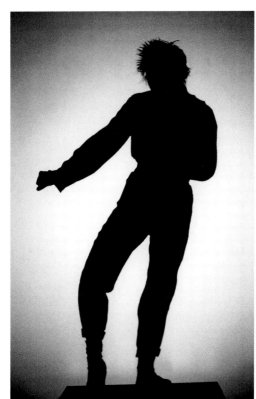
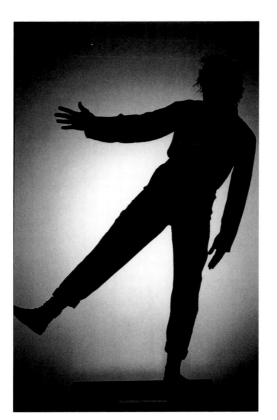

Anderson's dance moves functioned as conducting signals to the musicians on stage, as in the song "Smoke Rings" (1984)

SHARKEY'S NIGHT

Sun's going down. Like a big bald head.
Disappearing behind the boulevard. (Oooeee.) It's
Sharkey's night.
Yeah. It's Sharkey's night tonight. And the manager
says: Sharkey?
He's not at his desk right now. (Oh yeah.) Could I
take a message?

And Sharkey says: Hey, kemosabe! Long time
no see.
He says: Hey sport. You connect the dots. You pick
up the pieces.
He says: You know, I can see two tiny pictures of
myself.
And there's one in each of your eyes.
And they're doing everything I do.
Every time I light a cigarette, they light up theirs.
I take a drink and I look in and they're drinking
too.
It's driving me crazy. It's driving me nuts.

And Sharkey says: Deep in the heart of the darkest
America.
Home of the brave. He says: Listen to my heart
beat.
Paging Mr. Sharkey. White courtesy
telephone please.

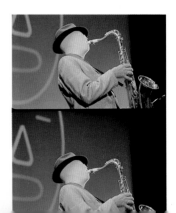

SHARKEY'S DAY

Sun's coming up. Like a big bald head.
Poking up over the grocery store.
It's Sharkey's day. It's Sharkey's day today.
Sharkey wakes up and Sharkey says: There was
this man . . .
And there was this road . . .
And if only I could remember these dreams . . .
I know they're trying to tell me . . . something.
Ooooeee. Strange dreams. (Strange dreams.)
Oh yeah.

And Sharkey says: I turn around, it's fear. I turn
around again
And it's love. Oh yeah. Strange dreams.
And the little girls sing: Oooeee Sharkey.
And the manager says: Mr. Sharkey? He's not at
his desk right now.
Could I take a message?
And the little girls sing: Oooeee Sharkey. He's
Mister Heartbreak.
They sing. Oooeee Sharkey. Yeah. He's Mister
Heartbreak.

And Sharkey says: All of nature talks to me.
If I could just figure out what it was trying to tell
me. Listen!
Trees are swinging in the breeze.
They are talking to me.
Insects are rubbing their legs together.
They're all talking. They're talking to me.
And short animals . . .
They're bucking up on their hind legs. Talking.
Talking to me.
Hey! Look out! Bugs are crawling up my legs!
You know? I'd rather see this on TV.
Tones it down.
And Sharkey says: I turn around, it's fear.
I turn around again, and it's love.
Nobody knows me. Nobody knows my name.

And Sharkey says: All night long I think of those
little planes up there.
Flying around. You can't even see them. They're
specks!
And they're full of tiny people. Going
places.

And Sharkey says: You know? I bet they could
all land on the head of a pin.
And the little girls: Oooee Sharkey!
He's Mister Heartbreak. They sing: Oooooee. That
Sharkey!
He's a slow dance on the edge of the lake. He's a
whole landscape gone to seed. He's gone wild! He's
screeching tires on an oil slick at midnight on the
road to Boston a long time ago.
And Sharkey says: Lights! Camera! Action! TIMBER!
At the beginning of the movie, they know they have
to find each other.
But they ride off in opposite directions.

Sharkey says: I turn around, it's fear.
I turn around again, and it's love.
Nobody knows me. Nobody knows my name.

You know? They're growing mechanical trees.
They grow to their full height. And then they chop
themselves down.
Sharkey says: All of life comes from some strange
lagoon.
It rises up, it bucks up to its full height from a
boggy swamp on a foggy night. It creeps
into your house. It's life! It's life!
I turn around, it's fear. I turn around again, and it's love.
Nobody knows me. Nobody knows my name.

Deep in the heart of darkest America. Home
of the brave.
Ha! Ha! Ha! You've already paid for this. Listen to
my heart beat.

And the little girls sing: Oooeee Sharkey. He's a
slow dance on the edge of the lake. They sing:
Oooeee Sharkey
He's Mister Heartbreak.
Paging Mr. Sharkey. White courtesy
telephone please.
And Sharkey says: I turn around, and it's fear.
I turn around again, it's love.
And the little girls sing: Oooeee Sharkey. Yeah.
On top of Old Smokey all covered with snow.
That's where I wanna, that's where I'm gonna
That's where I'm gonna go.

BLUE LAGOON

I had this dream
and in it I wake up in this small
house. Somewhere in the tropics. And
it's very hot and humid
and all these names and faces are
somehow endlessly moving
through me.
It's not that I see them, exactly; I'm not
a person in this dream; I'm a
place. Yeah . . . just a place. And I
have no eyes,
no hands, and all these names and
faces just keep . . .
they keep passing through. And
there's no, no
scale. Just a lot of details.
Just a slow
accumulation
of details.

I got your letter. Thanks a lot.
I've been getting lots of sun
And lots of rest. It's really hot.

Days,
I dive by the wreck.
Nights,
I swim in the blue lagoon.

I always used to wonder who I'd bring
to a desert island.
Days,
I remember cities.
Nights,
I dream about a perfect place.

Days,
I dive by the wreck.
Nights,
I swim in the blue lagoon.

Full fathom five
thy father lies.
Of his bones
are coral made.

Those are pearls
that were his eyes.
Nothing about him fades.
But that suffers a sea change.
Into something rich
and strange.
And I alone am left to tell the tale.
Call me Ishmael.

I got your letter. Thanks a lot.
I've been getting lots of sun. It's really
hot.
Always used to wonder who I'd bring
to a desert island.

Days,
I remember rooms.
Nights,
I swim in the blue lagoon.
I saw a plane today. Flying low
over the island.
But my mind
was somewhere else.

And if you ever
get this letter.
Thinking of you.
Love and kisses . . .
Blue
Pacific
Signing off.

GRAVITY'S ANGEL

You can dance. You can make me laugh.
You've got x-ray eyes.
You know how to sing. You're a diplomat.
You've got it all.
Everybody loves you.

You can charm the birds out of the sky.
But I, I've got one thing.
You always know just what to say. And when to
go.
But I've got one thing. I loved you better.

Last night I woke up. Saw this angel.
He flew in my window.
And he said: Girl, pretty proud of yourself, huh?
And I looked around and said: Who me?
And he said: The higher you fly, the faster you fall.
He said:
Send it up. Watch it rise. See it fall.
Gravity's rainbow.
Send it up. Watch it rise. See it fall.
Gravity's angel.
Why these mountains? Why this sky?
This long road. This ugly train.

Well he was an ugly guy. With an ugly
face.
An also-ran in the human race.
And even God got sad just looking at him. And at
his funeral all his friends stood around looking
sad. But they were really thinking of all the ham
and cheese sandwiches in the next room.
And everybody used to hang around him. And I
know why.
They said: There but for the grace of the angels go I.
Why these mountains? Why this sky?
Send it up. Watch it rise. See it fall.
Gravity's rainbow.
Send it up. Watch it rise. And fall.
Gravity's angel.

Well, we were just laying there.
And this ghost of your other lover walked in.
And stood there. Made of thin air.
Full of desire.
Look. Look. Look. You forgot to take your shirt.
And there's your book. And there's your pen, sitting on
the table.
Why these mountains? Why this sky?
This long road? This empty room?
Why these mountains? Why this sky?
This long road. This empty room.

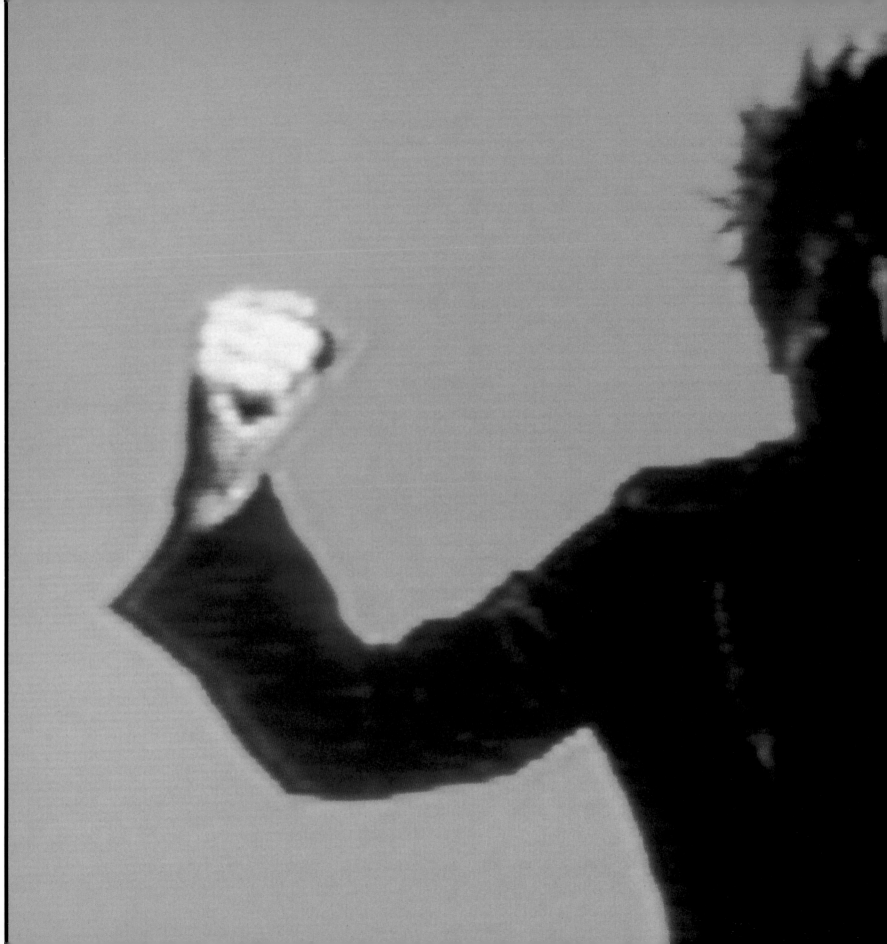

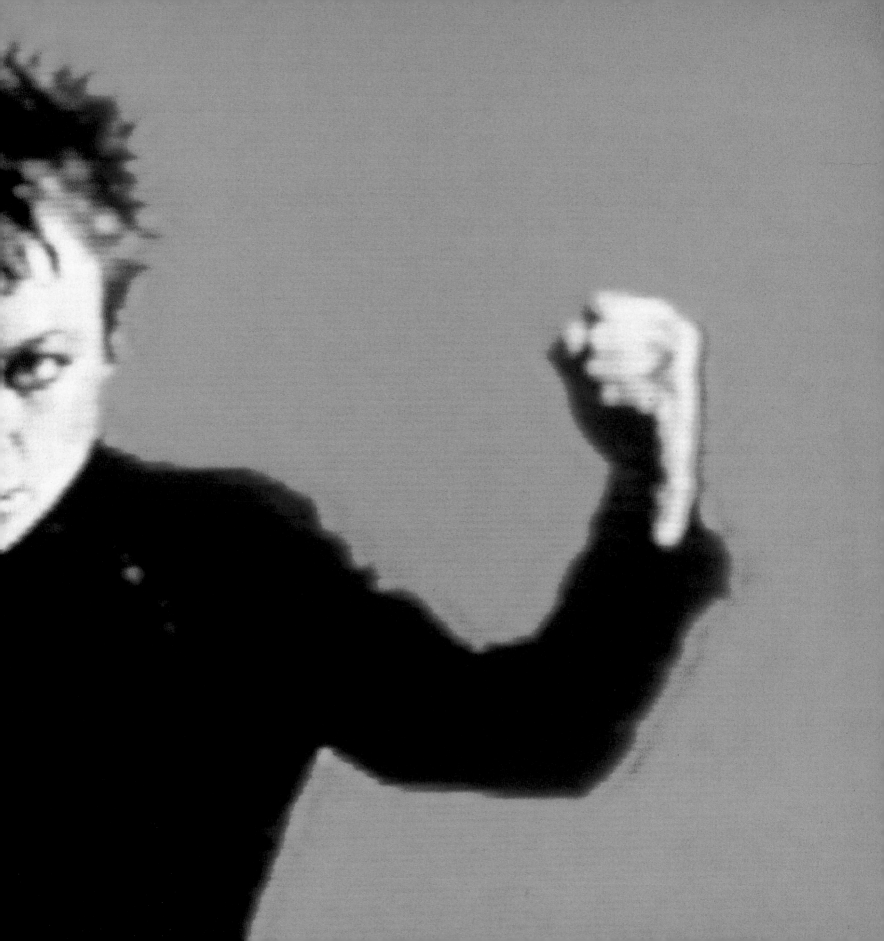

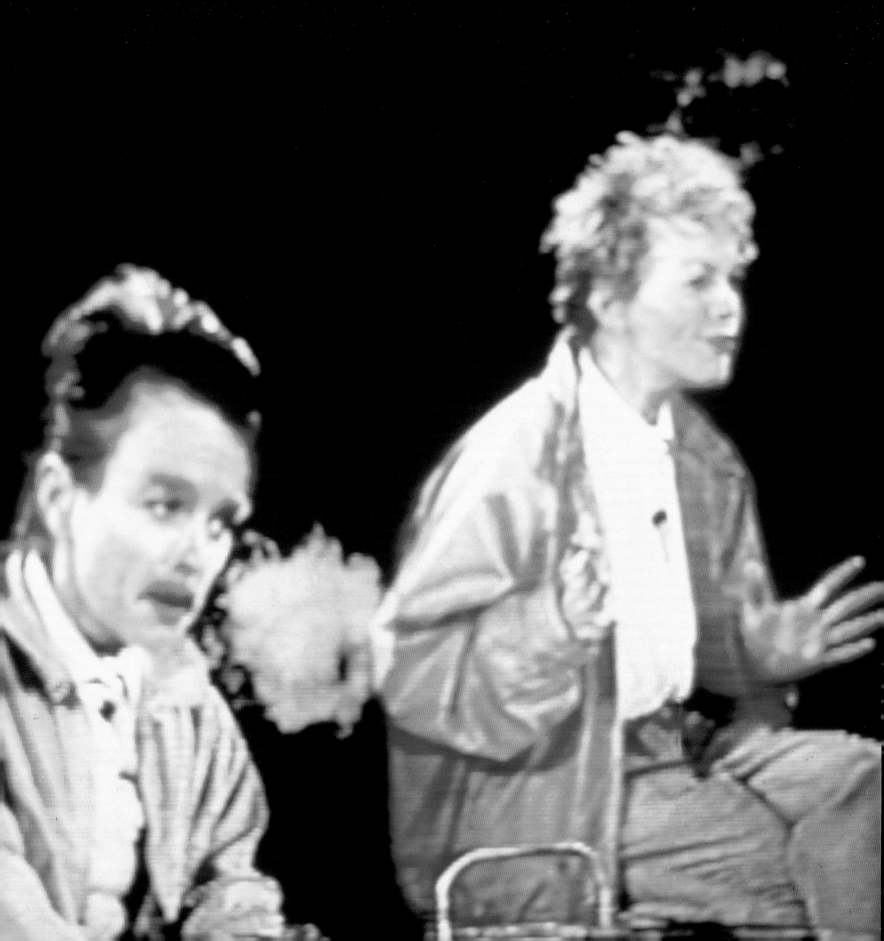

"Saturday Night Live." 1986

Anderson performed several songs on the "Saturday Night Live" show. Tony Danza was the host. Above: with Phil Balou and Benny Diggs

LEFT AND OPPOSITE:
***What You Mean We*, from "Alive from Off Center." 1986. An eight-part series of half-hour segments showcasing performance videos by artists. Produced by KTAC-TV, Minneapolis/St. Paul, and the Walker Art Center, Minneapolis**

The title of Anderson's series was taken from the popular television show "The Lone Ranger." Whenever the heroic cowboy instructed Tonto, his Indian side-kick, to do something particularly dangerous, Tonto would reply, "What you mean we, Kimosabi?"

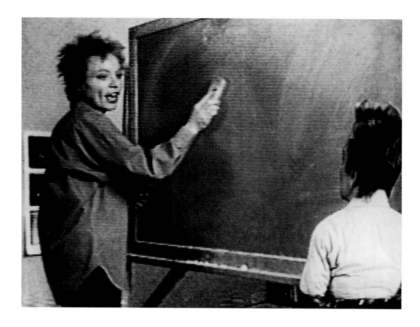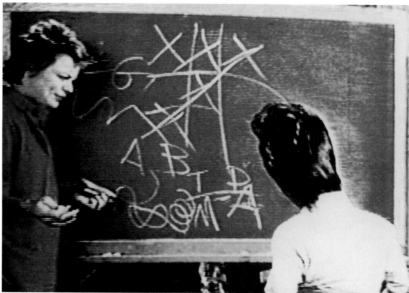

***Artist Introductions*, from "Alive from Off Center."
1987. Produced by PBS**

In addition, Anderson made ten short videos that served as
prefaces to videos on the work of other artists, in much
the same way that "Masterpiece Theater" is introduced by
a host. She appeared with a male video clone of herself.
"The video clone was created by a digital stretching and
compressing effect," Anderson explains.

Anderson and the clone are discussing the meaning
of choreography and its relation to dance. "It's like this,"
Anderson remarks to the clone. "Choreography is the
geography of dance. Like Steve Martin said, 'Talking
about music is like dancing about architecture.'"

OPPOSITE:

***Talk Normal*. 1987. Video, 90 min.**

Anderson gave a performance-lecture on her work that
included clips from her earlier video *Personal Service
Announcements* and the clone from "Alive from Off Center"
as well as songs and demonstrations of various instruments.
This presentation was made into a video and exhibited the
same year at the Tokyo International Video Biennial. A small
book in Japanese and English was also published. "Today
I'll be talking about language, television, and music, but I
should warn you that I'll also be talking a lot about myself.
And that's because I recently celebrated my fortieth birthday,
and I'm still not sure whether I feel more like four ten-year-
olds or ten four-year-olds," Anderson said.

Personal Service Announcements. **1990. Six videos,**
each 1 min. Aired on VH-1

Anderson made six *Personal Service Announcements* in
lieu of conventional promotional music videos for her new
album, *Strange Angels*. The videos are somewhat ironic in
mood, but their subject matter—military spending, the
national debt, the national anthem, women's salaries, tech-
nology and television—indicated Anderson's position on
the relationship of art to politics at the time. The Gulf War,
censorship battles in Congress, the so-called feminist back-
lash, and other topics dominated her lectures and the many
panel discussions in which she participated. "I thought of
myself as a spokesperson," she has said, "and I believed that
I should speak out on 'the issues.'"

B SIDE OF THE NATIONAL ANTHEM

You know, now that there's some talk about changing the
national anthem to "America the Beautiful," I think it's a
good time to look at the one we've got.

Now I have to say I really like "The Star Spangled
Banner." It is hard to sing though, with all those arpeggios.
I mean you're out at the ballpark and the fans are singing
away and it's sort of pathetic really watching everyone try
to hold on to the melody.

The words are great though. Just a lot of questions writ-
ten during a fire. Things like:

Hey! Do you see anything over there?

I dunno, there's a lot of smoke.

Say, isn't that a flag?

Hmmm. Couldn't say really, it's pretty early in the
morning.

Hey! Do you smell something burning?

I mean, that's the whole song! It's a big improvement
over most national anthems though, which are 4/4 time.
(We're number one! This is the best place!)

I also like the B side of the national anthem, "Yankee
Doodle." Truly a surrealist masterpiece.

Yankee Doodle came to town
riding on a pony.
Stuck a feather in his hat
and called it macaroni.

Now if you can understand the words to this song you
can understand anything that's happening in the art world
today.

Carmen. **1992. Music video, 30 min.**
Commissioned by Expo '92, Seville, Spain.
Directed by Laurie Anderson

This short version of Bizet's famous opera presents a day
and a night in the life of a contemporary Carmen, who
works in a tobacco factory amid racing conveyor belts and
noisy machinery. There is no dialogue in the video, only a
collage of music from the opera.

Beautiful Red Dress. 1990. Music video, 3 min.,
14 sec. Directed by Kristi Zea. Produced by Owen
Electric Pictures, Warner Brothers Records

In this music video Anderson mocks the clichéd excuses
used by the male establishment to suppress women—
"they say women shouldn't be the president cause we go
crazy from time to time"—and complains of the fact that
"for every dollar a man makes, a woman makes 63 cents."
She emphasizes the ironic feminist message of *Beatiful Red
Dress* by using an all-girl band all dressed in red.

BEAUTIFUL RED DRESS

Well I was down at the Zig Zag
That's the Zig Zag Bar & Grill
And everybody was talking at once
and it was getting real shrill.
And I've been around the block
But I don't care I'm on a roll—I'm on a wild ride
Cause the moon is full and look out baby—
I'm at high tide.

I've got a beautiful red dress
And you'd look really good
standing beside it.
I've got a hundred and five fever
and it's high tide.

Well just the other day I won the lottery
I mean lots of money
I got so excited I ran into my place and I said:
HEY! Is anybody home?
Nobody answered but I guess that's not too weird
Since I live alone.

I've got a beautiful red dress
And you'd look really good
standing beside it.
Girls?
We can take it. And if we can't
we're gonna fake it
We're gonna save ourselves
Save ourselves
We're gonna make it. And if we don't
we're gonna take it
We're gonna save ourselves
Save ourselves

Well they say women shouldn't be
the president
Cause we go crazy from time to time
Well push my button baby here I come
Yeah look out baby
I'm at high tide.

I've got a beautiful red dress
And you'd look really good
standing beside it.
I've got a little jug of red Sangria wine
and we could take some little sips from
time to time
I've got some bright red drop dead lips
I've got a little red car
and mechanical hips
I've got a hundred and five fever!!!

OK! OK! Hold it!
I just want to say something.
You know, for every dollar a man makes
a woman makes 63 cents.
Now, fifty years ago that was 62 cents.
So, with that kind of luck, it'll be the year 3,888
before we make a buck. But hey, girls?

We can take it. And if we can't
we're gonna fake it
We're gonna save ourselves
Save ourselves
(Yeah tell it to the judge)
We're gonna make it. And if we don't
we're gonna take it
We're gonna save ourselves
Save ourselves
We've got a fever of a hundred and five
And the moon is full
And look out baby
It's high tide.

Well I could just go on and on and on . . .
But tonight
I've got a headache

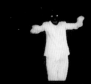

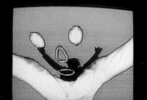
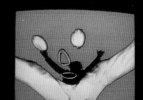

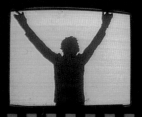
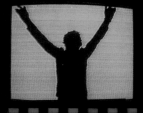
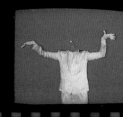

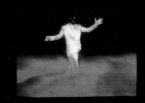

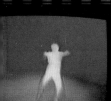
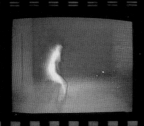

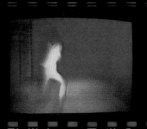
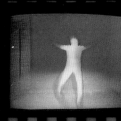

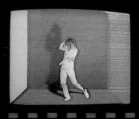
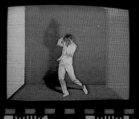
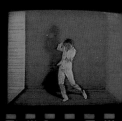

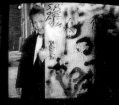

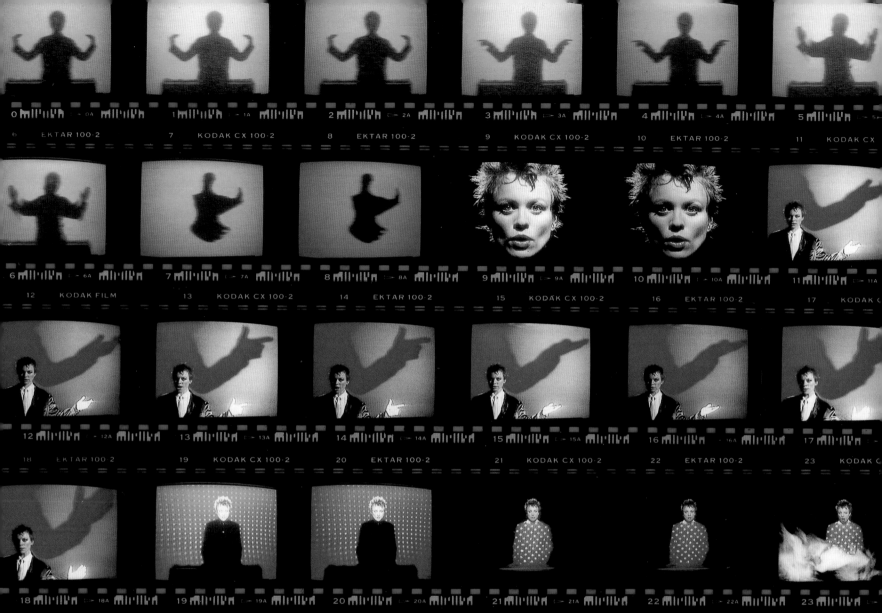

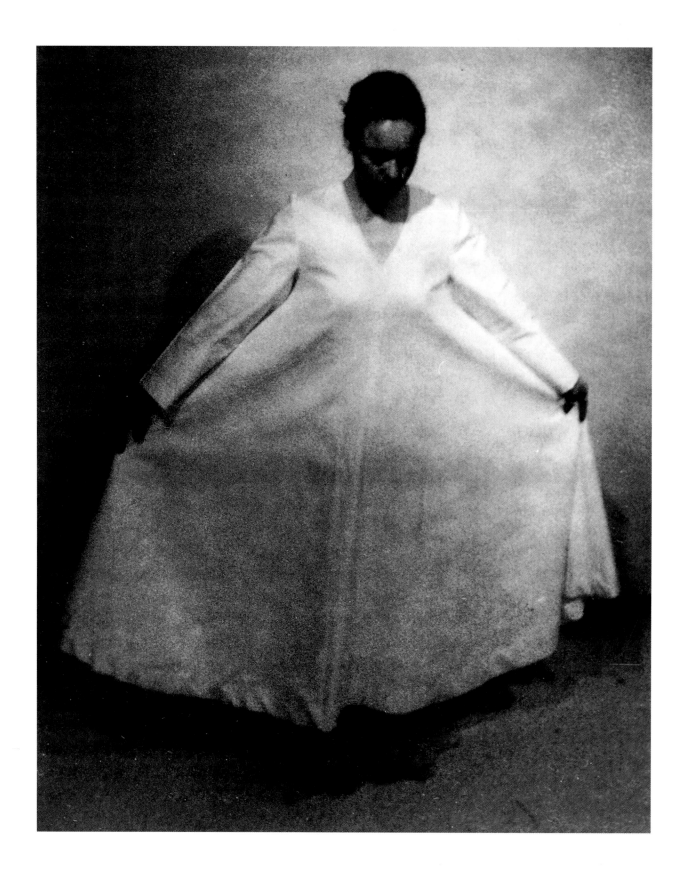

BODY INSTRUMENTS

From her earliest sculptures, standing objects made to match her own height, or her mudras, which contained imprints of her hand, Anderson experimented with ways in which to integrate herself, and sometimes lose herself, in the larger scheme of her work. She has used her body as a screen onto which to project film and as an object from which to project shadows onto screens. She has wired her body to amplifiers to transform it into a drum that resonates whenever she taps any part of her body or moves it forcefully, as when she stamps or turns. It has been a transmitter of sound, as in *Handtable*, and of light, as in *Home of the Brave*, when a small bulb placed in her mouth caused her cheeks to glow from the inside.

The devices Anderson uses—whether a Screen Dress or a Pillow Speaker—are simple and surprising combinations of everyday objects and low technology.

Drawing for Audio Glasses. **1979–80. Designed by Laurie Anderson, built by Bob Bielecki**

Anderson wore these glasses in *United States*.

(LA) "A contact microphone is mounted on the bridge of dark glasses. I made these glasses when I pulled the contact mic off my violin and tried putting the mic inside my mouth. This didn't work so I attached it tightly to my skull, braced by the glasses. When I knocked on my head, it sounded like a huge reverberant space. When I clicked my teeth together, it sounded like an enormous door being slammed shut. They're dark glasses to represent a kind of mental darkness."

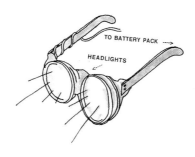

Drawing for Headlight Glasses. **1983. Designed by Laurie Anderson, built by Bob Bielecki**

Anderson also wore these glasses in *United States*, when she walked along the diving board that extended over the orchestra pit. The Headlight Glasses looked like welding glasses with flashlights for lenses, as though light beams shone from Anderson's eyes powered by an electrical source inside her brain.

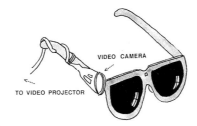

Drawing for Video Glasses. **1992. Designed by Laurie Anderson, built by Bob Bielecki**

In *Stories from the Nerve Bible*, Anderson wore a pair of dark glasses with a tiny video camera attached at one side. When a taped monologue by Admiral Stockdale (an excerpt from the 1992 U.S. vice presidential debates) was shown during the performance, bright lights were turned on the audience. Anderson's tiny camera scanned the first several rows and projected the audience onto the screen and monitors on stage.

OPPOSITE:

Songs and Stories for the Insomniac. 1975. Artists Space, New York, and Museum of Contemporary Art, Chicago

In these performances Anderson wore a long white shift that she called a Screen Dress, onto which film was projected as she played the violin and told stories.

Anderson with the Pillow Speaker in her mouth, 1978–79

Pillow Speaker (in mouth) runs to cassette deck which plays violin solo—lips phrase and modulate sound.

Anderson explains, "The Pillow Speaker is commercially available and usually used at night. You put the speaker in your pillow and learn German in your sleep. I tried this but when I woke the next morning, I didn't know any more German than I had the night before. I did, however, feel anxious, depressed, and paranoid. So anyway, being an oral person, I decided to put the speaker in my mouth, and discovered that I could modulate the sound by moving my lips. Also, the potential for electrocution is always a thrill." With the speaker in her mouth, Anderson puckered her lips and pulled them back in such a way that she modulated the sound coming out of the cassette deck to which the speaker was connected, and which was playing a violin solo she had prerecorded. Anderson herself made the violin sounds by moving her lips around the speaker, and this produced an eerie effect.

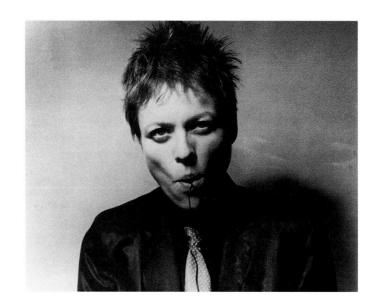

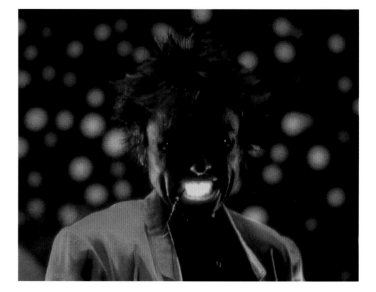

Anderson with a battery-powered light in her mouth in *Home of the Brave*, 1985

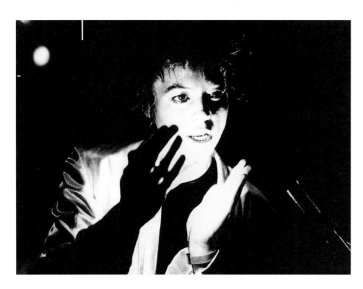

Anderson with battery-powered hand-lights in *Home of the Brave*, 1985

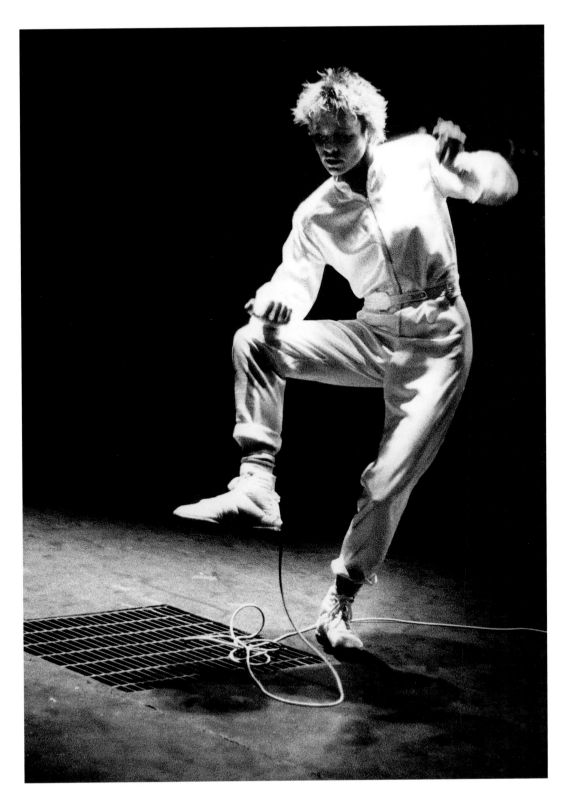

**Anderson performing "Drum Dance" in
Home of the Brave, 1985**

(LA) "For 'Drum Dance,' I designed a suit with electronic
drum sensors built in—the ultimate portable instrument.
I had taken a cheap drum machine apart to try to fix it.
I realized all the sensors still worked even when the cables
ran many feet away from the circuit board. Because the
sound was so loud, so out of proportion, I had to make the
movements bigger, wilder. I had to dance."

451

40 × 50 PROJECTION
SCREEN : FRONT
+ REAR

451

421

.421

C.F.

R.P.
LIGHT
SOURCE
FOR SAX PLAYERS' SHADOWS

B.O.

RP
SAX PLAYER

BEYER 160

BEYER 160

PLATFORM
MONITOR

REMOTE
HOUSE MIC
② PZM/8

MEZZANIN
CPC SPLITTE
BOARD IN

CK-8

REAR HOUS
① U 87 ON
LIGHT BRID

NEON VIOLIN

NEON BOW

TAPE BOW
VIOLIN

TAPE
BOWS

BL

LIGHT
BULB
FLIES

R.B.

ACCORDION

S.K.

R.H.

BAGPIPES

BEYER
260

A.M.

BEYER 260

RADIO MIC

RUBBER
HAMMER

949 HARMONIZER
910 HARMONIZER
LEXICON PCM41

CONTACT
MIC
GLASSES

CASETTE
DECK

PILLOW
SPEAKER

BEYER 260

L.A.

CASIO

SYNCLAVIER

DIVING
BOARD

SM 58

P.O.

PROP

MONITOR

COMPUTER
TERMINAL

MONITOR

STAGE SETS

No matter the distances Anderson traveled, she invariably took parts of her own environment with her in the form of her stage sets, which consisted of film and slide projections that were shown in her performances. Like family photographs propped on a hotel night table, they usually included mementoes of home—pictures showing a corner lof her loft, a lamppost on the street where she lived, night scenes that were unmistakably New York—and they were as autobiographically relevant as the stories she told. She also made a special effort to connect a performance to the particular site where it was being given, in much the same way that she incorporated the language of the host country in her songs and stories. She did this by taking photographs of the empty theater as soon as she arrived at a new location; they were developed into slides that afternoon and included in the evening's show.

Anderson's densely packed stages always contained an expanse of "sky," a neutral, timeless, and unchanging zone onto which laser beams or images of smoky clouds could be projected. She admits to always having been fascinated by the sky, which she attributes to her midwestern background. "There's nothing there but sky," she has said. Anderson's stage sets also represented her ideal domestic architecture—a continuously responsive environment wired with vocoders, electric pianos, faders, and amplifiers that can fulfill, instantaneously, her visual and aural desires.

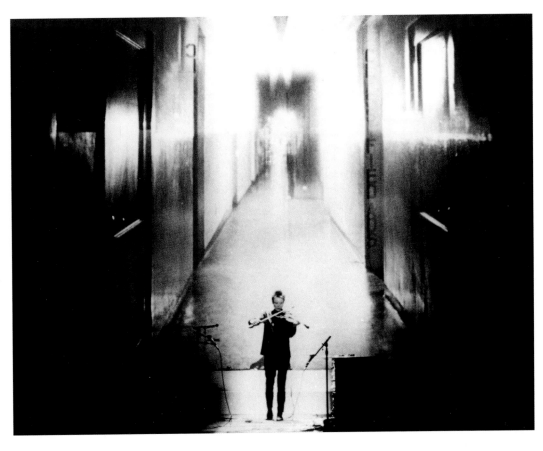

Anderson performing *Songs for a Foreshortened Hallway* in *United States*. 1983

Anderson recalls: "Projections were used to extend the stage space. A platform with a single step allowed the performer to enter 'film space' and become part of the image. This platform was a kind of bridge between the second and third dimensions. In this work, footsteps were recorded on the Tape Bow and played forwards and backwards as the live performer walked along a corridor of light. On screen, the performer walked forward slowly."

One of the stories from *Songs for a Foreshortened Hallway* is about Eskimos and a man she once saw on the Bowery:

"There are Eskimos who live above the timber line. There's no wood there for the runners on their sleds. So instead, they use long frozen fish which they attach to the bottoms of their sleds to slip across the snow.

"I saw a man on the Bowery. He was wearing ancient, greasy clothes and no shoes but brand-new bright white socks. He was standing on two small pieces of plywood and as he moved along the block, he bent down, moved one of the pieces slightly ahead and stepped on it. Then he bent down again, moved the other piece slightly ahead and stepped on it."

OPPOSITE:
Tech diagram for *United States*. 1983

Drawing for Diving Board. **1983. Magic marker on paper, 24 x 36 in.**

Anderson builds devices into each of her performances that will bridge the boundary between performer and audience, between stage and auditorium. In *United States* a diving board—a ramp with landing lights on either side—projected over the orchestra pit. She also used it in her film *Home of the Brave.*

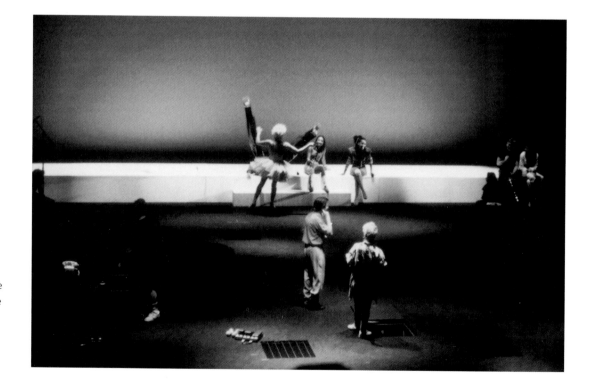

Stage set for *Home of the Brave.* 1985

Anderson designed the stage for *Home of the Brave* to function as a precisely tuned environment so that each camera angle would frame a song in a particular way. She also made sure that all the electronic paraphernalia of the stage were hidden from the camera's view. "We built a raised stage, three feet above the existing stage," she recalls of the film set. "Under this lid was a hotbed of electronics."

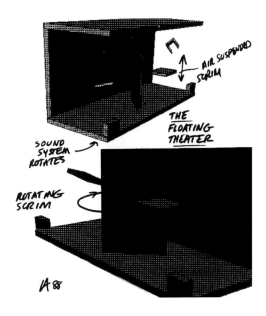

Digital stage set for *Stories from the Nerve Bible*. 1992

The set for *Nerve Bible* was designed in digital format. Steel I-beams were bolted together to form a large rectangular post and lintel system across the stage, from which a series of screens was hung. Slide and film projections continuously transformed the setting throughout the performance from architectural landscapes suggesting the preindustrial era to computerized depictions of cyberspace and beyond.

***The Floating Theater*. Designed 1988; unrealized**

Anderson's dream stage would be an electronic wonderland of her own devising. It would include her signature imagery of revolving globes, shifting skies, planes, city streets, suburban homes, lakes, and mountains. At the touch of a button from a central console, she could call up the East Coast or the West Coast, lagoon or jungle, concocting on stage a plug-in city of the kind imagined by such architectural dreamers of the 1960s as the London group Archigram.

Laser tunnel in *Stories from the Nerve Bible*. 1993

A dramatic laser tunnel was featured toward the end of *Stories from the Nerve Bible*. It referred to one of Anderson's own stories, which included a reference to Stephen Hawkins's description of time as a tunnel, and to the theme of the future, which dominated the entire production. The tunnel was designed by Norman Ballard and was created using light and smoke.

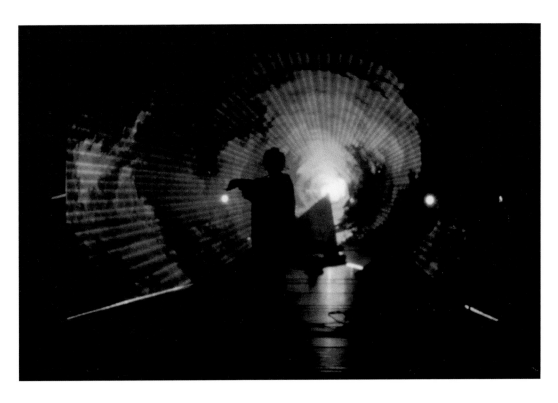

"What I'm trying to say is that here we are in the late twentieth century
and we're designing our own personal control rooms, the ones in our homes
and offices and studios. And the stories we tell ourselves are about how to get
more and more perfect, more and more in control. And while I'm fascinated
with the process, I wonder what kind of art will be made without anarchy."

The 1990s

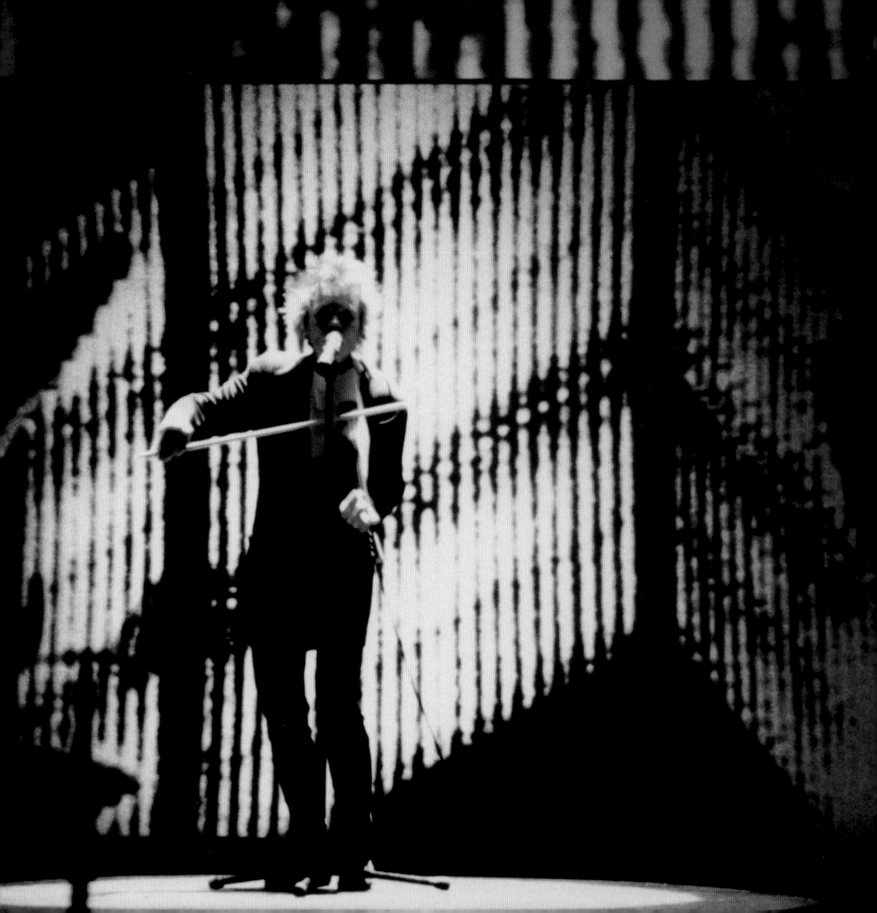

The Persian Gulf War, censorship battles in Congress, and a relentless conservatism marked the opening years of the 1990s in America. Anderson's material, in the form of long talks that she gave in theaters and college auditoriums as a solo performer, focused on these topics to such an extent that she said she felt that she was becoming more political commentator than artist. Then, during the election campaign of 1991, and for a short while afterwards, it seemed that the great hope for the art community would be the Clinton presidency. Instead, "everything fell apart with Clinton," Anderson observes. "It let people off the hook—everyone I knew suddenly became apolitical."

Stories from the Nerve Bible, which opened in 1992 at the Seville World's Fair, reflected this transition; it began as a political diatribe and ended as a meditation on time and technology. The production itself was more highly amped than any she had presented before, and it took busloads of technicians and trailers of equipment to install and run the show in each of the one hundred and fifty theaters where it was presented. Its technological tentacles overran the auditorium; in the lobby of each theater, computers with a specially designed CD-ROM program were set up to allow viewers to explore background material of *Nerve Bible* and to enter "The Green Room," where they could leave messages for Anderson and occasionally exchange ideas with her in real time. "It was an amazing moment for me," Anderson recalls, "because it seemed possible to cross over not only into industries like Warner Brothers, with everything they had to offer, but also into the new software companies. Their ability to mix images, other visuals, and sound offered a great way for performance art to get out into the world."

Anderson worked with several of these companies throughout the decade, creating a CD-ROM and Web pages, and designing complex installations and instruments that could not have been produced without their brainpower. "The 1990s have been about attempting to find partners within the colliding worlds of technology and art," says Anderson, who is always on the lookout for new ways to produce her ambitiously inventive, and not inexpensive, performances. "But it can be difficult to find common ground between the two. Artists end up as 'content providers' and the companies move on because the projects are not particularly economical." At the end of the decade she finds herself at a loss to describe the political climate—"it's hard to say what's happening politically at the moment"—but refers instead to the need for an economic analysis of the country—"people are very focused on money." As always, she examines these contemporary currents and her role as an artist within them. Her conclusion is poignant. "I feel responsible for expressing a kind of darkness," she told an audience after a recent presentation of *Songs and Stories from Moby Dick.* "It means I'm not really buying into this dream that technology will save our lives and make us more informed, happier people. It often makes people lonelier, which is why I go to all this trouble to load up trucks and tour people around. It's important to make work that gets people away from their monitors."

OPPOSITE:

Empty Places. 1989–90. Premiered at the Spoleto Festival in Charleston, South Carolina, in June 1989 and at the Brooklyn Academy of Music, New York, that October

In 1990 Anderson toured the show throughout the United States and Europe, giving 150 concerts over a period of eight months.

Pages 146–47: Stills from *The Human Face*. 1991. 60 min. An independent production for BBC-TV directed by Nichola Bruce and Michael Coulson. Aired on "Arena," an arts program, edited by Nigel Finch

Anderson was the presenter in this documentary on the history of the face in art and science. She wrote several short stories for the film and appeared in various latex masks to illustrate Victorian theories about the relationship between personality and physiognomy. In one section she slowly peels off a layer of skin from her face to reveal the same face below. In another, her face has a marble cast, like a classical statue. In a third, it is distorted to look like a seventeenth-century caricature. In still another, her entire head is elaborately transformed into that of a baboon. Anderson's many faces in this film underline her continuing fascination with the notion of alter-egos and how these can best be used in performance to present a range of beliefs on any one subject, and to deflect attention away from the single "I" at the center of her work.

EMPTY PLACES

Empty Places, the stage version of Anderson's album *Strange Angels*, was as complicated to present as the record was to produce. Two thousand slides were rear-projected onto four twenty-foot-high towers. Ten screens and forty-five film and slide projectors were used. In addition, there were projectors positioned at the front of the house, aimed at a large screen hung at the back of the stage. "After several weeks on the road, we were able to get the entire system running in just a few hours," Anderson recalls.

Empty Places was almost entirely about the politics of the United States at the end of the affluent 1980s. Unforgettably beautiful songs like "Coolsville," "Hiawatha," "Strange Angels," and "Ramon" summoned up ominous images of presidents and power, and the poignant suffering of those without it—the armies of homeless people on America's streets. The show also included deeply unsettling personal stories about ailments and accidents, such as a nerve disease Anderson had contracted in South America that resulted in a loss of night vision and long bouts of dizziness, and a fall down an exposed manhole in New York City, which put her in a leg cast for several weeks. "Suddenly all the screens would come alive with bluebirds, picket fences, and roses blooming," Anderson has said of the visual imagery of *Empty Places*, "only to be immediately transformed into a hellish city street piled with garbage."

She recalls, "Like many people, I slept through the Reagan era politically. When I woke up, everything looked really different. Homeless men and women were living on the streets of New York, hundreds of thousands of Americans were dead or dying of AIDS, and the national mood was characterized by fear, intolerance, and straight-ahead greed. Suddenly everything seemed deeply unfamiliar. Was this really my country? I decided to write about this new place, not because I had any solutions, but because I needed to understand how and why things had changed."

Empty Places made connections between Anderson's feelings about a country in crisis and her own sense of physical vulnerability, the one seemingly symptomatic of the other. She drew her audiences together into a circle of collective guilt for believing in the promises of Reagan's government and for accepting the compromises that followed, but she did this by appealing, above all, to their intelligence. Her songs and stories were extraordinarily discerning and poignant at the same time, and they were as ironically humorous as ever. In addition, they were rendered with a level of lyricism that would be the hallmark of the album *Strange Angels*.

(LA) "I wanted to tour with *Empty Places* because I like the energy created by people gathered in one large space. Storytelling has always been about people huddling around a fire. To me, electronics has the mystery and power of fire, and basically my method is to drag a lot of equipment usually used in recording studios or visual post-production houses out onto a stage. Of course this equipment has a tendency to blow up or malfunction, but fortunately I like the excitement of things going wrong. It's my only chance, in a highly technological situation, to improvise.

"I shot the images for *Empty Places* mostly at night, wandering around alone with my cameras—largely to show the way the Reagan era looked at the end of the decade out on the street.

"That's one of the things that *Empty Places* is about. Ronald Reagan promised people a lot of things that were completely unrealistic—he promised them a movie—and watching this rickety dream fall apart was pretty unbearable for me, because it created a lot of disillusionment and suffering.

"*Empty Places* is an inverted pyramid. It begins with a lot of ideas about politics and music, moves through some cinematic songs about the United States, and then narrows down to a very simple end, a story about how I fell down an uncovered manhole and ended up in an emergency room sitting next to a deeply troubled homeless woman. Since I usually pride myself on my work having three or four meanings, it was really scary to me to end the performance with this single pointed message about personal responsibility."

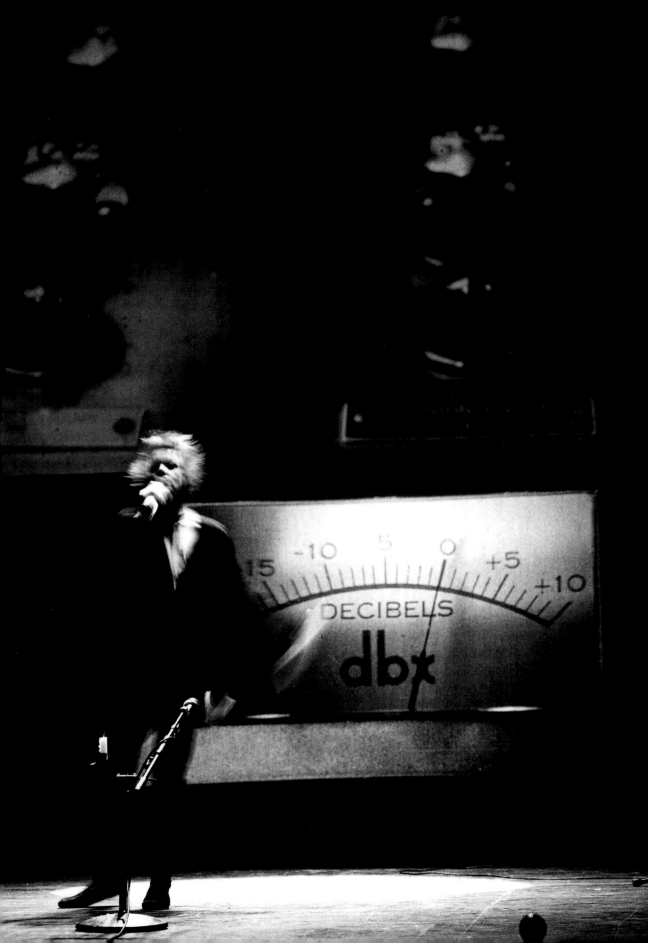

POLITICS AND MUSIC

Good evening.
Tonight's topics are politics and music.
Now there are those who say that politics and art
just don't mix.
But before we begin, I just want to say a word about
Sonny Bono. I mean the guy bothers me.
Ever since he was elected mayor
of Palm Springs,
it seems like singing politicians are everywhere.

I do have to say, however, I was happy to learn that the
singer Alice Cooper is still running for office and he's got
a really great slogan. His slogan is:

"A troubled man for troubled times."

Now he's got my vote on that slogan alone.

But of course now that so many singers are
doing politics,
a lot of politicians are starting to sing.
And lately it's been a really great time to study
the political art-song format.
I mean, just how do people convince each other of
things that are basically quite preposterous?
It's an art form. Listen carefully, and you discover
these aren't speeches at all,
but quite sophisticated musical compositions.
Now take a guy like Hitler. You listen to his speeches.
They're all rhythm—no pitch. I mean Hitler was a
drummer. A really good drummer.
And he'd always start with a really simple
kick/snare idea. You know:
BOOM CHICK! BOOM CHICK!
BOOM CHICK! BOOM CHICK!

He'd lay down this really solid groove and people
would start moving to it.
And then he'd add a few variations:

BABA BOOM CHICK
BABA BOOM CHICK
BABACHICK BOOM CHICK!!

And then he'd take a really wild solo and they'd all be
yelling and dancing.
Yeah!
Now don't forget these were the people who invented
the Christmas tree.
So in their minds, see, there's this fir tree out in the for-
est and they say,
YA! This tree must be inside the house!
We must go get it and bring it *inside* the house.
Inside! Inside!

They've got this thing about nature
and it's the same with music.
They've got to do something with it.
They got to bring it on home.

So they're stompin and movin and groovin
and their feet are all synched up to those drums
and they're moving like one giant thing.
And pretty soon they've got to go somewhere
they've got to get out
they've got to go someplace
like Poland.

Or take Mussolini. You listen to his speeches.
And he's singing grand opera.
Doing all the parts.
And he's hitting all those hard-to-reach
high notes.
FRONTIERE! FRONTIERE!
He was always singing about the frontier.
And all those fans with their ham sandwiches
up in the third mezzanine are going nuts
and it goes on for hours and hours.
Yeah, they go wild, those opera fans!

But of course the all-time American master of this art form
was Ron Reagan.
And when Reagan wanted to make a point,
he would lean right into the mic
and get softer
and softer
until he was talking like
this.
And the more important it was
the softer and the more intimate
it would get.
With lots
and lots of
pauses.
Like he was trying to remember something that happened
a long time ago.
But he could never really quite put his
finger on it.

And when he talked
he was singing to you.
And what he was singing was
*"When you wish
upon a star."*

MY EYES

Sometimes I wish I hadn't got that tattoo.
Sometimes I wish I'd married you.
One hundred fires. One hundred days.
Sometimes I feel like a stranger.
Sometimes I tell lies.
Whoa ho! Sometimes I act like a monkey.
Here comes the night.

And then kerjillions of stars start to shine.
And icy comets go whizzing by.
And everything's shaking with a strange delight.
And here it is: the enormous night.
And oo my eyes!
They're looking all around. And oo my feet!
I'm upside down.

If I were the president, if I were queen for a day,
I'd give the ugly people all the money.
I'd rewrite the book of love—
I'd make it funny.
Wheel of fortune. Wheel of fame.
Two hundred forty million voices,
Two hundred forty million names.

And down in the ocean where nobody goes,
Some fish are fast. Some are slow.
Some swim round the world. Some hide below.
This is the ocean.
So deep.
So old.

And then kerjillions of stars start to shine.
And icy comets go whizzing by.
And everything's shaking with a strange delight.
And this is it: the enormous night.
And oo my eyes!
They're looking all around.
And oo my feet!
They've left the ground.

So cry me a river that leads to a road
That turns into a highway that goes and goes
And tangles in your memories;
So long. So old. And oo my eyes!
They're looking all around. And oo my feet!
They've left the ground.

HIAWATHA

By the shores of Gitche Gumee
By the shining Big- Sea- Water
Downward through the evening twilight
In the days that are forgotten
From the land of sky blue waters

And I said: Hello Operator
Get me Memphis Tennessee
And she said: I know who you're tryin to call darlin
And he's not home
He's been away
But you can hear him on the airwaves
He's howlin at the moon
Yeah this is your country station
And honey this next one's for you.

And all along the highways
And under the big western sky
They're singing Ooo oooooo
They're singing Wild Blue.
And way out on the prairie
And up in the high chaparral
They hear a voice it says: Good evening
This is Captain Midnight speaking
And I've got a song for you
Goes somethin like this:

Starlight, Starbright
We're gonna hang some new stars
In the heavens tonight.
They're gonna circle by day
They're gonna fly by night
We're goin sky high. Yoo Hooooo hooo.
Yeah yoo hooo Ooo Hooooooooo

So good night ladies
And good night gentlemen
Keep those cards and letters coming
And please don't call again.

Geronimo and little Nancy
Marilyn and John F. dancing
Uncle took the message
And it's written on the wall.
These are pictures of the houses
Shining in the midnight moonlight
While the King sings Love Me Tender.

And all along the watchtowers
And under the big western sky
They're singing Yoo hooooo
They're singing Wild Blue.
And way way up there, bursting in air

Red rockets, bright red glare
From the land of sky blue waters
Sent by freedom's sons and daughters.
We're singing Ooo hooooooo
We're singing Wild Blue.
We're singing Ooo hooooooo
Ooo hooooooooo

And dark behind it rose the forest
Rose the black and gloomy pine trees
Rose the firs with cones upon them
And bright before it beat the water
Beat the clear and sunny water
Beat the shining Big- Sea- Water

FALLING

A couple of months ago I was getting out of a cab
and I turned around and fell right down
into an open manhole.
Yeah, right into the New York City
sewer system.

And when I was down there, I looked around
and said to myself:
This is exactly like one of my songs!
And then after I'd been down there
a little longer
I thought:
No, it's not.
So the ambulance took me to the hospital and parked
my wheelchair in the emergency room.
And I sat there watching this long line of misery
passing by.
Gunshot wounds, stabbing victims, and as the night
wore on,
the old people started to come in.

And there was this old woman sitting next to me.
She was a bum and her feet were bleeding
and swollen up like grapefruits
and she kept saying:
"Look at my feet! Look at my feet!"
And I couldn't.

And there was an old man sitting on the other side of her
and she kept saying:
"My feet. Look at my feet!"
And he did.
And he said:
"That must really hurt."

COOLSVILLE

Coolsville Coolsville
Coolsville Coolsville
So perfect So nice

Hey little darlin,
I'm comin your way little darlin
And I'll be there Just as soon as I'm
all straightened out
Yeah just as soon as I'm
perfect.

Some things are just pictures
They're scenes before your eyes
And don't look now I'm right behind you
Coolsville Coolsville
So perfect So nice
So nice!

And down by the ocean
under the boardwalk
You were so handsome we didn't talk
You're my ideal I'm gonna find you
I'm goin to Coolsville
So perfect So ideal

This train This city This train

Some things are just pictures
They're scenes before your eyes
And don't look now I'm right behind you
Coolsville

She said:
Oh Jesus, why are you always
in the arms of somebody else?
He said:
Oh man! I don't need anybody's help
I'm gonna get there on my own.

This train This city This train This city
This train

VOICES FROM THE BEYOND

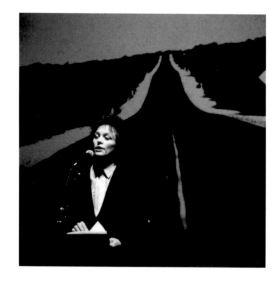

Voices from the Beyond. 1991. The Museum of
Modern Art, New York

Part of a six-evening performance series that accompanied
the exhibition *High and Low: Modern Art and Popular
Culture*, with Laurie Anderson, Eric Bogosian, David Cale,
Brian Eno, Spalding Gray, and Ann Magnuson, organized
by RoseLee Goldberg

Returning from a strenuous year-long international tour,
with its bus-loads of equipment and crew, Anderson
responded with considerable relief to an invitation to partici-
pate in a performance series at The Museum of Modern Art
in New York. The small ribbon of a stage in the museum's
film auditorium allowed for nothing more than an electronic
synthesizer and amplifier on stage, and a single screen at her
back. Working with these limitations, Anderson chose to
project an image of an empty road throughout the perfor-
mance, and to use this simple format as a platform for dis-
cussing political conditions in the country that she had noted
as she toured the United States and viewed it from abroad.
She read most of her remarks from note cards, punctuating
her sentences now and then with chords on the synthesizer.

This evening would mark a turning point for Anderson.
It was the first time that she had performed entirely on her
own in almost a decade, and it was the first time in as many
years that she had appeared in a small auditorium rather
than on the stage of a large concert hall. Both conditions
pleased her enormously, and this led to a return to her tour-
ing style of her earlier years, when she had traveled alone
around the country, meeting people and taking the temper-
ature of the times. "I loved being on tour with this talk,"
Anderson has said, "because I got to go so many places
alone, without the trucks of equipment and crews that tours
usually entail. I met lots of people this way." She also real-
ized that she had much more to say. "Over the next few
months, the talk expanded to a three-hour, free-form ramble
on censorship, power, art, women, communism, AIDS, Anita
Hill, etc. As national and world events unfolded, I incorpo-
rated them into the talk, which I presented at many colleges
and theaters."

These talks included one of the key issues raised by the
High and Low performance series, which was an assessment
of the meaning of the terms "high art" and "low art" and
of the ways in which artists, especially performance artists,
had contributed to the debate. Anderson considered it the
goal of artists to "enter their own culture," and in the essay
she wrote for the catalogue to the series, she pinpointed the
moment in time when she realized it was possible for her
to do so.

Anderson explains, "The first time I realized that I could
work outside of the avant-garde circuit was 1978. I was
scheduled to do a performance in Houston, and since the
museum wasn't really set up for this sort of thing—no stage,
no chairs, no sound system—the performance was booked
into a local country-and-western bar. The advertisements

suggested some kind of country fiddling, so a lot of the
regulars came. They arrived early and sat along the bar, so
when the art crowd showed up—dressed in black and
fashionably late—there was nowhere to sit. It was a
strange-looking crowd. About halfway through the concert, I
realized that the regulars were really getting it. What I was
doing—telling stories and playing the violin—didn't seem
bizarre to them. I remember that I felt great relief. The art
world was after all quite tiny and I'd been doing concerts for
the same hundred people. This was a whole new world."

In *Voices from the Beyond*, Anderson returned to her prime
medium, storytelling, in its purest form. Without the usual
embellishment of songs or multimedia projections, she
summed up a particularly intense moment in contemporary
American history—the U.S. army had recently invaded
Kuwait and would bomb Iraq just ten days after her appear-
ance at The Museum of Modern Art—for audiences who
were mostly unprepared for her new performance style. Yet
they were wholeheartedly engaged because she described
an America that they could easily recognize. "I wasn't sure
whether *Voices from the Beyond* was actually art," she said,
"and neither were the audiences." But, she said, she felt
that political conditions were such that she "had no choice
but to think out loud about the issues." In the end, the
format of the performance was a kind of "mental movie."
"I found that with no visuals, I was able to make a lot of
logical and verbal jump cuts," she explains.

Being on the road gave Anderson the opportunity to
collect oral portraits of Americans en route, just as she used
to do. It was a spontaneous process that she felt recon-
nected her with some of her favorite writers, Mark Twain
and Herman Melville, for example, whose book writings she
has referred to since her earliest songs, as well as to Ernest
Hemingway. She observes, "Mark Twain used to travel
around the United States and read his work, which I felt was
very important, as important as the books. To me, hearing
the author reading his story changes one's view of how the
author actually looks at things."

Writers who also perform their work, such as those with
whom she had shared a stage at the Nova Convention more
than a decade earlier—William Burroughs, Allan Ginsberg,
John Giorno—always fascinated Anderson for the ways in
which they specifically directed their language at live audi-
ences and made sure that every word was heard and under-
stood. Such delivery of written texts transformed material
entirely—"the most boring things you can imagine become

fabulous when the author reads them," Anderson notes. It was composer Robert Ashley who had made these connections very clear to Anderson early on. "I think his first recording of *Private Parts* [1978–84] made the biggest impression on me," she notes. "In that record, you can really hear the words that he's saying."

In *Voices from the Beyond*, Anderson's various delivery techniques could be more clearly isolated and examined. Although she used a natural speaking voice, it was her pitch and cadence that gave particular meaning and a subtle the-atricality to her text. In addition, her manner of dropping her voice to an intimate whisper, and pausing before delivering an unexpected punch line, had a way of holding the audi-ence's attention throughout her delivery. "I love stories that end in a question mark," she says, referring to another mas-ter storyteller she admires, Jorge Luis Borges, "or the kind of drop-dead stories that suddenly end. They just run into a brick wall." Finally, it was Anderson's range of voices— "audio masks," she calls them—that provided the rhythmic undertow and variety to her spoken solos. She used her "voice of authority"—a male voice—to make pronounce-ments, give orders, and to tell mostly political stories, and she employed a "sweet soprano" or "neutral art voice" for texts that were far more analytical and discursive, as well as for issues relating to women. Such artificially constructed sounds were the result of her fascination with the voice and with language as character tags, often within the same individual. "Most people use about ten voices," Anderson said. "One is at the bank, another on the phone, and so on. I try to make songs that use different voices and then make them more distinct."

Anderson wrote the first draft of *Voices from Beyond* in the fall of 1990, during the media and arms build-up to the Persian Gulf War. "Compared to a lot of the art being pro-duced," Anderson says, "the Gulf War had a lot going for it: a gripping story, super high-tech equipment, a vivid, villain-ous enemy." In the text she made connections between politics, the media, and the avant-garde art world, piecing together in the process an intricate picture of post–cold-war America.

(LA) "I've been thinking about the future because of all the things that have been happening in the last year or so, things that have made my own work more political and have opened my eyes to things in American culture that have been hidden away for a while and everybody's frantically looking around for someone to blame. I guess the standard explanation is the simplest. After decades of being told, 'THE RUSSIANS ARE COMING! THE RUSSIANS ARE COMING!' we have to face the fact that, after all this time, not a single Russian ever showed up."

Anderson interspersed her social and political commentary with reflective stories about her art—how the eye sees, how the ear hears—as well as with personal anecdotes:

"You know, people often ask me whether I'm a filmmaker or a musician and it always reminds me of that question: So if you could have the choice between having no eyes and no ears which would it be? I could never really decide. I mean first of all the eyes can be very stupid. They can slip out of focus and miss really important things. "Yeah we were here all right . . . and open . . . but we're just blobs of jelly after all—we didn't see a thing.

"Also, the eyes are really kind of primitive. They're like pre–World War II field cameras. I mean the lenses are very crude—you can't do any zooms. And the pans look really terrible and the dolly shots are a mess what with your feet moving up and down like that all the time—it's not too smooth.

"For example, let's say you walk into a restaurant and here's what your eye is really seeing: the door swings open and there's an awkward jerk backwards and the flash of somebody's arm. Then a rickety scan of the restaurant as you look for a table. Suddenly the floor lurches into view as someone bumps into you.

"If at the end of the day you looked at the rushes of this shoot you'd immediately fire the cameraman.

"But the point is when you think back on the same scene in the restaurant or when you dream about it, suddenly the camera work has really improved. You see the establishing shot, a bird's eye view of the restaurant followed by a two-shot of you and your dinner partner. Things are really well lit and fairly well cut.

YOUR MIND HAS FIXED IT ALL UP FOR YOU.

"And it's this doctored-up fake that passes for vision— not the actual chaos we see through our eyes. And the same thing happens when you try to picture the past or the future. Things get filtered through your memories and your expectations and they smooth it all out."

"I've always thought that one of the most serious defects of the human body was that you couldn't close your ears. You can't point them anywhere or close them. They just sort of hang there on the sides of your head. But an acupuncturist explained to me that the pressure points in ears are very important because the whole body is represented right there in the ear. The ears, he said, are vestigial fetuses—little versions of yourself—one male and one female, and he showed me: here's the lobe—that's the miniature upside down head—and this curve here is the spine, and right here are the little genitals—and that was when I went back to wearing hats."

Anderson questioned how artistic production could possibly compete with the seductive power of the media, and how artists could survive at all, if their aesthetic sensibilities were instantaneously incorporated into the advertising world by savvy art-directors, as was the practice throughout much of the 1980s. It had become almost impossible, Anderson pointed out, for artists to remain outside the mainstream for any length of time. "The reason for this," she said, "is speed" and the voracious scavenging of media types in downtown New York for something "new-new-new." In her estimation, the time-lag between the avant-garde and main-stream (between downtown and uptown New York), which used to be counted in decades, was approximately two days. "The lifetime of an artist is getting to be more like that of a pop star," she said. "A year, eighteen months."

Returning to the fold of a museum for an evening's per-formance brought home to Anderson the protective nature of that avant-garde; "it's a safe place for artists to work out ideas that seem a bit peculiar to the general public." It allowed her to do whatever it was that she wanted to do, without feeling obliged to satisfy expectations of producers or mainstream audiences. When asked how she felt about being perceived as a musician in the pop world, she replied, "but I still think like an artist."

Anderson would use this style of evening-length performance-commentary again in 1996, when she toured a solo work, *Speed of Darkness*, which was a series of spoken texts on the condition of America in the final years of the twentieth century.

STORIES FROM
THE NERVE BIBLE

Stories from the Nerve Bible (1992) was Anderson's fifth full-length multimedia work, after *United States* (1983), *Mister Heartbreak* (1984), *Natural History* (1986), and *Empty Places* (1989–90). It would involve the most elaborate computer-generated stage effects, including a row of television monitors across the stage, and some of the most spectacularly lit sets that she had yet created. Anderson's poignant songs and powerful imagery shifted back and forth between live and projected images (some of which showed the audience, caught on a tiny video camera attached to a pair of Video Glasses Anderson wore) and animated the stage and auditorium by creating "a series of visual landscapes." The material was a compilation of new writing and old, of recollections from the past and questions about the future—some dating from during or shortly after the Persian Gulf War of 1990–91—and it brought together politics, religion, art, and war in a combination that was made even more forceful when *Stories from the Nerve Bible* reached its final destination, Israel. "The strangest thing about performing *Stories from the Nerve Bible* in Israel was the show in Tel Aviv. On the screen there were pictures of buildings that had been blown up in the Gulf War. These buildings had been only blocks away from the theater."

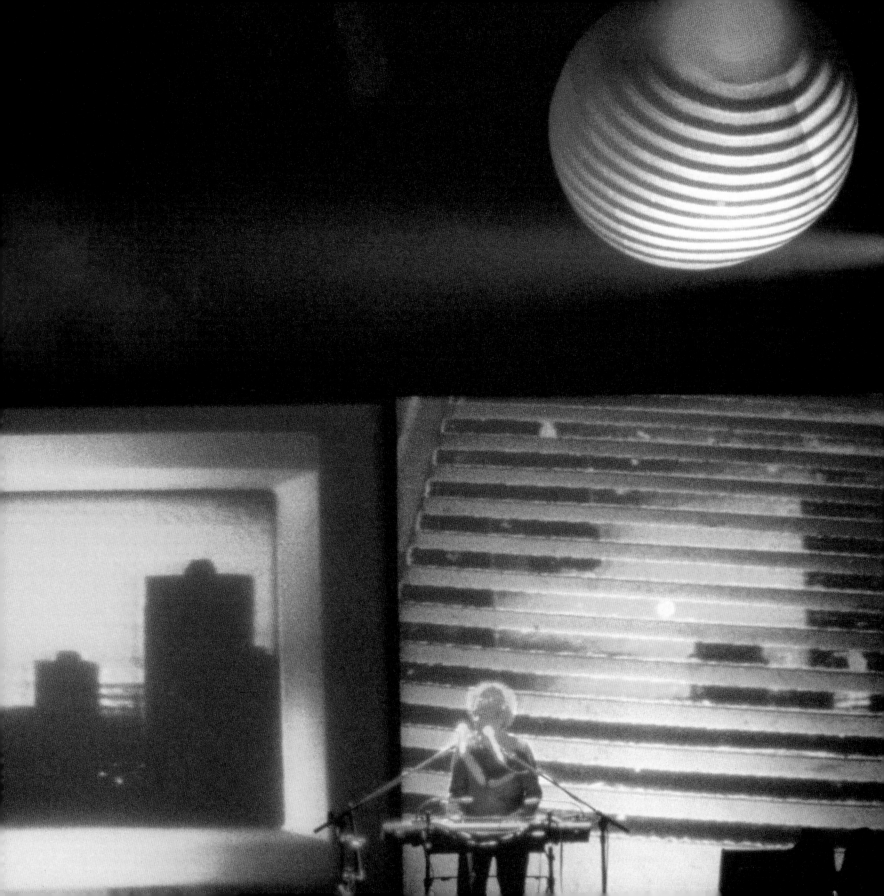

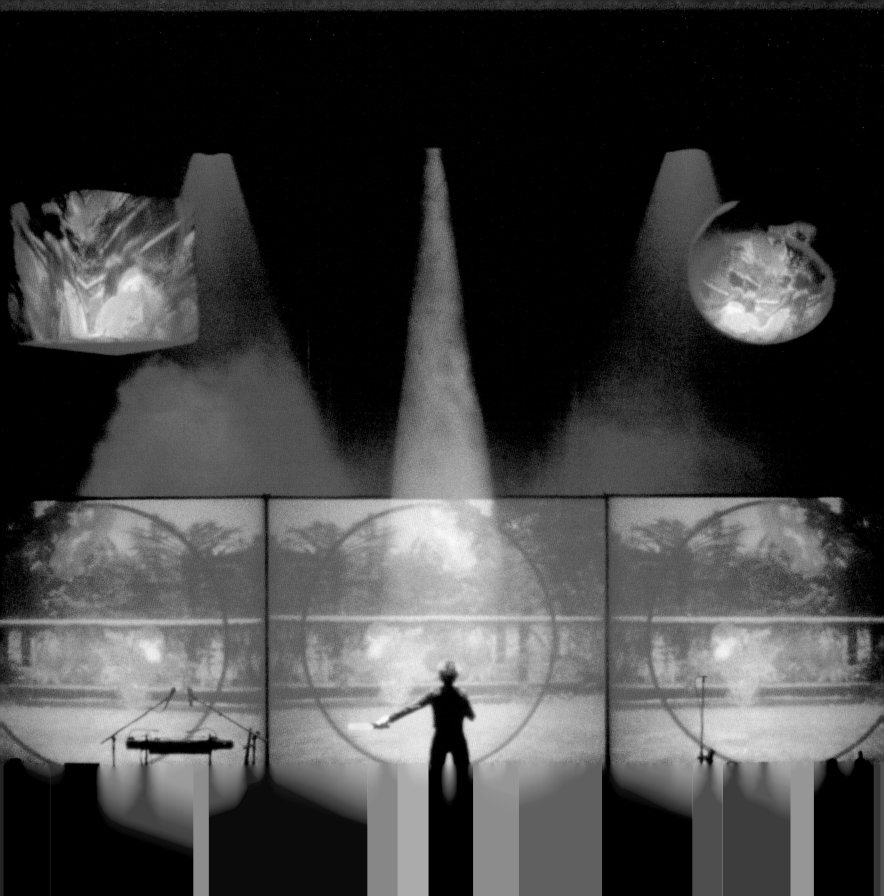

WAR IS THE HIGHEST FORM OF MODERN ART
F.T. Marinetti

During the Gulf War I was traveling around Europe with a
lot of equipment and all the airports were full of security
guards who would suddenly point to a suitcase and start
yelling, "WHOSE BAG IS THIS?"

(Explosion)

"I want to know right now who owns this bag!" and huge
groups of passengers would start fanning out from the bag
just running around in circles like a Scud missile was on its
way in.

I was carrying a lot of electronics, so I had to keep
unpacking everything and plugging it in and demonstrating
how it all worked and I guess it did seem a little fishy, a lot
of this stuff wakes up displaying LED program read-outs
have names like "Atom smasher" and so it took a while to
convince them that they weren't some kind of portable espi-
onage system.

So I've done quite a few of these sort of impromptu new
music concerts for small groups of detectives and customs
agents. I'd have to set all this stuff up and they'd listen for a
while and then say "So what's this?" and I'd pull out some-
thing like this filter and say "This is what I like to think of as
the voice of authority" and it would take me a while to tell
them how I used it for songs that were about various forms
of control and they would say:

"Now why would you want to talk like that?"

And I looked around at the swat teams and undercover
agents and dogs and the radio in the corner tuned to the
Superbowl coverage of the war and I'd say:

Take a wild guess.

Finally of course I got through. It was after all American-
made equipment and the customs agents were all talking
about the effectiveness, no, the beauty, the elegance of the
American strategy of pinpoint bombing, the high-tech surgi-
cal approach which was being reported on CNN as some-
thing between grand opera and the Superbowl, like the first
reports before the black-out when TV was live and every-
thing was heightened, and it was so euphoric.

NIGHT IN BAGHDAD

Oh it's so beautiful, it's like the Fourth of July,
It's like a Christmas tree, it's like fireflies
On a summer night.

Here I'm just going to stick this microphone
Out the window and see if we can't hear a little better.
Can you hear it? Hello, California. Can you hear us?
Come in.

Oh it's so beautiful, it's like the Fourth of July
It's like a christmas tree, it's like fireflies
On a summer night.

And I wish I could describe this to you better
But I can't talk very well right now 'cause I've
Got this damned gas mask on.

So I'm just going to stick this microphone
Out the window and see if we can't hear a little better.
Hello, California? What's the weather like out there?

And I only have one question:
Did you ever really love me?
Only when we danced.
And it was so beautiful. It was like the Fourth of July.
It was like fireflies on a summer night.

SOMEBODY ELSE'S DREAM

You know the reason why some nights
you don't have a dream?
When there's just blackness?
And total silence?

Well, this is the reason:
It's because on that night
you are in somebody else's dream.
And this is the reason you can't be in your own dream
because
you're already busy
in somebody else's dream.

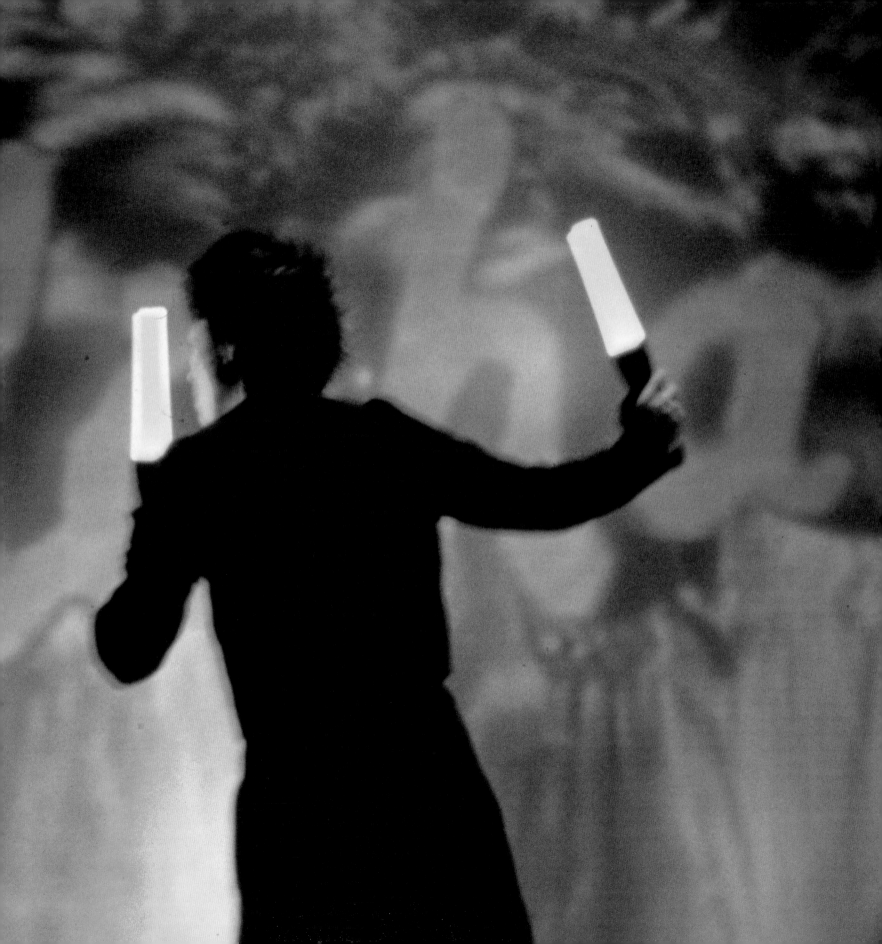

Stories from the Nerve Bible
April 1993, Philadelphia, Pennsylvania

#1. PRESET
STAGE: all screens are out
 M-1 keys in pit
 camera, neon bow, violin center stage
 House to half; House Out; Go cue for LA
 & Audio

#2. STORIES (app 15 mins)
AUDIOTAPE DAT #1 (birds)
STAGE LA at keys in pit
119

In 1980 as part of a project called "Word of Mouth," I was invited—along with eleven other artists—to go to Ponape, a tiny island in the middle of the Pacific. The idea was that we'd sit around talking for a few days and then the conversations would be made into a record. The first night we were all really jetlagged but as soon as we sat down, the organizers set up a huge array of mics and switched on a bank of 1000-watt lights and we tried our best to be as intelligent as possible.

Television had just come to Ponape a week before we arrived and there was a strange excitement around the island as people crowded around the few sets. And then the day after we arrived, in a bizarre replay of the plot of the first TV show broadcast to Ponape, prisoners escaped from a jail, broke into the radio station, and murdered the DJ. Then they went off on a rampage through the jungle armed with lawn mower blades. In all, four people were murdered in cold blood. Detectives were flown in from Guam to investigate. At night I stayed around the cottages with the other artists listening out into the jungle.

l 20 Pole
Finally the chief of the biggest tribe on the island decided to hold a ceremony for the murder victims. The artist Marina Abramovic and I went, as representatives of our group, to film it. The ceremony was held in a large thatched lean-to. Most of the ceremony involved cooking beans in pits and brewing a dark drink from roots. The smell was overwhelming. Dogs careened around barking and

everybody seemed to be having a fairly good time—as funerals go.

After a few hours, Marina and I were presented to the chief who was sitting on a raised platform above the pits. We had been told we couldn't turn our backs to the chief or—at any time—be higher than he was. So we scrambled up onto the platform with our film equipment and sort of duck-waddled up to the chief. As a present I'd brought one of those little "Fred Flintstone" cameras—the kind where the film cannister is also the body of the camera—and I presented it to the chief. He seemed delighted and began to click off pictures. He wasn't advancing the film between shots but since we were told we shouldn't speak unless spoken to, I wasn't able to inform him that he wasn't going to get twelve pictures—but only one very very complicated shot.

After a couple more hours, the chief lifted his hand and there was absolute silence. All the dogs had suddenly stopped barking. We looked around and saw the dogs. All their throats had been simultaneously cut and their bodies, still breathing, pierced with rods, were turning on the spits.

The chief insisted we join in the meal but Marina had turned green and I asked if we could just have ours to go. They carefully wrapped the dogs in leaves and we carried their bodies away.

l 50
LIGHT CUE
In 1984, as part of the press for the tour I was doing in Japan, I was asked to go to Bali and speak about the future with the prince of Ubud. The idea was that I would represent the western world, the prince the southern world, and the Japanese press representative would represent whatever was left. The conversations would be published in a large book (scheduled for release one year after the concert tour). As press, this didn't seem like a great way to advertise the concerts, but it sounded like fun anyway.

I stayed at the palace in one of the former king's harem houses. Each of the king's wives had had her own house guarded by a pair of live animals—a bear and a fox for example. By the time I got there years later, the menagerie had dwindled a bit. My house was "guarded" by two fish swimming around in bowls.

l 13
Bali was extremely hot in the afternoons and the conversations with the prince drifted along randomly from topic to topic. The prince was a bon vivant, trained in Paris. He spoke excellent English and when he wasn't in the palace he was out on the bumpy back roads racing cars. So we talked about cars—a subject I know absolutely nothing about—and I felt that, as far as representing the western world went, I was failing dismally.

On the second night, the prince served an elaborate feast of Balinese dishes. At the end of the meal, the conversation slowed to a halt and after a few minutes of silence he asked, "Would you like to see the cremation tapes of my father?"

The tapes were several hours long and were a record of the elaborate 3 month ceremony shot by the BBC. When the king died the whole country went to work building an enormous funeral pyre for him. Practically everyone in Bali contributed something—a woven mat or intricate chains of braided straw—bits of pottery and cloth.

l 77
After months of preparation (during which the king continues to reside in the living room) they hoisted his body to the top of this rickety, extremely flammable structure and lit a match. The delicate tower crumpled almost immediately and the king's body fell to the ground with a sickening thud. This didn't seem to disturb anyone but me. The prince considered the ceremony a triumph. His father had been touched by fire and hadn't flown away.

l 30
He explained that when a Balinese dies, the soul turns into a bird and sits by the house for a while. The big danger is that it will escape and fly out over the ocean. The Balinese hate water, don't swim, don't trust it. So the idea is to keep the bird within earshot until the body can be burned and the soul can safely ascend, finally, to heaven.

l 88
l 85
LIGHT CUE
1n 1974 I went to Mexico to visit my brother who was working as an anthropologist with the Tzotzil Indians—the last surviving Mayan tribe. The Tzotzil speak a lovely birdlike language and are quite tiny physically. I towered over them.

Mostly I spent my days following the women around since my brother wasn't really allowed to do this. We got up at 3 am and began to separate the corn into three colors. Then we boiled it, ran to the mill and back and finally started to make the tortillas. All the other womens' tortillas were 360 degrees, perfectly toasted, perfectly round. Even after a lot of practice, mine were still lopsided and charred. When they thought I wasn't looking, they threw them to the dogs.

I 65

After breakfast we spent the rest of the day down at the river watching the goats and braiding and unbraiding each others' hair. So usually there wasn't that much to report. One day the women decided to braid my hair Tzotzil style. After they did this, I saw my reflection in a puddle. I looked ridiculous but they said, "Before we did this, you were ugly. But now maybe you will find a husband."

I 77

I lived with them in a yurt, a thatched structure shaped like a cupcake. There is a central fireplace ringed by sleeping shelves, sort of like a dry beaver dam. My Tzotzil name was "Loscha" which, loosely translated, means "the-ugly-one-with-the-jewels." Now, ugly, OK. I was awfully tall by the local standards. But what did they mean by the jewels? I didn't find out what this meant until one night when I was taking my contact lenses out and—since I'd lost the case—carefully placing them on the sleeping shelf. Suddenly I noticed that everyone was staring at me. I suddenly realized that none of the Tzotzil had ever seen glasses, much less contacts, and that these were the jewels—the transparent, perfectly round jewels that I carefully hid on the shelf at night and then put, for safe-keeping, into my eyes every morning. So I may have been ugly but so what? I had the jewels.

LIGHT CUE

Full fathom five thy father lies.
Of his bones are coral made.

Those are pearls that were his eyes.
Nothing of him that doth fade.

But that suffers a sea change.
Into something rich and strange.

And I alone am left to tell the tale.
Call me Ishmael.

LIGHT CUE
I 50

The summer of 1974 was brutally hot in New York and I kept thinking about how nice and icey it must be at the north pole and then I thought: wait a second, why not go? You know, like in cartoons where they just hang "Gone to the North Pole" on their doorknobs and just take off.

I 79

I spent a couple of weeks preparing for the trip, getting a hatchet, a huge backpack, maps, knives, sleeping bag, lures, and a three-month supply of bannock—a versatile high protein paste that can be made into flatbread, biscuits, or cereal. I had decided to hitchhike and one day I just walked out to Houston Street, weighted down with seventy pounds of gear, and stuck out my thumb.

C10

"Going north?" I asked the driver, as I struggled into his station wagon. After I got out of New York, most of the rides were trucks until I reached the Hudson Bay and began to hitch in small mail planes. The pilots were usually guys who had gone to Canada to avoid the draft or else embittered Vietnam vets who never wanted to go home again. Either way, they always wanted to show off a few of their stunts. We'd go swooping low along the rivers, doing loop de loops and "Baby Hughies." They'd drop me off at an air strip, "There'll be another plane by here 'coupla weeks. See 'ya! Good luck!"

I 77

I never did make it all the way to the pole. It turned out to be a restricted area and no one was allowed to fly in—or even over it. I did get within a few miles though, so it wasn't really disappointing. I entertained myself in the evenings cooking or smoking—watching the blazing light of the huge Canadian sunsets as they turned the blade of my knife into bright red neon as it lay by the fire. Later I lay on my back looking up at the northern lights and imagining there had been a nuclear holocaust and that I was the only human being left in all of North America and what would I do then? And then when these lights went out, I stretched out on the ground, more alone than I had ever been, watching the stars as they turned around on their enormous silent wheels.

I finally decided to turn back because of my hatchet. I had been chopping some wood and the hatchet flew out of my hand on the upswing. I did what you should never do when this happens: I looked up to see where it had gone. It came down WWWWFFFFF!! just missing my head and I thought: My God! I could be walking around here with a

hatchet embedded in my skull and I'm ten miles from the airstrip and nobody in the world knows I'm here.

LIGHT CUE

Remember me is all I ask
and if remembered be a task
Forget me.

Daddy Daddy it was just like you said:
Now that the living outnumber the dead

Where I come from it's a long thin thread
Across an ocean down a river of red
Now that the living outnumber the dead

Speak my language.

BLACKOUT at "language"

#3. WIND (30 secs)
VIDEO E: blue
ACTION Guy, Greg., & Cyro in position
 during blackout,
 LA moves to center
BAND Accordion and Bass Drone
 begin immediately

STAGE Wind machines on at "language"
 F&G down
 SLIDERS MOVE IN HALFWAY
 35 SCREEN DOWN

ACTION LA moves to center, gives hand cue,
 leaves upstage
 puts on Bodysynth (Bodysynth tested)

STAGE M-1 keys in pit are struck

#4. TITLE MUSIC (1:40 mins)
AUDIOTAPE: DAT # 2 Title Music
 (drums & groans) on at hand cue
BAND: accordion, bass, percussion
VIDEO: On at hand cue
 35: Book burning
 A&D: Book burning
 F&G: Smoke

BUHL SLIDE: *Stories from the Nerve Bible* on at
40 seconds
out at 55 seconds

#5. BODYSYNTH (2 mins)

ACTION: LA enters along path from upstage,
STAGE sliders close after LA passes through
opening
BAND Bodysynth: Breath/heartbeat D-70
RM
Come here little girl. Get into the car.
It's a shiny red one—a brand new
Cadillac.
Come here little girl.
hand signal
BLACKOUT at hand signal
BAND accordion & bass drone
(10–20 seconds)

#6. GULF (1:50 mins)

BLACKOUT

AUDIOTAPE DAT # 3 (wind & percussion; 1:30
xfades to birds)
on at hand signal

VIDEO: On after 10–20 seconds of bass drone
when sliders are in place
35: Gulf
ABCD: Gulf
E: Gulf

SLIDES: "War is the highest form of modern art"
On 30 seconds after Gulf begins—
Italian Futurist Marinetti
Add 3 seconds after quote is up
2 second fade of all after 10 secs

BAND begins when slide goes out

STAGE Sparkler Smoke bombs behind the
monitor beam on at third video
"explosion" (app 1:37 from begin-
ning of Gulf cue)
additional smoke from hose behind monitor
beam

35 SCREEN blacked out after 3rd
video "explosion"

AUDIOTAPE: DAT # 4 (SFX explosion) at 3rd video
"explosion" with Sparkler Smoke Bomb
(DAT #3 continues but at low level)

ACTION LA to monitor beam after 3rd explosion

7. GRANDMOTHER (4 mins)

BAND: Violin & voice: H3000 622;
Ahh-haaaaa Ah-haaaaaa

VIDEO fade up during "ahh-haaaa . . . "
ABCD: Whirlwind (road & coals
in background)
F&G: Flames

SLIDES: On 5 seconds after video appears
5 seconds each w/ fades
Wild beasts shall rest there
and their houses shall be filled with
snakes
And ostriches shall dwell there
And the hairy ones shall dance there
And sirens in the temples of pleasure.
Isaiah 13:21

AUDIOTAPE: DAT #3 completely out after slides
BAND accordion, bass, percussion

Aaa-haaaaa
Lately I've been thinking about the
future—maybe because things have
been happening so fast—or maybe
because the end of the millenium is
coming up.
Whenever I think of the future I think
of my grandmother—
She was a Southern Baptist from the
Holy Roller school and she had a very
clear idea about the future and of
how the world would end—in fire—
like in Revelations in fire—like in
Revelations
When I was 10 years old, my grand-
mother told me the world was going
to end in a year. So I spent the whole
year praying and reading the Bible
and telling all my friends and
alienating all my relatives. And by
the end of the year, *I was ready!*

As much as *Stories from the Nerve Bible* was about current affairs, a frequent refrain throughout was a report of a telephone conversation about the future with one of her all-time heroes, John Cage, which took place some months before he died. Anderson had hoped for his insights into the next century, knowing full well that Cage's answer would be as elliptical as ever.

So here are the questions. Is time long or is it wide?
And the answers?
Sometimes the answers just come in the mail
and you get a letter that says all the things
you were waiting to hear, the things you
suspected, the things you knew were true.
And then in the last line it says:
Burn this.

Stories from the Nerve Bible was also the title of a book on Anderson that was published in 1994. An annotated personal overview of twenty years of her work, it included themes such as technology, dreams, language, politics, and art. Her comments about the book could just as easily be applied to aspects of the performance:

"I've tried so many times to picture the United States, which is also the background for everything my work is about: memory, language, technology, politics, utopia, power, men, and women. I've tried to understand and describe some of the ways this country continues to remake itself, and I have always been interested in its many coexisting contradictions like Puritanism and violence, mass culture and art. It is also a collection of the many voices and talking styles that characterize English as spoken by Americans; the voices of machines, politicians, sitcom stars, nuns, and Ouija boards. Along the way, I've tried to touch on related topics such as the invention of ventriloquism, the relationship of music and architecture, technology as a primitive form of parasite, animation, aesthetics, and fanaticism."

Anderson talked about the meaning of the phrase "Nerve Bible." "It is of course, the body," she wrote, referring to the ways in which the book (and the performance) is divided into head and heart, mind and imagination, and all the senses. "It is like that drawing in medical books of the human body called 'The Sensory Homunculus,' a depiction of the relative proportions of the sensory neurons as they're presented in the brain," she explained. But "Nerve Bible" also

speaks of the part religion has played in Anderson's life, from her childhood, spent in the heart of the Bible Belt close to a grandmother who was a Southern Baptist missionary—"she practically had the Bible memorized," Anderson has said—to her longstanding involvement with Buddhism. "I'm from the Bible Belt, first of all, and I'm just telling the same mixture of midwestern Bible stories that I always have. They're a mixture of the most mundane things with a fabulous twist to them."

The fact that the *Nerve Bible* tour ended in Israel was especially meaningful to her. "And Jerusalem? It looked just the way my grandmother had described it—pristine, white, majestic. Except that it was full of guns. Guns and bones. I'd come to Jerusalem hoping to find out something about time and timelessness, something about how an ark could turn into a whale or into a book. But *Stories from the Nerve Bible* is about the future, and it didn't have any answers, only questions."

From the very beginning Anderson has referred in her work to her religious upbringing. Wearing a white smock with a ruffled collar and loose trousers in *Duets on Ice*, or her *Screen Dress* in *Songs and Stories for the Insomniac*, she looked more like a choir girl than a downtown New York musician. This perception was reinforced by such objects as a sponge cross, which she wore around her neck in *Duets*, and references to hymns and Bible quotations in that and many subsequent pieces. She was baptized by total immersion in 1958, in the First Church of Christ. She has an intimate connection to Bible stories she heard as a child and vivid recollections of religious experiences with her grandmother, and she has integrated them into her life as an artist in a particularly heartfelt way. Angels have frequented the various landscapes that Anderson has described and inhabited on stage and they have become less angelic and more argumentative as her work has matured. "Last night I woke up / Saw this angel," she sings in "Gravity's Angel" (1986). "He flew in my window/And he said: Girl, pretty proud of yourself, huh?"

Anderson's quest for authenticity and calm in a swiftly spinning world has led her to investigate a range of spiritual realms and forms, from charismatic evangelism to Indian mudras, palm readings, Buddhist retreats, and visits to Tibet and the Holy Land. Her work comprises a complicated world of instinct and intellect, human and animal, past and future. It also reveals an overall motif of profound awareness and concern for other people—"I've written a lot of stories for nobodies"—and for animals—"I'm positive that animals have emotions." "The art I aspire to make," she wrote in the catalogue to the *High and Low* performance series, "helps people

live this life as well as possible. Art must address the issues—sensually, emotionally, vividly, spiritually."

Like all of Anderson's performances, *Stories from the Nerve Bible* was carefully constructed and structured. She explains:

"It began with a room full of charts and diagrams showing how things relate to each other. I then tried to build the idea of time into the structure of the piece. For example, the set is a thirty-six-foot-long girder I-beam, and you just slide along that track, and then above, it's kind of T-shaped, so there's a path going back up the stage. Most of the stories happen in present time; things that can be changed happen along one axis and the things that cannot be changed happen along another. Now I doubt that anybody who ever sees it is ever going to pick that up.

"There are lots of short stories about the passage of time and longer things about it as well. There are maybe twenty images of time, from little alarm clocks to time codes. There's a story about Stephen Hawkins, who describes time as this huge tunnel. In one of his lectures—which are really wonderful, it's really amazing to hear his voice—he envisions this image of the black hole imploding, and what happens to the information about all the objects that have disappeared. He proposes that all the information about all sorts of things begins to skid down an infinitely long tunnel. In other words he's proposing that nothing's ever lost, that you can reconstruct everything by using all the debris of information in the black hole."

THE RIGHT TO BEAR ARMS

You know, in the last year there have been a lot of arguments in my country about the Bill of Rights. Of course, the Bill of Rights is amazing. It guarantees freedom of speech, freedom of the press, religion, the right to trial by jury, and so on, but at the moment a lot of Americans are fighting about what the thing really means.

For example, let's take a look at the Second Amendment, the right to bear arms. This amendment was written two hundred years ago, back when people were bagging possum. So it's pretty hopelessly outdated now as a concept.

The founding fathers also probably hadn't imagined that eighth graders would be showing up at school armed with semiautomatic weapons.

And they probably didn't predict that at the end of the twentieth century the privately owned arsenals in this country would dwarf almost every other country's national stockpiles. Because, ladies and gentlemen, the current figures are these: two hundred and sixty million Americans, two hundred million guns.

WHERE I COME FROM

Sometimes when you hear someone screaming,
It goes in one ear and out the other.
Sometimes when you hear someone screaming,
It goes right into the middle of your head
And stays there forever.
I hear these voices, at the back of my head.
I'm holding my ears, then my ears turn red.
My hands are clean. My hands are clean.

WILD WHITE HORSES

In the Tibetan map of the world, the world is a circle and at the center there is an enormous mountain guarded by four gates. And when they draw a map of the world, they draw the map in sand, and it takes months, and then when the map is finished, they erase it and throw the sand into the nearest river.

Last fall, the Dalai Lama came to New York City to do a two-week-long ceremony called the Kalachakra, which is a prayer to heal the earth. And woven into these prayers were a series of vows that he asked us to take, and before I knew it I had taken a vow to be kind for the rest of my life. And I walked out of there and I thought: "For the rest of my life? What have I done? This is a disaster!"

And I was really worried. Had I promised too much? Not enough? I was really in a panic. And there were all these monks walking around. Had I promised too much? They had come from Tibet for the ceremony and they were walking around midtown in their new brown shoes and I went up to one of the monks and said, "Can you come with me to have a cappuccino right now and talk?" And so we went to this little Italian place. He had never had coffee before so he kept talking faster and faster and I kept saying, "Look, I don't know whether I promised too much or too little. Can you help me please?"

And he was really being practical. He said, "Look, don't limit yourself. Don't be so strict! Open it up!" He said, "The mind is a wild white horse and when you make a corral for it, make sure it's not too small. And another thing: When your house burns down, just walk away. And another thing: Keep your eyes open.

And one more thing: Keep moving.
Cause it's a long way home.

TIME TUNNEL

You know Stephen Hawking has this theory—about information and where it goes when iit disappears. According to this theory, when a black hole implodes, all the information about the objects that have disappeared begins to skid down an infinitely long tunnel. All those numbers and calculations and deviations are swirling around in a huge whirlwind.

So here are the questions: Is time long? Or is it wide? Are things getting better or are they getting worse? Can we start all over again?

You know I did an interview with John Cage and I spent some time with him and I noticed that he seemed to be such a happy guy. I mean he was eighty years old and he was always smiling——a lot of old people are in pretty bad moods by that point but he wasn't, and I was supposed to be asking him about music and information theories but what I really wanted to know was whether he thought things were getting better or worse. Because I'd been looking around and that was something that was really on my mind but it seemed like such a stupid question that I was afraid to ask so I talked around it for a while sort of building up to it and I was saying things like, "Well according to theories of evolution, if there was a race between a modern horse and a prehistoric horse the modern horse would win because it's faster more efficient it has adapted and are we like that, too? And then on the other hand according to Richard Dawkins there are some problems with this, for example, it would have been a great thing if fire-breathing animals had evolved—I mean this would have been a very convenient thing, just wwwf! cook your food on the spot and then asbestos-coated nostrils could have evolved so the nose wouldn't get singed," and so on, and finally Cage said, "Um, exactly what are you trying to say?" And I said "Arethingsgettingbetteroraretheygetting-worse?" And he stopped only for a moment and said, "Oh better. Much better. I'm sure of that. It's just that we can't see it. It's just that it happens so slowly."

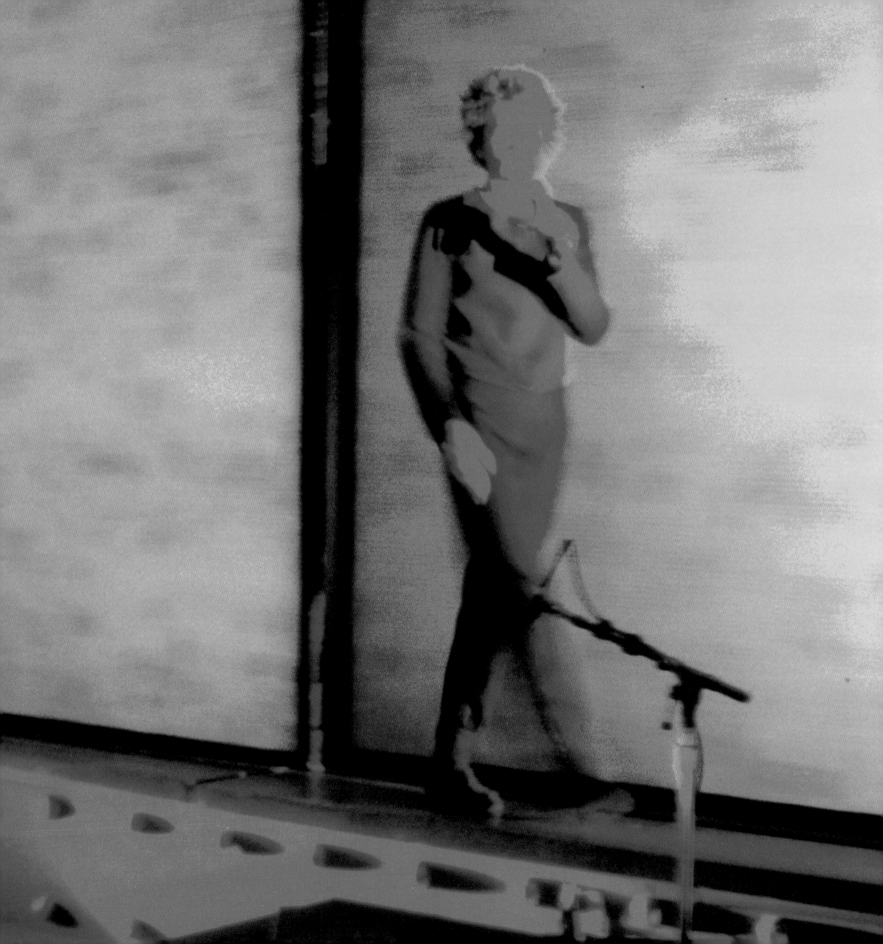

The Green Room was a Web site on the Internet that ran for the six-month duration of the *Nerve Bible* tour. The "Green Room" is theater-world parlance for the backstage hospitality room in theaters, where friends and fans gather to meet performers after the show. Anderson created an electronic version of the room on a Web page to "talk to people and find out what they were thinking." "I've spent more than half my life on the road," Anderson has said, emphasizing a significant aspect of a life devoted to performing live and making connections with different audiences around the world. Accessibility has always been a governing ethos of her material, and in the Green Room, Anderson finally created a situation that would allow for two-way communication between herself and her audience. Her interest lay in attempting to find "an underground"—places where people could exchange ideas and information, be artists rather than entrepreneurs, and provide a counterpoint to the aesthetics and values of corporate America.

(LA) "So where is the avant-garde? I found them on the net, via our 'Green Room' Web site, which we set up at every venue as a way to have contact with people. And I find them on the road—large and enthusiastic audiences who are willing to take on the challenging material in the show. I get to meet them, too, artists of all kinds who hand me their novels, plays, DATs and cassettes of their music. Will there be an outlet for their talent? It's very hard to be a young artist today. If you're talented at making images, the pressure is on to work in a multimedia corporate setting just to get to use the cool equipment. And there's a narrowing version of what culture can and should be in this country. At the moment the net is still a free zone for the exchange of ideas and information. Can it also be a place for artists? How long will it be before entrepreneurs figure out how to charge even more for this information, and then to regulate it? One of the reasons I went on the *Nerve Bible* tour in the first place was to see whether there actually is something that might be called 'the Underground.'

"Fort Lauderdale. Our last stop! (in the USA). We arrived a day early since the show in Orlando, which was booked at the Tupperware Convention Center (!), was cancelled. The only thing I really wanted to do was parasail. It's lovely up there in your rope chair sailing along. Probably the most privacy I've had in half a year.

"Came down and dropped in at the beach bar where the news on TV was all about the terrorist attack in Oklahoma City. Unimaginable. It didn't occur to me for a while that a long section of the *Nerve Bible* centers around the nightmare of surprise attack, so I quickly made a lot of edits in the text. Observations like "Terrorists are the only true avant-garde artists left because they're the only ones who are capable of really surprising people . . ." seemed so crude in the face of the smashed building that had crushed so many people. Also deleted a long section about how to protect yourself from terrorists, which in the light of the tragedy seems next to impossible.

"Lisbon, Coliseu dos Recreios. Can this really be the last show? I've now spent almost half a year of my life rehearsing and doing *Nerve Bible*. There have been a lot of nights when the house lights go out and the show begins (again!) that I've thought, 'I cannot possibly do or say these things again.' Why can't I be like an actress and just do it technically, professionally? Maybe it's because I'm saying my own words again and again and it just becomes a unique form of psychological torture, caught in a hellish loop of my own words. Once the performance starts, I'm usually O.K. and can find plenty of things to do to make it better. Here at least I have the challenge of doing part of the show in Portuguese, which is a truly difficult language. So many of the sounds just don't exist in English.

"Thanks to all of you who have been coming into the 'Green Room'! I have read just about everything that's come in. I just wish I'd been able to respond from the road. As it turned out, it's been difficult to get phones and we were moving so fast that I could barely keep up with everything. Anyway, one of my projects when I get back to New York will be to make contact with as many writers as possible. I also hope to keep the Web site going because it's really been a great way to find out what's been going on. Also I hope to extend it in a few ways. So check in again!"

PUPPET MOTEL

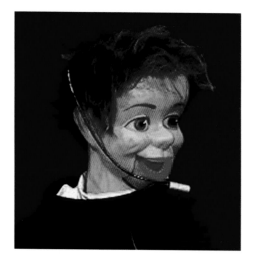

Digital Dummy

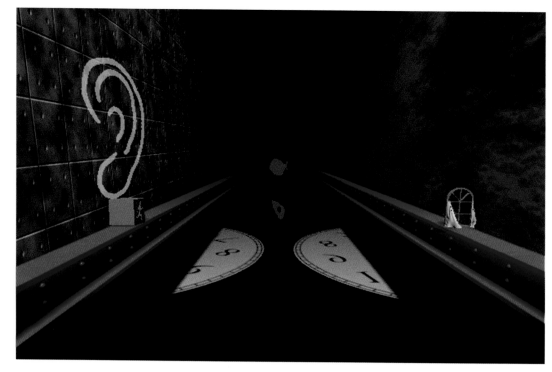

The Hall of Time

Laurie Anderson with Hsin-Chien Huang. *Puppet Motel*. **1995. CD-ROM. Produced by Voyager**

One of the first full-fledged CD-ROM's by an artist, Anderson and Hsin-Chien's *Puppet Motel* is a virtual building of thirty-three rooms, including a hall of time, a planetarium, a Green Room, an aquarium, and an anechoic chamber. Anderson notes:

"*Puppet Motel* is a little museum. You can find violins that were used in my early performances. You can even listen to the audio palindromes which I made for the Tape Bows." It includes videos of her violin-playing ventriloquist's dummy, as well as illustrations of the elaborate set she built for the *Nerve Bible* tour. An original feature of the CD-ROM is its capactiy to make links beyond the net. "You could tune into BBC radio, for example," Anderson says. A recurring theme is writing and writer's block. Also featured is a special "writing room," which contains icons of images "that repeat and repeat in my work: dogs, ice skates, planes, clocks, telephones. I use them all the time but they mean different things at different times. . . .

"The most difficult thing with *Puppet Motel* is imagining the role of the person who is going to be doing this . . . there is no good word for the person who uses CD's! It used to be Listener or Reader, and now in CD-ROM language it is the User, but that's a drug term, so I hope somebody comes up with a good word for this person, because I think it will clarify a lot of things.

"I think it is a very one-to-one situation and I try to make the CD-ROM fairly flexible—almost like turning on a TV or listening to a radio—you could look at images and affect them a lot. There's a section in the Detective Room, for example, where you're asked if you would like to re-edit *Crime and Punishment*—so you can work on that and there's a little editing music that goes along with it and you can listen to it or not.

"There's this idea that people staring at their screen is a kind of lonely experience, and to a certain extent I agree that it is not a very social thing, but on the other hand you could say that it's antisocial to stay home and read a book as well."

OPPOSITE:
The Attic

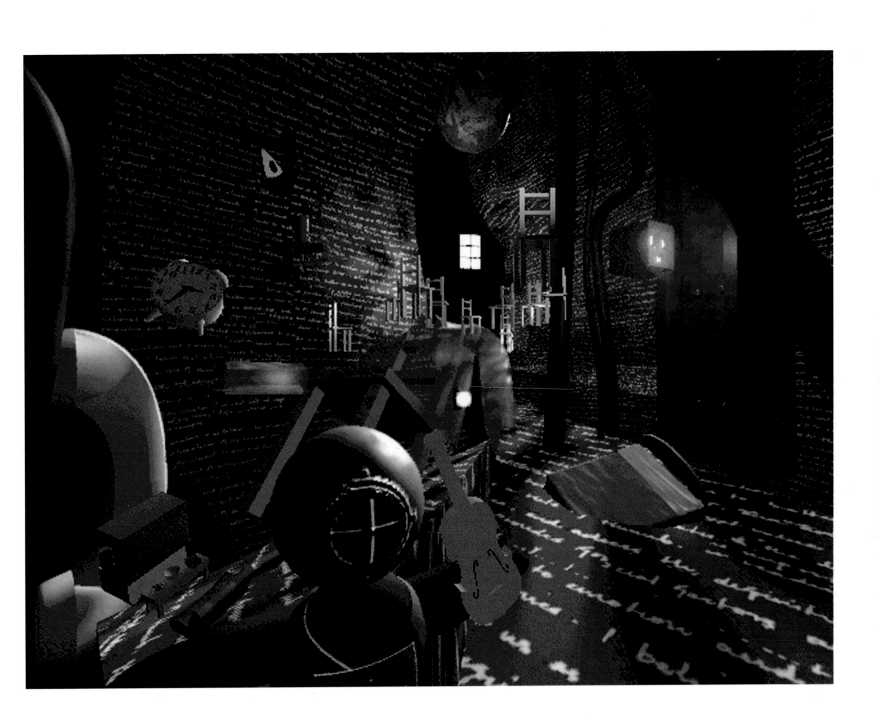

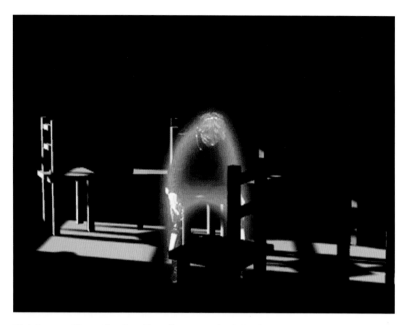

Plato's cave. The artist describes the mystery of shadows

The flashlight is used to reveal constellations

The computer mouse becomes an acupuncture tool

Using the mouse, a small chair can be made to revolve. It is also an entryway into other areas

The digital dummy arrives on the *Nerve Bible* set and explains the performance

The viewer enters a virtual motel room where all of the appliances and objects are active

The viewer can edit Anderson's computer animations on a small TV screen

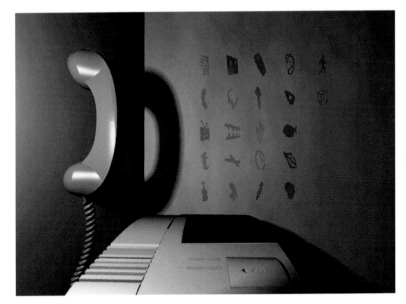

The viewer can leave or receive messages in the answering room

Laurie Anderson with Hsin-Chien Huang. *Here.* **1996. Web page included in the exhibition *Under Capricorn: Art in the Age of Globalisation* at the Stedelijk Museum, Amsterdam, and the City Gallery, Wellington, New Zealand. The Web page may be visited at http://www.stedelijk.nl.capricorn.anderson**

In her collaborations with Hsin-Chien on *Puppet Motel* and *Under Capricorn*, for CD-ROM and Web page, respectively, Anderson sought to discover new methods for engaging the viewer in thinking about language. "*Here* began when I decided to write a song with only the one hundred most frequently used words in English," Anderson explains. "The list I was working with was generated from written English as it is used in national news magazines. This original list, however, had very few nouns. It also included 'men' but not 'women,' 'no' but not 'yes,' and other such peculiarities." Anderson employed these words to create maps for the Web page, which function as a highly personal, visual thesaurus. Viewers are encouraged to use Anderson's maps as templates for their own writing.

Speed of Darkness. 1996–98

Speed of Darkness was a low-tech, stripped-down solo performance that premiered in Salt Lake City, Utah, in 1996 and toured the United States and Europe for two years. On stage were two banks of keyboards, a pair of microphones, and a digital violin. As Anderson played the instruments she combined old stories and new ones in a diatribe against everyday life in the computer age. "I mean I'm spending so much time fixing things and learning new systems, and I'm thinking, 'Wait a second, is this how technology is improving my life?'" Anecdotes about Cree Indian rituals being interrupted by a crew of documentary filmmakers, about cybersex, the Unabomber, Dolly Parton's Dollywood theme park, and the cloning of sheep were included in this lecture-performance.

(LA) "Sometimes it's hard to believe that everybody is so incredibly enthusiastic about the digital revolution. I have to say that I'm getting a little burned out on all this stuff. I now have eleven computers and it's a really big job keeping up with the updates and things keep crashing and I've gotten to the point where half the time all I want to do is throw all this stuff out the window—floppies, zip drives, monitors, mice—everything—just get rid of it. I mean I'm spending so much time fixing things and learning new systems and I'm thinking, 'Wait a second. Is this how technology is improving my life?'

"And I find myself rereading the Unabomber's message to the world and thinking, 'He's right! It's true. Technology is taking the human race on a reckless ride to nowhere.'

"And speaking of rides, who thought of this phrase, 'The Information Highway' anyway? I think it was Dick Cavett who said, 'Highway? That's something long and gray and boring that kills forty to fifty thousand people a year.'

"To sum it up, I'm ready to join the Lead Pencil Club, which is a sort of loose oragnization I just found out about and it's based on Long Island and this club advocates abolishing all electronics and going back to lead pencils and magic markers. But the thing is it's a little hard to get in touch with any of the club members actually . . . so if you want to join it's pretty difficult.

"Of course the main thing about technology is that it's really big and really powerful and not very many people really understand it. So what do you do with something big and powerful that you don't understand? You worship it. So there's a lot of voodoo and a lot of morality that gets attached to it—like that technology is really great and will make our lives so much better and easier—or that on the other hand technology isolates people, turns them into weird, antisocial loners typing away alone in their room (as if reading a book isn't also a deeply antisocial thing to do).

"The thing that scares me is that every day technology is getting more global, corporate, monolithic, and impossible to escape. Recently someone said the saddest thing about the fall of the Berlin Wall is that you can no longer defect. There's nowhere left to go. And now that technology is everywhere in the world, most artists, like everyone else, are having to figure it out.

"One of the main things I learned from going to all these futuristic tech conferences is that there is no such thing as an artist anymore. We are now officially known as content providers. Why does this sound like something from the Chinese cultural revolution?

'Content providers—we'll house them over there.'

"At first I thought this name was one of the most chilling things I'd ever heard. Then I thought about it for a while and I sort of got used to it—and after a year of hearing it I'm completely adjusted. Now I actually like it. It sounds sort of practical and positive and inevitable."

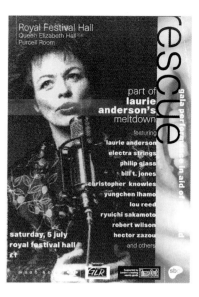

Meltdown Festival. 1997. Royal Festival Hall, London

For this annual summer festival, Anderson organized a series of concerts by artists including Brian Eno, Richard Foreman, Philip Glass, Spalding Gray, Bill T. Jones, Christopher Knowles, Yungchen Lhamo, Ken Nordine, Lou Reed, Salman Rushdie, Ryuchii Sakamoto, Electra Strings, Robert Wilson, and Hector Zazou. One of the evenings was a fundraiser for War Child, a foundation that provides aid for child victims of war. Anderson herself participated in several of the concerts and performed *Speed of Darkness*.

ART INSTRUMENTS AND INSTALLATIONS

From the very beginning Anderson created instruments that were clever reconfigurations of simple low-tech devices— speakers, mics, tape cassettes were attached to violins or bows, sunglasses or suits. Each was an ingenious creation for making sounds and images that were entirely her own. In addition, each doctored instrument was directly connected to one part or another of her body, resulting in highly personal, idiosyncratic objects with a distinctly human aura. Her vocoder-altered voices provided conversation partners for her on stage; bows could "speak" sentences when run through custom-made violins. In the 1990s she approached high technology in the same thoughtful and even ironic vein. Her Video Bow sometimes caught the audience on tape and projected their images on screens behind her, while her Talking Stick, which depends on the latest computerized software to function, looks at first like nothing more than a simple rod. Both are flexible objects that she designed to move with her on stage as a way of countering the rectangular format of computer imagery and screens. Her installations are equally inclusive of viewers, who become enveloped in each work. They put their ears to the plastic lips of a talking parrot, they huddle together in a "shower of sound," or they make eye contact with an "out of body" prisoner.

***Hearring.* 1997. Brass, copper, circuit board, loud-speaker, lithium battery, Plexiglas, wire, 3⅜ x 1¾ x 1 in. Special edition of 100 made for *Parkett* magazine**

This earring features a recorded message, approximately twenty seconds long. Some of the recordings are of Anderson playing her violin, others feature her reading a story.

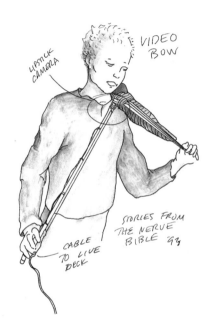

***Drawing for Video Bow.* 1992**

A tiny "lipstick camera" (so-called because the video camera is as small as a lipstick) obtained from a military surplus store is mounted on the end of a violin bow, so that as Anderson plays, it photographs her head as well as the lights and trusses and the structure of the theater around her. These images are then projected onto the screen. She explains, "We used something called a 'dustloop,' which makes video look like old Super-8 film—full of scratches and smudges of dust—and we keyed the live video over that. The result was a series of images that evoked the past but was very obviously of the present as well." This feature was used in the *Nerve Bible* for a song called "World Without End," which is about remembering. It ends with the line, "When my father died we put him in the ground/ When my father died it was like a whole library burned down."

OPPOSITE:
***Blood Fountain.* 1994. Computer-generated images**

In this proposal for a monument for Columbus Circle in New York City, Anderson conceived of a fifty-foot-square marble obelisk surrounded by a pool of glowing red liquid, which would spill out of the top of the structure. The monument would be inscribed "And nowhere is my heart." The project was sponsored by the *New York Times Magazine* as a memorial to murder victims. This work was presented as an installation in the *Hugo Boss Awards Exhibition* at the Guggenheim Museum in the form of a four-by-six-inch video projection installed in a vitrine in a wall.

Tilt. **1994. Carpenter's level, sensors, computer chips, and speakers, 36 x 2 x 1 in. (Above: entire object; below: two details)**

"I was frustrated with the limitations of left-right stereo sound," Anderson has said of this playfully interactive object, "and I wanted to make something that showed the three-dimensionality of sound in action. The sailboat was the visual mechanism that indicated the movement of sound from one side to the other."

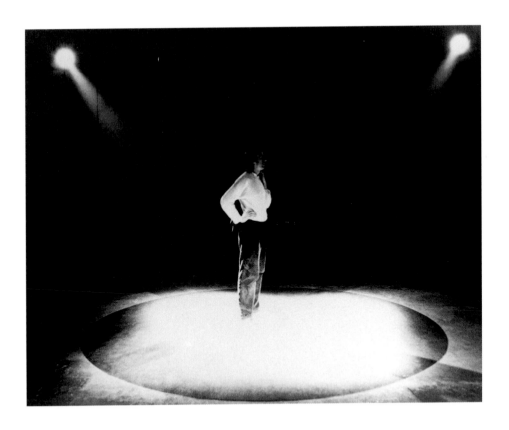

Whirlwind. 1996. Akademie der Kunst, Berlin

Anderson made this piece for the Sonambiente Festival
für Hören und Sehen. It is a thick dish eight feet in diameter
fitted with forty-eight speakers and suspended from the
ceiling, like a kind of giant shower-head that produces
three-dimensional, focused sound. Visitors standing beneath
it can hear Anderson telling stories based on notions of time
and space, the speed of light versus the speed of sound.
"We are moving at the speed of darkness. We are traveling
at the speed of darkness," she whispers.

Computer drawings of elements from Anderson's installation in the *Hugo Boss Awards Exhibition*, Guggenheim Museum SoHo, New York, 1996

Anderson was one of six finalists for the Hugo Boss Award in 1996. As part of the award program, an exhibition of the work of the six finalists—Laurie Anderson, Janine Antoni, Matthew Barney, Cai Guo Qiang, Douglas Gordon, and Yasumasa Morimura—was held at the Guggenheim.

Her installation comprised a series of darkened rooms that contained several storytelling devices directed at viewers in one-on-one encounters: a talking pillow (the viewer lays his or her head on the pillow to hear the recording), a telephone (lift the receiver and hear a story), a video and sound projection onto a small clay figure (the projection is a film of Anderson telling anecdotes about visits to a psychiatrist), and an animatronic parrot, Uncle Bob. Stuffed with electronics, the life-size bird has a "servo motor," which turns the

bird's head, and an "envelope follower," which allows the beak's movements to be synchronized with a synthetic, computer-generated voice. "I've often used digital voices, combining them into groups of back-up singers—an electronic Greek chorus—but I wanted to see if a single synthetic voice could work," Anderson comments. "It's quite easy to record what he says—just type it into the computer and you can hear it immediately."

Anderson continues, "I've always been completely fascinated by parrots, and I decided to make this electronic parrot after spending a lot of time with my brother's parrot. This bird—his name is Uncle Bob—has a vocabulary of about five hundred words, and it's uncanny to listen to him." Writing a monologue for the parrot, Anderson remarks, was like "finding a whole new voice—a voice that didn't sound anything like me. And it didn't have much to do with the way I think either. He could say anything." In fact, Uncle Bob even

complained about the competitive aspect of the exhibition: "Competition!" he says, "I love it. It's very very very American. I like to know what is best, and what is not as good."

Parrot Commentary:
"Damn . . . damn . . . damn . . . the destination disk is full. The hard drive is full. The hard drive is full. Please check the scratch disk on your hard drive La dee daw.

La dee daw. . . . I'm a little teapot short and stout, tip me over and pour me out. Did you know that Edgar Allan Poe wrote that song? It's true! God, I love that song. And Poe also wrote that story about the raven. What a great story! Really, really great. Very moving. Excellent."

DAL VIVO

Dal Vivo (Life). Milan, 1998.
Fondazione Prada, Milan

The installation was organized in two parts and comprised a darkened oblong gallery, its floor covered in black sand, with a dozen eight-inch-high clay statues scattered on the floor. Films of Anderson seated were projected onto each statue. Each told a different story that the viewer could hear by bending down low, with an ear close to the projector. A soft, chattering sound filled this room. The second room contained a life-size projection of a prisoner on a life-size clay statue.

In *Dal Vivo*, Anderson used the principles of one of her earliest works, *At the Shrink's*, in which an image of herself was projected onto a small clay statue, thus giving a two-dimensional image three-dimensional form. But whereas *At the Shrink's* employed the simplest projection device to make a fake hologram, *Dal Vivo* is a testament to technology of the 1990s. The image of a prisoner, sitting in a jail five miles away, is projected via cable onto a full-size model of the same person installed in a gallery space. Virtual reality is made entirely surreal as the prisoner appears live in the space; "a virtual escape" was the way the prisoner described it.

Dal Vivo began as a project for the Kunsthalle in Krems, a small town in Austria, which used a deconsecrated medieval church as the venue for its exhibitions. Anderson discovered that from the bell tower of the church one could see into the maximum-security prison in the center of town. She proposed her project *Life*, in which a live video feed would project the image of an incarcerated prisoner onto a life-size cast in the church. "The piece shows contrasting attitudes to the body of the church (incarnation) and of the prison (incarceration)," Anderson explains. "It also raises the notion of what it is that the different institutions, prison and gallery, choose to guard." For various reasons *Life* did not take place in Krems but was realized instead as *Dal Vivo* at the Fondazione Prada in Milan, in collaboration with the San Vittore prison. "It was a very emotional project for me," Anderson recalls of a work that involved prison visits, an exchange of letters with a man jailed for life, and a meeting with his girlfriend. The atmosphere of the installation was highly charged—by the sounds of the visitors approaching ("You had to walk across the gravel to get to him—crunch, crunch, crunch," Anderson says), by the eerie sensation of watching a "live" prisoner who could neither see nor hear those who were looking at him ("He's really there but really not there"), and by "the Greek chorus of little projectors" that greeted viewers as they came and went ("They're mostly talking about alchemical situations—how you have to pay in time for what you've done"). It also raised questions about the concept of judgement: "He was posed more like a judge than a prisoner," Anderson points out.

These are some of the stories the figures told:

THE GOLD COIN

You know, Alexander the Great wasn't killed at the battle of Macedon like everybody thinks he was. In fact, he was captured during the battle by a huge tribe of yellow men and forced to fight in their army as a slave.

Thirty years went by and finally his captors, who could see what a great fighter he was, decided to pay him. So they gave him a bag of gold coins. Alexander took one of the coins and looked at it and on it was his own picture. And he said, "This is from the time when I was Alexander the Great."

THE LAST GREAT WORLD WAR

Danny Hillis, the man who invented the millennial clock, told me about his idea for a movie. He said: "Here's the plot: Aliens are on their way to earth and they've been traveling for thousands of years through the universe taking pictures of the earth as they zoom towards it. Now they're almost there and they have a huge archive of images; a time lapse of the Alps as they're pushed up from the ocean floor, an enormous volcano that spewed fire and ashes over the earth and covered it for hundreds of years, the construction of the Great Wall of China and so on. As they got closer to earth the pictures were bigger and more and more in focus.

"So the aliens contact the earth and they say, 'We have these pictures—pictures of the history of the earth—more than that we have pictures of the crucifixion. And they're for sale.' And then they send a few samples to prove they have the pictures. A giant bidding war breaks out and the Last Great World War breaks out because of photography."

SAND

The first time I made contact with someone on a Web site it was with a guy who said his interests were music and sand. And I said "Sand?" I have a kind of special interest in sand. When I was on my first and only LSD trip I went to the beach and spent about twelve hours lying there looking at grains of sand. I had decided to make a collection of the sand and the idea was to choose just six of the most perfect and representative grains—a project that took all day and well into the night. I still have this collection in a small box lined with velvet and it has a little light that automatically turns on when you open the box. I took some pictures of the sand with an electron microscope and I sent the pictures to this guy at his Web site. And it took a few days to discover that the person I was talking to was actually a four year old kid and that his interest in sand was going out into his backyard and playing in his sandbox.

And it was great. I would never have come up to this guy at a party and said, "Hey let's talk about music and sand." On the other hand maybe this wasn't a four-year-old kid at all. This could have been anyone. It could have been an eighty-year-old woman just pretending to be a four-year-old kid. I wouldn't know. Copy Paste Repeat Return File Edit . . . Hey! Where did everybody go?

(LA) "All the figures in *Dal Vivo* were made by carving the image from projection, from light. This is the only way to make light wrap correctly around a three-dimensional form.

"I've made *Dal Vivo* because I'm interested in the theater of real time and in the magic of the disembodied body. The prisoner is present in time but spatially remote. Voiceless, unseeing. *Dal Vivo* looks at the way telepresence has altered our perception of time and the body. It is about voyeurism, our fascination with judgement and justice and the functions of guarded institutions—both prison and cultural institutions.

"My biggest concern as an artist is that *Dal Vivo* is primarily a meditation on time and the body, not an invasion of the prisoner's privacy or an investigation of his crime. I imagine *Dal Vivo* as the combination of an Egyptian tomb, a time warp, and a meditation chamber."

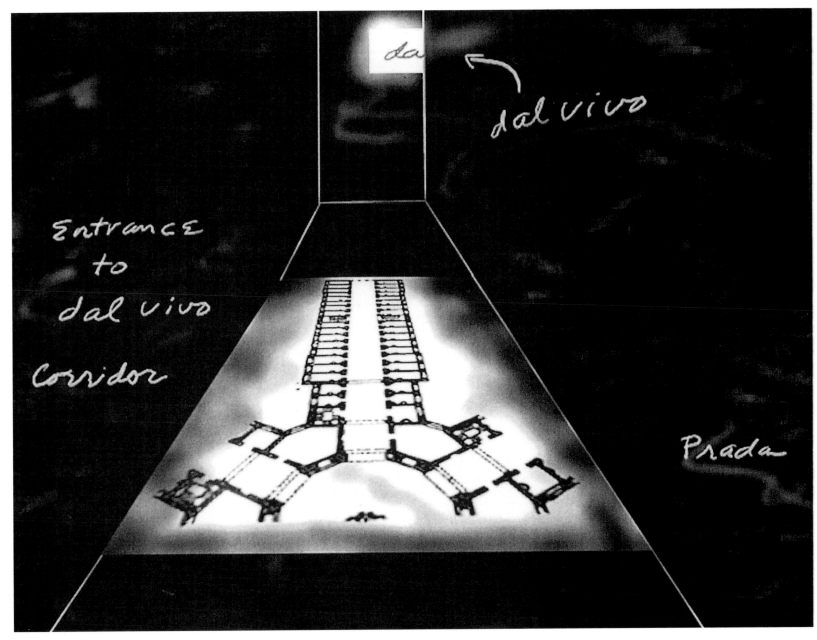

Drawing for "Dal Vivo (Life)." 1998. Computer-generated drawing of the project space

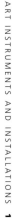

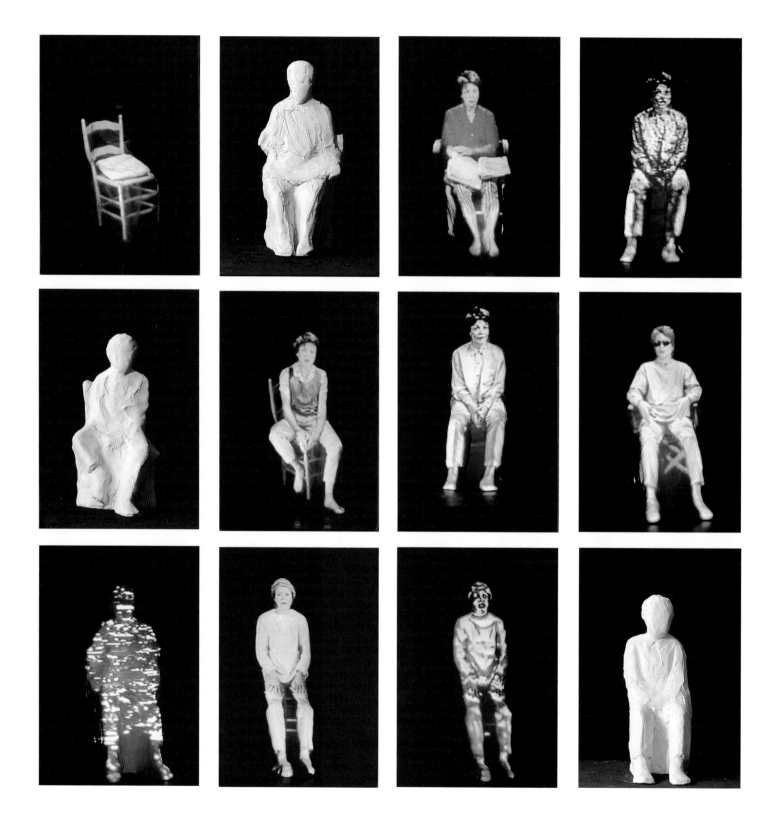

(LA) "On my first visit to San Vittore, I met a dozen prisoners. Supposedly I was to pick my prisoner/collaborator from this group of 'volunteers.' We sat in a small room while I explained my project. I had never seen inmates like these. Many of them were extremely articulate. Quite a few of them were stylishly dressed (mostly Armani) and it seemed a bit like some kind of corporate board meeting. That is, until you looked at their shoes (slippers), and realized that these guys weren't going anywhere later.

"As we talked, I realized that they had already chosen someone. They let me know this gradually, subtly, by simply directing my attention more and more to a small man in the corner. The man they had chosen was a bank robber named Santino (or Saint). Apparently he would get some time off his sentence if he cooperated with 'authorities' (meaning us in this case). His fellow prisoners seemed to feel that he deserved this break and that he would be a good spokesman. When I asked Santino what he thought of the project he said, 'I see it as a virtual escape.' I had found my collaborator. Or he had found me."

Anderson with the Talking Stick in *Songs and Stories from Moby Dick,* 1999

The Talking Stick is a digital remote-controlled instrument, which she designed with Bob Bielecki and a team from Interval Research Corporation. As Anderson explains, "It's a very physical way of accessing audio samples. It uses a process called 'granular synthesis,' which breaks sound into tiny segments, which can be played back in various ways." It is six feet long and has a moveable sleeve to access the sounds. In *Songs and Stories from Moby Dick*, several performers use the Talking Stick. It can be held and played in various ways to suggest a harpoon, a gun, a staff, a violin, and a jackhammer. It also serves as a light, and in one song, which is performed in Latin, the sticks are bunched together as "a kind of offering." A six-foot bank of computers is needed to operate them.

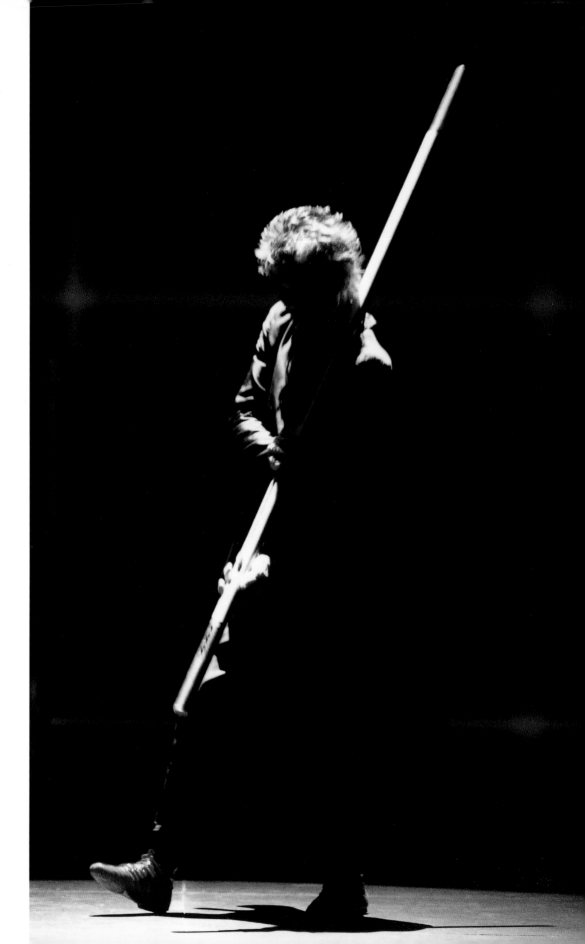

SONGS AND STORIES FROM MOBY DICK

**Songs and Stories from Moby Dick. 1999.
An electronic opera. Premiered at the Brooklyn
Academy of Music, New York; American and
European tour included Los Angeles, Spoleto
Festival USA, Charleston, South Carolina, Palermo,
and Paris**

Songs and Stories from Moby Dick is Anderson's first large-scale, multimedia production since *Stories from the Nerve Bible* in 1995. Unlike all her previous performances, *Moby Dick* is based on a preexisting text, Herman Melville's extraordinary novel, which was published in 1851, and it includes three actors who perform with her on stage (also a first in the history of her oeuvre). It includes new inventions, such as the Talking Stick, and every aspect of the production depends entirely on computers. Yet in many ways, *Moby Dick* develops thematic threads that have been constant in Anderson's work from the start. "It's about Americans," Anderson explains. "It's got maps, it's got water, it's got darkness and authority." It has alter-egos and doubles—there are at least two Ishmaels—and performers, including Anderson, each play many roles and have a range of voices. Finally, the production is about Melville, a master storyteller to whom Anderson has referred in numerous works throughout her career.

Songs and Stories from Moby Dick does not directly raise political issues in the way that Anderson usually does in her work; instead it is deeply philosophical—metaphorical, even—in its emphasis on Melville's search for the meaning of life. "So what does Melville have to say to late-twentieth-century Americans?" she queries. "Obsessive, technological, voluble, and in search of the transcendental, we're a lot like our nineteenth-century forebears," she says. "For me, a key question is asked, almost as an afterthought, at the end of Father Mapple's famous sermon, 'for what is man that he should live out the lifetime of his God?' Yes, really. What do you do when you no longer believe in the things that have driven you? How do you go on?" Anderson no doubt asks these questions of herself, and *Songs and Stories from Moby Dick* is her musically lush and visually dazzling reply-in-progress. No matter the layers of meaning or the breadth of geographic landscapes covered in her latest production, Anderson keeps the material close to home and to her own belief system.

(LA) "I've been thinking about two epic American stories that are about work and control. They're both stories about teams of people working in ships. The stories are *Star Trek* and *Moby Dick*, and their ships are the *Enterprise* and the *Pequod*. These stories are separated by about a hundred and fifty years, and although they have a lot in common—very long voyage, a powerful captain, dangerous encounters and wild adventures—they couldn't be more different.

"In *Moby Dick*, the ship is pretty high-tech by nineteenth-century standards; it's a kind of floating factory. Except in this ship the captain is completely crazy. But what finally happens in *Moby Dick* is pretty horrendous. The captain goes more or less insane, the ship in snapped in half, the crew drowns, and the captain is dragged to the bottom of the ocean by the whale he has fanatically hunted. The end. And there aren't even little epigrams like in *King Lear*, when at the end the king learns that he can love some people a little bit. In *Moby Dick* it just ends. And it's such an incredibly dark story. You can't imagine telling a story like that now. For example, the *Enterprise* exploding in a huge accident and all the debris disappearing into a black hole and in the last shot there's a single spaceman turning around, swimming around and around alone in space. 'Call me Ishmael.' The End. This would never happen, even if the series was slated to go permanently off the air."

The opening song, "Audite," is sung by three performers holding illuminated Talking Sticks. "Audite" is an invocation in Latin inspired by Corsican singers whose vocal style, Anderson notes, is "somewhere between Gregorian and Muslim chanting."

> Listen, O people of the land
> To this story of the ocean.
> And how they looked for what they wanted.
> And how it ate them in the end.
> Speak, machines, of liberty.
> Speak through the air of our time.
>
> *Audite o vos in terra habitandes*
> *Hanc fabulam, audite de oceano.*
> *Et quo modo petiverint id quod desiderant.*
> *Quoque modo eos tandem consumpserit.*
> *Loquimini, o machinae, de libertate.*
> *Loquimini, o machinae, per aerem temporis nostri.*

Musically, *Songs and Stories* is propelled by violin-based duets that sound like orchestral fragments, rhythm sections of electronically processed drum solos, and the clicking patterns of sperm whales in underwater conversation. The tenor and baritone voices of the three male performers combine to make a very different Anderson sound. "There are six ensemble songs for the guys," Anderson notes. "I've never really written for male voices before."

Much of the music carries the weight and sometimes unbearable tension of the famed ship captain on his mission of revenge, but it can also be dreamy and even convey a subtropical lilt as it follows changing weather patterns at sea. "Cabin boy Pip has a theme called 'Boy Overboard,'" Anderson says. "It is for processed guitar and bass, and it has a streaming sound that accompanies windy letters tumbling across the screen."

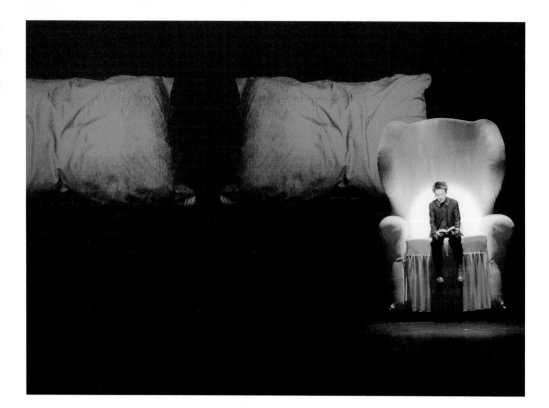

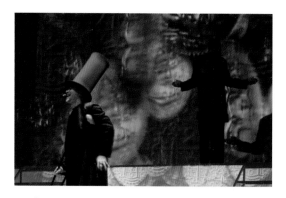

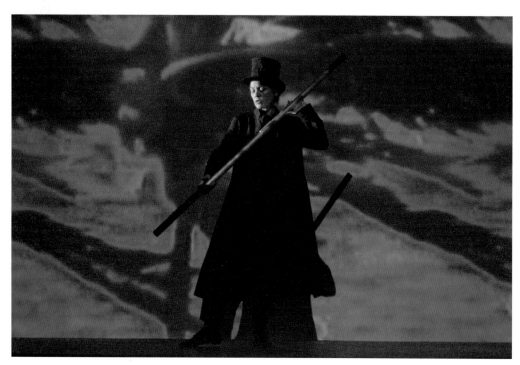

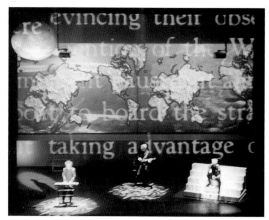

As with all her major productions, Anderson would edit and trim *Moby Dick* once it was up and running on stage. The Philadelphia production lasted more than two hours, while the final version presented at BAM was a tight ninety minutes. New inventions, such as the Talking Stick, and oceanic imagery were mixed with signature elements taken directly from her oeuvre, such as the running man, the slept-on pillows, and the Lens Head. With Miles Green, Tom Nelis, Skúli Sverrisson, Anthony Turner, and Price Waldman.

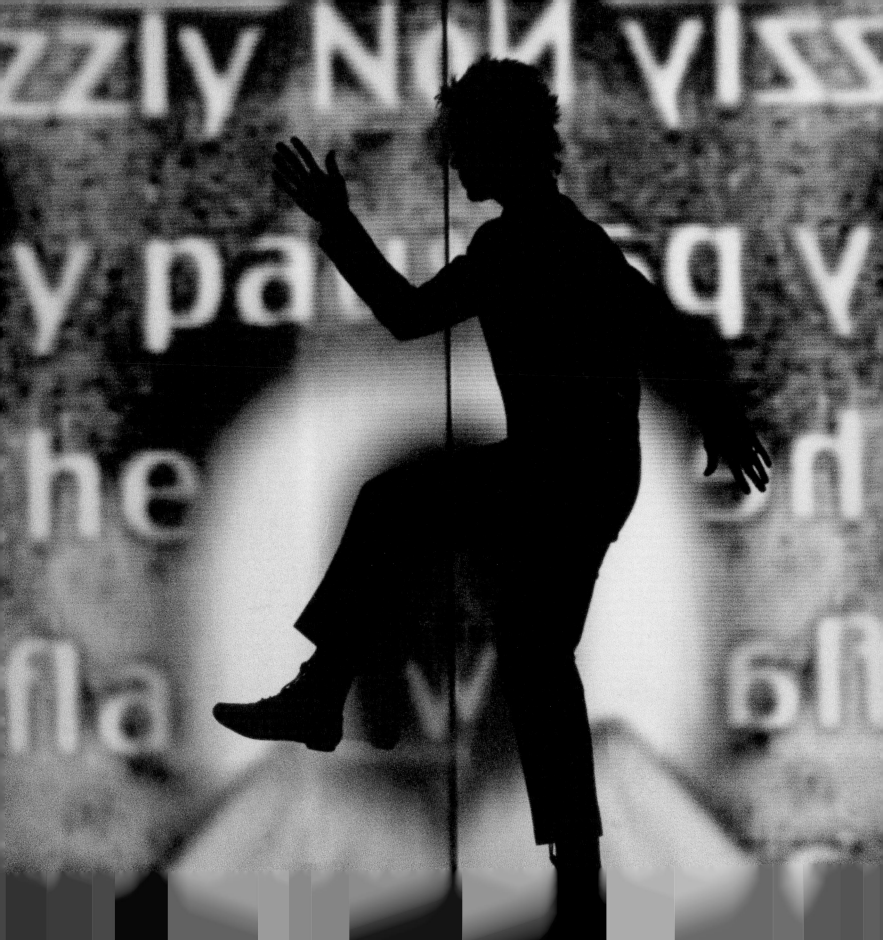

PIECES & PARTS

They say that in 1842 on a plantation in Alabama
The slaves unearthed a huge skeleton,
The bones of a giant whale, a leviathan,
From the time when all the world was covered with water
From the Andes to the Himalayas,
And even Alabama was deep down under.

The slaves looked at the huge bones and they said:
These must be the bones of a fallen angel.
These must be the bones of a fallen angel.

And out on the ocean, out on the water
We look for a sign of him.
He looks like a giant snow hill, a fountain
Then he disappears. He's a speck on the horizon.

We see him only in parts
The flash of a tail, his beating heart.
He's in pieces in parts.

It's easier for a camel
To slide through the eye of a needle
Than to find a whale
Who hides at the bottom of the ocean.

It's easier to sail around the world in a coffee cup
Than to see a whale when he comes rising up.

Sometimes he looks like a small white weasel
Sometimes he looks like a deep blue field
When he dives down where he hides
Full fathom five where he abides.

We see him only in parts
A fountain, fins, a speck on the horizon
Giant teeth, an open mouth
Look out, look out, look out, look out.

It's easier for a camel
To slide through the eye of a needle
Than to find a whale
Who hides at the bottom of the ocean.

Hit an elephant with a dart
He just reaches around and pulls it out with his trunk
But hit a whale in the heart
And the ocean turns red. It turns red.

We see him only in parts.
His tiny eye, his beating heart.
He's in pieces in parts.

Get hit in the head
And there may be a few things you can't recall
But get hit in your heart
And you're in pieces. In parts.
Pieces and parts.

ONE WHITE WHALE

How to find you
Maybe by your singing
A weird trail of notes in the water.
One white whale in all these oceans
One white whale.

Slipping through the nets of silence
Under polar ice caps miles down
You leave your echoes in the water
One white whale in all these oceans
One white whale.

BOY OVERBOARD

Pip the cabin boy. He slipped and fell.
Landed in the water
He fell into another world.
Boy overboard. Boy overboard.

He slipped slow motion down
A ringing in his ears
Ding dong bell.
He fell. He fell. He fell.

Shafts of light everything is striped
Underwater light.

The sweet things of the world
The thundering hills the cheeks of young girls
They become just thoughts.

Pip the cabin boy. He dropped down to the bottom
He fell without a sound
And down on the ocean floor he walked around.
Boy overboard. Boy overboard.

Pip saw God the weaver working at his loom.
God said, listen Pip, even if you drown, down here in the gloom
Even if you call, I can't see you.
I can't hear you. I'm busy.
All creation mechanical. All creation mechanical.

LAST MAN

Up in the masthead high above the deep black sea
Sparkling rain is wrapping all around me
Comets fly by, planets turning in their spin
I whirl, I whirl around with them.

I fly through the silent night
I'm part of it, a tiny speck, a molecule
A drop in the heart of it.

On bright days the great white clouds go sailing by
They look like giant whales and boats in pursuit of them.
On dark nights great panoramas in the sky
And down below me the ocean's rolling

But then I think, what if I slip?
Or move my foot or hand a bit?
I'd find myself falling
Through a hole in the world
Down into the summer sea.

Some believe that there's a bigger plan
And accidents are just another part of it
But I am just a simple man
I'm flying, I'm falling into the heart of it.

And if a man is what he knows
Then I would be a tiny speck, a molecule
Just a drop in the heart of it

There are divers who go down
They walk on the bottom of the ocean just to take a look
around
But if I fall from way up here what would I be?
Just another drop in the heart of the green sea.

And the waves roll and the crests and the swirls
And if I slip I would fall, I'd be falling
Through a hole in the world.
And the waves roll and the crests and the swirls
And if I slip I would fall, I'd be falling
Through a hole in the world.

MECHANICAL MAN

Carpenter, come over here. I need a new leg. This one
here is splinters.
This time make it waterproof so I can stand in the rain.
Take my legs, get rid of them. Let the sharks finish them.
Make me, make me, make me a mechanical man.

Make me strong a hundred fold. A metal fist of solid gold.
Make my eyes cold. Make my eyes cold.
Make my arms into giant cranes. Give me thousands
and thousands of acres of brains.
Make my muscles into pulleys and chains.
Make my muscles into pulleys and chains.

Cut my heart out. Leave my spleen.
Make my hands magnets
That will pull me, pull me, pull me towards Moby Dick.

Fill me full of mercury. An iron hand sharpen me.
Say that I was lost at sea and this new man replaces me.
Make me, make me, make me a mechanical man.

Take away my memory. Erase it all. Flatten me.
Make me make me make me a mechanical man.

Make my hands magnets. Make my hands giant magnets
That will pull me pull me pull me towards Moby Dick.
Make my hands magnets
That will pull me pull me pull me towards Moby Dick.

NOAH'S SONG

Noah was a righteous preacher. He was the son of
Abraham. His righteousness was leaking all over the land.
God said to Noah, "Listen, I'm gonna flood out the world.
I'm gonna drown all the men and women. I'm gonna
drown all the boys and girls." Hey! Hey Hey! Line em up.
Line em all up. Line em all up.

So get yourself an architect. Build yourself a boat. Fill it full
of animals and make sure that it floats. On the midnight
watch old Noah, he's down in the hold. He's preaching to
all the animals. He's saving their zombie souls. Line em up.
Line em all up. Line em all up.

Now just imagine what it was like in there. Forty days and
forty nights. A floating zoo. Green and brown fur. Rotten
fruit and urine. Darkness darkness everywhere. Endless
rain. And crowded? They couldn't turn around in their
stalls. Yeah they were dropping off like flies and when they
did their tiny souls floated up and out. Extinct forever.

Yeah promise me a rainbow, go ahead. Promise me
this rain will end.

Now the fish down in the ocean, they didn't need no Ark.
They were happy swimming down there in the dark. Down
there in the dark. The mighty squid, the dolphin, they
never get rounded up. The little shrimp, the great whales,
old Noah couldn't count em up.
He couldn't line em up. Couldn't line em all up. Couldn't
line em all up.

Yeah promise me a rainbow, go ahead. Promise me
this rain will end.

I need something to drink. I need a reason a reason not
to think.
And tell me this: What is a man if he outlives the lifetime
of his God?
What is a man? What is a man?

BIOGRAPHY

1947–71

LA is born June 5, 1947, in Chicago, the second of eight children of Mary Louise Rowland (b. 1926) and Arthur Anderson (1910–1999). Her maternal grandparents were from Scotland and England, paternal grandparents were from Sweden and Ireland. The family lives in a large redwood house in Glen Ellyn, Illinois, designed by LA's mother as a series of large connecting rooms for family play and entertainment. LA begins violin lessons at age 7 and becomes a member of the Chicago Youth Orchestra in 1961. Is selected as Junior Miss Illinois in 1965 and travels to Europe as part of Talented Teens USA that same year. Also in 1965 leaves Chicago to attend Mills College as a pre-med student. Moves to New York the following year and enrolls at Barnard College; graduates summa cum laude with a BA with honors in art history in 1969. During a year between college and graduate school she takes sculpture classes with Sol Lewitt and Carl Andre at the School of Visual Arts, where she makes a series of "talking boxes."

1972

As a graduate student at Columbia University majoring in sculpture, LA also studies art history with Meyer Schapiro, printmaking with Tony Harrison, and philosophy with Arthur Danto. Focuses on texts by Merleau Ponty on phenomenology and perception, and studies Buddhist literature on mudra (postures and hand gestures representing the states of higher consciousness). After graduation, writes art reviews for various magazines and teaches art history at colleges in New York City. Executes a series of performances in which she sleeps in public places; performs *An Afternoon of Automatic Transmission,* an outdoor car concert in Rochester, Vermont; meets artists Joel Fisher and Richard Nonas; writes *October,* a handmade diary; and creates *Ecotectural Fables,* a series of collages about the relationship between animals and architecture.

1973

LA organizes *O-Range,* a performance with her students in a stadium at City College, New York, followed by a mixed-media exhibition of the same name, which includes film loops and photo-text works at Artists Space, her first gallery show. Meets artist Vito Acconci; also meets composer Philip Glass and sits in on his rehearsals (as do many artists), about which Sol Lewitt says, "I do my best work at Phil's rehearsals." LA describes New York of the early '70s as "Paris in the '20s," and notes the lack of boundaries between disciplines. Her artist friends include Gordon Matta-Clark, Tina Girouard, Jene Highstein, Dicki Landry, and Keith Sonnier. LA is part of *Thought Structures,* an exhibition at Pace University, and writes *Transportation Transportation,* a series of booklets with twenty-six pairs of stories constructed around the alphabet. Some of these stories will reappear in *United States* ten years later. LA exhibits *Object/Objection/Objectivity,* a work comprising texts and photographs of men who make comments about her as she passes them on the street.

1974

DEARREADER, a black-and-white 8-mm film/performance codirected with Bob George, is shown at Holly Solomon Gallery. *As:If,* Anderson's first multimedia gallery performance, takes place at Artists Space. LA receives a CAPS grant and visits her anthropologist brother Thor in Chiapas, Mexico, where they live with a group of Tzotzil Indians. She also hitchhikes to the north pole, camping in remote areas. Performs *Tales from the Vienna Woods* at Projects Gallery in Boston; *How to Yodel* in an evening of performance called "Soup and Tart" at The Kitchen, New York; and *Tales from the Vienna Woods* at various venues in the United States and Europe. LA's loft is broken into and almost all her possessions are destroyed or stolen, an incident that she records in a handmade, thirty-six-page booklet, *Light in August.* She constructs *Windbook,* a diary of handwritten stories and photographs installed in a box, whose pages are turned by small hidden fans. At the Clocktower, New York, LA performs *In the Nick of Time,* a performance with film projection, and *Duets On Ice,* an outdoor work in five New York City locations, in which she wears ice skates set in blocks of ice and plays her Self-Playing Violin, a violin with a cassette player installed in its body, which accompanies her playing.

1975

LA moves into a new loft on Canal Street, where she installs a twenty-tree "forest" of small pine trees. Works at ZBS Media, an experimental recording studio in upstate New York, where she meets Bob Bielecki, an audio engineer and designer with whom she will collaborate on developing numerous unusual musical instruments. Records *Talking Book,* and performs *Songs and Stories for the Insomniac* at Artists Space, the Museum of Contemporary Art in Chicago, and Oberlin College in Ohio. Performs *Out of the Blue* at the University of Massachusetts, Amherst, and at alternative spaces and museums in Europe, and *Duets on Ice* in Genoa, Italy. Shows *At the Shrink's,* a fake hologram created by projecting a Super-8 film loop onto an eight-inch clay figure, at Holly Solomon Gallery, New York. Forms the Fast Food Band with friends Peter Gordon, Jack Majewski, Arthur Russell, and Scott Johnson, and they appear at the Fine Arts Building in New York, performing the "Fast Food Blues," a long song-complaint about photo documentation. She and Bielecki make the Viophonograph, a turntable mounted on a violin that is played with a bow in which a record needle has been inserted. She writes her first dance score, for Mary Overlie.

1976

LA presents *For Instants: Part 3, Refried Beans* as part of "Line Up," a performance series at The Museum of Modern Art, New York, at a four-day festival of performance at the Whitney Museum of American Art, New York, and later at colleges and alternative spaces in the United States and Europe. Receives a grant from the Gallery Association of New York State and works with downtown musicians including Arthur Russell, Scott Johnson, and Rhys Chatham. Records several songs produced by Peter Gordon at ZBS Media. Performs *Stereo Stories* at the M.L.D'Arc Gallery, New York, and *English* while on tour with performance artists Julia Heyward and Jana Haimsohn in Germany, Denmark, and Holland. Performs *Road Songs* at St. Marks Poetry Project and *Songs* at Meet the Composer at the New School in New York. LA and Bob Bielecki design the Tape Bow Violin; a Revox tape is mounted where the bridge would normally be, and the bow is strung with a single strip of prerecorded audiotape instead of horsehair.

1977

LA performs *Songs for Lines/Songs for Waves* at The Kitchen; "On Dit" at the Paris Biennale; and "That's Not the Way I Heard It" at Documenta in Kassel. She presents *Some Songs* in Belgium, Italy, and Holland; *Audio Talk* at the New School, New York; and *Stereo Decoy: A Canadian–American Duet,* an outdoor work, at Art Park, Lewiston, New York. Receives grants from the New York State Council on the Arts and the National Endowment for the Arts. Records *Songs for Airwaves* for 110 Records, a small New York label run by Bob George. Meets Charles Amirkhanian, electro-acoustic musician and then director of KPFA/Berkeley, and spends two weeks at a Buddhist retreat. Works with Tina Girouard and publishes stories in *Individuals,* edited by essayist and critic Alan Sondheim. Shows *Jukebox,* an installation of texts with photographs and 45-rpm records, at Holly Solomon Gallery. Makes *Numbers Runners,* an interactive phone booth. Builds *Acoustic Lens,* a rubber sphere inserted between two rooms, whose lens gathers sound and delivers it to a precise point in a room. Meets Michel Waisvisz, the Dutch composer. Writes "New York Social Life," a rapidly spoken, extremely lengthy run-on sentence that ironically illustrates the life of artists in downtown New York, which is recorded by New Music Electronic and Recorded Media, Berkeley, California.

1978

LA travels around America, hitching rides most of the way. Works as a migrant cotton picker near Covington, Kentucky; meets Mister Spoons, a well known professional spoon player; and writes *Notebook,* a collection of scores and stories. Spends part of the year in Berlin. Performs as an emcee at the Nova Convention, where she meets writer William Burroughs. Performs *Down Here* at the Texas Opry House in Houston and *For Instants* in a variety of alternative spaces. Writes "Like a Stream," a piece for orchestra and talking chorus, which is performed in Washington, D.C., New York, and Minneapolis. Finishes *A Few Are, Songs for Self-Playing Violins,* and *Suspended Sentences,* which are performed mostly in Europe. Constructs *Handphone Table* for the Projects room at The Museum of Modern Art, New York. Shows *Quartet for Four Subsequent Listeners* (*Notes/Tones*) at Holly Solomon Gallery and at And/Or Gallery in Seattle. Presents *Nightdriver,* an installation of slides and audio, at the Wadsworth Atheneum in Hartford, Connecticut. Is

invited to conduct a seminar with nuns on the spoken word at a Benedictine convent in Wisconsin; writes music for *Harrisburg, Mon Amour,* a play by David Shapiro. Meets Andy Kaufman and operates as his straight man in comedy clubs in Manhattan and on Coney Island. Teaches at Cal Arts in Valencia, California. At a concert in Berkeley hears Charles Holland sing "O Souverain" from Massenet's *Le Cid.* In response, records "O Superman" a year later.

1979

LA receives an NEA grant and publishes *Words in Reverse.* Performs *Americans on the Move, Part I,* which becomes *United States, Part 1,* at The Kitchen in New York and at Carnegie Recital Hall in a special evening produced by Holly Solomon Gallery. Performs in the Cabrillo festival in Capitolo, California, and conductor Dennis Russell Davies encourages her to start writing orchestral works. She forms a trio, The Blue Horn File, with Peter Gordon and David Van Tieghem, which performs at the Mudd Club in New York. LA performs a musical evening with Gordon at the Customs House, New York, and participates in New Music New York, at The Kitchen, the first in a series of new-music festivals. Becomes increasingly involved in the music world as a musician/composer rather than as a performance artist, which strengthens the development of her own music and makes her aware of the advantages of straddling both worlds. Meets projection artist Perry Hoberman, who will develop special multimedia theatrical techniques with LA that will become central to *United States.* Hoberman works on Anderson's *Night Flight,* a slide installation in a downtown window in Graz, Austria. LA meets Roma Baran, an audio producer who records Anderson's songs for *Dial-A-Poem* and with whom she will work on several future albums. Wears Audio Glasses, dark glasses with tiny microphones that pick up and amplify the sound of her movements, in early performances of *United States, Part 2.*

1980

LA appears in Michael Blackwood's film *Fourteen Americans.* LA and other artists are invited to travel to Ponape to record "Word of Mouth" (an album of conversations with artists, sponsored by Crown Point Press), where she meets John Cage. *United States, Part 2* premieres at the Orpheum Theater in New York, sponsored by The Kitchen. It is her first extended piece in a real theater and is repeated over several nights. "Born Never Asked," performed by the

Oakland Youth Symphony and conducted by Robert Hughes, premieres at the Paramount Theater, Oakland, California. LA shows *Dark Dogs, American Dreams,* an audiovisual installation comprising twelve soft-focus portraits, each accompanied by an audiotape of one of LA's dreams read by the person photographed, at Holly Solomon Gallery.

1981

LA performs in the Anti-Inaugural Ball for Ronald Reagan at the Pension Building in Washington, D.C., sponsored by D.C. Space and WPA. Releases "O Superman" on 110 Records, initially pressing one thousand copies. The record reaches no. 2 on the London pop charts, which leads to Anderson signing with Warner Brothers Records. She records *Big Science,* coproduced with Roma Baran, which will be her first album to appear on the Warner Brothers label. Also records several songs for *You're the Guy I Want to Share My Money With* with William Burroughs and John Giorno, for Giorno Poetry Systems Records. Begins to work with music agent Greg Shifrin. Receives a Villager Award and appears in *Film du Silence* with Catherine Lahourcade, made for Channel 3 in Paris. *Scenes from United States,* a three-dimensional exhibition, is shown at Holly Solomon Gallery. LA embarks on an extensive European tour, performing in museums, alternative spaces, and music festivals. Back in the United States, tours rock clubs with Giorno and Burroughs (whom she notes disappears from time to time into shooting galleries to keep up his target practice). "It's Cold Outside" is performed by the American Composers Orchestra at New Music America in San Francisco and at Carnegie Hall, New York. Anderson meets the British director Nigel Finch.

1982

LA receives a Guggenheim fellowship and releases *Big Science* on Warner Brothers Records. Works at the Anderson Art Ranch in Colorado, where she makes prints and lithographs with printmaker Bud Shark. While working in Abbey Road Studios in London, mixes a score for Michael Mann's film *The Keep.* The Westdeutscher Rundfunk performs "It's Cold Outside," directed by Dennis Russell Davies, in Cologne, Germany. LA goes on European tour, performing in Norway, Denmark, Sweden, Scotland, Holland, Switzerland, England, France, and Germany. Records a flexidisk of "Let X=X" for the February issue of *Artforum* magazine.

1983

LA performs the eight-hour *United States* over two evenings at the Brooklyn Academy of Music in New York and the Dominion Theater in London, and at an all-night concert in Zürich. *Laurie Anderson, Works from 1969 to1983*, a multimedia exhibition, is organized by Janet Kardon at the Institute of Contemporary Art in Philadelphia; it travels in the U.S. to Houston, Los Angeles, Berkeley, and New York, and to England, Scotland, and Ireland. LA records on Nona Hendryx's album *Nona*. Writes the score for *Set and Reset,* a collaboration with choreograher Trisha Brown and artist Robert Rauschenberg, which premieres at the Brooklyn Academy of Music.

1984

LA meets musician Peter Gabriel and writes and performs the song "This Is the Picture" for *Good Morning Mr. Orwell,* a live video broadcast from venues around the world, organized by Nam June Paik to celebrate the new year and George Orwell's book *1984.* Following Japan tour (arranged by producer Rande Brown) Anderson goes to Bali, where she meets the prince of Ubud, and their conversations about the future are recorded and published in Japan. Records vocals for Jean-Michel Jarre's record *Zoolook* and appears on "The David Letterman Show." Meets Wubbo Occhels, the Dutch astronaut, and Gideon Kremer, the Russian violinist, while performing on "Beo's Bahnhof," a live TV show produced in Munich. Musician Nile Rodgers works with LA in the studio; he plays on *Mister Heartbreak* and produces a groove-oriented version of "Language Is a Virus" for the *Home of the Brave* film soundtrack. *Mister Heartbreak* album is released and LA tours the United States, Canada, and Japan to promote it. LA is nominated for a Grammy Award for "Gravity's Angel." Begins to look for financial backers for a film documenting the concert. Is included in several group exhibitions and festivals, including *Disarming Images* at the Art Museum Association of America, Los Angeles, the National Video Festival, which is screened at the Art Museum Association of America, and *Give Peace a Chance* at the Peace Museum in Chicago.

1985

LA directs *Home of the Brave,* filmed by John Lindley in 35-mm Panavision at the Park Theater in Union City, New Jersey, and produced by Paula Mazur. Based on a performance from the 1984 *Mister Heartbreak* tour, it includes

musicians, a game show hostess, a horn section, stagehands, and Latin percussionists. LA finds the dual roles of star and director of the film to be overwhelming. Performs in the Serious Fun Festival in New York. Wears white suits instead of black ones on stage (she calls this her "new minstrel era") and takes on the image of entertainer in an American Express advertisement. LA describes the mid-1980s, a time of media fascination with the art world, as a period when the downtown art community was broken apart by escalating real estate values.

1986

Natural History, a compilation of new and recent songs and stories, tours the United States, Europe, Japan, and Australia. LA discovers she has a bad stutter when speaking Japanese, which she picked up from her Japanese coach. Owing to the pressure of constant performing, LA takes lessons with a voice coach, Joan Lader, and discovers entirely new ways to use her voice. LA appears as the musical guest on "Saturday Night Live," hosted by actor Tony Danza. Meets writer and movie director Wim Wenders. Tapes *What You Mean We?,* a half-hour video for the TV show "Alive from Off Center," which features her clone, a digitally produced male version of herself, with whom she conducts interviews. *Home of the Brave* is screened at the Rio Film Festival. Linda Goldstein becomes her manager. LA writes the score for Spalding Gray's monologue film *Swimming to Cambodia,* directed by Jonathan Demme. Also writes the score for Robert Wilson's *Bird Catcher in Hell*, part of a larger performance, *Alcestis,* based on a work by Euripides, which premieres at the American Repertory Theater in Cambridge, Massachusetts.

1987

LA hosts an Ernie Kovacs special on PBS and shoots *Artist Introductions,* a series of ten short video pieces with the clone that introduces artists' videotapes on "Alive from Off Center" on station KTCA, Minneapolis. Goes to Bora Bora and shoots an underwater video. Receives an Honorary Doctorate from Philadelphia College of the Arts. Abbot Reb Anderson interviews her at the Zen Center in Green Gulch Farm, San Francisco. LA performs with Paul Simon and Bruce Springsteen in a benefit concert for New York Children's Health at Madison Square Garden, New York. *Home of the Brave* is presented at the Cannes film festival, and *Talk Normal*, a videotaped lecture by Anderson on her work, is screened at the Tokyo International Video Biennial.

1988

LA participates in the Serious Fun Festival at Lincoln Center, New York. Holds a press conference with Bishop Desmond Tutu in New York, in which he discusses the escalating political situation in South Africa. Begins recording *Strange Angels* with contributions by musicians Gideon Kremer, Arto Lindsay, Bobby McFerrin, and others. Takes formal singing lessons and discovers a new range for her voice. Her songs are now sung rather than spoken, and her newly found soprano voice increasingly replaces the male vocoder voice, which she had called the "voice of authority."

1989

LA mixes *Strange Angels* in Woodstock, New York, and the album is released later in the year. She appears on "The Eleventh Hour," an arts program on PBS. Hosts the New Music America Tenth Anniversary Gala at the Brooklyn Academy of Music. Presents an early version of *Empty Places* in Rio, which later premieres at the Spoleto Festival in Charleston, South Carolina. Shoots film for *Empty Places* at night in New York, focusing on empty warehouses and abandoned buildings and cars showing, she says, "the Reagan era at the end of the '80s." LA's work questions the role of art and the artist in the media culture; political and social conditions and censorship are increasingly the subject matter of her stories. LA steps out of a cab into an open manhole and spends an evening in a hospital emergency room. The plight of several homeless patients becomes a poignant story in *Empty Places*.

1990

LA takes *Empty Places* on a 150-concert, six-month tour of the United States and Europe. Appears on "The Tonight Show" with Jay Leno and receives an Honorary Doctorate of Fine Arts from the Art Institute of Chicago. Tapes *Personal Service Announcements* for public television, using her air time to discuss topics such as military spending, the national debt, women's salaries, technology, and television. Performs in *One World, One Voice*, a BBC documentary. Participates in Composer-to-Composer Forum in Telluride, Colorado, and in the International Conference on Art, Science, and Technology in Cologne, Germany. Tapes *Beautiful Red Dress*, a music video directed by Kristi Zea. Gives keynote speech on the subject of censorship and the public outcry about the rap group 2 Live Crew for the New Music Seminar, New York. Teaches meditation at the Lama Foundation in Taos, New Mexico. Travels in East Germany and writes a film script

(never produced) entitled *Neue Welt 2000,* about an imaginary European arts festival that takes place on a train. LA, Peter Gabriel, and Brian Eno plan a music theme park with the organizers of Expo '92 in Seville.

1991
LA plays a double bill with bandleader Cab Calloway on New Year's Eve at the Limelight, New York. Participates in Art Futura, an annual performance series and conference on digital art and electronics in Barcelona, where she meets futurist writer William Gibson. Presents *Voices From the Beyond*, a one-person performance-lecture with minimal backdrop and only two instruments (violin and keyboard) at The Museum of Modern Art, New York, as part of the performance series organized by RoseLee Goldberg that accompanies the exhibition *High and Low: Modern Art and Popular Culture.* Spends a large part of the year traveling in the United States updating and expanding the talk. Serves as a jury member of the Berlin Film Festival, chaired by film director Volker Schlondorf. Travels to China to meet musicians and work on a film score, which was never produced, for director Chen Kaige. Contributes drawings and stories to a BBC documentary, *The Human Face,* and appears, cosmetically transformed, in the shape of a werewolf, a Greek bust, and a police sketch. LA meets the Dalai Lama at the Cathedral of St. John the Divine in New York. Appears as a guest on Spanish TV's "Viva El Espectáculo," and guest directs the Telluride Film Festival in Telluride, Colorado. Writes the score for Spalding Gray's film *Monster in a Box.*

1992
LA participates in a censorship debate on CNN's "Crossfire." Directs a music video, *Carmen,* commissioned by Expo '92, in Seville, Spain. *Stories from the Nerve Bible* premieres at Expo '92 in Seville and travels elsewhere in Spain and to Germany. LA works with Cyro Baptista, the Brazilian percussionist. Performs at the launch of Arte TV, a European arts channel, at the Strasbourg Opera House, France, and works at Steim Studio, Amsterdam, with Michel Waisvisz, director of the studio and an electronic composer, experimenting with MIDI systems. Meets musician Lou Reed in Munich at a music festival, and he invites her to read one of his songs during a performance there. Is founding member of Women's Action Coalition (WAC), formed in response to the Anita Hill–Clarence Thomas hearings in Washington, D.C. Participates in an evening at Town Hall, New York, a benefit for The Kitchen, which includes members of WAC.

Interviews composer John Cage for an issue of *Tricycle* magazine and later that year pays tribute to him at his memorial service at Symphony Space, New York. Hosts a pre-election Party for Change with actor Rob Morrow. *Stories from the Nerve Bible* is presented in Jerusalem and Tel Aviv.

1993
LA performs with Philip Glass, Tibetan flutist Nawang Khechog, and poet Allen Ginsberg at Town Hall, New York, in a benefit for Tibet House. Meets with members of the National Council on the Arts in Washington, D.C., and speaks on censorship in the arts and its relationship to arts funding. Performs *Stories from the Nerve Bible* at the Annenberg Center in Philadelphia with musicians Cyro Baptista, Greg Cohen, and Guy Klucevsek. Treks in the Tibetan Himalayas accompanied by twenty-seven yaks, eight sherpas, and ten other hikers and becomes dangerously ill with altitude sickness. Tours European music festivals with Baptista, Dougie Bowne, Cohen, and Klucevsek. She opens for Bob Dylan in Lisbon, and works on an album, *Bright Red,* with Brian Eno.

1994
Bright Red is released on Warner Brothers Records. *Stories from the Nerve Bible,* a twenty-year retrospective book of LA's work, is published. LA tours the United States and Europe reading excerpts from *Nerve Bible.* Receives a Distinguished Alumna award from Columbia University School of the Arts. Collaborates with artist Sophie Calle for the show *La Visite Guidée* at the Museum Boymans-van Beuningen in Rotterdam. Writes score, *Bridge of Dreams,* for a full-length choreographic work by Molissa Fenley, commissioned by Deutsche Oper, Berlin, with sets by Kiki Smith.

1995
LA releases *Puppet Motel,* a CD-ROM on the Voyager label, and tours the United States and Europe for six months with *Stories from the Nerve Bible.* Releases *The Ugly One with the Jewels,* a live recording made at Sadlers Wells in London, on Warner Brothers Records. Designs audio hats for the War Child benefit fashion show and contributes to the War Child benefit art exhibition. Collaborates with Brian Eno and students from the Royal College of Art on *Self Storage,* an audio installation in a London warehouse. Works with producers tomandandy on remixes for *Bright Red,* and starts *The Green Room,* a Web site with information about the *Stories from the Nerve Bible* tour. Performs at Site Santa Fe

in Santa Fe, New Mexico. Works with a Dutch radio station to produce a four-hour retrospective audio show of her work. Performs and speaks at a Buro computer conference in Kassel, Germany, and gives the keynote speech for the Art and Technology Cyber Fair at Cooper Union, New York. Works with tomandandy on "1983 A Merman I Would Be," a Jimi Hendrix cover for the D. A. Pennebaker film *Searching for Jimi Hendrix.*

1996
LA gives the keynote speech at MILIA, the International Content Market for Interactive Media, in Cannes. Participates in a multimedia exhibition, *Electra,* at the Henie-Onstad Art Center in Oslo, and gives keynote speeches at MacWorld Tokyo and the TED conference of international electronic media in Monterey, California. Receives honorary degrees from Cal Arts and Pratt Institute. Collaborates with Bill T. Jones on the dance performance *Bill and Laurie: About Five Rounds,* at the Joyce Theater, New York. Gives a speech at the Imagination conference in San Francisco, where filmmaker Spike Lee and Brian Eno also speak. Panel discussion with the three follows. Acts as host for Channel 13's "Reel New York." Presents *Whirlwind,* an installation at the Sonambiente Festival für Hören und Sehen at the Akademie der Kunst, Berlin. Creates *Here,* a Web site for Voyager and the Stedelijk Museum, Amsterdam. Participates in the symposium Music After 2000 at Columbia University; receives the Marlene Award for the Performing Arts in Munich. Creates an installation for the *Hugo Boss Awards Exhibition* at the Guggenheim Museum SoHo in New York. In San Francisco participates in the Other Minds festival and lectures as part of the Multimedia Pioneers Series at San Francisco State University. Takes part in "Nova Revisited," a concert tribute to William Burroughs held in his hometown of Lawrence, Kansas. Premieres *Speed of Darkness*, a stripped-down, solo performance.

1997
LA participates in the Sydney Festival, a theater festival in Australia. Performs *Speed of Darkness* in the United States, Europe, and Australia. Performs in *The History of Art and Science*, a movie directed by Naoto Tanaka (TV Man Union-Japan) and produced by Alternate Current, New York. Performs with Lou Reed for "Hard Rock Live!" aired on VH1. Contributes videos of *Sharkey's Day* and *National Anthem PSA* to the Digital Video Wall, programmed by The Museum of Modern Art, New York, in an underground atrium and

walkway near the museum. Receives the Ludwig Award for creative achievement in Aachen, Germany. Designs the *Hearring* for a special edition (no. 49) of *Parkett* magazine. Curates the Meltdown Festival at the Royal Festival Hall in London; it features performances by Brian Eno, Richard Foreman, Philip Glass, Spalding Gray, Bill T. Jones, Christopher Knowles, Lou Reed, Salmon Rushdie, Ryuichi Sakamoto, and others. Anderson participates in *Perfect Day,* a BBC video of thirty different artists singing Lou Reed's best-known song. Presents a keynote address at the International Symposium of Electronic Art at The Art Institute of Chicago. Contributes to *Unbuilt Roads, 107 Unrealized Projects*, a book edited by Hans-Ulrich Obrist and Guy Tortosa, which contains only works of art that could not be or were never completed by the artists who conceived them. Forms ETC (Electronic Theater Company) in partnership with Interval Research Corporation.

1998

LA presents a lecture, "Formication or the Sensation of Being Covered with Ants," at the National Geographic Society in London (sponsored by the Royal College of Art). Covers "Ready for Battle," an event produced by the Society for Creative Anachronism, for National Public Radio. Reads the poetry of Seamus Heaney at New York's Town Hall to launch National Poetry Month. Creates *Dal Vivo (Life)*, a multimedia installation at the Fondazione Prada, Milan, in conjunction with the Casa Circondariale-Milano San Vittore (Milan's prison), curated by Germano Celant. Exhibition of LA's work at Artist's Space marks its twenty-fifth anniversary. LA is represented by Sean Kelly Gallery, New York.

1999

LA participates in Seminars with Artists, a lecture series at the Whitney Museum of American Art. Produces *Songs and Stories from Moby Dick*, a multimedia stage production based on Herman Melville's novel. It previews at the Prince Music Theater, Philadelphia, and premieres at the Brooklyn Academy of Music, and tours nationally and internationally with performances in Los Angeles, the Spoleto Festival USA in Charleston, South Carolina, Palermo, and Paris. Develops the Talking Stick, a new high-technology musical instrument, with Interval Research of Palo Alto, California. Is a feature lecturer at The Kitchen, New York. Signs new multiyear recording contract with Nonesuch Records, part of the Warner Music Group. Is voted one of the "100 Greatest Women of Rock 'n' Roll," and appears in VH1's television series of the same name. Is commissioned by the American Composers Orchestra and Dennis Russell Davies for an orchestral work to be performed at Carnegie Hall, New York, in February 2000.

RECORDS, FILMS, VIDEOS, CD-ROM's, SCORES, AND SONGS

RECORDS

Except where noted, all records were produced by Warner Brothers

1995 *The Ugly One with the Jewels*. Live recording made at Sadler Wells, London

1994 *Bright Red*. Coproduced with Brian Eno; featuring Phil Ballou, Cyro Baptista, Joey Baron, Adrian Belew, Arto Lindsay, Lou Reed, and music director and bass player Greg Cohen

1989 *Strange Angels*. Coproduced with Roma Baran; additional production by Arto Lindsay, Leon Pendarvis, Ian Ritchie, Peter Scherer, and Mike Thorne

1986 *Home of the Brave*. Music from the film; coproduced with Roma Baran

1985 *United States Live*. A five-record set documenting the performance at the Brooklyn Academy of Music

1984 *Mister Heartbreak*. Coproduced with Roma Baran, Bill Laswell, and Nile Rodgers

1982 *Big Science*. Coproduced with Roma Baran
"Let X=X." Flexidisk packaged with Feb. issue of *Artforum*

1981 "O Superman." 7" EP; coproduced with Roma Baran; originally released on 110 Records

1980 *Word of Mouth*. Six-record set featuring conversations with artists; produced by Crown Point Press

1979 *Songs from Americans: The Nova Convention*. Giorno Poetry Systems Records, New York

1978 "Three Experiences," on *Big Ego, the Dial-A-Poem Poets*. Giorno Poetry Systems Records, New York

1977 "New York Social Life" and "Time to Go," on *New Music of Electronic and Recorded Media*. 1750 Arch Street Records, Berkeley, Calif.

FILMS, VIDEOS, AND CD-ROMS

1997 *Perfect Day*. Video, 4 min.; Laurie Anderson and various artists covering well-known Lou Reed song in a special promotional video for BBC television

1995 *Puppet Motel*. CD-ROM; Laurie Anderson with Hsin-Chien Huang; produced by Elizabeth Scarborough; Philippe Stessel, associate producer; distributed by LTI Voyager

1992 *Carmen*. Music video, 15 min.; a day in the life of a contemporary Carmen; commissioned for Expo '92; directed by Laurie Anderson

1991 *The Collected Videos*. A collection of video and film work from 1980 to 1990; Warner-Reprise Home Video

1990 *Personal Service Announcements*. A series of six pieces that were produced instead of making a standard music video; topics included the national debt, the national anthem, and military research
Beautiful Red Dress. Music video, 3 min. 14 sec.; directed by Kristi Zea; shot at CBGB's, New York; Warner Brothers

1989 *Talk Normal*. Video, 60 min.; an illustrated lecture in English with Japanese subtitles; Pioneer LDC

1987 *Artist Introductions*. Videos; introductions to artists' videotapes on "Alive from Off Center"; PBS

1986 *What You Mean We?* Video, 30 min.; features the first appearance of the digital clone and the song "Progress"; commissioned by KTCA and WGBH for "Alive from Off Center"

1986 *Language Is a Virus*. Music video, 7 min. 52 sec.; Warner Brothers
Home of the Brave. 35-mm feature-length concert film; directed by Laurie Anderson; produced by Paula Mazur; performers include Joy Askew, Adrian Belew, William Burroughs, three of the Five Blind Boys from Alabama, Dolette McDonald, Janice Pendarvis, David Van Tieghem, and Sang Won Park; featured in "Director's Fortnight" at the Cannes Film Festival and Rio Film Festival, 1987

1984 *This Is the Picture*. Music video for *Good Morning Mr. Orwell*, a "satellite spectacular" linking Paris and New York, with live and taped segments, celebrating Orwell's novel *1984;* organized by Nam June Paik in collaboration with Peter Gabriel
Sharkey's Day. Animated music video; directed by Laurie Anderson; Warner Brothers

1981 *O Superman*. Music video, 10 min. 57 sec.; directed by Laurie Anderson; Warner Brothers

1974 *DEARREADER*. 8-mm black-and-white film, 45 min.; a collection of stories and songs codirected with Bob George; starring Geraldine Pontius

SCORES AND SONGS

1995 "1983 A Merman I Would Be." Cover of Jimi Hendrix song on soundtrack of D. A. Pennebaker film *Searching for Jimi Hendrix*; produced by tomandandy

1994 *Bridge of Dreams*. Score for the choreographic work by Molissa Fenley; commissioned by Deutsche Oper Berlin

1993 "Tightrope" and "Speak My Language" appear on the soundtrack of the film *Faraway So Close,* directed by Wim Wenders

1991 *Monster in a Box*. Score for the film written by Spalding Gray, directed by Nick Broomfield

1988 "Angel Fragments" composed and performed for the film *Wings of Desire,* directed by Wim Wenders

1986 *Swimming to Cambodia*. Score for the film written by Spalding Gray, directed by Jonathan Demme
Bird Catcher in Hell. Score for the performance by Robert Wilson, part of *Alcestis*, premiered at American Repertory theater, Cambridge, Massachusetts

1985 *Something Wild*. Underscoring for the film directed by Jonathan Demme

1983 *Set and Reset*. Score for the choreographic work by Trisha Brown

1982 *The Keep*. Score for the film directed by Michael Mann
"It's Cold Outside." Piece for orchestra and electronics performed by the Westdeutscher Rundfunk, Cologne, Germany, conducted by Dennis Russell Davies

1981 "It's Cold Outside." Poem for orchestra and electronics performed by American Composers Orchestra, Carnegie Hall, New York, conducted by Dennis Russell Davies

1978 "Like a Stream." Piece for orchestra and talking chorus performed by local musicians in Washington, D.C., New York, and Minneapolis

SELECTED BIBLIOGRAPHY

ARTICLES BY LAURIE ANDERSON

"Control Rooms and Other Stories: Confession of a Content Provider." *Parkett*, no. 49 (1997): 126–45.

"Dazed and Bemused." *New York Times,* Sept. 28, 1997, 66–68.

"Artists, Audiences, and Censorship." *Dialogue* 16 (Sept.–Oct. 1993): 12–13.

"From Americans on the Move." *October* 4 (Spring 1979): 45–57.

"Confessions of a Street Talker." *Avalanche* (Berkeley, Calif.), no. 11 (Summer 1975): 22–23.

"Take Two." *Art-Rite* (New York), no. 6 (Summer 1974): 5.

"Artists Space Gallery: New York." *Artforum* 12 (Mar. 1974): 81.

"Sylvia Sleigh and Jackie Ferrara." *Artforum* 12 (Jan. 1974): 79–80.

"Mary Miss." *Artforum* 12 (Nov. 1973): 64–65.

"About 405 East 13th Street." *Artforum* 12 (Sept. 1973): 88–90.

"Galleries." *Arts Magazine* 46 (Nov. 1972): 70–71.

"David Budd: Continental Drift." *Art News* 70 (Summer 1971): 32–33.

BOOKS BY LAURIE ANDERSON

Stories from the Nerve Bible: A Retrospective, 1972–1992. New York: HarperPerennial, 1994.

Empty Places. New York: HarperPerennial, 1991.

Postcard Book. Privately published, 1990.

Home of the Brave. Privately published, 1986.

United States. New York: Harper and Row, 1984.

Top Stories #1. Buffalo, N.Y.: Hallwalls, 1979.

Words in Reverse. Buffalo, N.Y.: Hallwalls, 1979.

Notebook. New York: Wittenborn Art Books, 1977.

Light in August. New York: Privately published, 1974.

The Rose and the Stone. Privately published, 1974.

Transportation Transportation. New York: Privately published, 1973.

Handbook. Privately published, 1972.

October. Privately published, 1972.

The Package. New York and Indianapolis: Bobbs-Merrill, 1971.

Moore, Margaret, with illustrations by Laurie Anderson. *Certainly Carrie, Cut the Cake: Poems A to Z.* New York and Indianapolis: Bobbs-Merrill, 1971.

BOOKS AND ARTICLES ON LAURIE ANDERSON

Allen, Jennifer. "Look to the 80's, A Special Section: Live Art." *Life Magazine* 3 (Jan. 1980): 83.

Amos, Patrick. "Laurie Anderson at Mandeville (La Jolla)." *Images and Issues* 2 (Fall 1981): 73–74.

Apple, Jacki. "Commerce on the Edge: The Convergence of Art and Entertainment." *High Performance* 9, no. 2 (1986): 34–38.

———. "Performance Art Is Dead, Long Live Performance Art!" *High Performance* 17 (Summer 1994): 54–59.

Art international d'aujourd'hui, exh. cat. Brussels: Palais des Beaux-Arts, 1981.

Artpark 1977: Program in Visual Arts, exh. cat. Lewiston, N.Y.: Earl W. Brydes Artpark, 1977.

Art-Rite (issue devoted to performance art), no. 10 (Fall 1975): 3–37.

Banes, Sally. "Fashionable, Fiddling, Facile Tricks." *The Village Voice* (Nov. 5, 1980): 79.

———. "Laurie Anderson's Disjointed *States.*" *The Village Voice* (Feb. 22, 1983): 93.

Berger, Maurice. *Endgame: Strategies of Postmodernist Performance—Robert Morris, Laurie Anderson, Robert Longo*, exh. cat. New York: Hunter College Art Gallery, 1984.

———. "The Mythology of Ritual: Reflections on Laurie Anderson." *Arts Magazine* 57 (June 1983): 120–21.

Bronson, A. A., and Peggy Gale, eds. *Performances by Artists.* Toronto: Art Metropole 1979. Contains notes from *Like a Stream*: 42–48.

Budney, Jen. "Terra Vision: Laurie Anderson's Use of Technology." *Parkett*, no. 49 (1997): 158–67.

Burckhardt, Jacqueline. "In the Nerve Stream." *Parkett,* no. 49 (1997): 146–57.

———. "Laurie Anderson: *Ich bin eine Geschichtenerzahlerin* oder digitale Feuerzeichen." *Kunstforum International* (Germany), no. 134 (May–Sept. 1996): 213–19.

Carr, Cindy. "Media Kids: C. Carr on Replicants." *Artforum* 29 (Mar. 1991): 18–21.

Casademont, Joan. Review (*Dark Dogs/American Dreams,* Holly Solomon Gallery). *Artforum* 18 (Summer 1980): 85.

Celant, Germano. *Laurie Anderson: Dal Vivo.* Milan: Fondazione Prada, 1998.

Champagne, Lenora. *Out from Under: Texts by Women Performance Artists.* New York: Theatre Communications Group, 1990.

Chris, Cynthia. "Voices from the Beyond." *High Performance* 14 (Winter 1991): 48.

Christgau, Robert. "Christgau's Consumer Guide" (review of *Big Science*). *The Village Voice* (June 1, 1982): 78.

———. "The Year the Rolling Stones Lost the Pennant." *The Village Voice* (Jan. 27, 1982): 36–37.

Coe, Robert. "Four Performance Artists." *Theater, Yale School of Drama/Yale Repertory Theater* (Spring 1982): 82–85.

———. "Taking Chances. Laurie Anderson and John Cage." *Tricycle, The Buddhist Review*, no. 4 (Summer 1992): 53–59.

Cokes, Tony. "Laurie Anderson at 57th Street Playhouse, New York." *Art in America* 74 (July 1986): 120.

Copeland, Roger. "Laurie in Wonderland." *Theatre Communications* 5 (Apr. 1983): 14–17.

———. "What You See Is Not What You Hear." *Portfolio* 5 (Mar.–Apr. 1983): 102–5.

Cubitt, Sean. "Laurie Anderson: Myth, Management, and Platitude," in John Roberts, ed., *Art Has No History! The Making and Unmaking of Modern Art.* London and New York: Verso, 1994.

Dasgupta, Gautam. "Laurie Anderson, *Americans on the Move: Parts I and II,* The Kitchen." *Performance Art,* no. 1 (1979): 47.

Davis, Peter G. "The Eclectic Circus." *New York Magazine* (Feb. 21, 1983): 57–58.

Dery, Mark. "From Hugo Ball to Hugo Largo: 75 Years of Art and Music." *High Performance* 11 (Winter 1988): 54–57.

———. "Laurie Anderson Goes for the Throat." *High Performance* 7, no. 2 (1984): 8–9, 80.

Drukman, Steven. "Laurie Anderson." *Artforum* 33 (Summer 1995): 110.

Ecrans politiques, exh. cat. Montreal: Musée d'Art Contemporain, 1985.

Fergier, Jean-Paul. "Home of the Brave." *Cahiers du cinéma* (Paris), no. 405 (Mar. 1988): 49–50.

Flood, Richard. Review ("O Superman"/"Walk the Dog"). *Artforum* 20 (Sept. 1981): 80–81.

Frank, Peter. "Artists Go on Record . . . The Next Song You Hear on the Radio Might Well Be Art." *Art News* 80 (Dec. 1981): 74–76.

———. "Auto-Art: Self-indulgent? And How!" *Art News* 75 (Sept. 1976): 43–48.

———. Review (*Jukebox*, Holly Solomon Gallery). *Art News* 75 (Mar. 1977): 146–48.

Furlong, William. "Laurie Anderson: An Interview." *Audio Arts* (cassette), London, 1981.

Gibbs, Michael. "Internet Art: New Works." *Art Monthly* (London), no. 200 (Oct. 1996): 72.

Glaser, David. "Spectacle in Recent Art." *Art Criticism* 2, no. 2 (1986): 11–21.

Glueck, Grace. "Art People." *New York Times*, June 5, 1981, C22.

Goldberg, RoseLee, ed. *High and Low, Modern Art and Popular Culture: Six Evenings of Performance*, exh. cat. New York: The Museum of Modern Art, 1990.

———. "Performance—Art for All." *Art Journal* 39 (Fall–Winter 1980): 374.

———. *Performance Art from Futurism to the Present*. New York: Abrams, 1979.

———. "Performance: The Golden Years," in Gregory Battock and Robert Nickas, eds. *The Art of Performance: A Critical Anthology*. New York: E. P. Dutton, 1984.

———. *Performance: Live Art Since 1960*. New York: Abrams, 1998.

———. "Public Performance: Private Memory." *Studio International* (London) 192 (July–Aug. 1976): 19–23.

———. "What Happened To Performance?" *Flash Art* (Italy), no. 116 (Mar. 1984): 28–29.

Gordon, Kim. "I'm Really Scared When I Kill in My Dreams." *Artforum* 21 (Jan. 1983): 54–57.

Gordon, Mel. "Laurie Anderson: Performance Artist." *The Drama Review* 24 (June 1980): 51–64.

Greene, A. "Caught in the Art: Video Performance Is Making Strange Bedfellows of Robert Altman, Shirley Clarke, and Laurie Anderson." *American Film* 7 (June 1982): 66–70.

Halbreich, Kathy. *Culture and Commentary: An Eighties Perspective*, exh. cat. Washington, D.C.: Hirshhorn Museum and Sculpture Garden, 1990.

Hatton, Brian. "Urban Kisses: New York at the ICA." *Artscribe* (London) (Dec. 1982): 16–21.

Hayman, R. I. P. "Laurie Anderson's *United States I–IV*." *Brooklyn Academy of Music Review* (Feb.–May 1983).

Heinemann, Susan. Review ("How to Yodel in Soup and Tart" at The Kitchen). *Artforum* 12 (Mar. 1973): 81–82.

Heynen, Pieter. "Laurie Anderson Tussen Gregoriaans en de Velvet Underground." *Museumjournal* (Amsterdam) (Aug. 1980): 185–88.

Hilburn, Robert. "Laurie Anderson LP Leads Pop Music into the 80's." *Los Angeles Times*, May 30, 1982, 62.

Hill, Andrea. "Being Bad." *Artscribe* (London) (Oct. 1982): 16–20.

Holden, Stephen. "Laurie Anderson's Future Pop." *Rolling Stone* 16 (June 10, 1982): 55–56.

———. "Pop: 3 Artists in Mixed Media." *New York Times*, Oct. 27, 1981, C15.

Howell, John. "Art Performance: New York." *Performing Arts Journal* 2 (Winter 1977): 28–39.

———. *Laurie Anderson*. New York: Thunder's Mouth Press, 1992.

Johnson, Tom. "New Music, New York, New Institution." *The Village Voice* (July 2, 1979): 88–89.

Kivy, Peter. "Talking Singing." *The SoHo Weekly News* (Apr. 26, 1979): 29.

Klepac, Walter. "Some Postmodern Paradigms." *C* (Toronto), no. 30 (Summer 1991): 19–25.

Kroll, Jack. "An Electronic Cassandra." *Newsweek* (Feb. 21, 1983): 77.

Kubisch, Christina. "Time into Space/Space into Time: New Sound Installations in New York." *Flash Art* (U.S.A.) 13 (Mar.–Apr. 1979): 16–18.

Kuhn, Annette. "Why Is Performance Art Different from All Other Art?" *The Village Voice* (Feb. 23, 1976): 84, 86.

Lamoreux, Johanne. "On Coverage: Performance, Seduction, Flatness." *Artscanada* 38 (Mar.–Apr. 1981): 25–27, 51.

Larson, Kay. "An Alternative (Not an Echo)." *The Village Voice* (Oct. 8, 1979): 110–11.

———. "For the First Time Women Are Leading, Not Following." *Art News* 78 (Oct. 1980): 64–72.

Laurie Anderson: Works from 1969 to 1983, exh. cat. Philadelphia: Institute of Contemporary Art, 1983.

Légendes: Laurie Anderson, Antonin Artaud, Roland Barthes, Georg Baselitz, Gaston Chaissac, exh. cat. Bordeaux: Musée d'Art Contemporain, 1984.

Lessard, Denis. "Revolutions Per Minute (The Art Record)/*Big Science*—Laurie Anderson." *Parachute* (Canada) 28 (Sept.–Nov. 1982): 33–34.

Lifson, Ben. "Laurie Anderson: *Dark Dogs, American Dreams*." *Aperture*, no. 85 (1981): 44–49.

Livres d'artistes, exh. cat. Paris: Centre Georges Pompidou, 1985.

Loder, Kurt. "Laurie Anderson Could Change the Way That We Look at Music—Literally." *Rolling Stone* 16 (July 8, 1982): 22–23.

———. "Laurie Anderson's 'O Superman.'" *Rolling Stone* 15 (Sept.17, 1981): 45.

Lorber, Richard. Review ("Quartet for Four Subsequent Listeners [Notes/Tones]," Holly Solomon Gallery). *Artforum* 17 (Dec. 1978): 68–69.

Marsh, Anne. "Bad Futures: Performing the Absolute Body." *Continuum* (Australia) 8, no. 1 (1994): 280–91.

McAdams, Lewis. "Nightclubbing with William Burroughs, John Giorno, and Laurie Anderson." *High Performance* 5 (Winter 1982).

McKenna, Kristine. "Laurie Anderson." *Wet* (Sept.–Oct. 1981): 24–30.

Mifflin, Margot. "The Sleep of Reason: Artists and Their Dreams." *High Performance* 10, no. 2 (1987): 50–53.

Miller, John. "Art-and-Pop-Crossover (1)." *Kunstforum International* (Germany), no. 134 (May–Sept. 1996): 192–93.

Miller, Larry. "70-tals honst; New York." *Paletten* (Göteborg, Sweden), no. 40 (Apr. 1979): 2–11.

Moire, Beverly. "The Next Wave: New Masters at the Brooklyn Academy of Music." *In Performance* (monthly guide to the Brooklyn Academy of Music) (Sept. 1982): 12–14.

Morgan, Stuart. "Home Truths: Laurie Anderson." *Artscribe* (London), no. 32 (Dec. 1981): 21–23.

———. "Laurie Anderson: Big Science and Little Men." *Brand New York*, no. 32 (1982): 77–85.

Muchnic, Suzanne. "A Discursive Discourse on the Arts-As-Opera." *Los Angeles Times*, May 2, 1983, 1–2.

Munk, Erika. "Slight of Hand." *The Village Voice* (Feb. 22, 1983): 93–94.

A New Beginning, 1968–1978, exh. cat. Yonkers, N.Y.: The Hudson River Museum, 1985.

Newman, Michael. "Polemics: Closed Circuits." *Art Monthly* (London) 6 (Nov. 1981): 34–35.

Oliva, Achille Bonito. *Europe/America: The Different Avant-Gardes.* Milan: Deco Press, 1976.

On Track: An Exhibition of Art in Technology, exh. cat. Calgary, Alberta: NOVA, 1988.

Osment, Noel. "Laurie Anderson." *San Diego Union* (May 1977).

Owens, Craig. "Amplifications: Laurie Anderson." *Art in America* 69 (Mar. 1981): 120–23.

———. "The Allegorical Impulse: Toward a Theory of Postmodernism, Part 2." *October* 5 (Summer 1980): 59–80.

Palmer, Robert. "3-Day Nova Convention Ends at the Entermedia." *New York Times,* Dec. 14, 1978, C18.

———. "Laurie Anderson: Ephemeral Turns Permanent." *New York Times,* Apr. 21, 1982, C19.

Perreault, John. "Report from Micronesia: Panoply in Ponape." *Art in America* 68 (May 1980): 35–40.

Perrone, Jeff. "Words: When Art Takes a Rest." *Artforum* 15 (Summer 1977): 34–37.

Pincus-Witten, Robert. "Notes." *Art-Rite* (New York), no. 6 (Summer 1974): 21.

Pontbriand, Chantal, ed. *Performance: Text(e)s and Documents.* Montreal: Parachute, 1981.

Prinz, Jessica. *Art Discourse/Discourse in Art (1960–1985).* New Brunswick, N.J.: Rutgers University Press, 1991.

Rapaport, Herman. "Can You Say Hello?: Laurie Anderson's *United States.*" *Art Criticism* 6, no. 3 (1990): 43–62.

Ratcliff, Carter. "Looking at Sound." *Art in America* 68 (Mar. 1980): 87–95.

Reynaud, Berenice. Review (*Americans on the Move*, The Kitchen). *Performance Art*, no. 1 (1979): 46.

Rickey, Carrie. "14 Americans." *The Village Voice* (May 5, 1980): 56–57.

———. "Laurie Anderson and Peter Gordon, *Commerce* at U.S. Custom House." *Artforum* 18 (Sept. 1979): 74–75.

Rockwell, John. *All American Music: Composition in the Late Twentieth Century.* New York: Alfred A. Knopf, 1983.

———. "Disks: Nova Convention that Saluted Burroughs." *New York Times,* Dec. 27, 1979, C11.

———. "Laurie Anderson: American Music Unbound." *Esquire* (Dec. 1982): 136–39.

Sandow, Gregory. "Laurie Anderson: *American on the Move.*" *The Village Voice* (Nov. 5, 1980): 78–79.

Scarpetta, Guy. "La Deuxième Constellation New Yorkaise." *Art Press* (France), no. 63 (Oct. 1982): 14–16.

———. " Laurie Anderson: Le Romantisme de la technologie" (interview). *Art Press* (France), no. 162 (June 1980): 24–26.

Shafransky, Renee. "O Supergirl (filming *Home of the Brave*)." *American Film* 11 (Apr. 1986): 54–55.

Shapiro, David. "Laurie Anderson at Artists Space." *Art in America* 62 (Mar.–Apr. 1974): 111 ff.

Shewey, Don. "The Performing Artistry of Laurie Anderson." *New York Times Magazine* (Feb. 6, 1983): 27–28, 55, 59.

———. "The United States of Laurie Anderson." *The SoHo Weekly News* (Nov. 5, 1980): 10–12.

Shore, Michael. "Punk Rocks the Art World." *Art News* 85 (Nov. 1980): 78–85.

Siegel, Jeanne. *Artwords 2: Discourse on the Early '80s.* Ann Arbor, Mich.: UMI Research Press, 1988.

Smagula, H. J. *Currents: Contemporary Directions in the Visual Arts.* Englewood Cliffs, N.J.: Prentice Hall, 1983.

Smith, Philip. "Lady Sings the News." *Gentlemen's Quarterly* 32 (Nov. 1982): 194–96.

Sofia, Zoe. "Contested Zones: Futurity and Technological Art." *Leonardo* (U.S.A.) 29, no. 1 (1996): 59–66.

Sondheim, Alan. *Individuals: Post-Movement Art in America.* New York: Dutton, 1977.

———. "Laurie Anderson: Procedure and Text." *Parachute* (Canada), no. 14 (Spring 1979): 9–12.

Soundings, exh. cat. Purchase, N.Y.: Neuberger Museum, State University of New York, 1981.

Sparkman, David. "Laurie Anderson Interviewed by David Sparkman." *Washington Review* 6 (Oct.–Nov. 1981): 25–26.

Sterrit, David. "Revolution in American Popular Music: Energy and Unpredictability Are Common Themes in the Diverse Forms the New Sound Can Take." *The Christian Science Monitor,* June 29, 1982, 9.

Stevens, Mark. "Three for the 80's." *Newsweek* (Mar. 26, 1979): 92.

Stewart, Patricia. "Laurie Anderson: With a Song in My Art." *Art in America* 69 (Mar.–Apr. 1979): 110–13.

Sturken, Marita. "The Gentrification of Video." *Afterimage* 13 (Nov. 1985): 4.

Summer, Melody, Kathleen Burch, and Michael Sumner, eds. *The Guests Go To Supper.* Oakland, Calif.: Burning Books, 1986.

Swan, Annalyn. "The Sound of New Music." *Newsweek* (June 29, 1981).

Taiuti, Lorenzo. "Didattica dell'arte in Europa: Video a Venezia—Linz Festival." *Terzo occhio* (Italy) 21 (Sept. 1995): 37–39.

Taylor States, Sarah. "Laurie Anderson." *Reallife Magazine* (Winter 1982–1983): 24–27.

13th World Wide Video Festival, exh. cat. The Hague: World Wide Video Centre, 1995.

Under Capricorn: The World Over—Art in the Age of Globalisation, exh. cat. Wellington, New Zealand: City Gallery, 1996.

Ver Meulen, Michael. "Say Hello to Laurie Anderson." *TWA Ambassador Magazine* (Oct. 1981): 63–76.

Verner, L. "Comment(t)aire Laurie Anderson ou l'eros-machinerie d'une performance." *Revue d'esthétique* (France), no. 11 (1986): 134–36.

Walsh, Michael. "Post Punk Apocalypse." *Time* (Feb. 21, 1983): 68.

White, Robin. *View.* Oakland, Calif.: Crown Point Press, 1979; reprinted in Ellen Johnson, ed., *American Artists on Art: From 1940 to 1980.* New York: Harper and Row, 1982.

Wooster, Ann-Sargent. "Laurie Anderson: *Empty Places.*" *High Performance* 13 (Spring 1990): 65.

Word, Image, Number, exh. cat. Bronxville, N.Y.: Sarah Lawrence College, 1975.

Zerbrugg, Nicholas. Unpublished interview with Laurie Anderson. January 30, 1991, London.

ACKNOWLEDGMENTS

A very special thank you to the photographers who have so vividly captured Laurie Anderson's work over many years; to Maura Reilly, Bettina Funcke, Alpesh Patel, Johanna Burton, and Sarah Choi for their insightful and invaluable assistance during various stages of preparing this book; to the Writers Room; and to Diana Murphy and Ellen Nygaard Ford, editor and designer, respectively, at Abrams, for their extraordinary sensitivity and intelligence in realizing this book. Thanks always to Dakota, Zoe, and Pierce Jackson, Pauline Goldberg, Lillian Kiesler, Jill Poller, and Dorothy Hurley for their ideas and constancy. Finally, a heartfelt note of gratitude to Laurie Anderson, for her remarkable ability to speak so many languages—of art, music, culture, politics, and desire.

INDEX

Page numbers in *italic* indicate illustrations.

Abramovic, Marina, 23
Absent in the Present (Looking into a Mirror Sideways)
 (photograph), *25*
Acconci, Vito, 12, 14, 18, 38, 40, 54
Acker, Kathy, 58
Acoustic Lens (invention), 75, *75*
Adams, John, 86
Afternoon of Automative Transmission, An (concert), 37, *37*
albums/records, 13–14, 20, 92, *93*, 111, 124–25, 127, 134.
 See also songs
aliens, *104*, 105
"Alive from Off Center" (video), 127, 131, *131*, 132, *132*
American Beat Poetry, 18
Americans on the Move, Part I (performance), 60, *60*, *61*
Ammann, Jean-Christophe, *20*
Ammann, Judith, *20*
Anderson, Laurie, *95*, 154; in "Alive from Off Center," *130*,
 131, 132, *132*; in Bali, *23*; with battery-powered hand-
 lights, *140*; with battery-powered light in mouth, *140*; in
 Beautiful Red Dress, 135, *135*; in Blue Horn File, *19*; with
 Burroughs and Giorno, *20*; on cover of *Big Science, 84,*
 85; in "Drum Dance," 141, *141*; education of, 25, 27,
 32, 34; in *Empty Places,* 148, 149, *151*; family of, 25,
 28, 50; in Fast Food Band, *18*; with Van Tieghem, de
 Marins, Fisher, Obrecht, *88–89*, *93*; with Headlight
 Glasses, *108–9*; in "How to Speak French," *95*; in *The
 Human Face, 146–47,* 149; in "Language Is a Virus,"
 113, *114–15*; in "Langue d'Amour," *113*; with Lens
 Head, *75*; in London, *21*; as migrant worker in Kentucky,
 14; in Milan, *20*; in New York, 32; in Nova Convention,
 59; in *O-Range, 40, 41*; in "O Superman," 90, *91*; in *O
 Superman* video, *128–29*; in *Personal Service
 Announcements,* 134, *134*; with Pillow Speaker, *140*; in
 "Private Property," *98,* 99; in "Radar," *116,* 117; religion
 and, 25, 164; at *ROSC '80, 17*; on "Saturday Night
 Live," *131*; in "Sharkey's Night," *110*; in "Smoke Rings,"
 121; on *Strange Angels* album cover, *124*; with Talking
 Stick, *184*; in *Talk Normal,* 132, *133*; in "Talkshow," *95*;
 in *United States, 88*; with violin, *15, 26,* 27, 28, *29, 41,
 52, 55, 56, 59, 60, 66, 73, 76, 77, 78, 79, 81, 107*, 143;
 in *Voices from the Beyond,* 154; in "White Lily," *111*
Anderson, Patrice, *73*

Andre, Carl, 34
animals, 106
animation, *82–83*, 118–23
Anti-Inaugural Ball, 85
Arte Povera, 16, 77
art instruments, 175–77
Artist Introductions (video), *132*
Artists Select Artists series, 40, 41
Artists Space, 15
Ashley, Robert, 13, 16, 86, 155
As:If (performance), 48, *48, 49,* 50, 53, 80
Askew, Joy, *115*
At the Shrink's (installation), 20, 54, *54,* 180
attic, in *Puppet Motel, 169*
Audio Glasses (body instrument), *139*
audiovisual installations, 70–72
"Audite" (song), 185
"Auto-Da-Fé" (concert piece), 37
Avraamov, Arsenij, 37

Baldessari, John, 42
Bali, *23*
Ballard, Norman, 145
Balou, Phil, *131*
bands, *18,* 19
Baran, Roma, *22,* 87
Beautiful Red Dress (music video), 135, *135*
Beckley, Bill, 18
"Beginning French" (story), 61
Belew, Adrian, *110,* 111, *115*
Benjamin, Walter, 17, 21, 124
Beuys, Joseph, 18
Bible, 19, 50, 164
Bielecki, Bob, *22,* 74, 75, 77, 80, 86, *139,* 184
Bigelow, Kathryn, 58
Big Science (orchestral adaptation), *84,* 86, 87
"Big Science, Little Men" (song), 85
Bird Catcher in Hell (score), 111
"Black Water" (song), 50
"Bless This Bran" (song), 50
Blood Fountain (installation), *174,* 175
Blue Gene Tyranny, 16, 18, 125
Blue Horn File, *19*

"Blue Lagoon" (song), 86, 123
Bobadillo, Isidro, *110,* 111
body instruments, 14, 139–42
Bogosian, Eric, 14, 154
books, 20, 42–46
Borges, Jorge Luis, 155
"Born Never Asked" (orchestral adaptation), 62, 86, 87
Box with the Sound of Its Own Making (Morris), 16, 37
"Boy Overboard" (song), 185, 188
Branca, Glenn, 18
Brantuch, Troy, 13
Brecht, George, 37
Broodthaers, Marcel, 18
Brown, Trisha, 12, 22
"B Side of the National Anthem" (song), 134
Buchholz, Fred, 27
Budapest, *8–9*
Buddhism, 28, 33, 99, 164
Burckhardt, Jacqueline, *20*
Burroughs, William, 17, 18, *20,* 58, *58,* 99, 117, 154
Burton, Scott, 12, 38
Bush, George, 85
Butler, Bobby, *114*
Butler, Sam, *115*
Buy Buy Wright: Film/Song in 24/24 Time (score), 63, *63*

Cage, John, 16, 23, 58, *58,* 63, 77, 164
Cale, David, 154
Cancellation (etching), 46, *46*
car concert, 37, *37*
Carmen (music video), 134, *134*
Carter, Jimmy, *114*
CD-ROM's, 23, 149, 168–72
Chatham, Rhys, 18
Chord for a Room (installation), 16, *64,* 65, 68
Clearmountain, Bob, 125
Clevinger bass, 80, *80*
"Click!" (song), 50
"Closed Circuits" (song), 75, *75,* 97
Coe, Robert, 22, 86
computer mouse, and *Puppet Motel, 170*
"Concerto for Land Rover with Six-Cylinder Backup"
 (concert piece), 37

concerts, 37, *37*

Coney Island, January 14, 1973, 4–6 p.m. (photograph), 39, *39*

"Confessions of a Street-Talker" (story), 77

"Coolsville" (song), 125, 150, 153

C7500 (exhibition), 41

Cunningham, Merce, 58

Dadaists, 11

Dal Vivo (Life) (installation), 15, 16, 20, 23, 54, 180–83, *181, 182, 183*

dance moves, *121*

"Dance of Electricity, The" (song), 105

Darboven, Hanne, 18

Dark Dogs, American Dreams (audiovisual installation), 71, *71*

Davis, Anthony, 86

"Day the Devil, The" (song), 125

DEARREADER (film), 25, 47, *47*

Demme, Jonathan, 111, 117

"Democratic Way" (song), 97

diaries, 46, 47

Diesler, Martin, *20*

Diggs, Benny, *131*

digital violin, 78, *78,* 80

Diving Board, drawing for, *144*

Dog Show (film), 106

"Don't Lose It Now!" (song), 50

Doormat Love Song (invention)*,* 68, *68*

Drake, Frank, 95

drawings, 42

"Dream Before (for Walter Benjamin), The" (song), 17, 21, 124

dreams, 13, 28, 38–39, 71, 106

"Drum Dance," 141, *141*

Drum Suit (body instrument), 14, 139, 141, *141*

Duchamp, Marcel, 16, 18

"Duck's Foot Dissolve" (projection system), 86

Duet for Door Jamb and Violin (invention), 65, 66, *66*

Duets on Ice (performance), *52–53,* 53, 80, 164

dummy: digital, *168, 171;* with violin, 78, *78*

Dupuy, Jean, 65, 80

Eight Standing Figures (sculpture), *36*

Electric Chair (invention), *68*

Empty Places (performance), 39, 111, 124, 125, *148,* 149, 150, *151,* 152–53, 156. *See also "Strange Angels"*

"Engli-SH" (song), 58

Eno, Brian, 16, *22,* 154, 173

etchings, 42, 46

exhibitions, 40

fake hologram (invention), 54, 65, 69, *69,* 81, *81,* 87, 180

Fast Food Band, *18*

"Fast Food Blues" (song), 18

Fenley, Molissa, 22

Film Projection from Inside Purse (invention), 65, *65*

films, 14, 25, 41, 47, 58, 106, 110–17, 118, 146–47, 149

Fine Arts Building, 18

"Finnish Farmers" (story), 107, *107*

Fisher, Charles, *88–89, 93*

Fisher, Joel, 32, 42

flashlight, and *Puppet Motel, 170*

Floating Theater, The (stage set), *145*

Fluxus artists, 11, 16, 37

Flying Geese (etching), 42, *42*

Foreman, Richard, 173

For Instants: Part 3, Refried Beans (performance), *56–57,* 63, 77

"From the Air" (song), 96

Futurists, 11, 37

Gabriel, Peter, 22

George, Bob, 22, 47, 92

Ginsberg, Allen, 58, 154

Giorno, John, 18, *20,* 58, 154

Girl on the Beach (audiovisual installation), 71, *71*

Girouard, Tina, 32

Glass, Philip, 16, 32, 58, 86, 173

"Gold Coin, The" (story), 180

Gordon, Douglas, 15

Gordon, Peter, 16, *18, 19,* 86, 87

"Gravity's Angel" (song), 79, 80, 123, 164

Gray, Spalding, 14, 154, 173

Green, Miles, 186

Green Room (Web site), 167

Handbook (book), 42

hand-lights, battery-powered (invention), *140*

Handphone Table (invention), 74, *74*

Handtable (sculpture), 139

Handwriting (Mudra) (sculpture), *33*

Harley, Rufus, 87

Harmonizer, 58

Harris, Susie, 32

Hawkins, Stephen, 145, 164

Headlight Glasses (body instrument), *108–9,* 139

Hearring (art instrument), 175, *175*

Hemingway, Ernest, 89

Herbert, George, 74

Here (Web page), 172

Hesse, Eva, 36

"Hey Ah Hey" (song), 55

Heyward, Julia, 56, 58, *59*

"Hiawatha" (song), 150, 153

Hiemarch, Britta, 87

High and Low: Modern Art and Popular Culture (exhibition), 154, 164

Highstein, Jene, 32

Himalayas, *27*

Hoberman, Perry, 22, 86, 127

Holland, Charles, 90

hologram. *See* fake hologram

Home of the Brave (film), 14, 79, *110,* 110–17, *111, 112, 114–15, 116, 117,* 118, 127, 139, *140, 141;* costume sketches for, *113;* diving board in, *144;* stage set for, *144*

Homer, 18

"Hotel Hot Dogs à la Laurie Anderson" (recipe), 69

"Hour of Power" (song), 50

"How to Speak French" (segue), 95, *95*

How to Write (film), 118

How to Yodel (performance), *80*

Huang, Hsin-Chien, 168–72

Hugo Boss Awards Exhibition, 174, 175, 178–79, *178–79*

Human Face, The (film), *146–47,* 149

Hutchinson, Peter, 18

ideograms, 118, *119*

"I Dreamed" (sound on Tape Bow), 81

"If You Can't Talk About It, Point To It" (song), 17

"If You Were a Sport" (song), 50

"Individuals" (story), 57

installations, 15–16, 20, 23, 54, 65, 67, 69–71, 149, 174, 175, 178–83

Institutional Dream Series (wall piece), 18, 38–39

Internet. *See* Web pages

Interval Research Corporation, 184

In the Nick of Time (performance), 50, *50,* 65

inventions, 22, 64–76, 87, 108–9, 127, 184, 185

"Is Like" (song), 50

"It's Cold Outside" (Talking Orchestra piece), 62

"It's Not the Bullet That Kills You (It's the Hole)" (song), 70

"It Tango" (song), 96

Johnson, Scott, *18*

Jonas, Joan, 13, 14, 38

Jones, Bill T., 22, 173

Jukebox (audiovisual installation), 62, 70, *70,* 71, 72, *72*

"Kerjillions of Stars" (song), 19

Khumalo, Bakhiti, 125

Kitchen, The, 18

Knowles, Christopher, 173

Kos, Joe, *73,* 87

Kosuth, Joseph, 18

Kounellis, Jannis, 77

Kristeva, Julia, 17

Landry, Richard, 32, *110,* 111, *114*

language, 16–19, 58, 118

"Language Is a Virus" (song), 17, 85, 99, 113, *114–15,* 127

"Language of the Future, The" (song), 17, 28, 59

"Langue d'Amour" (song), *113*

laser tunnel, *2–3, 145*

"Last Great World War, The" (story), 180

"Last Man" (song), 189

Lawson, Thomas, 13

Leary, Timothy, 58

Lens Head (invention), 75, *75,* 186

"Let X=X" (song), 86, 97

Levine, Sherrie, 13

Lewitt, Sol, 34

Lhamo, Yungchen, 173

Lhotski, Tina, 58

Light in August (book), 42, *43*

"Lighting Out for the Territories" (song), 109

"Like a Stream" (Talking Orchestra piece), 62

Lippard, Lucy, 41

Longo, Robert, 13, 14

"Lower Mathematics" (story), 112

Lyndsay, Arto, 125

Magnuson, Ann, 14, 154

Magritte, René, 18

Mailman's Nightmare, The (audiovisual installation), 71, *71*

Majewski, Jack, *18*

Man with a Box (photo-narrative installation), 41, *41*

March Cancelled (sculpture), 34, *34*

Marins, Anne de, 87, *88–89*

Matta-Clark, Gordon, 32

Matthews, Max, *80*

McDonald, Dolette, *75, 110,* 111

McFerrin, Bobby, 125

McLuhan, Marshall, 17

"Mechanical Man" (song), 189

Meltdown Festival, 173, *173*

Melville, Herman, 19, 25, 28, 47, 89, 185

Memory (mudra sculpture), 33

Mister Heartbreak: album, *62,* 111; performance, 78, 111, 113, 156

Mitchell, Eric, 58

Moby Dick (Melville), 19, 185

"Monkey's Paw, The" (song), 125

Monk, Meredith, 13, 86

Moorman, Charlotte, 16, 77

Mori, Mariko, 15

Morris, Robert, 16, 37

Motor-Vehicle Sundown Event (G. Brecht), 37

mouth, battery-powered light in, 139, *140*

Mudd Club, 18, 19

mudras, 30–31, 33, 118, 139

music, 16, 86–87. *See also* albums/records; songs

music videos, 134, 135

"My Eyes" (song), 152

Natural History (performance tour), 111, 156

Nature (mudra sculpture), 33

Nauman, Bruce, 14

Nelis, Tom, *28,* 186

neon violin and bow, 79, *79, 81*

"New York Social Life" (song), 72, *72*

New York Times, Horizontal/China Times, Vertical (assemblage), *35*

Night Court, 100 Center Street, December 29, 1972, 10:30 p.m.–1 a.m. (photograph), 38, *38*

Nightdriver (installation), *67*

"Night in Baghdad" (song), 159

"1976" (song), 50

"Noah's Song" (song), 189

Nonas, Richard, 32

Nordine, Ken, 173

notation, 118–23

Nova Convention, 18, 20, *58,* 58–59, *59,* 77, 154

Numbers Runners (installation), 69, *69*

Object/Objection/Objectivity (photo-narrative installation), 18, 41, *41*

Oblowitz, Michael, 58

Obrecht, Bill, 87, *93, 110,* 111

October (book), 46

"Old Flames" (song), 50

"On Dit" (performance), 58

110 Records, 92

"One White Whale" (song), 188

Oppenheim, Dennis, 54

O-Range: exhibition, 40, *40;* film, 41, *41;* sound work, 40, *40*

orchestral adaptations, 62, 86, 87

"O Superman" (song), 13–14, 85, 86, 87, 90, *91,* 92, *92,* 127

O Superman (video), *4,* 127, *128–29*

Out of the Blue (performance), *55*

Package, The (book), 42, *44–45*

Paik, Nam June, 16, 77

parrot. *See* talking parrot

Pendarvis, Janice, *75, 110,* 111

performance-lectures, 132, 133

performances, 10–13, 14, 15, 17, 18, 19–20, 21, 23, 27, 28, 29, 38, 39, 48–61, 63, 73, 77, 80, 81, 86–110, 111, 113, 124, 125, 138, 139, 143, 148, 149, 150–67, 173, 184–89

Personal Service Announcements (videos), 127, 132, 134, *134*

"Phase and Shape" (video projection), *73*

photographs, 25, 38, *74*

photo-narrative installations, 41

"Pieces & Parts" (song), 188

Pillow Speaker (body instrument), 139, 140, *140*

Piper, Adrian, 56

Plato's cave, in *Puppet Motel, 170*

Poe, Amos, 58

"Politics and Music" (song), 152

Ponape, 23

Ponce, Daniel, *110,* 111

Pontius, Geraldine, 37, 38, 47

postcards, 69

Prison (mudra sculpture), 33

"Private Property," *98,* 99

pulped-paper sculptures, 30–31, 33, 34

Puppet Motel (CD-ROM), *168,* 168–72, *169, 170, 171, 172*

Quartet for Sol Lewitt (score), 62, *62*

"Radar," *116,* 117

"Ramon" (song), 19, 150

Rauschenberg, Robert, 37

Reagan, Ronald, 85

records. *See* albums/records

Reed, Lou, 22, 173

"Right to Bear Arms, The" (story), 165

Rist, Pipilotti, 15

Rochester Horn and Engine Society, 37, *37*

Room-as-Camera, The (invention), 65, *65*

ROSC '80, 17

Rowland, Louise Edith Orban Phillips (grandmother), 25

Ruscha, Ed, 42

Rushdie, Salman, 173

Russell, Arthur, *18*

Sagan, Carl, 95

Sagan, Linda, 95

Sakamoto, Ryuchii, 22, 173

Salle, David, 13, 14

"Sand" (story), 180

"Saturday Night Live" (TV appearance), *131*

"Say Hello" (song), 81, *94,* 95

Schlemmer, Oskar, 78

Schnabel, Julian, 14

Schneider, Peter, 37

Schwitters, Kurt, 18

scores, 62–64, 111

Scorsese, Martin, 117

Screen Dress (body instrument), 51, *138,* 139, 164

sculptures, 30–31, 33, 34, 35, 36, 139

segues, 95

Self-Playing Violin, 80, *80*

Seven Weekends in March (sculpture), *34*

"Sharkey's Day" (song), *62,* 122

Sharkey's Day (video), *126,* 127, *127*

"Sharkey's Night" (song), *110,* 111, 122

Sherman, Cindy, 13, 14

Simmons, Laurie, 13

slow-scan video system, 73, *73*

Smith, Patti, 58, *58*

"Smoke Rings" (song), *121*

"Somebody Else's Dream" (song), 159

Some Experiments (invention), 66, *66*

songs, 11, 12, 13–14, 17–18, 19, 21, 23, 28, 38, 50, 51, 55, 58, 68, 70, 72, 73, 74, 81, 85, 86, 87, 90, 91, 92, *94,* 95, 96–97, 98, 99, 105, 106, 109, 111, 113, *121,* 122–23, 124–25, 134, 150, 151–52, 156, 159, 164, 175, 185, 188–89. *See also* albums/records

Songs and Stories for the Insomniac (performance), 51, *51,* 139, 164

Songs and Stories from Moby Dick (performance), 19–20, 23, *28, 29,* 149, *184,* 184–89, *186, 187*

Songs for a Foreshortened Hallway (performance), *143*

Songs for Lines/Songs for Waves (film-video performance), *7,* 73, *73*

Sonnier, Keith, 32

Sontag, Susan, 58

Soundings (Rauschenberg), 37

sound tracks, 111

sound works, 40

Speaking Swedish (film), 58

Speed of Darkness (performance), 155, 173

stage sets, 143–45

Stereo Decoy: A Canadian-American Duet (installation), 67, *67*

"Stereo Song for Steven Weed" (song), 68, 70, *70*

Sterne, Laurence, 25, 47

stories, 13, 25, 51, 57, 58, 59, 61, 77, 85, 107, 112, 127, 143, 150, 154–55, 159, 165

Stories from the Nerve Bible (book on Anderson), 164

Stories from the Nerve Bible (performance), *2–3, 5,* 23, 27, 78, 111, 127, *139, 145,* 149, 156–57, *156–57, 158, 160,* 161, *166,* 175

Strange Angels (album), 111, *124,* 124–25, 127, 134. *See also* "Empty Places"

"Strange Angels" (song), 150

Street Wall Journal, The (book), 42

Street Works I–IV, 38

Strings, Electra, 173

Sukavati, Putra, *23*

Sverrisson, Skúli, 186

"Sweaters" (song), 96

Swimming to Cambodia (sound track), 111

Synclavier, *62,* 78

Talking Orchestra pieces, 62

Talking Parrot (invention), 175, 178–79, *179*

Talking Pillow (invention), 74, *74,* 178

Talking Stick (invention), 20, 184, *184,* 185

Talk Normal (video), 132, *132*

"Talkshow," 85, 95, *95*

Tape Bow Trio, *73*

Tape Bow Violin, 15, 16, *17,* 20, 62, 73, *73,* 80, *80,* 81, *81,* 143

Taylor-Wood, Sam, 15

technology, 14–15, 23, 149

television, 127

Ten Days in May (sculpture), *34*

Tesla, Nikola, 74

"That Chicken Float As I Lie" (song), 50

"That's Not the Way I Heard It" (performance), 58

Tilt (sculpture), 176, *176*

"Time Tunnel" (story), 165

tours, 78

Tudor, David, 77

Turner, Anthony, *28,* 186

Twain, Mark, 25, 89

Two-Track Song for Sliding Doors (invention), 68, *68*

Under Capricorn: Art in the Age of Globalisation (exhibition), 172, *172*

United States (performance), *1, 10, 11,* 11–13, *12,* 60, 69, 75, 79, 81, *86–87,* 86–110, *88–89, 91, 92, 93, 94, 95, 98, 100, 101, 102, 103, 104, 105, 106, 107, 108–9,*

111, 113, *139*, 143, 156; animation figures used with, *82–83*; book, 42; diving board in, *144; Part 1, 63; Part 2*, 85, 86, 90; tech diagram for, *142*

Van Tieghem, David, 16, *19*, 87, *88–89*, *115*, 125
ventriloquist puppet. *See* dummy
Video Bow (invention), 127, 175, *175*
video clone, 132
Video Glasses (body instrument), *139*, 156
video projections, 73
videos, 4, 20, 23, 126–38
violin(s), 12, 15, 16, *17*, 19, 20, 22, *26*, 27, 28, 29, 51, 62, 73, 77–81, 86–87, 143; Anderson with, *15, 26, 29, 41, 52, 55, 56, 59, 60, 66, 73, 76, 77, 78, 79, 81, 107, 143*; dummy with, *26*, 27, 78, *78*
Viophonograph, 15, 20, 77, *77*, 81, *81*
"Voice Drums" (sound on Tape Bow), 81
Voices from the Beyond (performance-talk), 21, *154*, 154–55

"Waiting for You" (song), 50
Waldman, Ann, 58
Waldman, Price, 186
"Walking & Falling" (song), 96
"Walk the Dog" (song), 106
wall pieces, 18–19
War Child (foundation), 173
"War Is the Highest Form of Modern Art" (story), 159
Warner Brothers Records, 13–14, 92, *93*
Way You Moved Through Me, The (photograph), *74*
Web pages, 23, 149, 167, 172, *172*
Wegman, William, 42
Weiner, Lawrence, 18
"Well-Tempered Beep, The" (concert), 37
Wenders, Wim, 22
What You Mean We (video), *130*, 131, *131*
"Where I Come From" (story), 165
Whirlwind (installation), 15, 177, *177*
"White Lily" (song), *111*
White on White (score), 63, *63*

Whitman, Walt, 87
"Wild White Horses" (story), 165
Wilson, Robert, 13, 22, 86, 111, 173
Windbook (book), 20, 46, *46*
With Hidden Noise (Duchamp), 16
Wittgenstein, Ludwig, 17
Women's Action Coalition (WAC) protest, *24, 26*, 27
Women's Bathroom, Schermerhorn Library, Columbia University, April 3, 1972, 1–4 p.m. (photograph), 38, *38*
"Word of Mouth," 23
"World Without End" (song), 175

"Ya!" (song), 50
You're the Guy I Want to Share My Money With (album), 20

Zappa, Frank, 58
Zazou, Hector, 173
Zeta MIDI violin, 80, *80*

PHOTOGRAPH CREDITS

MAST HE AD

MONK